A Psychoanalytic Engagement with the Arts

A Psychoanalytic Engagement with the Arts applies Freud's anthropological writing and theories to contemporary works of fiction and poetry.

Giuseppina Antinucci offers close readings of the works of contemporary literary figures Chimamanda Ngozi Adichie, Amelia Rosselli, and Jhuma Lahiri, from a psychoanalytic standpoint. Through these close readings, Antinucci uses the interweaving of the characters' psychology with the demand of their social context to interrogate the factors that impact on their capacity and condition for survival. Throughout, she applies the Freudian concept of *Kulturarbeit* – the quota of psychic work pertaining to the symbolic order – and considers contemporary human experiences of migration and border-crossing, reparation, trauma, and critical race theory from a psychoanalytic perspective. Adopting Winnicottian, Lacanian, and Freudian methodologies, Antinucci adeptly illustrates the impact of psychoanalysis on art and vice versa, offering a novel way to approach contemporary issues of the psyche and human experience.

Using a psychoanalytic engagement of contemporary fiction to address the complexity of human existence, this volume will be of interest to psychoanalysts, as well as researchers and students interested in the intersection between psychoanalysis and the creative arts.

Giuseppina Antinucci is a Fellow of the British Psychoanalytical Society and a Full Member of the International Psychoanalytical Association. She divides her time between Milan and London, while also teaching widely in the UK and abroad. She is on the Editorial Board of the *International Journal of Psychoanalysis, Psychoanalytic Quarterly*, and Routledge's New Library of Psychoanalysis series, and is a member of the organizing committee of the European Psychoanalytic Film Festival and has authored several articles and book chapters on the intersection of psychoanalysis and the arts.

A Psychoanalytic Engagement with the Arts

Culture and *Kulturarbeit*

Giuseppina Antinucci

LONDON AND NEW YORK

Designed cover image: "Klippen Am Meer" by Paul Klee

First published 2026
by Routledge
4 Park Square, Milton Park, Abingdon, Oxon OX14 4RN

and by Routledge
605 Third Avenue, New York, NY 10158

Routledge is an imprint of the Taylor & Francis Group, an informa business

© 2026 Giuseppina Antinucci

All rights reserved. No part of this book may be reprinted or reproduced or utilised in any form or by any electronic, mechanical, or other means, now known or hereafter invented, including photocopying and recording, or in any information storage or retrieval system, without permission in writing from the publishers.

Trademark notice: Product or corporate names may be trademarks or registered trademarks, and are used only for identification and explanation without intent to infringe.

British Library Cataloguing in Publication Data
A catalogue record for this book is available from the British Library

ISBN: 978-1-032-69694-2 (hbk)
ISBN: 978-1-032-68554-0 (pbk)
ISBN: 978-1-032-69695-9 (ebk)

DOI: 10.4324/9781032696959

Typeset in Times New Roman
by Taylor & Francis Books

For Sean and Lianna

Contents

	Acknowledgements	viii
	General introduction	1
1	The work of *Kultur*, the being of nature	11
2	For a psychoanalytic perspective on the malaise of the culture	33
3	The universally human: Interweaving the subjective and the societal	45
4	Believe me, do not believe me: The durwan's (gatekeeper's) paradox	71
5	Characters: Fictional, real, verisimilar, and plausible	98
6	Ideals in a world without fathers	115
7	Americanah: The blogger, the humourist	157
8	The intermittent epiphanies of trauma: The melancholic discourse of the trilingual poet Amelia Rosselli	180
	Index	204

Acknowledgements

Writing this book has been a labour of love. Both writing and being in love can feel like a rollercoaster ride, with moments of elation alternating with doubts, self-doubts, despair, trepidation and desire. Alongside the imaginary companion-readers and not always friendly inner voices, the real accompaniment of friends and family has been crucial, I could not have done it without their interest and confidence in my project. Too many to list, they will recognize themselves reading these lines.

I am grateful to the Routledge team who have worked with me: Ruth Bourne and Reanna Young for their assured professionalism, Ayushi Awasthi for her attentive, patient, and diligent work and for designing the book cover. I have felt in a direct line with her in India, she always responded prompted to all my queries, patiently guided me and helped me navigate the meanders of technology and copyrights. Thank you, Ayushi.

I especially want to convey my gratitude to my editor Zoe Meyer, whom I met in Cannes in a sunny spring day during a European Psychoanalytical Federation conference. In the course of a leisurely walk along the sea-front promenade, sipping cups of coffee, we connected instantly, sharing our love for literature and language. Zoe's enthusiasm about my project – unbeknown to her and to me at that time – has been crucial in facilitating my bringing together my passion for psychoanalysis and the arts. Thank you, Zoe, for what I felt then and understood après coup, of the significance of our encounter.

I am grateful to HarperCollins Publishers for their permission to quote substantially from *Americanah* and *The Interpreter of Maladies*. Their UK based contracts assistant, Sam Burt, competently helped me extricate myself from the complexities of the globalized publishing world.

Thanks also to Lorenzo Barberis of Garzanti Editore in Italy, for working hard to locate the copyrights holder of the Amelia Rosselli estate, which was disseminated literally all over the world and is finally collected in the Rosselli Archive in Pavia. I also thank Jennifer Scappettone for her permission to quote from her bilingual selection of Rosselli's corpus.

The chapter on Rosselli is an expanded version of an earlier paper published in the *International Journal of Psychoanalysis*, and I wish to thank Routledge for their permission to reprint it.

General introduction

Preliminary remarks

East, West, North, and South; past, present, and future: they all converge at the crossroads of the Freudian *divan* – the legendary couch – the exquisite locus dedicated to the narration of the magic of stories – as Marina Warner remarks. A mainstay of our collective imaginary, the iconic couch has become the metonymy of psychoanalysis and a metaphor of the transformational potency of images and speech when addressed to a listening Other. Admittedly, in fact, a narration is always addressed to someone, or a reader, who is interpellated by the written text in the exercise of transference, which is nourished by fantasies, projections, imagination, desires, and is ubiquitous in human affairs. Freud gave words to his own subjective response to works of art in his paper about Michelangelo's Moses, the sculpture he repeatedly visited, was disturbed by, and whose aesthetic form he thoughtfully interrogated and was interrogated by.

In her review of the semiology of the Freudian couch Warner writes that it is the "prime symbol of psychoanalysis", it is embedded in our imaginary with the ornamental rugs that gesture to the "multiple borders and interlace of an oriental carpet, mirror the narrative of the [1000] *Nights*,...deepen the connections between the character and function of the stories and the method of psychoanalysis: encipherment and decipherment" (Warner, 2011, 411).

Freud's mindset, his very mode of thinking was imbued with literariness, and he famously received the literary Goethe prize. Amongst the many psychoanalysts exercised by the discursive juncture of literature and psychoanalysis, Pontalis deftly captures this motif in Freud's opus, to which he dedicated the book *Freud avec les écrivains* (2012), where he contends that illustrious and admired writers, especially Goethe, Mann, and Schnitzler, occupied a privileged position in Freud's imaginary as doubles, companions, inspirational geniuses, or rivals. Testimonials of his inner conversations with writers are his texts of 1908, *Delusions and dreams in Jensen's Gradiva* and *Creative writers and daydreams*, inspired by Jensen's novella. Additionally, these essays were a conduit to the

development of the concept of the construction of fantasies, rooted in and powered by the infantile unconscious and sexuality.

Parenthetically, coeval to *Gradiva* is *Family romances* (1909) which informs my reading of Jhumpa Lahiri's short story *When Mr. Pirzada came to dine*.

If artists have employed their genius and intuition to articulate and represent the depths, vagaries, and mysteries of the human psyche, it became Freud's and his followers' project to investigate the epistemic common ground between psychoanalysis and the arts. An arduous and, at times, byzantine proposition – I may add – to preserve with poise their dialogical reciprocity, in the face of the temptations to slide towards the logic of a dominant master discourse from both sides.

I will limit myself to emphasize the tension that traverses Freud's corpus, from which the emancipated reader will evince the spectrum of his positions: from the application of psychoanalysis to the writer, his biography, the fictional characters, or to the work of art itself – interpreted as a compromise formation akin to neurotic symptoms – to expressing awe and deference, as he does when he turns to the poets in the navigation of mysterious and unknown depths. Crucially, Freud appears to surrender and defer to the poet towards the close of his paper *Femininity* (1933), when he admits that the "dark continent" of female sexuality and the pre-oedipal remit of our psychic life troubled his epistemic logos. At this point Freud the "conquistador" of the unconscious bequeathed his female colleagues and the poets the honour and onus of further exploring the uncharted territory with the compass of their intuition.

Regrettably overlooked is the short paper Freud published anonymously in 1920 with the title "A note on the prehistory of the technique of analysis" (Freud, 1920). As the title indicates, the essay amounts to sparse notations, of remarkable interest all the same, because it shows Freud's mind at work with the travail of formulating the principles of free associations. The piece contains in filigree precious suggestions regarding the interlacing of psychoanalysis and literature in Freud's mind which, parenthetically, prove to be germane to my reading of Amelia Rosselli's poetry, as I will illustrate in chapter 8. In the essay, Freud refers to a book written in 1857 by Dr Garth Wilkinson, a mystic, poet and physician, wherein he proposes the method of "Impression" that consists in choosing a theme and letting the mind associate words and phrases to that theme, regardless of how strange it may seem. What will unfold is the development of the theme, produced by the mental movement which is "the response to the mind's desire for the unfolding of the subject" (1920, 263). Through this *laissez-faire* method, a command is imparted to "the deepest unconscious instincts to express themselves" (1920, 264), showing how much this "is essentially the method of psychoanalysis applied to oneself", and it further evidences how much Freud's method is "an artist's method" (1920, 264). In fact, purposefully employing it as a tool to delve into the unconscious depths, both literature and psychoanalysis legitimately champion the method of free association to envision the new,

unfamiliar, uncanny. Could it then be suggested that a quota of self-cure might well be implicated in all writings, through the handling of psychic material to be shaped within the structuring frame of the aesthetic form? And the psychic movement reverberates in the readers who, through the channel of identification with the staged drama, reach their own depth and vicariously retrace their own unyielding zones, with cathartic effects.

There is an irreducible albeit fecund tension in Freud's posture vis-à-vis the artists, and he oscillates between feeling understood – almost *being analyzed* – by their work, thereby attesting to the superiority of their intuitive knowledge, and exerting his *emprise* over the aesthetic objects, to the point of tautologically superimposing some discrete theoretical propositions, as if in need of consensual cross-disciplinary validation. The latter results in a practice that narrows down the field of study to a psychobiographical or, worse, to a pathobiographical interpretation of the art object, reducing it to the status of symptom of the artist's neurosis. This apprehension of psychoanalysis as a master discourse coexists with the countering dialogical humility in Freud; unfortunately, such legacy inherently informed the discipline he fathered for a protracted length of time afterwards. A veritable embodiment of its exasperation, Marie Bonaparte's book on Edgar Allan Poe is an egregious illustration of such profession of the hermeneutics of wild analysis, only to embarrass itself as a poorly disguised ex-cathedra attempt to appropriate the writer and his work, that through good fortune preserve their generative elusiveness. Mercifully and rightfully, in recent times psychoanalysis has increasingly found a more comfortable place in multidisciplinary conversations, and a more harmonious accord has replaced the execrable practice of the early days that only resulted in suspiciousness towards psychoanalysis, which was exiled from the arts and humanities. Of necessity, the profession of conjunction presupposes the respectful reciprocal hospitality and openness to the polylingualism that bespeaks the human condition. For a comprehensive historical review of this vast topic, Jean-Michel Rabaté's *The Cambridge introduction to literature and psychoanalysis* (2014) is a commendable source: it is a scholarly monograph that also traces the comparatively diverse itineraries of this field of studies in Anglo-American and European cultures.

Ironically, the quality of Freud's writings, most notably of his case histories, has stood the test of time; paradigmatic is his text based on Leonardo da Vinci's biography that reads like a novel, whilst his wild analysis of the artist's psyche – which Freud inferred from the mistranslation of the Italian *nibbio* as *vulture* – merely sponsored his theories of infantile sexuality, conflict, wishes, defenses, repression, sublimation, and inaugurated the infamous psychobiographical method, which resulted in well-deserved critique of reductionism and/or naïveté (Freud, 1910). Conversely, Freud avers his subjectively intense emotional response to the sight of Michelangelo's Moses in San Pietro in Vincoli, Rome, and his ingenuity has been referenced as an instance of unwitting introduction through aesthetics the not-yet-conceptualized

countertransference which has become a pivotal theoretical, clinical, and technical tenet. Whether the reader's response to art ranks with countertransference, transference or rather inheres in the more universal human sensitivity, the subjective resonance to a work of art has found its rightful place in the field of aesthetics, since the theory of the unconscious has decisively joined the cultural conversation.

This present monograph proposes the working hypothesis of the presence of an undercurrent of mutuality between psychoanalysis and the arts, whereby each puts the other to work to ascertain the spaciousness of given concepts that are often subjected to a process of hybridization. To quote but a few problematic examples: trauma, melancholia, mourning, the uncanny, reparation, the irrepresentable: these were originally clinical tools and have gradually infiltrated the language of aesthetic, literary and art critique. But do these concepts mean the same thing in each epistemic field? Is there a literature or art of trauma? Can an object of art repair personal and/or collective wounds? And if so, how? Does the commingling of terminology designate the same order of phenomena and experiences of the human subject? Or are we rather witnessing cases of unacknowledged calques, at the risk of overextending the remit of a given concept to the limit of meaninglessness?

Unarguably the undercurrent traversing both psychoanalysis and the arts is cradled in their shared endeavour to get to grips with the specific demands of *Kultur* and the malaise it engenders, as it morphs into the psychic structurization of human subjectivities.

Essays on the "art of trauma", Laub & Podell (1995), or Kandar Attias' idiomatic "aesthetic of repair", or else Phillida Barlow's "damage and repair" formal aesthetic are intriguing varieties of the said cross-fertilization. But does something get lost in the conceptual transmodal migration? Regrettably, an in-depth analysis of this vast topic is beyond the scope of this book, and I can only refer the reader to the available extensive publications, whilst it remains an important task to draw attention to their comparable, often convergent, yet diverse epistemic motives and languages.

The circumscribed scope of my project is to splice psychoanalysis and literature and consider how the vicissitudes of history and culture reverberate in selected works of fiction, with the additional corpus of a poet. More specifically, the first chapter focuses on the Freudian concept of *Kulturarbeit*, which a detailed work of re-reading can trace as a leitmotif throughout his oeuvre, whether it constitutes its unequivocal explicative focus or is but adumbrated as a slightly out of focus background. The contemporary rediscovered relevance of psychoanalysis in psycho-social and multidisciplinary studies bespeaks Freud's position as a cultural commentator and theorist *avant la lettre*, a phenomenon which could be considered as a process of foregrounding what was mostly latent in his work. When put to work – and aided by reflecting on the vagaries of translation – his neologism *Kulturarbeit* (work-of-culture) proves to be singularly pertinent to the analysis of the

situated fictional characters in some contemporary narratives which showcase the complexity or denounce the utter impossibility of mourning massive historical traumata. The first chapter will expatiate upon Freud's coinage of the term *Kulturarbeit*, whose translations have inflected semantic variations and consequently informed various research fields.

With different articulation albeit along similar lines, Said gestures to the significance of the Freudian opus to promote the understanding of cultural phenomena, when he affirms that "Freud was an explorer of the mind, of course but also, in the philosophical sense, an overturner and a re-mapper of accepted or settled geographies and genealogies" (Said, 2003, 27). Diverse geographies and genealogies register on the spatio-temporal coordinates of cultures which – as Said reminds us – need to be historicized with unprejudiced curiosity towards otherness, to tease out shared preoccupations and interests, whilst forgoing the lure of ideological refuge, in search of what is already known. In fact, according to Said, the enduring Freudian lesson is his incitement to inhabit *otherness* at all times in navigating the otherness-of-the-unconscious of human subjectivities across times and places.[1]

Psychoanalysis and forms of artistic representations

Fortuitously, albeit felicitously, Arthur Schnitzler's sixtieth birthday morphed into a document inscribed in the history of the checkered dialogue between psychoanalysis and literature, but only *a posteriori* could its overdetermined semantics be (re)constructed. On this occasion Freud addressed to him a letter that stands as a salient archival record, accrued by its significance of attesting the complexities, ambiguities, and ambivalence that troubled the father of psychoanalysis and the consequent dialogue of the discipline and literature.

The celebratory event certainly occasioned Freud's analysis of the fantasies, youthful passions, ambitions, and disposition which contributed to his transference entanglement with the novelist as internal object – as can be inferred piecing together the letter with extracts from his autobiography. Freud was alive to his anxieties that had consistently promoted refined maneuvers to avoid any personal encounter with the playwright which, ironically, must have been a heroic feat, for they lived in the same neighborhood and were learned men who frequented the same stately Viennese intellectual circles!

The figure of time the Greeks named Kairos, namely, the fleeting and highly charged tempus to be seized, also as an opportune moment for self-exploration, must have spoken to Freud, if he was prompted to breach his silence and address a greetings missive to Schnitzler. Freud's chosen register might be interpreted as confessional, in any event it is intimate, as befitting his desire to aver that he had dedicated his life's work and scientific mind to the study of the slippages, errors, gaps, and failures of the discourse of reason, the nocturnal creations, and the quotidian epiphanies of the existence of the *other scene* of the unconscious, that is, the same crepuscular realm

animating his fiction. With ingenuity Freud articulates his paradoxical feelings when reading Schnitzler's works whose fictional characters and world are so uncannily familiar, he delves into the same depths of the human psyche and explores the facilitations, conflicts, compromises, and neurotic suffering demanded by living in orderly society. Freud experiences an admixture of recognition, empathy and gratitude laced with admiration and envy; he punctuates the novelist's gift for situating the subject in his/her historical context, whose conventions, imperatives and rewards are processed in the internal world, where drives, affects – the life of the body – is subjectivized through words, thoughts, and signifying interests, always in dialectical conflict with the mores of a particular civilization. Freud writes:

> Not that I am easily inclined to identify myself with another, or that I mean to overlook the difference in talent that separates me from you, but whenever I get deeply absorbed in your beautiful creations I invariably seem to find beneath their poetic surface the very presuppositions, interests, and conclusions which I know to be my own. Your determinism as well as your skepticism – what people call pessimism – your preoccupation with the truths of the unconscious and of the instinctual drives in man, your dissection of the cultural conventions of our society, the dwelling of your thoughts on the polarity of love and death; all this moves me with an uncanny feeling of familiarity. (In a small book entitled *Beyond the Pleasure Principle*, published in 1920, I tried to reveal Eros and the death instinct as the motivating powers whose interplay dominates all the riddles of life.) So I have formed the impression that you know through intuition – or rather from detailed self-observation – everything that I have discovered by laborious work on other people. Indeed, I believe that fundamentally your nature is that of an explorer of psychological depths, as honestly impartial and undaunted as anyone has ever been, and that if you had not been so constituted your artistic abilities, your gift for language, and your creative power would have had free rein and made you into a writer of greater appeal to the taste of the masses.
>
> (Freud, 1922, 2018)

Freud's twinning identification with the writer, while remaining alive to the differences, is based on their dispositional inclination for introspection and self-analysis, imbued with pensive undertow. They both navigate the expansions, suppressions, disguised traces, and inscriptions deposited in the subject's memory of relational vicissitudes transgenerationally mandated across times.

Traces and inscriptions primarily point to the construction of the human being vis-à- vis language, which is always already given and demands subjection to the symbolic order for the subject to come into being, albeit always as an asyndetic project: this broadly defines the province of culture from the

psychoanalytic perspective. Notwithstanding, the unconscious is the very point where language fails and exposes the fallibility of reason, and the embodied corporeality is all that remains, as the locus of the drives, sexual and aggressive, which exert centrifugal forces inherent in and oppositional to all cultures, forces always already in excess of urban reining in.

Julia Kristeva signposts the very junction of the subject historicity, as she glosses *Civilization and its discontents* reading it with Lacan to bring to the fore the political and ethical dimensions of Freud's text.

> Thou shalt not sleep with thy mother, and thou shalt not kill thy father. However, this biblical resurgence in Freudian thought, which (it is worth recalling) structures the psychoanalytic conception of the psychic apparatus, is the starting point for what Lacan, reader of Civilization and Its Discontents, calls an ethic "beyond the notion of a command, beyond what offers itself with a sense of obligation." [But]desire is not subordinated to a commandment exterior to it. To state this more positively, moral obligation is rooted in desire itself; it is the energy of desire that engenders its own censorship. Why? "We do not know," says Freud modestly. But "the work of Eros is precisely this." Now, what if Freud really has an answer to this question, through an insight that he reiterates throughout the course of his work?—namely, the emergence of thinking as realized in a shared language that reins in the drive and commands it. This "command" becomes, from then on, intrinsic to the drive insofar as the latter is human (a drive is from the beginning an interweaving of energy and representation), and raises it to another level of the psychic apparatus, where the drive becomes desire. The drive is translated into the code of social communication, always already structured by language, in which the dialectic of freedom can be played out.
>
> (Kristeva, 1999)

In the theoretical fictional normativity Kristeva extrapolates in performing her exegesis, the drives hone in on the aim of desire and freedom, after journeying through the negativity that all psychic work enjoins. She implicates the dialectic process whereby the unruliness of the impulsive forces finds compromise solutions and (they) are subsumed under – sublimated – the ethics of desire, marked by the primacy of Eros, i.e., pleasure. From a different vertex this process can fall under the rubric of *work of culture* (*Kulturarbeit*) because it enables the subject to inhabit a social world that should offer a measure of compensation for the renunciation of wildly egotistic pursuits. Authors such as Zatzman, in fact, maintain that the analytic cure is to a degree a veritable *work of culture*. But *Kulturarbeit* in turn always interpellates society, for it is urged to perform its own quota of labour to guarantee the safety of its citizens. But what if the societal substratum does not provide the ground for the subject's dialectical psychic process to come to fruition? What if the forces of negation

morph into unrest and unleash the destructiveness that corrodes the social fabric? What if the law of exchange which founds the societal pact falters, as in phases of upheaval, turmoil and descent into barbarism? Quite appropriately, barbarism has come to denote the negative of civilization from its ancient Greek onomatopoeic meaning indicating "the one who does not speak" but only babbles. It follows that culture and language, if not synonymous, are certainly commensurate categories for thinking. Where can pleasure, desire, and freedom be attached to when a society breaks down? Wherefrom their guarantees?

I propose the thesis that at such times writers act as custodians of language; they bear witness to the onslaught historical upheavals deal to the symbolic register; they represent the wound, the subjective predicaments of their characters and in so doing they salvage the symbolic, which is preserved in the aliveness of their passion and freedom. Their erotics of thinking aligned to their relatively detached observational posture permit to construct a narrative space hospitable to the reader; alluring them with the pleasure of reading. Freud portrayed an analogous dialectical itinerary in children's playing with words: they take language apart, disassemble and distort words, which they reconstitute under the aegis of the "yield of pleasure" (Freud, 1905).

Eros weaves a "yield of pleasure" in-texting thought and words in Jhumpa Lahiri's compositions *When Mr. Pirzada came to dine* and *A real durwan*, in Chimamanda Ngozi Adichie's *Americanah* and Amelia Rosselli's poetic output. All these works are set against backdrops of instances of veritable societal disintegration; respectively, the Partition of India and the subsequent civil unrest, Nigeria's reckoning with decolonization, and finally, the murder of Rosselli's father and uncle orchestrated by Mussolini's regime. These texts offer an elaboration of collective events that challenge and defy the work of mourning and perforce remain unelaborated. Through close reading of these writings and their formal strategies I will explore how the macro-history percolates into the many stories narrated. I argue that the writers' sensibilities register the cultural shuddering and entrust their thoughtfulness to their works, that bear witness to the profound wound inflicted to the symbolic order, which they articulate, and somewhat mend the rent by recovering the very possibility of speech.

When all is said and done, the writers' desire and ethics are conveyed by their artistry and manufactured cultural object which live an additional life as memorial objects and above all they donate to the readers a "yield of pleasure": this is unquestionably the work of Eros.

Book plan

This monograph comprises eight chapters:

Chapter 1 sketches the historical and intellectual context which prompted Freud to formulate his theory of the *Kulturarbeit*. Some political and ethical implications are discussed.

Chapter 2 traces some of the post Freudian developments and interdisciplinary applications of *Kulturarbeit*, linking them with the vagaries of the translations offered respectively by Laplanche and Strachey. The work of Kaës is discussed in some detail, as uniquely generative for its emphasis on the symbolic order and the function assigned to the meta-social and meta-psychic guarantors.

Chapters 3 and 4 offer close readings of two short stories from *The interpreter of maladies* by Jhumpa Lahiri, respectively *When Mr. Pirzada came to dine* and *The real durwan*. Pertinent psychoanalytic concepts are elected to illustrate how dramatic moments of the Partition of India are deposited in and inflect the protagonists' psyche. Their psychology is inscribed in the small groups they belong to, which are regarded as microcosms where massive traumata and the vicissitudes of complex mourning resonate.

Chapter 5 and 6 are dedicated to a close reading of *Americanah*, by Chimamanda Ngozi Adichie, a novel that offers many suggestions to an in-depth analysis of the work of identity of a post-colonial subject, the uncertainties and perils of identifications with parental imagos, and the structures of the dominion–subjection inflecting the internal object relationships.

Chapter 7 addresses humour. Thematically it follows on from *Americanah*, whose protagonist Ifemelu relies on humour as a multifaceted resource, in the service of self-preservation, an instrument of political resistance and of personal creativity. Freud's essays on humour are analyzed for their political implications.

Chapter 8 is dedicated to Amelia Rosselli, a trilingual poet whose father was assassinated by Mussolini's henchmen for his opposition to the regime. Her work is both the receptacle of personal and collective trauma and the site of the (re)founding of a language uncontaminated by the murderousness of history.

Note

1 Other(ness) has become an overused, saturated concept, understandably so, as it is so richly ambiguous and polysemic. But so is language itself, essentially ambiguous and consequently polysemic. The Cambridge Dictionary definition of otherness is "**being or feeling different in appearance or character from what is familiar, expected, or generally accepted**", hence it can easily become a marker of identity. More specifically in psychoanalysis the "other" is often used interchangeably with "the object", but to avoid confusion with "internal object", the quality of otherness in this monograph refers to what is external to the self, whether it might be really, imaginarily or phantasmatically so. I will employ the term "otherness" to signify the shift . from the position of sameness (narcissism) towards the non-me, all throughout this monograph, including the shifts of subject positions. In this more general sense *otherness* qualifies a psychic space able to accommodate the changes, the new, the quality that essentially recalls Winnicott's maternal capacity to host the non-me and the non-infant, alongside the me-and-infant-together. This quality extends to the space of culture- as Winnicott postulates- where the transitional functioning segues the transitional phenomena and outlines the potential area of mutuality and transformation.

References

Freud, S. (1905). *Jokes and their relation to the unconscious.* SE VIII.
Freud, S. (2018). *Published letters from Freud to Schnitzler* (1906–1931). Library of Congress.
Freud, S. (1910). *Leonardo da Vinci and a memory of his childhood.* SE XI.
Kristeva, J. (1999). Psychoanalysis and freedom. *Canadian Journal of Psychoanalysis* 7 (1):1–21.
Laub, D., Podell, D. (1995). Art and trauma. *IJP* 76(5):991–1006.
Pontalis, J.-B., Goméz Mango, E. (2012). *Freud avec les écrivains.* Paris. Gallimard.
Said, E. (2003). *Freud and the non-European.* New York. Verso.
Rabaté, J.-M. (2014). *The Cambridge companion to literature and psychoanalysis.* Cambridge University Press.
Warner, M. (2011). *Stranger magic.* The Belknap Press of Harvard University Press.

Chapter 1

The work of *Kultur*, the being of nature

In Freud's oeuvre the word *Kultur* first occurs in manuscript N, an addendum to the letter addressed to Fliess on 31 May 1897. Therein, broadly speaking, he defines the concept of the *sacred*, which at that time he essentially postulated as consisting in the individual's sacrifice of the complete satisfaction of their impulses to the advantage of the community. This sketches a provisional exemplar of *Kulturarbeit* and foreshadows the two vertexes which subsequently articulate the work of culture, one pertaining to the individual and the other to society through institutional provisions like the family, educational and reeducation apparatuses, government, morality and religion, in the exercise of their capacity to rein in the unruly aspects of human beings which they must relinquish piecemeal as they journey through maturation, in exchange of safety from danger, and well-being.

It appears evident how since the outset Freud aspired to formulate a theory whose breadth would embrace the human experience from its corporeal rootedness in nature to the highest and everlasting symbolic and artistic realizations, altogether pivoting on the dynamic work of the psyche and its transformative potential. Freud, in fact, thought of his metapsychology as a metaphorical scaffolding to support his hypothesis of the unconscious, which is unknowable, except for its phenomenal derivatives. In his metaphorical apparatus for thinking, the work of culture supposedly forms a nexus with the institutions of law, justice, regulatory government, scientific and technical progress, and the artistic creations that nourish intellectual and spiritual sensibilities.

For Freud, subjective and societal processes bear resemblances, singularity and/or plurality are on a par, being the product of compromise formations synthetically obtained through the elaboration of contrasting forces mediated by the psychic agencies of the id, ego, and superego. Notably, when he uncouples the subjective and the collective, Freud often uses *Kultur* in the anthropological sense, interchangeably with the affine terms of civilization, community, and society, to be set aside from the more ordinary meaning of aesthetic creations, which can potentially engender confusion. If *Kultur* is undoubtedly a polysemic term, as is often the case with the uniqueness of the

DOI: 10.4324/9781032696959-2

Freudian language – and precisely for this reason – such ambiguities solicit controversies, discussions, further developments, and new interpretations, which emerge more clearly when put to the test of translation, as Laplanche's contributions attest.

The interpretation of dreams (1900) first italicizes the neologism *Kulturarbeit*, a composite term, for which the German language shows proclivity but presents a veritable challenge to the translators. Strachey and his team rendered *Kultur* into *civilization*, and *Kurturarbeit* mostly into *cultural activity* and only once into *work of culture*, evidently flattening the subtleties and ambiguities of the original. Rather differently, Laplanche assayed to convey all the nuances and proffered three different interpretive phrases, each with nuanced connotations: they are, respectively, *cultural work*, the *work of culture*, and *work of the culture* (E. Smadja, 2013). With different emphases, albeit concertedly, the three paraphrases uphold the dynamic process and the resulting sublimatory creation of a new object but *work of the culture* is rather nuanced towards the task incumbent on the governing institutions whose primary responsibility is to guarantee sustainable living conditions for the polity.

Admittedly the interrogation of the cultural demand of sexual repression to mold a "civilized" and well-adjusted personality makes Freud a revolutionary critic of the mores of his times, as *"Civilized" sexual morality* (1908) indisputably attests. I will further expatiate on this brief essay which I now reference purely as an aside, with regard to the epistemological importance of distinguishing the two discrete but overlapping provinces of the *psychic work of culture* – one pertaining to the individual and the other to society. Freud so indicated in his coinage, whereas Strachey simplified it, as can be read in an introductory note to *The future of an illusion*:

> In view of Freud's sweeping pronouncement [...] ("I scorn to distinguish between culture and civilization") and of a similar remark in "Why war?" it seems unnecessary to embark on the tiresome problem of the proper translation of the German word "*Kultur*". We have usually, but not invariably, chosen "civilization" for the noun and "cultural" for the adjective.
>
> (Strachey Introduction to S.E. XXI, 4)

It could be argued that Strachey takes too literally Freud's avowed scorn, whose locution might instead gain traction if problematized: perhaps the enunciation gestures to the counter-transferential bitter disillusionment of Freud-the-social-critic who had laid bare the hypocrisy of and constraints imposed by the *Kultur* which predispose to neurotic suffering, what with the failure to perform its share of the work. Hapless and dismayed, perhaps Freud was venting his defensive scorn to assuage the disappointment caused by the unleashing of unprecedented devastation. So profound was the effect

of World War I that, amongst other clinical factors, it instigated a revision of his project of enlightenment through education and elucidation of sexual matters. Although cognizant that the defining trait of the drives is their inherent unruliness, always in excess of enculturation and restraints, Freud was confident that hospitable receptivity to the wild impulses could tame them into desires, accept a measure of personal satisfaction and transform "neurotic misery into ordinary unhappiness". So much he had laid bare in *Civilized' sexual morality*, as evinced by the quotation marks that convey with witty irony his exposé of the dark sides of modernity. I would go as far as to contend that the irony veers towards parody and gives away – inter alia – Freud's insight into the unconscious otherness of the domain of culture to denounce its double-standard and taxing apophatic ethos.

As previously submitted, Freud presupposes an analogic structure that traverses and intertwines the subjective and collective transformations geared towards binding the destructive forces and the excesses of perverse sexual practice that are inimical to and potentially undermining of civilization. Freud was at pains to set the keystone of his theoretical scaffolding in the concept of the unconscious, which he deemed operational both in individual personality and in groups, and he coherently established a conceptual isomorphism based on scientific positivistic premises. He positioned the driving force of progress within the development and incremental acquisitions of ego mastery, and famously stated "where id was, there ego shall be", a principle whose applicable scope is both subjective and objective. This vision carries the mark of the optimism of the scientist of the enlightenment, which indisputably makes for a problematic and questionable foundation as to its aptness to understand large groups. In any event, the concept worth noting is that positing the unconscious driving forces is expedient to arriving at the thesis that illness, regression and breakdown can present as malaise of and induced by the culture, which he clearly outlines in *"Civilized" sexual morality*. The subject's neurotic, perverse, psychotic, and/or traumatic symptomatology often, albeit not always, carries the implicit sign of the dysfunctional, even oppressive and savage milieu which must be signified anyhow in the subject's inner reality.

I will commence by trying to single out a few strands which compound the personal and scholarly antecedents concurring to determine Freud's terminological choice, whose semantic shadows prove to be so heuristically generative in contemporary discourse.

Freud

In *An autobiographical study* (1925), Freud avows his lifelong engagement with the humanities, to the extent that in his youthful school years he had prefigured a career in anthropology or in analogous humanistic subjects. When eventually his professional choice oriented him towards the medical

specialties, he still cultivated the catholic interests of a renaissance polymath, was an omnivorous reader of literature, history and mythology, and was aware of drawing from his learning much sublimated libidinal pleasures in addition to copious metaphors to corroborate his theoretical formulations, as he famously writes apropos of the Oedipus complex. His corpus is laced with references to artists whose perspicacity, gifts and sensitivity he admired and envied, for their capacity to intuit the more hidden, darker aspects of human beings which he laboured to ground in his scientific discourse, namely, his metapsychology. Despite the criticalities, the breadth and complexity of his theoretical constructions show Freud's polyhedric mind, exemplary of the Mittel European bourgeoise intelligentsia.

Prior to studying medicine, Freud received a classical education at the German Gymnasium, whose syllabus was comprehensive of history, philosophy, art, and literature, thereby he acquired an extensive knowledge of the history of culture, as Said remarked. He was well versed in modern philosophy, ancient Greek and Latin classics, literature and mythology; he estimated Dostoevsky's *Brothers Karamazov* to be the most powerful work of fiction ever written, on account of its succeeding in shaping into narrative representation three forms of parricide: real, fantasied, and psychic. These very themes he explores in his psychoanalytic writings about the structuring juncture of the Oedipus complex, its salience for the healthy and the neurotic subject, and for the reasonably well functioning – or not –*Kultur*.

The Oedipus complex follows the trajectory of the development of the child into a socialized adult, capable of internalizing the received norms, owing to the fact of being born into a triadic symbolic oedipal order. Freud proffered that culture follows a similar path, based on his notion of the "complemental series" which links phylogenesis and ontogenesis through the transmission of the foundational primal unconscious fantasies of seduction, the origin or children, and sexual differences. Whether the notion of phylogenesis has any purchase on contemporary psychoanalysis or otherwise, it opened for Freud an avenue to thinking about the genealogy of the psyche as embedded in intersubjectivity, whose corollary is both the unconscious transgenerational transmission of the culture pertaining to group identity, and the child's earliest epistemological investigations into its origin. In conclusion, provided that we steer away from biological or scientific misconceptions, the Freudian notion of phylogenesis might just be referred to its etymological signifier of the libidinal bond within the group – *philia of* one's own *genealogy*, meaning the love of the tribe – and indicate that the psychological birth of the subject is always already inter-subjective.

Freud extends his examination of the conflicting drives at work in the anthropological narratives of the foundation myths in *Totem and taboo* (1913) and *Moses and monotheism* (1937) and addressed social psychology in *Group psychology and the analysis of the ego* (1921). *Civilization and its*

discontent (1930) rounds off the cycle of anthropological narratives that mark Freud's return to his original absorption in humanistic studies.

In the lecture "Freud and the non-European", Said makes the point that Freud's genius consistently addresses the problem of the *otherness* located in the unconscious of the subject whereas attentiveness to cultural otherness was outside his episteme, essentially owing to his erudition being steeped in the Christian-Judaic world, which sources his texts with symbols, elegant metaphors and rhetorical figures. Likewise, it is crucial to factor in our own historical contingencies, amongst which the decolonization and massive diaspora that effect the urgency of our conversations on the somatopsychic and cultural variations of peoples deterritorialized and coming to cohabit foreign geographies. Cultural anthropology was a nascent discipline in Freud's times, when the marker of the intellectual conversation was the primary need to ideologically justify colonial expansions.

Still regarding Freud's capacity to decenter his gaze, Kristeva emphasizes his binocular vision, which heroically embraces the heterochronicities of the cultural traditions he upheld, whilst also attending to the questions raised by his contemporary mores. Tellingly exemplar is his encoding the sexual impulse within the ideology hegemonic over a given cultural imaginary; he points out that where libidinal satisfaction was uppermost for the Greeks –regardless the object – Christianity introduced the notion of sin, that could be somewhat amended by circumscribing its practice to marriage and the begetting of children. The object of love was idealized, eclipsing pleasure and desire, relegated to the status of vile animal instincts.

Returning to Freud's catholic writings: are his expansive narratives exempla of *Kulturarbeit*?

Kaës argues for this interpretation and deems *Moses* to be the epitome of a textual *Kulturarbeit* that features a paternal figure who aggregates a group with its own specific culture, gives it a narcissistically cohesive identity and its own religion (2012. Kaës reads, appropriates, critiques, and develops Freud's work, whose relevance renders it the intertextual cornerstone for a cross-disciplinary epistemology to gain insight into the underlying functioning of our contemporaneity, its presuppositions, conflicts, dictates, mandates, and engendered malaise. I will elucidate these topics in a later chapter.

The role of psychoanalysis in multidisciplinary discourse

The extensive quotations from Frazer's *The golden bough* – which Freud references amongst the most inspirational – evince that he was conversant with the current literature in the field of the nascent anthropology which dealt with the vexed question as to whether the constitutive factors in molding subjects of societies are primarily rooted in nature or culture. The culturologists assumed the primacy of the symbolic order, since they aspired to disengage the discipline of cultures from the more essentializing tendencies of

studies that prioritized biology, hence the notions of race. Social anthropology publications spoke to Freud and offered a complementary frame to his constructivist thesis that one is not born but becomes man or woman, heterosexual or homosexual, for sexuality is always a compromise formation, precarious and liable to be reorganized all throughout the life cycle. Psychoanalysis at core militates against naturalizing doctrines, whose dubious intent of supporting the discourse of power was alive in Freud's mind.

His revolutionary ideas – especially those pertaining to infantile sexuality – may appear to jar with his political conservatism, but the contradiction becomes less problematic bearing in mind that the two aspects coexist because in either case his emphasis was on the process, rather than the downright dichotomous taxonomy of civilized or uncivilized. In fact, he unambiguously and consistently argued against all forms of teleological and metaphysical foundations of civilizations and, arguably, he was equally suspicious of any revolutionary telos tending towards utopian illusions of happiness, being a self-styled realistic pessimist. If echoes of Darwin and Frazer's influences lace his conceptualization of the "primitive mind", this phrase was not subjected to analytical deconstruction as value laden in Freud's time, and he employs it synonymously with "the child within", "infantile omnipotence of thought", to denote the animistically inflected mental representations of the world. Reading historically is conducive to detecting the implicit in language whilst also appreciating that Freud here proposes the coexistence in the mind of a mode of functioning developmentally appropriate to infancy and childhood with a more mature and sophisticated modality. This heterogeneity is a characteristic of the unconscious logic, governed by primary processes which, unlike secondary processes, ignore contradictions and temporality; it follows that psychic structures and modes of functioning become automatic patterns and are never lost or fully superseded, for individuals, groups and cultures alike, making regression a viable possibility at critical junctures.

Present-day psychoanalysts phrase in more culturally neutral terminology the *archaic, primary, infantile* traces of the mind, to indicate the residual inscriptions of the universal experience of birth and early nurture. In Freud's time, conversations on nature versus nurture were rousing, to an extent because of the intellectual reverberations of historical and political movements. Suffice to say that some authors, like the craniologist and anthropologist Paul Broca, propended towards the essentializing classification of *primitive* and *civilized*, but his recourse to a pseudo-scientific argument based on biology and physiognomy is redolent with implications of superiority and inferiority. A more grounded historical reasoning, accrued by the epistemological contribution of psychoanalysis, has revealed the ideological use of the science to establish *racial* supremacy and mystify power relations, and we are savvy about this racialized rhetoric. For the Zeitgeist of the social world of the XIX century, the scientific logos was repurposed to the ideology

underpinning colonialism, then the driving force prevailing in the economy and politics. Ultimately, it might be hypothesized that the cultural unconscious is at work in the naturalized taxonomy of races and enlisted those pseudo-scientific formulations defensively to repudiate feelings of guilt and responsibility for the violent dehumanizing commerce of cultural others to amass fortunes and capitals.

A different ethos undergirded the publications of the cultural anthropologists, amongst whom was the German Franz Boas who emigrated to the United States and is considered the founder of the new field, while in Britain Edward Burnett Tylor similarly poured over the distinct manifest features of field researched societies. Each in their own way, broadly speaking the culturologists kindled a similar preoccupation with the specific functions that distinguish humanity from the animal kingdom, which they identified in the pre-disposition to symbolization. The symbolic register morphs into multifaceted ramifications, the primacy of which is undoubtedly attributable to language for its universalistic versatility, aligned to its flexibility to be contextually inflected. Language is uniquely positioned to be learnt through development, exchanged, narcissistically invested and transmitted in a permanent ebb and flow of tradition and innovation.

Electively exercised by the sociology of knowledge, French social anthropology accentuated the polyvalent functions of symbols, whose representational heterogeneity provides the basic structures for thinking the primary categories of the sacred and the profane. Exemplary of this orientation is the agnostic Emile Durkheim, who pioneered studies on the elementary forms of religion and saw the nexus of the social and the religious emerging from attending to ritualized practices. Occasioning the reiterative periodically coming together of collectivity, in fact, religion becomes the terrain for group self-mirroring and establishment of coherent group identity, in time and space. Furthermore, religion being a vector of intergenerational transmission of tradition, it instigates expansive interest in the modalities of such conveyance through primary nurture. If these areas of research galvanized the cultural anthropologists and sociologists, initially it fell on them to turn their inquiry to the human infant's inborn pre-disposition to traverse the enculturation process, to receive the education to enter the language domain and apprehend the linguistic signifiers and codes of the group, the ultimate guarantor of the social inscription of the criteria of membership and belonging.

The term *civilization* is analogously historically situated and carries political and ideological connotations: bridging the XIX and the XX centuries, it was the word elected by the French intellectuals who represented the middle classes opposed to the *Ancient Regime* in favour of the advent of a new bourgeoise epoch. In this latter case *civilized* became antinomic with *barbaric* or *primitive*, whenever racial or class superiority demanded from the sciences to reinforce the political bias with corroborative justification.

Freud was familiar with the historical import and semantic nuances of these fervent discussions; therefore, his choice of *Kultur* needs to be ascribed not only to his class and intellectual status but also to the preoccupation with the delay in reaching nationhood in Germany which percolated in Austro-Hungarian intellectual circles. The German upper classes, in fact, privileged the word civilization, which they borrowed from the French current use and stress on the urban and polite meaning. In so doing they reclaimed the adjective *civilized* and rendered it the distinguishing mark of the cultivated upper echelons of society, unlike the barbarian backward indigent populace.

In the Germanic world the glaring delay in reaching nationhood saturated the XIX century public conversation, it informed the aesthetics of Romanticism and the search for expressive artistic idioms, myths, folklore, and legends which could concede a frame to the sense of cultural identity. Marx applied his political and economic analyses to the internal institutional fragmentation that hindered Germany's attainment of unitarian statehood, compared with most of Europe where the prevailing organization was the nation-state, with a distinct sense of identity, endorsed by the shared language, myths, customs, and cultural patrimony. Parenthetically, it may be of some relevance that Italy like Germany straddled unharmoniously the feudal remnants and the drive to join the colonial expansionist powers, and in both parallel authoritarian regimes prevailed in the interwar period.

In conclusion, Freud advertently employs the term *Kultur*, and his choice is a testimony of his learning and of his liberal political preoccupation and allegiance.

I refer the reader to Eric Smadja's excellent study *Freud and culture* (2015) for a detailed and scholarly analysis of the multiple and complex determinants of Freud's rather unique interpretation of social anthropological texts, which hinges on the notion of psychic work and the allied concepts of working through, transformation and sublimation, he regarded as operational in the individual and cultural unconscious. In keeping with the francophone intellectual tradition, Smadja pays close attention to the analysis of language and its reverberation in the work of translation, that is a patent sign of the influence of Lacan on French psychoanalysis. These suggestions which stem from the translative work of language align to my approach to the enquiry into the collective mentality, also rooted in the tenets and method of the Freudian talking cure. Not to mention that the primacy of language to connote the cultural unconscious as always already symbolically deposited in language, permits to avoid any possible confusion with Jung's proposal of the collective unconscious or eventual slippages into mystical perspectives.

As a lateral addendum to Smadja's review of the semantic halo of words which nuance the in-group signifiers and patrimony, I would include the idiom *customs* and its synonym *mores*, both connoting cultural identity and tradition, but also the etymological roots of morality (ethics derives from

ethos, that is, character, customs). Customs, habitudes, lore, rituals, observances, and tradition: these idioms are inscribed in the associative field that articulate the set of assumptions of "how things are done at home" – the narcissistic, undifferentiated, unthought habitus – they nominate the class of familiar social practices and the interpretive grid to decode them.

Amongst the templates that organize pre- and infra-verbal primary identifications, the techniques of infant care occupy a privileged position and host messages for transgenerational transmission. Not only do they prescribe nurturing practices, but they also signify the group's valorization of the newborn: how to gaze and narcissistically invest it, interpret its distress and act on the attributed meaning, how to provide, satisfy, frustrate needs and desire. The body is the agent assigned to minister infant care, thereby instituting the corporeality compounded by perception and proprioception. It follows that the elective channel for adult–infant exchanges being primarily the mutual physicality, the body guards the sensual memory of the origins, somatically inscribed, hence encoded in the cryptography of the unconscious. Correspondingly, parental needs, fears, anxieties, and facilitations of attachment and separation, meaning and provisions for helplessness and dependence, are complexly inflected by their group alphabet of emotions, the tolerable and intolerable ones, to be accommodated or repudiated. In their totality, the cultural norms demand the identification of the individual with the collective in exchange for the feeling of belonging, aimed at molding the narcissistic core of identity. Moreover, connecting the term *mores* with ethos implicates the field of ethics, which has a bearing on the subjectivity of desire and its modulation in accordance with the law. Somewhat condensed, these themes are adumbrated and recur in the Freudian concept of sexual morality, which I will nuance in my examination of *"Civilized sexual morality and modern nervous illness* published in 1908.

For this study, the salient aspect of the human subjectivity I wish to emphasize is its cultural situatedness, whose axis is the helpless infant's body, needing the care of the adult group in a convergence of nature and culture that meet on the infantile body and its semantic representation.

To offer some conclusive remarks to contextualize the arrival of psychoanalysis on the intellectual scene of the XX century, it may be useful to point out how Freud's revision of his formulation of the psychic apparatus initiated in the 20s, joined the conversation of his times and was reprised afterwards. In the frame of reference rubricked under the second topography, the psychic agencies of the id, ego, and superego are tasked with negotiating the complex construction of the internal world and object relationships. The ego performs several functions, amongst them the identification with the lost or renounced objects, because, in a sense, the ego is a graveyard of mourned objects. Space does not allow to delve into the theory of identification, what is of relevance here is that both horizontal and vertical relationships – between members and with the leader(s) – are essentially constituted by bonds of

identifications. The theory of identification – and its application to the construction of identity – was saluted by the humanistic disciplines as a momentous contribution to their research. Clearly aligned to Freud's revision of the 20s is a different perspective on the subject, the psychic work to be attended to and, indeed, the external world, its vicissitudes and demands.

How the internal world is structured by multiple identifications speaks to group theorists like René Kaës. Analogously, it resonates with the sociologist Norbert Elias, who proposes that the subject of the structural model – or second topography – is a microsociological universe and that

> Freud conceived an eminently sociological model of the individual and an eminently individualistic model of society. This appears clearly when examining the concept of father of the origin, who embodies for the group testimony the set of social functions, but with the traits of an individual with no sense of structure. On the other hand, Freud depicts the individual in its multipolar complexity, a sort of miniature society, consisting of compartments that represent us, the father, the mother, etc.
> (Quoted in Smadja, 2013, 124, my translation from French)

The work of reading will assist in maintaining the focus, problematizing, and furthering these cross-disciplinary suggestions.

Illness: the scandalous satisfaction of the drives against repressive cultures

Freud bequeathed us a magnum opus which, as one might expect, contains radical ideas but, equally, affirmations that our modern sensibility easily construes as prejudicial, ridiculous, or utterly provocative. Indeed – as Elizabeth Roudinesco notes in her biography of Freud (Roudinesco, 2015) – the questioning and revolutionary scientist coexists with the conservative patriarch, sometimes in jarring contradiction. To epitomize his historical situatedness, some of his pronouncements about women and female desire confront the readers with juxtapositions, inconsistencies, and paradoxes. Freud can candidly state that women have contributed to civilization solely the invention of the aesthetics of weaving and plaiting because "[n]ature herself would seem to have given the model which this achievement imitates by causing the growth at maturity of the pubic hair that conceals the genitals" (1933 [1932], 132), and apparently sees no incongruity with his unprecedented provision of the talking cure he developed in the treatment of hysterics whose symptoms clamoured to give voice to their forbidden desire. Perhaps a less hasty perspective on the conversational rage of the 30s, might also discern Freud's hypothesis of a fundamental accord, namely, the weaving together of nature and culture. Be that as it may, germane to his unsettled and unsettling texts is their metaphorizing potential; hence to the literal interpretations of some vociferous

feminist circles, the contrapuntal voice of art historian Griselda Pollock speaks for the exquisite womanly sensitivity showcased in the production of aesthetic objects. On Freud's suggestion, Pollock capitalizes on the idiom "weaving" and draws from the Latin etymology *texere* semantic chains of sensorial images, words, and ideas like texture, textuality, the braiding of texts, and the intertwining of narratives in the context of the representation of subjectivities in relation to others and part objects (quoted in Martin, 2023). Perhaps Pollock reads into Freud's passage the movement of weaving and foregrounds the dynamic pair of concealment and revealment of aesthetic patterns, similar to Warner's choice of the words "encipherment and decipherment" to convey the rhythmicity of stories.

Returning to the psychoanalytic discourse *strictu sensu*, undoubtedly Freud was the first to give voice to the hysterics whose ailing and paralyzed bodies had been spectacularized for the voyeuristic pleasure of the male doctors' gaze, when they inspected, classified, but were unable to cure. Instead, he listened, gave credence to the weaving of their stories and offered the young women the analytic couch to entrust their bodies to, while the analyst sat behind to reflectively capture the drift of their unobjectionable transference and listen to their passionate, unhappy love narratives. In his consulting room Freud became cognizant of women's malaise owing to the social strictures, and the sparse life choices available to them, essentially reduced to the marriage contract that curbed and mortified their desires and their accomplished minds.

Freud had an introspective and critical mind, which led him to interrogate his own patrician position, on the cusp of authoritarianism, in the practice of hypnosis. Consequently, he cast away hypnosis and the subsequent "pressure technique" for the more democratic invitation to his patients to free associate, complementing the analytic listening with his freely hovering attention. The problems he encountered in analytic practice spurred his clinically grounded thought; from the consulting room he would then venture into hypotheses regarding the society that contributed to the increase of "modern nervous illness". By implicating his theory of the unconscious, his sociological analyses departed from the conceptualizations offered by philosophers, ethical theorists, social reformers, and the medical profession who merely enforced sexual abstinence and prescribed cold water as remedies for their patients' maladies.

The specialized observatory of the internal world offers an aperture to the modes whereby culture is sedimented and fashions subjectivities, inflecting the articulation of instinctual drives, satisfaction, renunciation, sublimation, ethics, and emotional conflicts. The habitus of navigating the unconscious sources Freud's conviction in taking a position as a critic of the excessive sternness of the sacrifice demanded of individuals, which ensues in psychological suffering: this is essentially the conclusion he arrives at in *"Civilized" sexual morality and modern nervous illness* (1908). The German titular word

Strachey translates with "Civilized" is *Kulturel*, which I would argue indicates that the sexual morality should not be listed under the rubric of the technological acquisitions of civilization but is the cultural ethos that saturates values and institutions, like abstinence and/or marriage. Strachey's rendition into *civilized* gestures to its opposite *uncivilized* that, with regard to sexual practice and morality, covertly loads the adjective with value judgment. Be that as it may, the quotation marks in the original and in Strachey's translation merit attention: perhaps they convey Freud's ironic posture, whereby he parodies and lays bare the hypocrisy of the self-proclaimed high value of the current sexual morality. Let us read the text closely.

"The forces that can be employed for cultural activities are [...] to a great extent obtained through the suppression of what are known as the *perverse* elements of sexual excitation" (189).

If the sexual instinct is displaceable and enforcing repression is socially legitimate because it leads to the *sublimation* of a portion of the sexual drive for higher achievements, this sacrifice should be ameliorated by justice and the freedom to choose what to be and who to love – according to Freud – and the demand should be commensurate to the subjects' capacity and not deny their rightful pleasure.

From the observatory of the inner world Freud crosses over to society and argues that the *Kultur* is responsible to secure the viability of the social contract and perform its share of work – *of the* culture – because too stern a demand tips the balance and the subjects' portion of the *work of culture* – in terms of social adjustment – predisposes them to fall ill and so they become unproductive members of their group. Freud's premise that psychosexuality is imbricated in the structure of character leads him to underscore that one of the deleterious consequences of repression is that people turn into weaklings, psychically impoverished and passive individuals, so they become easily suggestible by manipulative leaders.

As an alternative to enfeeblement and passivation, men might defensively exaggerate their virility and resort to adultery and promiscuous practices. Freud indicts the "'double' sexual morality" society conveniently procured as solution for the nervous illness intrinsic to marriage by the recourse to marital unfaithfulness only licit for men.

"But the more strictly a woman has been brought up and the more sternly she has submitted to the demands of civilization, the more she is afraid of taking this way out; and in the conflict between her desires and her sense of duty, she once more seeks refuge in a neurosis. Nothing protects her virtue as securely as an illness" (195).

The neurotic symptoms appear to be an unconscious ruse to obtain a modicum of satisfaction of the repressed desires – Freud deduces – therefore, they contain the seeds of revolt against the current mores, in that they contain the hostile impulses against the culture by masochistically turning the aggression inwards and at the same time eroticizing the process. Remaining

within the domestic confines, women displace their sexual desires and need for love onto their children, they become over-tender and over-anxious mothers, unconsciously seductive, and end up exposing their children to the damage of precocious sexual stimulation.

Freud – critical theorist *avant la letter* – outlines in this passage the transgenerational transmission of trauma-as-dissatisfaction and psychopathology. He also astutely intuits the plight of the children inhabiting the insalubrious environment of their parents' unhappy marriage and feeling torn by conflicting loyalties and ambivalent feelings of love and hate. Furthermore, his analysis complements and foreshadows Lacan's theory of the place of the father in the mother's mind, foundational to institute the tridimensional psychic space and endorsement of his authoritative word. Freud does not expatiate, nonetheless he clearly gestures to the complexity of psychic transmission and psychic structuralization, which is always already culturally embedded, as the overdetermined causation of psychological illness is, together with its signifying epistemology. He positively punctuates the forms of malaise connate with the ideal of womanhood fostered by society.

> [W]omen's upbringing forbids their concerning themselves intellectually with sexual problems though they nevertheless feel extremely curious about them and frightens them by condemning such curiosity as unwomanly and a sign of a sinful disposition. In this way they are scared away from *any* form of thinking, and knowledge loses its value for them. The prohibition of thought extends beyond the sexual field, partly through unavoidable association, partly automatically, like the prohibition of thought about religion among men, or the prohibition of thought about loyalty among faithful subjects.
>
> (199, original emphasis)

Unequivocal sentiments transpire in the landscape Freud depicts of *fin de siècle* Vienna, the city that offered but a very few women the opportunity to find their voices, tell their stories and repurpose their symptomatic *jouissance* into sublimated accomplishments. Exemplar of this arc is the patient first treated by Breuer and then by Freud, Bertha Pappenheim – whose case is inscribed in the history of psychoanalysis under the pseudonym of Anna O in *Studies on hysteria* – well known as a feminist activist and reformer. The face of a coin immortalized her effigy, and she wittily designated psychoanalysis as the "talking cure", by now an adopted and widely disseminated synonym for the therapeutic method.

In accordance with the previous, Freud's sensibility operationalized the setting most conducive to confidential speech which, additionally, morphed into the privileged observatory wherefrom he gained in-depth knowledge of his society. He enucleates the many ills correlated to the mandated *norm* he deemed inordinately repressive and impacting mental wellbeing. Above all he

deplored the cultural disarticulation of feelings of love and sexuality, in that they predisposed to psychopathology and (mal)adaptive forms of satisfactions, such as the refuge into autoeroticism, masturbation, and perverse practice, which are the ultimate ruse of the sexual impulse searching for an outlet, excluding the other's sensitivity.

Are the perversions – among other factors – also covertly fomented by the repressive regimentation of desire? And if so, do these practices satisfy the subject's unconscious hostility aimed at the repressive agencies? Freud's pronouncement is unambiguous in considering such practices as ethically objectionable, "for they degrade the relationships of love between two human beings from a serious matter to a convenient game, attained by no risk and no spiritual participation". He concludes the text with the clinical observation that "a restriction of sexual activity in a community is quite generally accompanied by an increase of anxiety about life and of fear of death which interferes with the individual's capacity for enjoyment" (203).

Freud offers a meticulous regard on the Viennese culture, to decipher its unconscious determination to foment the hostile forces that emerge as subjective suffering and militate against its own viability; when all is said and done, the failure in performing its share of *Kulturarbeit* looms over psychoanalysis. Freud will subsequently extrapolate and formalize the theory of the subterranean (self)destructive forces, never completely tamed, into the concept of the death drive, and more generally the place he allocates to aggression in *Civilization and its discontent*.

By way of conclusion, I would suggest that the analytic room is a place where *Kulturarbeit* is performed, because the talking cure involves the construction of a meaningful autobiographical narrative that enables the subject to live a more fulfiling life by liberating their psychic resources previously sequestered by their illness. Contemporary psychoanalysts such as Smadja, Kaës, Assoun, and Zaltzman – to mention only a few French authors – explicate and further develop the cultural aspect of the work of clinical psychoanalysis.

Civilization, discontent, malaise

Freud wrote *Das unbehagen in der kultur* in the aftermath of the Wall Street crash in 1929, whose wide-ranging ripple effects resonated the world over; the literal transcription of the titular meaning is "Malaise *in the* culture". Joan Riviere raised to the challenge of a troubling translation choice with her felicitous rendition into *Civilization and its discontent*. All the same, something was lost, because Freud located the malaise "in" the fabric of the aggregate the Western world presented to his observing gaze, whilst the coordinating conjunction "and" rather accentuates the semantic halo of the inevitable fact that when human beings live together, they must make sacrifices and renunciations with the attendant feelings of frustration. To Freud's

situatedness –"'in" – of a particular culture, Riviere's contrapuntal "and" responds with a subtle slippage into a generalizable, even essentializing factor. In all fairness, both meanings run through Freud's text which addresses the unconscious pact undergirding *any* socio-cultural assemblage inflected by the conflicting forces of Eros and Thanatos. If Freud masters a narrative that comprehensively oscillates between the foundational myth – recursive and a-historical – and the specific situatedness he observes through the lenses of the psychopathological precipitates, the Standard Edition is vector of a different emphasis; as the well frequented topos goes, translative interpretations lead to distinctive research and theories. The divergent paths of Anglophone and Francophone psychoanalysis amply showcase our truism, reflected in the translation work of, respectively, Strachey and Laplanche and their collaborators.

A close reader of *Civilization* can tease out several threads and foci, not always harmoniously coexisting; overall, Freud returns to his youthful fascination with the humanities, chiefly anthropology, and now an ill old man in his 70s, he concedes to his passion for the sweeping narratives and broad perspectives on things human. Therefore, he constructs a text that embraces his learning, reworks foundational mythical narratives, recapitulates his cultural and scientific achievements and leaves a testament for posterity. The single motif that provides unity and signposts for scholars of psycho-social disciplines is that all the conditions classed under the rubric of culture are inflected by the fundamental theory of the unconscious and the drives, which marks a veritable paradigmatic shift from the preexisting literature.

Civilization resounds with echoes of Plato's *Symposium* and Aristotle's *Nicomachean Ethics*, introduced by the questions of what constitutes happiness, prescinding from the consolatory responses and illusory promises of religion. Athens was a model location where Freud situated the incipience of his time-honoured logos, similarly, he proposed the notion of the libidinal drive which he traced historically in classical Greece. For instance, in the *Three essays* he accentuates the cultural encoding of what constitutes a legitimate and appropriate object of sexuality and compares the Greeks who pursued pleasure in and of itself (1905, footnote 2) with the Christians whose ethos prioritizes the object of love and relegates sexuality to the domain of evil and bodily impurity, an essentially unruly sinfulness that the sanctity of marriage and procreation supposedly elevates. This comparative perspective sets the ground for a dialectic of the universal – the drive – and its specific signifying context: sexuality, in fact, is always sourced by the infantile unconscious but is channeled in different culturally sanctioned directions. The ramifications of infantile states, fears, anxieties, and defenses reverberate in the propensity to faith, and in support of these views, *Civilization* reads: "The derivation of religious needs from the infant's helplessness and the longing for the father aroused by it seems to me incontrovertible" (1930, 72).

The helplessness of the subject and conceivable expectation of a response from their kin –extendable to the civil society – is the elected vertex that informs my reading and underpins my psychoanalytic approach to the texts I will examine in the following chapters. Vertex that offers a uniquely binocular vision of the characters' situated dispositions, their predicaments, and the psychic burden accruing from the failure of their cultural milieu, which they need to signify somehow. Unarguably their quandaries pertain to their subjective experience, but at the same time they unmask the *failure of the work of culture* and implicate us to bear witness to the regressive malaise *in* the culture. Indeed, when societal upheavals are intense enough to shake and fragment its foundations, the very support to the person's symbolizing process is undermined and consequently language is distorted, perverted, repressed and even obliterated altogether.

Returning to Freud's anthropological essay: he narrates that civilization was born of Eros and Ananke (Love and Necessity) and superseded a phantasmatic natural state of unrestrained, unbound egotism, until eventually a crucible of necessity, convenience, and empathy led to establish regulatory devises, checks, and balances.

Freud follows the Greek tradition of giving parentage to mythic beings. In the wake of Plato's theory of Eros as a *daimon* – that is, an intermediary – the son of Poros (expediency, resourcefulness) and Penia (poverty, longing and desire), Freud is exercised by the figure of mediation. It is useful, I would argue, to see the parallel and genealogical continuity between the *daimon* as agent of mediation – rather than the negative demonic principle – and the Freudian ego, whose salient function is negotiating between internal forces and external demands. Positioning Eros and Ananke at the cradle of civilization, Freud reiterates the heuristic value of the chain of pairs – like love and work, the pleasure and reality principles – to then insert the mediation of the ego, tasked with performing the psychic work to reach a compromise solution between contrasting forces. That "compromise solution" is a key concept for Freud, it rests on the notion of psychic work, which is fundamentally dynamic, underpinned by a dialectical logic and, crucially, it epitomizes all forms of transformative accomplishment.

The segue of the trajectory towards civilization is that, needing stability and instinctual satisfaction, human beings are drawn together by erotic desire, social bonds, and the exigency of cooperative work. This view of social relationships aligns with the Christian fraternal "agape" and the secular "philia" which Freud, however, needs to redefine as "aim inhibited homosexuality", to disjoin the term from the Christian version of agape and the commandment "love thy neighbor", that he critiques and thoroughly deconstructs by positing the theory of the imbrication of narcissism and object love. More cogently, he intends to reprise his theory of the libido as centrally rooted in the infantile and in bisexuality, because it is precisely the sublimation of homoerotism that morphs into bonds of affiliation. Freud

intends to demonstrate that the fraternal relationship has a narcissistic structure, the sibling being the same-as-me for the unconscious, thus the injunction "love thy neighbor" is fundamentally aporetic for him, it being only narcissistic love in disguise.

Freud reissues his trope of a supposed mythic genesis of the unconscious constituents of humankind apropos of bisexuality, clearly gesturing to Plato's story of the hermaphrodite alongside the biological knowledge currently available. His strategy consistently aims at establishing continuity with tradition whilst engaging it from the innovative perspective of the dynamic unconscious. He thus states that "[t]he individual corresponds to a fusion of two symmetrical halves, of which [...] one is purely male and the other female. It is equally possible that each half was originally hermaphrodite" (1930, 105). Undoubtedly Plato's *Symposium* makes a more illustrious intertext for psychoanalysis than *Genesis* with its original sin! More importantly, however, in regarding sexuality as a compromise solution, hence always unstable, Freud renders it the site of potential resistance to and revolt against any established order, owing to the frustration of total impulse satisfaction the social contract always imposes. The drives are essentially unruly and unknowable, being the epiphenomenal derivatives of the turbulent unconscious.

Living beings relinquish their egoism and pleasure to secure a modicum of protection from the anxieties attendant to the knowledge of inhabiting a mortal body, the uncertainty due to the unpredictable events of nature and to the fear of the aggression of other humans. In the first section of the text drive renunciation seems to set the ground for the frustration that can lead to aggression and neurotic illness. But then there is the question of aggression and Freud wavers with regards to its status: is it but a reaction to frustrated wish fulfilment, or rather is there something indomitable in the aggressive drive that can erupt in utter destructivity at any time, as in wars?

Disillusioned, in the end Freud acknowledges that the humankind's instinctual endowment includes a powerful portion of aggression whereby he does not hesitate to exploit and use the product of the other's work, "to use him sexually without his consent, to seize his possession, to humiliate him, to cause him pain, to torture and to kill him" and his conclusion is on a par with Hobbes' famous aphorism, quoted and italicized *"Homo homini lupus"* (1930, 111, original emphasis). In this passage Freud examines sadism, a component of the sexual drive constituted by the erotization of the aggression not subsumed by mature sexuality, not contained by sexual morality, not elaborated or sublimated for higher cultural achievements. Sadism is one of the possible outcomes of aggression, which Freud is impelled to conceptualize and track down in all its possible itineraries, as it is also unequivocal that a function of the *Kulturarbeit* is to regulate, contain, deflect, and channel it in collectively appropriate trajectories. This is a cultural provision that Kaës calls meta-psychic guarantee, and he postulates to be a "tertiary

principle". I will dedicate the next chapter to Kaës' perspective on *Kulturarbeit*.

Civilization closes on the somber note of the realization that human beings cannot always prevent the triumph of hostility and sadism, especially in modernity, when the technological "prosthetic gods", have "gained control over the forces of nature to such an extent that with their help they would have no difficulty in exterminating one another to the last man"(145). But the flipside of this hubris is an intensification of the feelings of uncertainty, anxiety, and guilt. This text exudes dismay to such an extent that the hypothesis that the author might have intuited the rapid sliding of Hitler's regime into a state of barbarism is certainly not so far-fetched, hence the concluding remark: "[n]ow it is to be expected that [...] the eternal Eros will make an effort to assert himself in the struggle with his equally immortal adversary", and to the above he added one year later: "But who can foresee with what success and what results?" (145).

It is here that the theorical figuration of the Father comes into its own in its multilayered valence, conjugated by the structural Oedipus complex, which is subsumed by the psychic work of culture, the symbolic third. In Smadja's concise words:

> The meaning of the Oedipus complex is thus neither to be a phase nor even only a complex, but a psychical structure that is constitutive of the subject, giving birth to cultural reformulations, that is, to collective symbolizations. Consequently, the Oedipus complex is foundational to identity and human community.
>
> (2011, 995)

Smadja's cultural signification of the Oedipus complex chimes in with Laplanche's theory that ascribes to culture a mythopoietic function through the provision of cultural narratives whose symbolic value acts as semantic backdrop to the individual construction of meaning.

The historical demise of the symbolic structures that support the subject's identity within their community is the theme that interweaves the next chapters. I will follow the psychic reverberations of socio-political turmoil in selected works of literature, tracing in particular the itineraries of identity and the questions it raises, respectively in: a) a little girl trying to make sense of what defines identity, b) the loss of home, c) a destitute Indian old lady who pretends to be something she is not, d) the search for an ideal self-image, like Ifemelu in Americanah, e) the fatherless orphans of war. The *fil rouge* is the bewilderment in search of a meaningful articulation of characters in search of a psychic home in the face of baleful crises of their cultural context and, consequently, of symbolic loss.

Freud had hypothesized the evolutive transformation of the horde into a civilized society: he narrates the foundational myth in *Totem and taboo* and

reprises it in *Civilization* as a structural metaphor to understand recursive collective vicissitudes. Through the unraveling of the *Kulturarbeit* the father of the primal horde returns as a spectral presence to haunt civilization, instigating a group functioning that unleashes violent murderousness and perverse sexuality infused with the death drive. It is a cultural narrative, but it may also be how Freud foreshadows the advent of the Nazi crimes against humanity. I trace a comparable involution of the social fabric, where the concept of the elision of structural phantasmatic father advantageously underpins all the narratives I intend to examine. If there is no possible recourse to the Law of the father, it follows that the barbarism of society instigates the deterioration of language, that loses its anchoring referent in reality and collapses into the onomatopoeic "bla-bla", the Greek word *barbarous* derives from.

The question of the Father, the symbolic, the law

In psychoanalysis the theoretical father-as-structure institutes the process of symbolization. Taking as a conceptual model the development of the nascent subject from helpless dependence to the entry into the world of language and culture, the father embodies the principle of separation from the carnal maternal principle and the narcissistic dyadic embroilment. His desire for the woman part of the mother repositions her as a lover and the hiatus of her absence opens the space for the baby to initialize its phantasmatic activity that will carry it towards dreaming, fantasy, and symbolic thinking. It follows that father represents the third position, firstly in the mother's psyche, where there is a place she "reserves for the Name-of-the Father in the promulgation of the law" (Lacan, 1977, 218). Lacan reworks the place of the father within the psychic apparatus and embeds in his expanded concept of the paternal metaphor the harbinger of the symbolic order, whose plural functions circumscribe the place of desire, conjugated with the law that primarily organizes the prohibition of incest and murder. Whenever this process fails, the allure of *jouissance* present in psychic structures where the maternal cocoon is the only safe domicile, fates the subject to a form of enjoyment unto death and psychosis that Laplanche names "sexual death drive".

The antecedent of Lacan's theory is Freud's *Totem and taboo*, where he refinds the law-giving-father of prehistoric culture. The figure of the father metamorphoses into a mythic icon whose developmental trajectory – from narcissistic, despotic, beaten, murdered, dead, through to protectively symbolic – organizes the transmutations, and details degrees of harmonious functioning of the individual and collective psyche. (For an extensive discussion of the topic I refer the reader to Perelberg's *Dead father murdered father*, 2015).

In the wake of Lacan, some contemporary authors including Aisenstein, Delourmel, Green, Kristeva, and Eizirik – to mention but a handful –

distinguish the paternal principle or function from the paternal role, to foreground the symbolic principle constitutive of desire and of the path that channels aggression and hostility into viable forms of social commerce. Freud also had addressed this process when he notably quipped that the first man who responded to the other's aggression by launching words instead of a stone, was the founder of civilization. Still, the permutation leaves its unconscious trace in the sense of guilt which, together with the set of values and ideals, compounds the cultural transmission across the generations and is structuralized in the psychic agencies of the ego ideal and superego. If the process goes awry, the figure of the horde provides a metaphor to understand the ultimate transgressions of the murder and incest taboos, which are the foundational pillars of societies.

Consequently, the resurfacing of the figure of the perverse narcissistic father can be read as signal of the failure of the *Kulturarbeit*, which is always a possibility for societies throughout history, chiefly so in critical phases when progress and civilization unravel and recede towards barbarism. But whose failure would this be, if we presuppose that the work of culture performed by the subject moves alongside that of the community, and the derailment ensuing in neurotic illness – or perversion and psychosis as the case may be – can come to pass on both organizing levels? And what forms does the "pathology of cultural communities" (144) take?

Winnicott's theory of the transitional space has contributed to refashion the previous discourse on culture, which he inscribes in the zone between subjectivities and their externality, to chart a location where the meaningful use of artifacts, cultural objects, and inventions can be situated and made available for shared enrichment and pleasure. Thus a group, a community, a nation gathers its sense of identity around a representational symbol, such as a flag, a sporting team, a national anthem and the likes. Winnicott frames the cultural domain in spatio-temporal metaphors which contain the subject's origin – the past – and the density of the heterogeneous temporalities of the present-ness and futurity where they can imagine their existential habitat to be becoming. The group, family, professional institutions, and country form the backdrop that silently underpins and bolsters the work of identity. Ultimately, the location of culture straddles the inside and the outside and partakes in both: it is the locus of the paradoxical co-existence of heredity, tradition, and reclaimed ownership that Freud entrusts to Goethe's words and Winnicott permits us to probe: "What you inherit from your father must first be earned before it's yours". This spatio-temporal accommodation of the process of identity facilitates working through the negativity of the non-me – otherness – besides the governing of aggression which is subsumed by the possibility of saying "no" and trusting that the other is there to listen and heed it. Freud's mythical first man of the burgeoning civilization who ingeniously utters the words "no, don't do that to me" to the threat of the stone launched by his fellow human, indeed expects to be heard. This gesture

instantiates the symbolizing process undergirded by the evaluating judgment based on the "yes" and "no", viz the *minding* embedded in intersubjectivity.

Reading Freud with Winnicott expands the heuristic reach of culture, whose real characteristics – whether promoting or hampering psychic development – imbue all individual vicissitudes. In this direction moves the entire corpus of Kaës, which hinges on the analysis of the unconscious intersubjective ties human groupings weave amongst the membership. In the next chapter I will return to Kaës whose publications address the psychopathology of culture as a specific factor; he notes the global restriction of the transitional space featuring in contemporary clinical presentations, what with the tertiary symbolizing processes failing to function as guarantors. As observed, the demise of the symbolic order opens a gulf and the thirdness regresses to the oppositional either–or logic of survival: either you or me, the space is too narrow to contain the sequence: me, me and not-me, other-than-me.

The psychoanalyst in the consulting room and in the public forum is tasked with performing the work of culture with his/her analysand to help to build a more cohesive subjectivity and repair the damaged fabric of thought in the face of the waning of the symbolic order.

In a similar mode, the arts perform their own work of culture: the artists' sensitivity and dispositional talent enable them to mend the symbolic process when it is frayed in times of crisis. Their aesthetic sentiment captures the disquiet of their times of which they become the witness and word-bearer; their voice speaks the plurality of their contemporaneity, thereby they reinitialize the process of morphing into a narrative the meaning that goes amiss in the collective disorientation. Whether they chant a mournful song – like Lahiri – or bellicose variations of rage – like Rosselli – or lace their narration with the ironic wit of their foreign observations – like Adichie – all the same, they employ different registers to restore the potential for representation. Their artistic idiom is a veritable talking cure by other means and diversely inflected, nonetheless it salvages subjectivities from the risk of precipitating into the helplessness and meaninglessness imbricated in moments of de-subjectivation, when the background of culture morphs into a violent impingement that causes disarray and the loss of feelings of safety.

These theoretical tenets inform my close reading of the literary output I will accost in the subsequent chapters.

References

Freud, S. (1905). *Three essays on the theory of sexuality.* SE VII.
Freud, S. (1908). *"Civilized" sexual morality and modern nervous illness.* SE IX.
Freud, S. (1913). *Totem and taboo.* SE XIII.
Freud, S. (1921). *Group psychology and the analysis of the ego.* SE XVIII.
Freud, S. (1925). *An autobiographical study.* SE XX.
Freud, S. (1927). *The future of an illusion.* SE XXI.

Freud. S. (1930). *Civilization and its discontent.* SE XXI.
Freud, S. (1933[1932]). *New introductory lectures.* SE XXII.
Freud, S. (1937). *Moses and monotheism.* SE XXIII.
Kaës, R. (2012). *Le malêtre.* Paris. Dunod.
Lacan, J. (1977). *Ecrits. A selection.* London. Tavistock Publications.
Martin, M.R. (2023). *Psychoanalysis and literary theory.* London & New York. Routledge.
Perelberg, R. (2015). *Dead father murdered father.* London. Routledge.
Roudinesco, E. (2015). *Freud: In his time and ours.* Harvard University Press.
Smadja, E. (2008). The notion of the work of culture in Freud's writings. *Psychoanalysis, Culture and Society* 13(2):188–198.
Smadja, E. (2011). The Oedipus complex, crystallizer of the debate between psychoanalysis and anthropology. *IJP* 92(4):985–1007.
Smadja, E. (2013). *Freud et la culture.* Paris. PUF.
Winnicott, D.W. (1967). The location of cultural experience. *The collected works of D. W. Winnicott* (Caldwell L., Taylor Robinson H. eds). Vol. 8. Oxford University Press (2016)

Chapter 2

For a psychoanalytic perspective on the malaise of the culture

Only recently has the anglophone tradition of psychoanalysis broadened its compass to view the subject in history, in keeping with the richness of cultural studies, psychosocial developments, and academic publications. In the strict psychoanalytic sense, this is concomitant with Winnicott's expansion and in particular with the application of his momentous theories of transitional object and intermediate space to outline the sphere of culture. According to Winnicott, culture is the locus of authentic habitation of the subject, theoretically imagined in their existential engagement with the dialectics of their internal and external reality and such a navigation route stands accessible all throughout life.

The discipline and practice of psychoanalysis is also culturally situated, it speaks local idiolects and responds to the impetus to further inquiry arising from contextual exigencies which, in the anglophone conversation, draw on the fields of critical theories and postcolonial studies, wherefrom originates the demand to approach systematically the way in which the domination–submission dialectic is structuralized within the psyche. Such contingencies are at variance with the French intellectual discourse, which is imbued with philosophy and structuralist linguistics, both of which are well-established in academia and set the tone for abstract thought and textual exegesis. This strain of erudite approach resulted in extensive application of the psychoanalytic method to the historiography and, among other factors, has judiciously advanced the Freudian project of discovering the unconscious forces operative in episodes of history and contributed to confer to psychoanalysis a reputable status. As a result, psychoanalysis has contributed research and clarified previously inexplicable events as, for instance, when in 1793 the post-revolutionary army exhumed all the royal bodies of the Saint Denis necropolis to symbolically dethrone and bury the ancient regime and inaugurate the new order (Assoun, 2018).

This tradition is compounded, on the one hand, by the methodology of historical studies of the *École historique des Annales* – introduced by Lucien Febvre and Marc Bloch – that first researched the history of mentalities, and on the other, by Laplanche's translations of Freud's body of work. Last, but

not least, French authors continue to promote and critique Freud's metapsychology and create theoretical bridges, mostly with Winnicott, but also with Klein and Bion's writings, endorsing interesting cross-fertilizations. Perhaps they are less encumbered by the weight of the Controversial Discussions (King & Steiner, 1992) than their British colleagues, evincing the extent to which the history of British psychoanalysis carries the burden of the acrimonious divisions that still shape group allegiances and have morphed into markers of identity.

René Kaës systematically proposes theories that typify the epistemic framework prevalent among French psychoanalysts, alongside Green, Kristeva, Deveraux, Assoun, Zatzman, Abraham, and Torok – to mention but a few. Their studies apply and forward Freud's intimation of the situatedness of the subject, who receives mandates and projections and acts on the transgenerational transmission; indeed, some go as far as postulating an unconscious genealogy of culture, thus foregrounding propositions which were previously only foreshadowed. Pertaining to the clinic, this frame of reference postulates that subjects always act in culturally meaningful ways and speak forms of malaise that need to be listened to in their manifest content, culturally contextualized and decoded if the analyst is to assist the recovery of speech in the psychic zones where deadening silence might prevail as, for instance, in the eventuality of crises, traumata, or natural disasters.

According to René Kaës the contemporary clinician is primarily called upon to bolster the precarious subject who experiences threats of depersonalization, fragmentation, and/or breakdown, and whose symptomatic emergencies are free floating, diffuse anxiety and depression. The person might register an alteration of the sense of time, which is either accelerated in the frenzy of activities and restlessness, or stalls in the stasis of apathy, lethargy and the procrastination attendant to feelings of despondency.

Such clinical presentations betray a melancholic organization which gestures to the impasse of the work of mourning. Can a society really facilitate the working through, in the face of a crisis of the symbolic compass that orients individual movement, like we presently witness? Mourning, in fact, can never be performed in isolation, and group rituals and practices are and have always been culturally implemented. But can this essential collective function be operational if the generalized affect state which infuses our culture is melancholy? The analyst observes how the manic defense, splitting, fear, and hatred of the work of thinking exacerbate the patient's predicament through the sedimentation of dysfunctional defensive organizers which, at the same time, appear to be socially sanctioned defenses from pain, grief, and guilt. Paradoxically, the current social adaptation demanded of citizens entails a mode of being in the world and functioning in a dissociative borderland. Consequently, when struggling for recognition, psychic pain can put the subject at risk of withdrawal of their libidinal investments on the self and the world and felt to be personal failure. Meaning itself turns into

meaningless negativity and can result in de-subjectivation: a "process without a subject", as Kaës affirms.

How can the analyst account for the advent of the culturally syntonic regime of dissociation, urgency and "presentism" – to borrow the felicitous definition coined by the historian Francois Hartog – where time has collapsed into an overarching present that obliterates the past-ness linked to the work of mourning and inscribable within the trajectory of autobiographical continuity?

Reprising Freud, in his book *Le malêtre* (2013) Kaës examines the hyper and postmodernity, with "its unbridled pursuit of money and possessions, and its immense advances in the field of technology which have rendered illusory every obstacle, whether temporal or spatial, to our means of inter-communication" (Freud, 1908, 184). Kaës thinks that the malaise of our civilization is largely the psychopathology of the demise of boundaries, viz the psycho-cultural skin that contains, defines, and establishes the contacts between the I and non-I. It is the in-between-area of the pre-conscious, the capacity for psychic mobility, compromise, and mediation: overall we can speak of the prevailing sufferance of the transitionality, which presents in various forms.

Working analytically with groups, Kaës has advanced some original contributions in the field of the cultural unconscious with the concepts of meta-psychic and meta-social guarantors, where the prefix *meta* connotes the space beyond the person's interiority, which extends to and implicates the reality shared with others. His proposition, albeit worded differently, chimes in with Laplanche's assertion that every "[c]ultural activity is an opening out on to the other, an address to the other" (1997, 664).

The dictionary gives the following definitions for guarantor: someone – and/or institutions – who respond and take responsibility for the realization of a task, a project; a guarantee is a protection, defense, safeguard, warranty. All the above terms point to the semantic pertinence of the parental and symbolic agency, namely the intra-psychic benevolent super-ego, which Kaës locates in the intermediate space of culture and names meta-psychic sphere. The superego is the psychic agency situated at the juncture between the individual and the collective – there is a cultural superego too – it sanctions the intergenerational pact and is designated to transmit its foundational taboos of incest and murder. The meta-psychic and meta-social guarantors function as framing structure (Green, 2002) to promote and support the work of identity and are imbedded in the narcissism that bonds the generations through the legacy of the ego ideals, belief systems and ethical values. Such values nourish a healthy ego-ideal, robust and qualified to engage in harmonious commerce with the super-ego, but can also become the expressive site of global psychopathology, when they turn into unrealistically inflated self-expectations.

This conceptual architecture undergirds Kaës' understanding that all "individual psychic life is framed and guaranteed by institutions and processes of the psycho-social environment which supports and structures the subject's psyche" (Kaës, 2012, 101, author's translation). They act as scaffoldings to sustain and delimit the space shared by a family, group, educational apparatus, professional body, country, that is, any particular organized assemblage which the individual member is both subjected to and subject of. Henceforth, psychic reality is at all times a composite crossing over of the intrapsychic, intersubjective, and transsubjective, where unconscious structuring alliances, mandates, and pacts of disavowal coexist, are unconsciously transmitted, and internally structuralized.

A distinguishing feature of Kaës' writings is his interest in the constitution of the psyche, that he views as always already imbedded in its genealogy. In this regard he proposes that since the introduction of the structural model with its three agencies, and the development of the theory of mass and group psychology, Freud devised a psychic genealogy whose polyhedric resonances manifest on the dual register of the experience of the body and the relationships within the group. In fact, the transmission implicates the intrapsychic, intersubjective, and transsubjective (Kaës, 1993) group knowledge inflected by the technique of infant care, education and enculturation that inform the subject's developmental trajectory. The central concern of this genealogy is the modality of historical inscription, in that the id with its contents is received unconsciously from the previous generations; the ego – which develops from the id – is also partly unconscious, whilst also being open to the solicitations of actual coeval relationships and reality-based perceptions, and lastly the superego, heir of the working through and waning of the Oedipus complex, and is consequently shaped by the parental superego. Moreover, the latter formulation reframes as unconsciously deposited history all the characteristics and predispositions previously classed under the rubric of constitutional endowment; further scrutiny, in fact, reveals psychic contents inscribed in the received heredity as a sort of memorial to previous generations still alive in the present, that instigate the work of memory, thinking, and symbolization in the here and now. Those hunting presences demand appropriate burial before their loss can access the symbolic, once they become ancestors.

The drive to signification inflected through the symbolic process is equally contained in the genealogical transmission: it traces a movement from the past towards the constitution of the "subject plural" that will come into being through multiple identifications. Kaës emphasizes that Freud inaugurates a radical practice, which centers on the problematic nature of the subject, inhabited by internal divisions, different voices and temporalities which demand continuous centripetal psychic work to counteract the de-centering alienating effects. He adds that with the theory of the structural model of the psychic apparatus, Freud gave a scientific foundation to the famous

aphorism that Goethe conveyed through Faust's words "What you inherit from your father must first be earned before it's yours". This statement is in keeping with Freud's reiterated declaration that writers reached human truths before his laborious psychoanalytic studies.

Narcissism: a figure of the group mentality

Kaës thinks that the transition from *Totem and taboo* (1913) to *On narcissism* (1914) is a radical marker of Freud's trajectory towards theorizing (inter) subjectivity. The latter work, in fact, begins with an outline of the internal workings of a subject superficially appearing to be ensconced in his/her lair, in pursuit of egotistical preoccupation and phantasmatic auto-erotic desire, where the ultimate fantasy is kissing one's own lips. As the text unfolds, however, Freud demonstrates that a closer survey of the proclaimed vaunted autonomy of the subject-system reveals its fictitiousness, owing to its rootedness in the renounced self-love of the parents, who lavish their loving (self) regard on *their* Majesty the baby, in the hope of vicariously fulfilling their own frustrated desires. So, the narcissistic structure reveals to contain an adhesive attachment to the archaic object, undifferentiated from the ego. More than disarticulating narcissism from object love complexly intertwined – Kaës maintains – Freud's aim is the study of the structure of narcissism, which is a part of the personality, the locus of primary identifications, and of the link with the ancestry, broadly indicated as the father of the prehistory of culture.

Certainly, the hypothesis of the nuclear structure is further corroborated when Freud wryly concludes that parental love, ordinarily considered to be the epitome of selfless generosity, "is so moving and at the bottom so childish, is nothing but the parents' narcissism born again" (1914, 91). The intimate phantasmagoria thesis gains traction from the further hypothesis that the loving parents project onto their offspring their bid for freedom and rebellion, parenthood being a conduit to the vicarious satisfaction of their triumphant disregard for cultural civilities, and a revenge against the insufferable constrains, which they keep in abeyance for their majestic baby, whose every wish should be satisfied, beyond the reins of conscience, guilt, and conflict. The shadow on the burgeoning ego of the internalized object and its trajectory is the point of departure of the later conceptualization of the narcissistic structure whose unconscious core always pivots on the undifferentiated self–object relationship (Sandler & Sandler, 1998).

Another prominent facet of narcissism is the ego-ideal which "opens up an important avenue for the understanding of group psychology", because ideals have an individual and a social side, they bring together a family, a group, a nation, through mutual identification and recognition of their symbolic representatives. Parenthetically, this aspect of group and/or cultural identity can be exacerbated and morph into the "narcissism of minor

difference", whenever the recourse to aggression is deemed to be the only means of buttressing the group cohesion to fight the inimical other in the face of real and/or phantasmatic existential threats (Freud, 1917, 1921, 1930; Volkan, 1987).

Kaës inquires into the narcissistic libidinal reservoir of the whole group that sources the parents' capacity to cast their loving gaze on their baby, when they passionately claim the newborn to their human community, name and inscribe it in their genealogy, and invest it with the expectant anticipation of its heroic destiny. In so doing, they also stake their claim on the atemporal continuity of the generations, which somewhat assuages the daunting awareness of their own transience.

Kaës reframes intersubjectively the reflexive and reflecting functions, which he locates in the family and/or group's mind, wherefore the mirror mutates into a dual reflecting device, because if the parents validate and invest with their erotics and semantic drive the newborn, they expect a reciprocal recognition in return, when their children admire and adopt their personality traits identifying with them and share their *weltanschauung*. It follows that for Kaës narcissism is always already embedded in the group matrix that claims and seduces the infant to life, but he does not shy away from drawing attention to the violence inherent in the foundational gesture which demands subjection in order for the subject to develop.

Kaës draws on the theoretical model of the mother's invitation to her infant to engage bodily and psychically through mutual gaze, where the inevitable moments of mis-attunement offer an opportunity for the couple to learn how to recover the lost accord and rhythmicity. These early exchanges compile a veritably shared gestural system of signs that lays the foundation for the later acquisition of language. The wisdom of the tribe forms the background unobtrusive presence for the nurturing (m)other to lean on to provide the circulating sustenance; in a sense, the baby at the breast meets culture by drinking the milk that is always already culturally and erotically contaminated. Also, ambivalent feelings run through the primal bond, as in all human engagements, and evince from the foundational violence whereby the collectivity imposes its meaning when interpreting the infantile spontaneous gesture to carry the embodied semantic into the field of language. Undoubtedly a civilizing acquisition, language itself is always predicated on violence and the loss of the totality of the unlanguaged omnipotent infantile universe. Grief and mourning work are implicated.

In conclusion, identity is embedded in the group matrix, it is constituted by primary identifications with the father of the prehistory – meaning the narrativized origin of the culture – as well as secondary post-oedipal identifications with the relinquished childhood love objects. Additionally, for Kaës identity is essentially paradoxical, in that it is always changing, whilst preserving a stable nucleus, as the Latinate etymological root *idem*, which means *the same* testifies. This definition renders operational this important concept

that only recently has entered the psychoanalytic vocabulary. The psychoanalytic theory of identity addresses the protean process, it is dynamic, shapeshifting, plural, i.e., well disarticulated from the static stricture of essentialism which potentially borders on racism, to locate it, instead, in the transitional space of culture. In alignment with Winnicott's formulation, Kaës writes: "Freud had emphasized how the narcissistic *nexus* of the generation is the thorny issue of the complex of the narcissistic system. The very fact that it is transmitted, imposed and later found/created indicates its intergenerational and transgenerational scope" (126, original emphasis, author's translation).

I have dwelt on the topic of identity because it is crucial to my understanding of the characters and contexts portrayed in the narratives that are the objects of my thematic reading: it is an arresting theme for *Americanah*, for the young narrator of *When Mr. Pirzada came to dine*, and the disenfranchised refugee *Boori Ma*. Ultimately identity is painfully interrogated through all the critical predicaments examined. More generally, identity acquires a special salience in the crossing of borders and cross-cultural world of our contemporaneity.

Psychoanalytic clinicians like Kaës bring to our attention that patients arrive to the consulting room expressing their malaise organized and signified by the feeling of uncertain identity and lack of self-boundaries, and I will judiciously employ the outlined framework in my textual analyses. Here I will limit myself to emphasize the complexity and richness of the theory of identity when contextualized in the discourse of culture, its malaise, and the failure of the *Kulturarbeit* it lays bare.

Guarantors of transitional psychic space

The thesis of the meta-psychic and meta-social guarantors has a purchase on the pertinence of psychoanalysis to the study of cultures in that it articulates dialectically the nexus between internal and external reality but preserves the specific reach of each field, rather than collapsing them into one.

Consistent with the experience of playing, going to the theatre and analogous projects unfolding within a spatio-temporal frame, the transitional space of culture demands to be constructed and safeguarded from the potential disruption of inner or outer causation. Akin to a metaphorical skin formation, the cultural membrane interfaces the outside and the inside, thereby promoting the development of psychic life which depends on the assured protection from threats of violence, cataclysmic events, traumata, and the concomitant confusion and chaos, because those junctures result in psychic fragmentation and the signifying process goes awry. How can we account humanistically and psychoanalytically for manifestations of demented destruction, abuse of power and similar infringements of psycho-physical existence but by reflecting on them as instances of failure of the *Kulturarbeit*?

In *Civilization and its discontent* (1930) Freud posits that the repression of the complete satisfaction of the excesses of sexuality is the precondition of any associative life and the ineludible discontent is a feature of *any* culture, albeit more conspicuous in the subjects who fall ill for actual or psychogenic causation. Of a different order is the task demanded of *culture per se* to contain the aggression inherent in all human beings through the institutions of care and education, law and social justice, designed to acknowledge needs, and restrain the threats to the stability of the polity. It is equally incumbent upon culture to provide substitutive aims and objects to channel aggression in sublimated forms for collective benefit and leisure, as in sporting events, the pursuit of self-realization in a profession or the manipulation of material to produce art and the vicarious enjoyment it grants through identification.

This Freudian disjunction is the starting point that Kaës develops with his formulation of the functions of guarantee and responsibility, concepts which enrich psychoanalysis and whose tributaries come from the field of ethics. The meta-psychic functions topographically reside in the space-in-between, and the construction of identity leans on them for the role models, figures of identification, signifying projects and ideals they legate: amongst them is a construct, mythic and foundational, also known as the "father of the pre-history". Periods of socio-political crisis, upheaval, wars, viz humanly instigated destruction, deal a blow to the meta-psychic layers, cause the disarray of the symbolic order and consequently fracture the libidinal bonds of cross-identifications within the group. The very realm of culture unravels if the interdict of murder is undermined, it being a foundational taboo like incest; therefore, to license homicide is tantamount to disengaging it from the province of the law and its superego representative.

With respect to the transgenerational effects of environmental interference, we may return to the pathogenic potential Freud had anticipated in *"Civilized" sexual morality* (1908), when he mused on the anxieties and inhibitions of the children of unhappy marriages, sequestered as captive sufferers of their parents' frustrations. How can these children undertake their infantile epistemophilic projects if they are afraid to think what they unconsciously sense to be too painful? The investigative movements famously known as primal fantasies – Where do babies come from? How has sexuality come to me? What is the difference between men and women? – are bound to be affected. Eventual outcomes might be distortions or inhibitions of the drive to theorize, which is an asset when children are to inscribe themselves in their genealogical project of filiation and it also undergirds their intellectual ambitions. The cascading effect impacts memory and curiosity both of which may be impeded and hinder the work of subjectivation which is, indeed, based on the historical markers of ontological situatedness.

Kaës references Nathalie Zaltzman who radically interrogates the nature of the *Kulturarbeit* to befit the contemporary world which in the postwar epoch has shifted to being a regime of transmission of trauma. She claims

that the question of the root cause of psychological suffering must be repositioned, and wonders whether it still lays in the exigencies to perform the *Kulturarbeit* or, rather, culture enforces individual mental work to elaborate their relationship to evil, to integrate and take (unduly) responsibility for it. In that case the culture intromits into the psyche unworked through violent contents that, not being amenable to translation and transformation, constitute a veritable form of enigmatic violation. On the heels of Zaltzman's line of argument Kaës arrives at formulating a pathology of the institutional structures, characterized by the absence of respondents, responsibility, remorse or reparation, which characterize the depressive position as theorized by Klein. Disavowal and projection of responsibility for crimes against humanity tinge the whole culture with melancholic hue and the repudiated guilt of the fathers befall the children, returning as their persecutory anxiety, ghosts, namely, guilt by another name and another face. Why did it happen? How did it happen? Who made it happen? These remain unanswerable questions.

Kaës lodges the transgenerational legacy of both psychic contents and of the signifying apparatus in the structure of narcissism that links temporalities, is traversed by the group ties that contribute to the feeling of belonging, and inflects the subjectivizing processes of filiation and affiliation. What is unconsciously passed on in the narcissistic structure to promote growth if contaminated by unelaborated traces, can become encysted in somatic events and other forms of defensive enclosures which keep them beyond the reach of thought.

The shift of attention on the intersubjective link wrought on the structure of narcissism – that is, the ecological niche of the ontological realization – has shed light on the long-lasting resonances of the unelaborated residues that appear in the present troubled identities. Similar lines of thinking as Kaës (1993) inspire Faimberg's work on the telescoping of the generations (2005), and Abraham and Torok's *The shell and the kernel* (1994), who propose the important concept of "melancholic encryption" of the unmourned. They assert that unburied lost objects cannot be relinquished, they return to haunt the subject and sequester them in melancholic crypts. They play "exquisite corpses" and hold the subject in a deadly embrace, full of passionate ambivalent jouissance that leaves no room for new attachments and lively investments, because their psychic destiny is incorporation, rather than grief and secondary identification. Furthermore, negated loss and impossible mourning work morph into mandates to the next generation whose highjacked lives harbor fantasies of revenge and redress, where letting go is likely to be misconstrued as betrayal. Only by reinitializing the mourning work can the crypt be exited, the trauma worked through and narrated, to finally be inscribed in History and biographical stories.

I refer the reader to the aforementioned authors' publications, which must be etched in the broader perspective of the reprise of the theory and

treatment of trauma in psychoanalysis –as Grubrich-Simitis (1997) astutely recognizes – that was solicited by the demand made on the clinic by the presentation of survivors of the upheaval of World War II and the genocide of the Holocaust, which impacted the next generations.

Regrettably, the category of trauma is now everywhere, employed as an overarching concept that risks losing its epistemic value, having even assumed the status of aesthetic utility – as in the citations of "the art" or "literature of trauma". Caveats are in order when concepts become too elastic, or their decontextualized employment effaces their epistemic efficacy to the point of meaninglessness.

The present work shirks overarching categorizations, rather it propounds to maintain the focus on the characters and analyze their psychological itineraries and the inner forces that speak the idiomatic rendition of their history. I argue that the melancholic impasse of the work of mourning permeates the present culture with its affective state, and its mute pain can neither be memorized nor forgotten but meaningfully returns in fictional representations.

To restore a life enhancing hope and refer to the textural structure underlining this book, I would like to call upon a cultural project photographed as aide-memoir, namely the *Mnemosyne Atlas* and archive of images Warburg conceived and began in Berlin. He died leaving it unfinished and it was later entrusted to the curation of Ernst Gombrich who, in his turn, could not terminate it. It may well be the project's destiny to remain incomplete, but perhaps this has always been its spirit because Warburg wanted it to be forever changing, like the waters inhabited by the Muses and Nymphs, that the Greeks figuratively imagined as sources of creative inspiration. The titular Mnemosyne is the goddess mother of the Muses, and her name means Memory, precisely like the human factor that links generations, temporalities, culture, and is at the core of identity formation. The archive is the site of the consigned memories, there to be reopened and accessed, to undo and resist any form of authoritarian repression. Memory reshapes and reinvests the future when it appears foreclosed by moments of destructions of civilizations; it infuses the artists' sensibility to generate new visions and new languages to salvage the symbolic process from its semantic crisis of reference.

Malaise "in" and engendered by culture

Violence attacks the capacity to think – as Kaës proposes – by piercing the skin-ego in threefold ways: it destroys the thought contents, the contact-barrier, and the boundaries that delimit and define the epistemic field. Consequently, the subject cannot apprehend the truth and the causes of historical phenomena which, if not inscribed in the process of signification, remain outside the cultural tradition and might eventuate in learning inhibitions

affecting the next generation, together with pathologies of identity. The violence of the State and sanctioned by the State poses a question that pertains both to the political and psychoanalytic discourses, because it is located

> at the junction of two disasters: the demise of the State of Law and the disaster of the subject forced to incorporate within the psyche a traumatic violence whose genesis belongs to a different order than its intrapsychic determinants: it pertains to that of politics.
> (Kaës, 2012 244, author's translation)

If the State does not acknowledge its responsibility, it inflicts further injury by obfuscating and obliterating the facts, which cannot be mourned, memorialized and commemorated or forgotten as situated in the past. My final chapter on Amelia Rosselli explores the intrapsychic rupture of the shock of learning about the murder of her father, when Mussolini's henchmen murdered him. The real murder of the father obstructs the formation of the symbolic structure of the dead father – testified by her episodic psychotic decompensation. Her extraordinary musical ear together with her talents bind her capacity to mend the rents – her psychic holes – and source her invention of the poetic forms to stage the violence that de-structures language and at the same time renews it. The unremitting frenzied lyricism of her rhythm acoustically mimics the violence of her linguistic gesture demolishing the very possibility of semantic expression necessary to its refoundation.

How to restore the pierced thinking envelope with the tools of psychoanalysis? Kaës sees in *Totem and taboo* the metaphorical representation of the turning points of civilizations, when they unravel and return to the state of nature – the Hobbesian *homo homini lupus* Freud quotes – to then having to realign and institute a new order, based on a different civic pact. The Father of the horde epitomizes the degradation of the paternal principle, no longer the organizer of a viable orderly community when his putative authoritative word is exposed as empty by the horizontal community of siblings. This movement explicates that authority exists when it is mutually recognized by the different generations who convene to establish a pact of authority. In historical junctures when it is fetishistically emptied or merely apophatic, then the polity demands that the brothers-citizens initiate the process to institute new pacts, new libidinal bonds and confer authority to a renewed symbolic paternal principle, to give credibility to the new order.

Broadly speaking, Kaës offers an interpretation of *Totem and taboo* as a founding myth written in our psychoanalytic heritage, a methodological tool to think about cultural vicissitudes when the psychic skin is pierced, the collective *Kulturarbeit* flounders and it is therefore incumbent to repair the fabric of thought.

The artists' works I analyze showcase this very constellation of societal disruptions and demise of the *Kulturarbeit* – understood as the psychic work pertaining to and guaranteed by the culture. The stalled or impossible collective mourning

gives life to the characters in search of a grounding narrative. Kaës' work on the group matrix of identity is especially advantageous to allow my psychoanalytical imagination to recreate the characters, for instance that of Ifemelu – the Americanah – in my work of culture through writing.

Arguably, artists recover the texture of meaning when cultures undergo phases of chaos and disarray, and somehow repair the breach of the semantic structure of representation that overwhelms subjects to the point of de-subjectivation. In so doing, the work of art can activate and perform a measure of the collective mourning work.

The psychoanalyst's contribution can shed further light on the individual resources that permit survival, resistance, and creative endeavours in the face of adversities: such assets are available to some, but not to all, which interrogates the factors contributing to the difference. Finally, readers will exercise their own capacity to reimagine and continue the work of thinking about these specific differences.

References

Assoun, P.-L. (2018). Sujet, culture et inconscient (conférence, 18 septembre 2018).
Freud, S. (1908). "Civilized" sexual morality and modern nervous illness. SE IX.
Freud, S. (1913). *Totem and taboo.* SE XIII.
Freud, S. (1914). *On Narcissism. An introduction.* SE XIV.
Freud, S. (1917) *The taboo of virginity.* SE XI.
Freud, S. (1921). *Group psychology and the analysis of the ego.* SE XVIII.
Freud, S. (1930). *Civilization and its discontents.* SE XXI.
Green, A. (2002). *La pensée clinique.* Paris. Odile Jacob. [Psychoanalysis: a paradigm for clinical thinking. London. Free Association Books, 2005.]
Grubrich-Simitis, I. (1997). *Early Freud and late Freud.* London. The NLP, Routledge.
Kaës, R. (ed.) (1993). *Transmission de la vie psychique entre les générations.* Paris. Dunod.
Kaës, R. (2012). *Le malêtre.* Paris. Dunod.
King, P., Steiner, R. (1992). *The Freud-Klein controversies 1941–1945.* London. The NLP.
Laplanche, J. (1997). The theory of seduction and the problem of the other. *IJP* 78:653–666.
Sandler, J., Sandler, A.-M. (1998). *Internal objects revisited.* London. Karnac Books.
Volkan, V. D. (1987). Psychological concepts useful in the building of political foundations between nations: track II diplomacy. *Journal of the American Psychoanalytic Association* 35:903–935.

Chapter 3

The universally human
Interweaving the subjective and the societal

This chapter and the next regard the liminal locus – geographical, cultural, and psychical – wherein dreams, daydreams, fantasies, family romances, fabrications, and indeed deceits source as original creations of the subject, in the face of losses attendant upon external circumstances entailing existential threats, that challenge their very being in the world. In the aftermath of any such occurrence, grieving for what is lost is the crucial, complex, and demanding psychic work, necessary to elaborate the wound and fashion a new identity, reaching the plastic capacity of the ego to host a plurality of subjectivities and invest libidinally new objects (Freud, 1915). This is the work of Eros, the life drive rebuilding from the ashes. I propose to explore how the itineraries of working through grief are fictionalized in two short stories of the collection *The Interpreter of maladies* by Jhumpa Lahiri, published in 1999 and honoured with prestigious international awards, amongst which the Pulitzer Prize. I intend to put Lahiri in conversation with psychoanalytic writers who provide theoretical frameworks to endorse my close reading of the texts. I primarily turn to Freud and Laplanche, whose concept of translation as foundational for the child's unconscious and essential constituent of the psychic work speaks to Lahiri's meditation on translation. The practice of translation always entails the loss of the literal or phantasmatic fullness of meaning, which leaves a trace, a gap, a space that Lahiri-the-writer inhabits creatively. Moreover, any transcription into a different semantic system involves the related questions of nomination and its flipside, the unnamed, commensurability, universalism, or particularism. Here Lahiri declares to adhere to the Italian poet Montale's position, whom she quotes when she establishes the coincidence of the unnamed with the very possibility of the universal, the universally human.

Freud based his own topographical model – fashioned on the dreamwork – on the transcription and re-inscription of dream images into words, whereby one semantic system morphs into another. One of the shibboleths of psychoanalysis is transference, which is but a translative re-transcription of a previous archaic sensorial language into speech addressed to the Other of the talking cure. A successful analysis comes to fruition when the fundamental

loss of the phantasmatic object is ultimately acknowledged and this process entails a painful loss of illusion because that very object is always an *a posteriori* ideal, constructed out of desire and need. This is another instance of the essential function of the mourning-work.

Lahiri is an Asian-American writer and translator whose engagement with languages and their crucial role in shaping identity, to the point of epitomizing the very fabric of thought, runs through her fiction and essays on translation. Amongst the latter it suffices to mention the titular monograph on self-translation, published in 2022.

Lahiri was born in London – but never lived there – into an Indian literary family, her father being a librarian and her mother a poet who composed in Bengali. Asked by the interviewer of an Italian TV channel if her given name Jhumpa had a discernible meaning in Bengali, Lahiri replied that her mother chose it for its onomatopoeic property, that is, a sonorous evocation of the rain. This autobiographical detail ascribes her access to a plurality of registers – symbolic, semantic, and sensorial, notably acoustic – to the very facts of her entry into the world, although hers might well be a screen memory, an *a posteriori* signifying attribution, like most autobiographical recollections are.

The family emigrated to the United States when Jhumpa was three years old, thereafter English began to inflect her engagement with the social world outside the family. As a result, her Bengali came to denote the province of permanence, of childhood, leading a metaphorical shadow-existence, whose growth was and remains stunted, and was swiftly superseded by her sophisticated use of English, which conferred to her word much authoritativeness – perhaps authority too – over her parents. The psychoanalytic literature abounds with clinical accounts of similar oedipal conflict and sense of guilt which pervade the internal world of children of emigrant parents, sometimes with stultifying consequences. Fortunately for Lahiri, her disposition to live between languages allowed her to pour into her writings the diasporic sense of displacement and nostalgia which imbued her upbringing and morphed into the salient moods that feature in most of her fictional settings and characters.

There is a curious level of complexity in the psychic vicissitudes of her two languages: both assigned at birth, they are equally susceptible to being sequestered within the semantic field of authority-as-dominion, whilst, at the same time, they condense the historical circumstances of the colonization of India. Lahiri's personal history and some of her fictional characters are arresting examples of the fecundity of the application of the psychoanalytic method to the study of the historical, socio-cultural, and political, refracted through the structuring of the psyche and cunningly deposited in the nuances of language(s). Lahiri's English is inherently ambiguous: its syncretism is a vehicle of narratives of subjectivation, emancipation, and authorship, but it is also the placeholder of the aftermath of colonization, which sharply contours collective and individual history. Notwithstanding, like all historical

facts, these events can be plurally signified: one telling example is the Martinique poet Aimé Césaire who staked a claim to his *negritude* and equally to his entitlement to use French to convey his personal, political, and poetic dissident voice.

Somewhat differently, Lahiri relates how she feels Bengali and English to be both inner discordant idioms, equally jarring: does her statement implicate the internal structure I would define as the language(s) of *dominion?* Not just confined to the political sphere, domination also delineates a psychic construct that might be attached to and intertwined with any given language(s) albeit not wholly reduceable to the externality of the shared linguistic and symbolic order; it is destined, in fact, to be personalized, like all other signifying attributions.

From the perspective of psychic development, the subject–object relationship saturated with systemic domination marks the separation–individuation phase of toddlerhood and anality – within the paradigmatic linear temporality of maturation – that is reprised and remolded in the course of all subsequent reorganizations, which are predicated on mourning the previous equilibrium, in search of a new ontological posture. In fact, the spiraling alternation of diverse temporalities is the elective modality operating in all processes of adaptation, and offers opportunities for revisiting and elaborating previously unthought nodal experiences. In Lahiri's words – as I will explicate later – Italian came to signify a third position, a synthesis, a zone of freedom from the master–slave dialectic of power and submission.

Dominion and subjection are categories inherent to the structure of colonization – as Fanon astutely emphasizes in his classic *Black skin, white masks* (1952) – and are bound to inflect the trajectory of identifications. The sense of personal agency and potency are confusingly imbricated with this polarized logic and thereby effect the mimetic identification with the hegemonic defining Other, and the turning against the self. Based on his reading of Lacan's mirror phase, Fanon explicates that this strategy runs along the track of the alienating, albeit unavoidable, identification with the Other's image of the subject and the internalization of the master–slave construct.

Returning to Lahiri, her academic interests took her to Florence to study Renaissance arts. It came as a surprise, an arresting epiphany to feel a true foreigner in Italy, but paradoxically at home in her foreignness. Enveloped by the sound of Italian spoken in the streets, Lahiri fell in love with the language and, eventually, elected Rome as the place to inhabit, and the site of her transformation. She describes her self-taught Italian as a third language, free from her internal discord, that she sensed was so intimately intermingled with linguistic codes. Not only does Italian speak to her as an alive, musical, and literary language – of which she has become a *shuttle-translator* – but it also leans on the familiar Latin substructure she revisits in her translations, for instance, in the rendition of Ovid's *Metamorphoses* into English. With Italian, Lahiri has discovered a cross-cultural, transitional space where she

becomes the words that she makes, and by becoming a speaking-thinking subject, she occupies the location of the disjunction of her subjectivity from the unconditional and unthought out adherence to any pre-ordained linguistic order. She creates herself in the plurality of her internal narrating voices; in other words, by critiquing the stricture of the univocal subjection to any restrictive code, she metamorphoses herself into her own person.

Motifs of ethics and political resistance lace Lahiri's writings, they are finely chiseled into her characters' psychology rather than hollering from the page. This showcases that her characters come alive from her labour of sublimation, and the melancholy hue exuding from them engages the reader, for she addresses poignantly and mournfully the universally human sensitivity.

Parenthetically, the psychoanalytic theories of sublimations are complex and grounded in diverse theoretical frameworks. Of necessity here I can into only refer to this concept as an essential component of any psychoanalytic discourse on culture, on the heels of Kristeva who proposes that the need to signify (*semeiosis*) and to speak is quintessentially human. She thinks that Freud's entire body of work implicates sublimation, that it is the very condition of belonging to any culture, which is subtended and organized by language. The subject dynamically responds to the unceasing demands for the signification of the "combination of sensation, affect and cultural memory" (Kristeva, 2007, my translation) morphed into metaphors to traverse the arc from the body-of-the-drive to words.

In a conversation with Professor Howard Norman available on YouTube, Lahiri affirms that she recaptured her childhood as a vital part of herself when she began to speak and write in Italian, and now she self-translates into English her Italian writings. This back-and-forth movement will register familiar with the psychoanalyst as much as with the analysand, regardless the idiomatic specificity of any enunciation addressed to the phantasmatic Other of, and in, the transference. Amati-Mehler, Argentieri, and Canestri gesture to these varied linguistic possibilities in their titular emphasis on the foundation myth of Babel, reporting their analytic work with bilingual and/or polyglot patients (1990). Additionally, there is a sizeable psychoanalytic literature on the topic of analysis in a second or third language, the infantile conflicts, drive vicissitudes, the fantasies registered, encoded, and signified in one or more personal idioms. Authors such as Tesone (1996), Antinucci-Mark (1990), Antinucci (2004), Jiménez (2004), Movahedi & Homayounpour (2012) can be referenced, among many others.

As previously mentioned, beyond the intriguing suggestions that Lahiri's statement offers, her experience can be ascribed to the ubiquitous phenomenon whereby the child(hood) within the analysand is like a third language, co-created within the psychoanalytic process that conjugates in a new articulation the inchoate utterances of the un-named and previously un-spoken psychic contents, so that, by naming them, the patient gains greater freedom from internal conflicts and anxieties. Framed within the après coup

or *Nachtraglichkeit* – Freudian coinage to define the exquisite temporality of psychoanalysis – and the paradoxically finite/infinite space of the consulting room, the inner child can be found/created through the words addressed to the Other in the transference, to recover the freely associative nexus in the unconscious gaps and reach the hitherto unsayable. With the due differences, an analogous trajectory can be noted in Lahiri's writing.

Lahiri does not narrate a self-exploratory journey on the couch; rather, by relying on her literary perceptivity and imagination, she travels to another place, and in another language (Antinucci, 2004) she finds/creates a plurality of selves, through painstakingly listening to the foreign words she apprehends therein. She follows their itinerary towards previously unformulated thoughts, whose emotional and psychical capacity is accrued by journeying through unbounded spaces and temporalities, to access the province of fantasies, dreams, and other imaginative representations. Lahiri's work chimes with Kristeva's sentiment that the polylingual foreigner, if conversant with their internal world, can inhabit the free domain granted by their foreignness, that coheres around the porosity of their internal borders.

The interpreter of maladies

Lahiri sustains the thematic musical score of foreignness and polylingualism that she articulates in several emotional and circumstantial variations in her award-winning compilation of short stories *The interpreter of maladies*. The continuum of linguistic nuances departs from and comprehends the body, its ostensibly somatic maladies and the specific forms of malaise engendered by a situated cultural milieu, whose functions and disfunctions reverberate in the subject's inner world. Both maladies are there to be signified and interpreted – as the titular story gestures to – but, where the former demands translation into medical semantics, through the latter it is the psychosexual body that speaks the voice of conflict, strangulated anger, desire, and guilt, whose semantics befits the psychoanalytic discourse, its methodology, and therapeutic project. Just to mention parenthetically, Mr. Kapasi is the eponymous protagonist of the story, he works as a par-time taxi driver, is a self-educated man who speaks Standard Indian English with the tourists he shows Indian historic sites, and his second job is translating the body ailments of patients who speak a variety of dialects but cannot master the doctor's language. Therefore, without Mr. Kapasi's precious mediation, the sick could not survive or be cured. What is more, the ill are the uneducated poor, who never learnt the descriptive language of symptoms or the anatomical geography of the body and its organs, so they can only use nature-based metaphors or quotidian activities to communicate their suffering. This story would well deserve a detailed analysis, but I will concentrate on *When Mr. Pirzada came to dine* and *A real Durwan*, which I have selected for my

close reading, because their themes pertain more cogently to my main argument.

With the compass of the discourse articulated along the axes of the impact of historical events on subjectivities, their relationships and psychic life, I intend to spotlight the child-narrator in *When Mr. Pirzada came to dine* and the middle-aged woman in *A real Durwan* through whom to observe the psychic resonances of the partition of India. In the locus of the intersecting external and internal worlds, fiction weaves a narrative that opens to the psychoanalyst a space for close reading and thinking about subjectivities in distress, the elaborative and defensive strategies available that depend on their existential coordinates, like age, class, gender, and endowment. I will focus on the psychic work instantiated by a sudden loss: in the resulting chasm and to fill out the gaps, the imagination constructs unedited shapes – from dreams to daydreams, family romances, to utter fabrications: some are in the service of consolidating figurations, some sketch a parallel world wherein to ensconce and not be found. These neo-formations aim to console or fulfill an age-appropriate need: the imagination can represent a family romance, linked to the Oedipus complex – as Lilia exemplifies – but it can also lead to a falsifying imposture which shores up a shaky identity, to stave off full blown psychosis – as in the instance of Mrs. Durwan.

Psychoanalytic orienting frameworks

In *When Mr. Pirzada came to dine* the trope of the unexpected stranger's arrival is a catalyst to expose or change the hosting family's dynamics and throw into sharp relief previously unknown, even alien aspects of the protagonist and her relationships with others. It is a well frequented trope in literature and cinema, and a strategy to capture a moment in time which marks a point of no-return. In my textual analysis, I intend to approach it as compositional strategy which highlights Lilia's need to make sense of the current news and translate the cryptic information she receives from the adult world. The message is enigmatic – to quote Laplanche – it demands cognitively conscious research but, more in depth, the translation work might also be a present-day edition of the work of translation the child is always required to do starting from early infancy.

Laplanche proposes that Freud left incomplete his "Copernican revolution" when he shifted his epistemic lens on the unconscious fantasy undergirding infantile sexuality as the crucial determinant in the adult–child relationship. At that point, his inquiry crucially centered on construction of the unconscious fantasy of the child, seen as self-absorbed in its intra-psychic world. Conversely, the earlier trauma model of the psychic apparatus, formulated between 1983 and 1987, focused on Freud's intuition of the centrality of the seductive proposition of the adult, whose salience he later omitted, did not advance, neither did he abandon it. What is more,

Laplanche critiques Freud for not going far enough to explore the primacy of the adult in structuring the child's unconscious phantasy of seduction, unlike himself who always regards the Other as the prime motor in initializing the infant's epistemic research and the unconscious fantasies which fill in the gaps. Developing the concepts Freud formulated in his later writings on female sexuality, wherein the mother is the original seductress, Laplanche gives primacy to the (m)other who, via ministering bodily care transmits an enigmatic message imbued with, and compromised by, sexuality, which the infant cannot comprehend. The message emanates from the unconscious of the adult, who has traversed the Oedipus complex, and the childhood amnesia that sets in around its demise creates the repression barrier. Consequently, a quota of the transmission is unconscious, it is sexual, and informs the asymmetrical relationship between adults and children, with ethical implications, predicated on the parents' capacity to sublimate their desire and transform it into tenderness.

"The significance of this is not merely contingent – why, after all, is sexuality accorded a primacy over, say, the alimentary or the need for security? Because the primacy of sexuality opens directly on to the question of the other, and in the case of the child, on to the adult other in his alien-ness, the radical alterity of the other-thing [...] the unconscious, is only guaranteed by the other person [...] briefly, by seduction"(Laplanche 1997, 658).

Laplanche calls his theory of seduction "general anthropological situation", it is normative and marks the child's entry into the human world. A measured, temperate seduction to the eros of life – arguably – that must be conveyed with sensuous tenderness, whilst the adult sexuality is consigned to the *other scene* of the lovers' chamber, from which the child is excluded, but becomes the space to enter with conscious and unconscious fantasies, curiosity and imagination that compound the wish to know. Implicit in the general anthropological situation is the corollary that prohibitions and taboos are cultural initiation for the infant who drinks the milk imbued with the interdict to use it sexually or kill. Thus sublimated, seduction instantiates the infantile ego's work of translation of the enigmatic, sexually compromised message, but there is always an untranslatable trace that institutes and structures the unconscious through primary repression, which renders après coup the seducing Other a stranger "re-absorbed in the form of my fantasy of the other, my 'seduction fantasy'"(658). Ultimately, in the stranger, the subject senses the alien-unconscious-other-scene inside the self, marked by the returned of the repressed. Laplanche adds that this dialectic of internal–external reality is coterminous with the work of culture because "[c]ultural activity is an opening out on to the other, an address to the other" (663).

I will close-read the story of Lilia engaging in a psychoanalytic dialogue with Laplanche and Freud, particularly his *Three essays on the theory of sexuality* (1905) and *Family romances* (1909). In the latter text is written a return of the repressed Oedipus complex in displacement, in wait to be re-

edited and re-translated. It is a return of the repressed because the family romance is a phantasmatic creation of latency which developmentally follows the waning of the Oedipus complex, if growth proceeds unimpeded.

When Mr. Pirzada came to dine

In *When Mr. Pirzada came to dine* the narrator is ten-year-old Lilia, the only child of Indian parents, who lives in a university town north of Boston with her mother who is employed as a bank-teller and her father who has recently been nominated for tenure in an unspecified faculty. The family meet the titular Mr. Pirzada when he spends one year in the United States to research a variety of plants growing in New England for his project of writing a monograph, sponsored by the Pakistani government.

It is the year 1971, and a bloody civil war breaks out in the Eastern region of Pakistan, fighting for independence from the ruling West, thereafter Dacca is proclaimed capital of Bangladesh. In Dacca Pirzada left a wife of twenty years, seven daughters, a lectureship, and a beautiful three-story home; from his well-established life he was severed for months when the uprising began, and he watched the dramatic events on the television screen together with Lilia's family. Although far away, these historical events colour the emotional climate with their eruption of fratricidal violence, murders, deaths, family separations and losses, and determine the unfolding of the narrative, which culminates in his hasty departure, without a farewell.

Lilia and her story

Reminiscing the circumstances of the foreigner's ingress into her home, Lilia recounts that her parents had acquired the habit of recreating their sense of extended family by going through the university directory each semester to select the newly arrived fellow nationals and invite them to join their evening meals. That autumn they chose Pirzada, who willingly became a regular guest, and arrived every evening bringing confection for the girl.

Lilia has no distinct recollection of his first or last visits, instead, her memory vividly retains the images of the evening rituals: he would arrive, take off his shoes, hand his coat over to her, shake hands with the father, and all the while the food would be cooking in the kitchen, emanating the distinct aromas typically pervading Indian homes. Crucially, Lahiri emphasizes the circular ritualized temporality – Lilia does not remember the beginning or the ending, only the reiterations and she is comforted by her rituals – to foreground how the whole group struggles with conclusions and mourning work.

Mr. Pirzada's assiduous visits continued for about one year, he witnessed from afar the hostilities of the following March that caused the loss of three hundred thousand lives, and the ensuing expectable war with India, where

masses of refugees had tried to repair, until he eventually returned to Pakistan the following January, to be reunited with his family. A protracted silence followed, which surprised Lilia unlike her parents, who had insightfully anticipated they would never see him again. Eventually, six months later, a thank-you card broke the silence, with an accompanying concise reassurance that the Pirzadas were doing well. He further explained that at long last he had understood the words "thank you", which he had noted was a strangely recurrent, ever-present phrase in America, so unlike the Indian customary civilities. That same evening Lilia's mother cooked a special celebratory meal, but "I did not feel like celebrating" – Lilia secretly tells herself, recalling that it was only then, when "raising my water glass in his name, that I knew what it meant to miss someone who was so many miles and hours away, just as he missed his wife and daughters for so many months" (42).

Lilia's words sound like a confession of her intense feelings for Mr. Pirzada and wind up the tale leaving it for the reader to interpret the meanings of her secret passion. What is the nature of the girl's engagement with the uncannily familiar and unfamiliar stranger? The reader is a complicit guest invited to enter Lilia's room, to witness her secrets, her private liturgy, thoughts and worries. The room metaphorizes her mind which Lilia, like all latency children, treats like a treasure trove, whose keys are her exclusive possession, and she is sole custodian. Just like her diary, her room and her mind are guarantors of her privacy, for she is aware of being enveloped by her individual skin ego. What is the psychoanalyst/reader privy to? At first glance, there is a scene of shifting identifications and desires within the family, where Lilia is both the observer and the protagonist; a second look captures the reprise of the oedipal mis-en-scene, that is unconscious and only amenable to re-construction après coup, based on the structuring primal fantasies: who am I, where does sexuality come from? What is the difference between boys and girls? This is the other scene the psychoanalytic reading imaginatively constructs by virtue of listening to the unconscious derivatives which subtend the manifest storyline. My reading will develop along the axis of the fantasies, only partly conscious and mostly unconscious, the intimacy of a latency child typically teems with.

I propose the concept of the *family romance* and its close nexus with the Oedipus complex it dramatizes in displacement, to be the theme that impressed me compellingly and informed my reading. The family romance construction highlights at one remove the multifarious and emotionally hued strands of the Oedipus complex, whose ultimate function is to structure the child's internal world and bound their thinking space. I examine the specific manifestation it can acquire through the signification of migration and the relinquishment of the "other culture" of the origin that embeds and supports the feeling of identity of the parents. This is also the site for the inscription of the transgenerational cultural transmission, mostly unconscious too.

Lilia is an American girl, she attends an American primary school, celebrates Halloween, but she is also the unique repository of her parents' projections, fantasies, fears, ideals, desires, and expectations of what their foreign child is and will be becoming. To further complicate the picture, the parents might be at variance with each other, transmit inconsistent and confusing messages to their children, a well-known phenomenon the clinician encounters when couples need to process ambivalent feelings but defensively polarize them, which makes their conflict hard to shift. The clinician readily evinces from this mode of relating the presence of the couple's collusive bastion against the pain of mourning. Additionally, enculturation sits on the ambivalent feelings which pertain to the vicissitudes of the work of mourning, concomitant to the relocation to a foreign country, and this burden impacts the second generation with unconscious mandates and binding pacts. The diasporic parents might experience a crisis of legitimacy, feel dispossesses, and fear that their children will become truly foreigners, feel estrangement and shame, which elicit anxieties and defensive strategies to stave off the unmourned loss of the fantasy child "back home", who never was and never will come into being.

In the storyline Lilia's family could be seen to function like a microcosm, going through the enculturation process, and Mr. Pirzada serves as a catalyst to foreground the itineraries of migration. A more symbolic register resulting from this successful process is the sublimation of writing, as attested by the diasporic literature, replete with narrations of journeys of self-discovery, and the character's search for an aesthetic form to inscribe their biography in a story, their own story.

The family romances

Freud wrote the short essay *Family romances* in 1909, at a time when he was preoccupied with the origin of children's epistemophilic investigations roused by the transformation of the infantile sexual quest. Crucially, his interrogation led him to the field of children's theory-making; he was impressed by the recurring figure of the hero and eventually came to regard the *heroic* as a signifier of pertinence in their storytelling. The text was initially conceived as a contribution to Otto Rank's *The myth of the birth of the hero*, published in 1908, and regards the child's need of the heroic as a constituting factor of their mythic inventions. As Strachey points out in his translation of the Standard Edition, the idea of the family romances had been in Freud's mind for a long time, albeit initially he only attributed them to the paranoiacs. When he began to ascribe them to the wider and universal theorizing of childhood and linked them to the Oedipus complex, the feature that soon came to the fore was the nexus with infantile sexuality, and the love relationships in their various embodiments which, much as they present in

disguised formations, nonetheless, preserve the unruliness of desire (Laplanche & Pontalis, 1968).

Freud inserts the family romances in the development towards growth and separateness, accompanied by the child's disillusionment with the former idols, whereby s/he leaves behind the "most intense and most momentous wish [...] to be like his parents" (1909, 237). Meeting other families prompts comparisons, the dissolution of the remnants of infantile idealizations, and the unconscious questioning of the "wish to be like" the parents disrupt the primary identifications with them, previously needed for feelings of safety, stability, and the ego enhancing *weltanschauung* (world view). Renunciation of the unquestioned sense of belonging in transition towards fashioning a personal identity is emotionally taxing because of the narcissistic wound it brings in its wake. Thus, the fantasy that better, richer, nobler parents are the real parents and one day will come to the rescue, is meant to ameliorate the blow.

The foundation of the sense of identity pertains to the province of narcissism – which Freud will properly formulate in 1914 – but perhaps in this earlier text the structure of narcissism in the child–adult nurturing bond is implied under the rubric of identification and forged by mutual identification. The *Family romances* essay elects sexual rivalry and the exigencies of sharing the love object as the motivating factors fomenting the invention of the romances which have "two principal aims, an erotic and an ambitious one – though the erotic aim is usually concealed behind the latter too" (1909, 238).

In the tradition of Freud, Kristeva (2000) develops her view that the unconscious is founded on the co-presence of sexuality and thought, coexisting in language, albeit within an inveterate tension that renders problematically conflictual the manifest address of desire. Desire, nonetheless, finds its meandrous ways of speaking through gaps, dreams, and symptomatic compromise formations to both disguise and reveal the repressed wish. With this co-occurrence of somatic excitation and thoughtful symbolic creations in mind, let's examine how these dual registers – drives and thinking – come into play in the story of Lilia and Mr. Pirzada, beginning with questions of identity and desire respectively formulated as: who are you? What do you want from me? Who am I? What do I want from you? Such questions bear on the work of subjectivation – the "I" of identity and desire – and are the yarn available to children to spin their epistemological investigations.

Mr. Pirzada is not an Indian

Mr. Pirzada's assiduous visits have by now turned him into a consistent presence at the dinner table. One evening Lilia is setting the table with two glasses and asks for the third, for the Indian man, to which her father retorts that Mr. Pirzada is no longer considered an Indian, since the Partition of 1947. Lilia was aware of the historical fact named Partition, which she had earmarked as the proclamation of India's independence from Britain: noted

as a history lesson, she had not joined it with the markers of identity that clustered around what she understood as Indian-ness. Feeling disoriented, she wondered: what might then define the Indian? It made no sense to her because Pirzada and her parents

> spoke the same language, laughed at the same jokes, looked more or less the same. They ate pickled mangoes with their meals, ate rice [...] with their hands, [...] took off [their] shoes before entering a room, chewed fennel seeds after meals as a digestive, drank no alcohol, for dessert dipped austere biscuits into successive cups of tea.
>
> (1999, 25)

The child signifies identity through the observation of perceivable data gleaned from nature – biology, skin colours, looks – and culture, such as language, sense of humour, food, and its ceremonial, or religious, shared meanings. Lilia had previously fashioned subjective, historical, and structural elements in a way that suddenly no longer cohere if the set of identification markers – Pirzada, *like* my parents and *like* me – that had constituted the "I-me", both observing subject and observed object can arbitrarily be manipulated by powerful agents who impose new identity categories through the politics of *divide et impera* (divide and rule). Much more could be read in the father's words, but the crucial aspect to corroborate the psychic implications of the family romance is the *unraveling of the chain of primary* narcissistic identifications inaugurated by the sequence of *"like"*. The cascading effect is the curiosity about the stranger that instantiates Lilia's daydream of the family romances.

Freud had located in the phase of latency the creation of daydreams (1909), often occasioned by the encounter with a stranger. Expanding this motif to encompass the complexities of the subjectivizing process through the hurdles of a novel enculturation that segues migration, I would argue that Lilia's narration substantiates my psychoanalytic hypothesis based on the story, which could be read as a fragmentary case study of the reprise of the Oedipus complex in displacement, that is, the specific form of narration of the family romance.

The non-Indianness of Mr. Pirzada introduces a mystery for Lilia, an enigmatic signifier (Laplanche 1997) that always already implicates the sexual, the unconscious, for the adult and the child alike. Returning to the girl's fantasies, they are conscious and couch her curiosity in her concern for the plight of the Pirzada family having to endure uncertainty, deprivation, and separation. There is, however, an antecedent, a trace, not accessible to perception or observation, that morphs into her defensive reaction formations and hampers her capacity for sublimation, as I will illustrate commenting on a school incident. As Kristeva remarks, desire cannot say, but language is compelled to speak the unconscious, and in this case, the layer of

the family romance – as Freud proposed – has an apparent non-sexual component, albeit underlain by a sexual undercurrent.

Wise to Pirzada not being Indian, Lilia begins to regard him with heightened attention and curiosity to detect signs of his difference. On the factual level, the *divide et impera* logic of power had collectively solicited the emergence of the *narcissism of small differences* (instigating tribal hatred, suspicion, and fratricidal rivalrous violence during the civil war in India), whose psychic reverberation rendered Pirzada a non-family member, hence the exogamous guest, intriguing attractor of incestuous fantasies in displacement. A similar fate befalls the oedipal object that, as Freud remarks, morphs into the stranger of the family romance, which is an *a posteriori* construction to disguise the repressed incestuous object. Analogous process occurs in analysis, when the analyst becomes a transference object, a paradoxically familiar stranger. At this point Pirzada impersonates the heroic character of Lilia's imaginings, the prime motor of her arresting intensities and curiosities. The return of the repressed mobilizes the resurfacing of the previously unthought thought that incest is possible, albeit it will not incarnate in the flesh, but will be deposited in language and its eros sublimated.

The displacement has occurred and now sources the confessional and intimacy imbuing the narration. Lilia describes the impact on her of the man's patrician entrance, the smart tailored suits, silk ties, the fine wool of his coat, and the fez he impeccably wears. He unfailingly arrives bringing a variety of confectionery exclusively for her. Lilia conveys her stirring impressions through the sensuous language of the flesh (Kristeva, 2000) and the anticipated sweet pleasures of the gifts to be stored and eaten in the privacy of her room.

> I was charmed by the presence of Mr. Pirzada's rotund elegance and flattered by the faint theatricality of his attention, yet unsettled by the superb ease of his gestures, which made me feel, for an instant, like a stranger in my own home. It had become our ritual [...] and it was the only time he spoke to me directly.
>
> (29)

Charmed, flattered, unsettled are signifiers of seduction: Lilia uses them as adjectival attributes to describe her self-states, but being past participles, they are a passive mode of the verb. They are vectors for Lilia to convey her sense of being passively drawn into unfamiliar territories, as if in thrall, almost hypnotized, and she responds with complicitous excitement – *our ritual* – while the *faint theatricality* could be read as an invitation to enter a ludic, ambiguous game, something like "shall we play chivalrous rendering homage to the young lady of the manor?" Seduction, passivation, mystery, excitement, the fantasy of being the lady of the castle: it is a chain of signifiers of infantile sexuality, and Lilia recovers her agency in the active *our ritual* that functions contrapunctually to the pleasure of passivation.

What part does the cultural code play in this sequence charged with gestural equivocation? How would it be interpreted within the Indian norm? Could the strangeness belong to the American rules of conduct of the adults with children, which frames the incest taboo? The incest taboo is one of the parameters of the Oedipus complex, in its civilizing, structuring function; certainly generalizable, still it is always culturally inflected and nuanced. This passage situates us in a space of cultural suspension and interrogation, which is generatively deterritorializing for the reader, whose feelings of disorientation are elicited, prior to any possible interpretation. I would argue that the text displaces the emphasis on cultural misunderstandings onto the currency of the thank you formula, which Pirzada perceives to be ubiquitous in America, unlike in India. Lahiri might indicate that civility and civilizing taboos are a pair and, whilst she explicates the former, the sexual is encrypted in the narrative, to be detected in its dénouement, in what Pirzada understands afterwards.

On the traces of the sensuous sweetness of the honey-filled lozenges, signifier of the dance of seduction, and feeling uncannily estranged from her surroundings, Lilia is carried away, to an imaginative elsewhere: the three-story home? The mise-en-scene of her fantasy? Who is she there? What role does she play on that stage? Pirzada fathers seven daughters whose names all begin with the letter A, as their mother wished, whereas he still struggles to distinguish each one of them by their names. And separate them from their mother, which nomination does. If the seven sisters – seven is also the recurring number in fairy tales phratries – appear as a glutinous mass of indistinct sorority, unnamed or unclaimed by their father in his function of individuating and separating them from the excesses of the feminine maternal, Lilia, instead, is unique, an only child with a distinct identity. Does this make her the one and only, the favourite and the oedipal victor? What place does the overemphasis on individuality have on our western-based psychoanalytic theory, certainly more in tune with the American that the Indian ethos? The story raises questions that are fascinating and unsettling at once.

Like the psychoanalyst, the reader is tasked with filling in the gaps, saying what language fails but clamours to say. I propose that the *work of reading* is a *freely associative attentive* engagement that enlists personal sensibility, education, experience, imagination, and *weltanshauung* that, concertedly, compose the semantic frame wherein cultural codes are unconsciously inscribed. In such reading potential space, Lilia imaginatively travels to Dacca and joins the sorority, whilst she also retains the uniqueness of her name beginning with a different letter, easily memorized. More significantly, she is unique in the sense of being the favourite, the fortunate one who receives sweet gifts, when the Pirzada family's access to food is all but uncertain. Are they amongst the refugees who struggle to secure food and shelter in India? Contrarywise, Mr. Pirzada is safely moored in his American home, sheltered and invited to share the delicious food of Lilia's family.

The news reports are sparse and confusing, what with the dearth of reliable data the imagination has free rein to embroider idiosyncratic narratives that speak the emotional truth of the subject. Lilia is roused from her latency and entranced by the enigma, viz, the sexual. The rivalry underlying the construction of the hypothetical other scene of her family romance, in its more unconscious aspect, can be inserted as a missing link to account for Lilia's obsessional rituals and preoccupations that defend her from the return of the repress. In fact, she saves the sweets and begins to eat one at a time, accompanying her actions with prayers to reinforce her gestures; she only pretends to brush her teeth for her parents' sake, afraid, as she is, of washing away the intended magical effect of her prayer for Mr. Pirzada's family's safety. Could she also unwittingly pray to seek absolution for her guilty feelings for the pleasure of eating the sweets donated exclusively to her, and the forbidden arousal at the presence and attentions of the foreign "charmer"?

The psychic function of obsessional rituals consists in discharging into actions or reiterated gestures the affects – excitement and guilt or shame – and severing their tie with ideation, to neutralize the emotions. It is the habitual, age-appropriate defense in latency to stave off repressed psychic contents, above all infantile sexuality which, as Freud writes, is polymorphously perverse, does not know or accept boundaries, frustration, neither does it distinguish appropriate from forbidden incestuous objects, or know the inevitable compromises of mature genitality. Diversely conceptualized as the Freudian *infantile sexuality*, the *sexual* – with an accented "a", by Laplanche (1997) – or the *child within* by Sandler (1989), is a permanent psychic structure, liable to be reactivated in the adult's encounter with a child.

The Unconscious in the text

Jean Bellemin-Noel is an influential, albeit controversial, scholar of psychoanalytically informed literary criticism. In *Vers l'inconscient du texte* (1979), he proposes that the writer can no longer stake any claim on his/her work after publication, which situates it in the public domain, where it becomes an object for the reader to signify and interpret. Imbedded in structuralism and Lacanian theory, his overall hypothesis is that the unconscious is structured like a language, therefore its symbolic purview is always already given, comprehends, and subsumes all subjectivities. It follows that the reader would be able to uncover the unconscious messages expressed in the text, by virtue of their belonging and adhering to a prescribed linguistic context. And yet – the psychoanalyst will argue – the text is not the analysand freely associating on the couch, or the child patient playing, on the grounds that the dedicated psychoanalytic setting transmits a symbolic message that provokes the affectively charged conversation addressed to the transference object.

The radical critique of the *auteur* theory preponderant in the 60s, joining forces with Lacan's debunking of the individual illusion of unity and agency – a ruse of the ego trapped in the imaginary – are written in Bellemin-Noel's position. For him, as for Lacan, the subject is the subject of the unconscious, there is no subject of the enunciation, that is a statement liable to turn literary fiction into a process and a symptom with no author. After his earlier seminal contribution, however, in the '80s he revised his position to make room for the subject's enunciation, but his formulation remains within the linguistic compass.

Fundamentally dissenting from the linguistic turn of psychoanalysis initiated by Lacan, André Green repositions Freud's unconscious within the cauldron of the drives that branch out in a myriad of directions, from raw actions to sophisticated dream and verbal representations. For Green the unconscious derivatives are traceable in the heterogeneity of the signifiers, thereupon

"sexuality comes to be seen as a source of stimulation and a spur to the imagination and to thought, resulting in a spectacular explosion of collective and individual fantasies and of sexualised thought exerting a powerful incitement to action" (Green, 1997, 350).

Ultimately, the psyche signifies via different avenues, employing variable degrees of representational systems – from action lending itself to discharge bypassing thinking, to affects, fantasies, dreams, thoughts, and language – that come to fruition for the subject idiomatically, in life, in analysis and in works of art. In parallel – I would argue with Green and Kristeva – the reader can profit from several ports of entry, especially through affects, and employ the psychoanalytic corpus to understand the unconscious derivatives *in the text* – rather than *of* the text – to appraise their nuanced organization and the gradient of representational complexity the authors articulate through their strategies.

After this theoretical detour, let us return to Lilia, her privy turmoil and apotropaic manoeuvres. The feeling of guilt is everywhere and nowhere explicitly mentioned in the text, to indicate that Lilia is unaware of feeling it. Instead, she is mindful of her concern for the Pirzada family, she feels sad, worried, expectant, seduced, excited, embarrassed, awkward, but where is the guilt? Like all perceptive children, Lilia observes the adults and astutely captures their states of mind, genuine or sycophantic comportments, inconsistencies, duplicities, as when, for instance, just before eating, Mr. Pirzada put on the table the watch he kept in his breast pocket, set to the local time in Dacca and, although he never consulted it, it made for a shadow presence, the placeholder of the life in Dacca that had been lived eleven hours previously.

As an important point to substantiate my thesis that Lilia's father's declaration of Pirzada's foreignness might have ignited her fantasies, she recounts that she had noted the presence of the absent temporality in Dacca

previously, but the watch becomes an object of inquiry when appended to her curiosity for the shadow-life – unfolding there and then in Dacca- – after her conversation with her father. Only then does the watch acquire the status of a signifier, evidently she attributes meaning *a posteriori* to what she already knew, albeit unthinkingly. Through her narrative, the reader too can capture the ambivalence playing out in the group regimen, when the television broadcasts the horrifying images of war, murders, famine, and desperation of the shadow life of strife and privation in India and Pakistan, and all the while they enjoy a rich variety of food, joke amicably, laugh, and play Scrabble late into the night.

Guilt is un-named and at the same time overdetermined and motley: there is the collective sorrow and guilt of the fortunate ones who escaped the grievous conditions, which verisimilarly coexist with the elatedness for surviving and, mostly, for having previously chosen to relocate. Lilia's mother, in fact, seems to have mastered a reasonable accommodation to her American life; she has adopted a western hairstyle, works in a bank, cooks Indian food and ridicules the eating habits of her American colleagues in cahoots with her family, but she greatly appreciates that her daughter can go to the school of her choice and study concentratedly, undisturbed by the power cuts, like she and her husband had to endure back home. She is healthily ambivalent and would regard with realism the bettered life she has secured for herself and her loved ones. The father seems less resolved: he has just received a tenure nomination – a markedly prestigious attainment – nonetheless he is aggrieved that Lilia studies American history and geography and has very scanty notions of the complexities of Indian history and politics, including their aftermath on people's identities. His unresolved mourning has transmuted into irksome disappointment in his daughter, who senses it and fears the humiliation of always being found wanting. Lilia is tasked with making sense of and elaborating contradictory messages and confusing transgenerational mandates in the guise of parental projections, desires, and the burden of their incomplete and laborious mourning work.

Strikingly graphically, the text configures the mouth and the eyes, two openings into the world, as the sites of the economy of the group's ambivalence: the mouth for the pleasure of food, and the eyes for the punishing guilt assuaged by watching the spectacular atrocities. The defensive barrier preventing guilt from reaching the characters' awareness is the television screen that functions like an ingratiating ceremonial that manically absolves them whilst preserving their oral pleasures intact.

And Lilia? She partakes in the guilt – when joining in the routinely sought punishment through excessive exposure to the news – as well as the pleasure of food, which she relates with sensuously imbued locutions, as she describes finely nuanced aromas, colours, cooking drones, textures, and flavours. And her curiosity for the stranger Mr. Pirzada adds a private layer to the guilt, when she sees him positioning his watch on the table and she begins to

imagine the sorority's life in Dacca, who must be getting up to go to school, in the absence of their father whose presence she is fortunate enough to enjoy, together with all the sweet flavours he brings.

My critical engagement with Bellemin-Noel leads me to name the guilt not as a symptom of the text, rather, as absent from the manifest text, because the characters, particularly the narrator-protagonist names only the reaction formations that protect her from the potentially violent return of the repressed oedipal fantasies and desires, which are displaced onto the stranger. The text convincingly showcases a strategy that replicates by mimesis the defenses appropriate to the psychic functioning of the latency aged protagonist. Even the titular choice declares the presence of the narrator qua enunciating subject, and the reader identifies with the tempus of her reconstructed childhood, conveyed by the unspecified temporal adverb "when" and the verb "came", in the imperfect tense to render the reiterative activities. No beginning or ending, as Lilia avers that she has no recollection of Pirzada's first or last visit. In the final analysis, the interpretative choice of returning the enunciating subject to the text leads me to highlight Lahiri's authorial subjectivity who fictionalizes the intimate drama of a nine-year-old child, caught in the crossfire of historical upheaval and the cascading effects on her subjectivation process. Whatever omissions, gaps, and compromise formations disrupt the narrative linearity, they mirror the incomplete psychic metabolization of the experience that Lilia strives to assemble in the *a posteriori* temporality of the narration. The reader is thus showed the territory of childhood, identifies both with the little girl protagonist of her experience and with the reminiscing adult engaged in the construction of her story, and history, in the diphasic temporality that was theorized by Freud, viz, the psychoanalytic *nachträglichkeit*.

In agreement with Green and Kristeva, I would like to stake a claim for the centrality of affect and sexuality in the unconscious nexus, whose heterogeneity reverberates in the reader's unconscious and instigates further thoughts and plural interpretations of the text.

Food: the polysemic, polyvalent signifier

The television shows the humanitarian tragedy of the war victims, their losses and the famine that makes the life of the survivors and refugees so uncertain. En masse they seek refuge in India, whose capacity to accommodate and feed the refugees is greatly challenged until, predictably, a war breaks out between India and Pakistan, fomented backstage by the Superpowers. The Cold War colours the political climate in 1971 effecting polarizations, conflicts, and alignments. The geopolitics perturbingly externalizes the ruthless archaic imperative *kill or be killed*, where the friend or foe division is the marker of the struggle for survival and the attendant ontological anxiety.

In the story, food superbly provides a bridge between the psyche and the social, the flesh and the symbol, the body, and the mind. Partaking of the domain above and the domain below, food demands to be psychically imagined and thought about by the subject and culture alike. It is a remnant and reminder of the origins, when the infant encounters the world at the breast, which satiates its hunger, provokes, and stimulates the sensuality of the whole body polymorphously, inclusive of the skin, the internal organs, the mouth and the other orifices open to the Other. As Laplanche (1999) proposes, culture provides the code to decipher the incoming messages, which demand the translation of the signifying ego, through the structuring of fantasies. Such messages include the social which is transmitted by the parents, and are, therefore, irreducible to the sole vagaries and contingencies of experience, because they sit on and intertwine with the unconscious traces. In the story food condenses and represents all these layers of signification, I will tease out a few of them.

Returning to Lilia's suggestive ceremonials, she abstains from opening the plastic egg filled with cinnamon hearts and, to observe her taboo, she safely stows it in a jewelry box which she has inherited from her paternal grandmother. However, her deeds have not completely obliterated her thoughts, evincing when she valiantly struggles to distract herself from her conviction that Mr. Pirzada's family have all perished. But all to no avail. Hers is a conviction which, as Freud maintains, has the quality of the vivid clarity of heightened emotions. The contribution of the affects is apparent in the beholder's gaze, whereas Lilia's conviction resists the test of reality, it rather gains traction from not knowing the facts. Evidently then, her conviction must be the conscious reversal of her unconscious wishing them dead, which is defensively transformed into fear and the attendant guilt is ameliorated by magical procedures: the psychoanalytically minded reader thus concludes. She prays for the Pirzadas' safety, entrusting herself to the omnipotent magic of thought, to counter her restlessness, anxiety, and excitement over the man's presence. The overdetermination of the value and the symbolic meanings attributed to the treats is intriguing too. When the mother jokingly reproaches Mr. Pirzada for spoiling Lilia, his retort that she is a child who cannot be spoiled – a rather cryptic response – is imprinted in Lilia's screen memories. What does this mean? And why does he think so?

Lilia caches the treats in her grandmother's keepsake box, bequeathed to her as a precious heir loom which, interestingly, until now she felt too inhibited to open, be curious about, and claim as her own. What was she afraid of finding? Why was she chosen as heiress? Are there sisters, or cousins back in India? She must wonder. Does the case embody for her a genealogy that rouses such daunting feelings and anxieties that render it untouchable? It is an exquisitely feminine possession: what are the implications of inserting her feminine identity in that line? It is of note that through her evening secret practice, Lilia becomes the custodian of all her treasured

possessions and, in identification with the foreigner's other life in India, her thoughts turn to the grandmother she had never met or asked and thought about. The ceremonial renunciation of the instant pleasure of eating the confectionery accrues the magical effect she symbolically attributes to the treats that, among other things, make the grandmother come alive through the vehicle of the stranger-other-father. The partial lifting of her repression brings closer and telescopes the other scene, its spatiality at the junction between internal and external reality, and the temporality at the intersection of past, present, and future.

I have constructed a psychoanalytically plausible *other scene* that works as an affective undercurrent in the fictional character's mind, who is not quite ready to know. As Lidia must keep afloat the unknown, likewise the unsaturated text situates the reader in the open space where Lilia's turmoil cannot be known but can be intuited as related to her preoccupation and intense engagement with Pirzada – and whoever else he represents in her imaginary – to the point of disrupting her nocturnal relaxation and diurnal concentration on her schoolwork.

Lilia finds herself in such predicament when her class were studying the American Revolution and the teacher asked two pupils at a time to go to the library, and learn about one selected aspect to relate to the class. It came to Lilia's turn, and she teamed up with her friend Dora, but no sooner did she reach the library than she was distracted by the section labeled Asia, wherein she picked the book titled *Pakistan: a land and its people* and became engrossed in the chapter on Dacca. Unable to resume her assignment, she was interrupted by Dora, who worriedly asked what she was doing, and warned her that the teacher was looking for her. When Mrs. Kenyon arrived to check up on the girls, she harshly reprimanded Lilia for arbitrarily reading a book off the subject. Thereupon, a scene of humiliation follows, ethically implicating the reader: whose side does one take, the school authority's and the demand that the history lesson should exclusively address the American past, or the curious pupil's, second generation of Indian emigrants who wants to find out about Asia? On the manifest level, this excerpt concerns the syllabus, the making of an American citizen whose education is meant to cover local history and geography, the establishment of the polity, learning about the colonial past and several other themes pertaining to the social order. On a deeper level is situated Lilia's malaise, because she is discombobulated, restless, and suffers in solitude her inability to concentrate, for she senses that the sublimation securing her adequate performance is disrupted by the return of the repressed. She is unnerved by her curiosity, enticed and troubled by turns by her transgressiveness, and perturbed, owing to getting in trouble with the censorious Mrs. Kenyon.

An analysis of the structure of shame reveals a subtly intricate emotional constellation in that, perhaps, Lilia externalizes her self-reproach for her transgressive curiosity, rooted in the Oedipus complex, which is now

displaced elsewhere, and the teacher's punishment grants some relief from her internal conflict. Her teacher might therefore embody her shaming super-ego, that embarrasses and humiliates her, but also provides a containing boundary and brings her back to reality.

But of course, a view from the hypothetical theatre of the mind is not meant to be to the detriment of the analysis of socio-political factors which structure the dynamics of authority, power, and relationships more broadly. On the contrary, a comparative framework highlights the useful logic of "and/and", inclusive of the psyche and the social to eschew the rigidity of the dichotomous "either/or": internal or external, real or imaginary. After all, the psychosexual body is always already culturally situated, and so is thinking, that from its rootedness in the body branches out towards the other which – as Laplanche states – is the culture.

Halloween and All Hallow Eve

The story culminates with the Halloween festivities. All throughout the autumn and into the winter Mr. Pirzada continues to frequent the family home for the duration of his scholarly project, but the turn of events at the onset of winter abruptly changes the atmosphere, as a war breaks out between Pakistan and India, which begins to push back the masses of woeful Pakistani refugees demanding asylum. Factoring in the local causes of tension, the unrest seemed inevitable, because it was fomented backstage by the United States and Russia, engaged in the Cold War. In a sense, the bellicose climate traverses the three concentric circles of Lilia's psychic world, her own struggles, the conflict in Asia and, within the wider geopolitical radius, the Cold War. Lilia narrates that, forthwith, the evening conviviality gives way to the sombre and alert apprehensiveness, now that the three individual's families occupy territories engaged in hostilities.

Regarding Halloween, the festivity showcases the confusions of tongues and roles which resonates with the conflation of alive, dead, and ghoulish presences, sanctity and devilry, excitement and fear, all celebrated in the collective atmosphere of the triumphant magic and superstitions of Halloween. Internal and external scenarios are uncannily contiguous.

On the evening of October 31, Mr. Pirzada arrived with a puzzled facial expression due to the numerous pumpkins which had mushroomed into visibility on people's doorsteps, being unfamiliar with Halloween. Like all children, Lilia welcomed the opportunity to teach adults something they did not know, so she explained to him that the pumpkins were for carving into jack-o'-lanterns to scare off the ghosts. She added that the children played trick-or-treat to ensnare adults into giving them sweets or coins. Keen to profit from his entry into the American customs, the man endeavoured to learn the trade and master the skill on Lilia's instructions, but being a novice, his carving technique was too strenuous, and the jack-o'-lantern's mouth ended up

resembling a gaping hole. Lilia hastened to forgive Mr. Pirzada so that he would not be embarrassed, and the father expertly remedied the damage.

The parents had agreed that Lilia and Dora were now at the age when they could be allowed to go trick-or-treating unaccompanied and walk towards Dora's home, wherefrom Lilia's mother would collect her at the end of the evening. Pirzada arrived when the girls were ready to leave in their witch fancy dresses and expressed his fatherly solicitude about Lilia's clothes; he then wondered whether the girls would be safe on their own and went as far as offering to escort them. While talking, he lifted Lilia's cape to check if her garments were warm enough, and with ease of gestures touched her cheeks, covered with green eyeshadow. Lilia, however, read in his fatherly solicitude stirring sensual physicality, and she noticed that his concern soon resembled panic "but if it rains? If they lose their way?" He sounded so anxious that Lilia echoed her mother's reassurance, and her words realigned her with parental norm. Perhaps, identifying with her mother, she enlists her protective superego to hide her shame for catching herself thinking:

"Don't worry"... "It was the first time I had uttered those words to Mr. Pirzada, two simple words I had tried but failed to tell him for weeks, had said only in my prayers. It shamed me now that I had said them for my own sake" (35).

The tense awkwardness conveyed in this passage compounds the misunderstandings – or perhaps double entendre, the ambiguity – of the confusion of roles, tongues, and cultural codes. Dora, the white native American girl, is puzzled: "Why did that man want to come with us?" she asks, espousing the westerner's ethical code that inserts mistrust towards a stranger who steps into a fatherly role. How does the reader approach this enigmatic register? Almost to justify Mr. Pirzada, Lilia cagily mumbles to Dora that the man's daughters were missing, offers no further explications, but then, almost as an afterthought, she adds that he misses them, not having seen them for a while, when she realized that her friend's doubts had not been dispelled.

This dense, edgy picture is a nodal juncture, bringing together several codes and consequently lending itself to many interpretations: there is the level of the trauma and its temporality – is it only at this point that Mr. Pirzada is seized by the terror of losing his daughters, which would account for his overweening protectiveness. We know that the tempo of trauma is always its afterwardness. At this point, the story tells us that the news is increasingly worrisome, urging with intimation of impending catastrophe and it reaches Mr. Pirzada via the television screen: does this have the effect of renewing the previous shock, and force him to know what he might not have knowingly thought about?

More specifically regarding the fatherly apprehension, the reader might wonder how this is shared and inflected in an extended Indian family, but this begs the question as to what cultural codes have been transmitted to

Lilia who sees only too well the difference between Dora's family and hers. Is she embarrassed for not being a white, middle-class American? What does her Indian identity mean to her at this point? How reliable and steady is ethnic identity anyway?

A further level of psychic complexity concerns the erotization of collective traumata, which is in part manic defensiveness, aligned with the reprise of the emotional investment on life, whereby Eros triumphs. As a young member of the Indian group, Lilia is exposed to the totality of these forces, which turbocharge the enigmatic feeling and the erotization. Typically, children stake a claim on their experiences by investing them auto-erotically and their libidinal drive is further heightened by whatever exceeds their capacity to understand or is frightening. Ultimately the sexual, the enigmatic, and the traumatic are all entangled, and can be classed under the rubric of "seduction" because the child experiences them as events arriving from the outside, *non-me, other*, and are situated in the relationship with the adult, especially when they fail to shield them from excessive stimuli.

Since its inception, psychoanalysis endeavoured to untie the knot of psychosexuality: is it exogenous or endogenous? Rather and/or? In the face of such a veritable Gordian knot, Freud abandoned his attempts to solve the epistemic dilemma and settled for an unprecedented focus on the child's contribution to the psychic construction of their experience, of which sexuality is the prime motor. Reprising and advancing Freud's earliest model of the mind, with seduction having the status of a real event, Ferenczi (1932) and Laplanche (1997), amongst others, maintain that the asymmetry of the child's relationship with the adult carries, implicitly, a traumatic potential. And if *the sexual* is per se traumatic, it also marks the psychic trajectory of the appropriation of experience, it being co-terminus with the process of signification and subjectivation, along the line from flesh to thought (Kristeva 2000). If one pays close attention to Lilia's affect of shame for feeling selfishly pleased by Pirzada's concern for her, this points to the failure of her reaction formation, and she blames herself for being unable to comfort him for missing his daughters, rather she rejoices that she commands his worries.

After Halloween the story expedites towards its denouement: Pirzada is no longer a habitual guest, being busy with writing up his research in the students' lodgings, to hasten his departure. Finally, one afternoon Lilia's father drives him to the airport, when she is absent and there is no adequate leave taking, at least not that she recalls. Is it because there was no ceremonial parting, or rather that she did not want to know of his imminent departure? The latter is a more likely hypothesis and this omission, together with the textual emphasis on the intervening time lag, coheres with the segue of the narrative and my proposed reading. Only six months later, upon receiving his thank you card, in fact, when the family toast to his health, does Lilia acknowledge that he would not come back, she discards her propitiatory

sweets, and fully experiences her sadness. She learns what it feels like to miss someone very far away, so she silently notes.

A renunciation concludes the story, almost to replicate the necessary relinquishment of the oedipal objects when development institutes the waning of the complex. With the demise of her fervid phantasmatic engagement with the *other family*, her family romance must be mourned too. Freud does not conceptualize the destiny of the family romances which cannot stricto sensu be inserted in the linearity of development, as they are not reachable through observation, they are only sporadically remembered and are often only recovered in analysis. Therefore, the family romances seem to rather be ascribable to the structure of fantasy, which might bear some resemblance to the construction of the fantasy of *A child is being beaten* (1919), which Freud will flesh out ten years later. But in the economy of our reading of Lahiri's script, the family romance might function as Lilia's transitional narration that lays the groundwork for her becoming an adolescent. The trope of the stranger's arrival could therefore be seen as a catalyst that facilitates the surfacing of the repressed undercurrents, which is the task of adolescence to psychically reorganize.

Furthermore, more generally, the foreigner-as-other reveals the otherness in the self – the child within – that shapes the drives, desire, subjectivity, unbeknown to the conscious ego. The timeless trace of the infantile within contrasts with the variegated structures of temporalities of the narration: the *when* of the title inflects the reiteration of the rituals, and conveys the dimension of the habitual, the expected, perhaps the imaginary *forever* that a ten-year-old attributes to all meaningful relationships. Such cyclic temporality is another face of the density of the a-temporal unconscious trace and desire; by contrast, there is a subtle reference to Lilia being an adult reminiscing that *when time* as narrative time: in fact, she says, in passing, that as a grown up, she learnt the full complexity of Indian and Pakistani history. Not there and then, but here and now beats the tempo of her work of memory, on the contrary, *when* sponsors timelessness.

To wrap up this chapter, I wish to refer to a detail of the text which epitomizes how the cultural context prompts and adds complexities to the psychic process of the work of identity. When Lilia dons her Halloween witch fancy dress in the street, a neighbor exclaims: "I have never seen an Indian witch". Could this be an epiphanic moment for her, when she becomes cognizant of one aspect of her own otherness, seeing her features and skin colour reflected in the American-other's gaze? This is another instance of the ripple effect of the arrival of the stranger trope, which resounds without and within. Whether she felt – then – alienated by or identified with the mirror image provided by the white neighbor, and how she will subsequently inscribe this event in her biographical account can only be the reader's imaginative guess, because Lilia is not a child patient addressing her speech to an

analyst, but a fictional character articulating her aching longing for Mr. Pirzada through which she learnt what it means to miss someone.

All the same, the particular occurrence when Lilia sees herself as a uniquely Indian witch through her American neighbor's comment is a pregnant marker; life and literature abound with comparable momentous encounters with the foundational gaze of the other. What ethnic and cultural identity does the subject see mirrored in the intersubjective regard? The theme of skin colour as marker of identity provides a bridge with my reading of Americanah, in particular when the protagonist sees herself as a black woman for the first time through the gaze and the words of a white American.

In the final analysis, as fiction and characters receive temporary domicile in an attentive psychoanalytic other in intimate conversation with the writer, the encounter can birth an intertextual contribution situated at the intersection of the internal and external world of a latency Indian child.

References

Amati-Mehler, J., Argentieri, S., Canestri, J. (1990). *The Babel of the unconscious: mother tongue and foreign languages in the psychoanalytic dimension*. Intl Universities Pr Inc.

Antinucci-Mark, G. (1990) Speaking in tongues in the consulting room or the dialectic of foreignness. *British Journal of Psychotherapy* 6:375–383.

Antinucci, G. (2004). Another language, another place: to hide or be found? *IJP* 85:1157–1173.

Fanon, F. (1952) Peau noire, masques lanc. Editions de Seuil. *Black skin, white masks*. First published in 1986 by Pluto Press, London.

Ferenczi, S. (1932, 1949). Confusion of the tongues between the adults and the child: the language of tenderness and of passion. *IJP* 30:225–230.

Freud, S. (1905). *Three essays on the theory of sexuality*. SE VII.

Freud, S. (1909). *Family romances*. SE IX..

Freud, S. (1915). *Mourning and melancholia*. SE XIV.

Green, A. (1997). Opening remarks to a discussion of sexuality in contemporary psychoanalysis. *International Journal of Psychoanalysis* 78:345–350.

Jiménez, J.P. (2004) Between the confusion of tongues and the gift of tongues: Or working as a psychoanalyst in a foreign language. *International Journal of Psychoanalysis* 85:1365–1377. Kristeva J. (1999). Psychoanalysis and freedom. *Canadian Journal of Psychoanalysis*. 7:1–21.

Kristeva, J. (2000). The polymorphous destiny of narration. *IJP* 1(4):771–787.

Kristeva, J. (2007). Parler en psychanalyse. Des symboles à la chair et retour. *Revue francaise de psychanalyse* (71):1509–1520.

Lahiri, Jhumpa (2001). In conversation with Howard Norman. https://www.youtube.com/watch?v=DwiFG9TuFIE.

Lahiri, J. (1999). *The Interpreter of maladies*. London. 4th Estate, Harper Collins Publishers.

Laplanche, J. (1997). The theory of seduction and the problem of the other. *IJP* 78:653–666.

Laplanche, J. (1999). The other within: rethinking psychoanalysis: an interview with Jean Laplanche, John Fletcher and Peter Osborne, *Radical Philosophy* 102(July/August): 200031–41.

Laplanche, J., Pontalis, J. (1968). Fantasy and the origins of sexuality. *IJP* 49:1–18.

Movahedi, S., Homayounpour, G. (2012) The couch and the chador. *International Journal of Psychoanalysis* 93:1357–1375.

Sandler, J. (1989). *The id – or the child within?* London. Routledge.

Tesone, J. (1996) Multi-lingualism, word-presentations, thing-presentations and psychic reality. *International Journal of Psychoanalysis* 77:871–881.

Chapter 4

Believe me, do not believe me
The durwan's (gatekeeper's) paradox

The theme of this chapter concerns the phantasmagorical invention of new identities –evincing the failure of working through the loss – in a gauzy spatio-temporal location, a suspended bubble far away from the subject's original milieu. I intend to allude both to the real geography and to the metaphorical locus where the subject inscribes a narrative to secure a feel of continuity to their existence, to bridge gaps, mend holes, rents, and caesuras. Merleau-Ponty (1945) names these two territories respectively "geography" and "landscape": the first is a territorial extension, objectively perceived, the second outlines an inner topography for the architecture of the imagination. The newly edified contrivances can be situated along a wide spectrum, from dreams to fantasies to episodic or permanent hallucinations and delusions, which are more and more solipsistic and ex-centrically distant from shared conversational reality.

The dream-work actively uncovers the original pictography sourcing from the subject's nocturnal landscape, with its unanticipated affective densities to be teased out and elaborated, fought battles to be won or lost: all the same, the news comes from a psychic place in the vicinity of health, unlike the hallucinatory domain, which occupies an elsewhere split off and unbridged by realness. A measure of psychic work undergirds all these constructions: such is the Freudian lesson, namely, that our unconscious life is essentially dynamic, and this tenet has slowly but incrementally been woven into present-day humanism. Like a foreign or forgotten language, our inner landscape is amenable to and instigates translative processes, undoubtfully some renditions are more defensive and others more developmentally capacious. As any translation, this dynamic work entails a loss of the previous organization, situation, acquisition, relationships, sometimes in reality, other times in fantasy.

The work of identity is equally sensitive and involves imagination: it articulates the dialectic between inside and outside, leans on the support of a facilitating environment, and becomes particularly arduous, perilous – I daresay – for the psychic equilibrium, in the face of the existential challenges commanded by historical occurrences.

Lahiri's short stories are set against the backdrop of the Partition of India in 1947, which resulted in displacements, separations, and momentous losses, and was followed by further vicious internecine strife, which accrued the social and individual suffering. Lahiri's characters carry the burden of history and show its psychic reverberations when the uprooted individual needs to build a new habitation for the self, precariously building it on the ruins, ashes, and whatever remains of the previous order. Often, however, an empty space is all that is left of the past but garnering its vestiges therein and reassembling them in whatever way it is possible, serves merely to shore up a shaky identity.

Synopsis

A real durwan takes place in a shabby tenement and undefined habitat, at a time that feels suspended, except for the signs of the imminent rainy season, connoting the opaque temporality of cyclic iteration. The building block is situated somewhere in India, in the aftermath of Partition – so the reader can infer from the eerie atmosphere – and the narrative paints the picture of a group of survivors of some calamitous events who have been thrown together by the force of circumstances.

Boori Ma is the *durwan*, gatekeeper of the tenement. According to tradition, a real *durwan* is a man, whereas the protagonist is a woman, which is another marker of the exceptional nature of the circumstances. *Durwan* is an Indian-English word, whose Merriam-Webster given meaning and etymology are valuable historical references: "Persian *darwān*, from *dar* door (from Middle Persian, from Old Persian *duvar-*) + Persian *-wān* keeping, guarding, from Middle Persian *-pān*; akin to Sanskrit *dvār* door". Transformed through historical vicissitudes into a linguistic hybrid, the term *durwan* is genealogically still firmly rooted in the Middle East, which could be read, amongst other things, as a metaphor for several referential amalgamations of the itineraries of identities through the shifting times.

Boori Ma lives under the letter boxes, the residents allow her to occupy that corner gratuitously in exchange for her services, which essentially consist in guarding the dwelling, warding off intruders and thieves and keeping the stairs and communal areas clean. Her bedding comprises the tatty duvets she beats every morning to get rid of dust and mites. The tenement appears to be inhabited by people – perhaps all refugees – who live the ordinary life of the underprivileged.

The room Boori Ma principally and emotionally resides in, however, is her physicality, which is a restricted and desolate place, perhaps even more impoverished than her surroundings; her temporality is reduced to the sequence of sleepless nights: one, two, three, followed by her laborious days. In her utter helpless fatigue, she can seek relief only by shaking her bedding

to chase the mites she blames for disturbing her nights' repose. This is how she presents to the reader.

> As she started up the four flights to the roof, Boori Ma kept one hand over the place of the knee that swelled at the start of the rainy season. That meant that the bucket, quilts, and the bundle of reeds which served as her broom all had to be braced under one arm. Lately Boori Ma had been thinking that the stairs were getting steeper; climbing them felt more like climbing a ladder than a staircase. She was sixty-four years old, with hair in a knot no larger than a walnut, and she looked almost as narrow from the front as she did from the side.
>
> (70)

Such a direct, uncompromising depiction of the sheer physical situatedness of the protagonist violently strikes the reader with the image of an abject body, and this feeling sharply contrasts with the sympathy one feels for her, in identification with the other residents. They cast their benevolent gaze on her quirks, including the children who tease her, while she plays with them. Everyone perceives her sadness and regards her as a lonely figure of sorrow, conjecturing that she must have endured many losses. "Her mouth is full of ashes" they say about her, articulating the bitterness, disappointment, and despair with a bodily metaphor aptly fitting her concrete somatic mode of speaking. Disappointment, and contraction of the temporal horizon "without a glimmering of a future that is being shaped" (Freud, 1915, 275) are malaise of war times; if Boori Ma embodies them and the group put them into words, Freud inscribes them within broader psychic and anthropological semantics.

Boori Ma's full-bodied animation only transpires in her voice, "brittle with sorrow [...] and shrill enough to grate meat from a coconut": thus twice a day her litany makes her predicaments known to the world. Hers is both a lamentation and a consoling phatic gesture, and her recital provides the sonorous score which accompanies her while she goes up and down the stairs, maintaining the building in good working order.

Let's listen closely to her narration: after Partition she was deported to Calcutta and was separated from her husband, four daughters, a two-story brick house, rosewood *almari* (cupboard) and several caskets whose skeleton keys she jealously guards, together with the collapsible gate keys and her entire life savings. (Arguably in the skeleton keys all temporal dimensions collapse into a single concrete object!)

Her shrill voice ritually narrates both her current plights and her past life, which she embellishes with rich details, such that she makes it resemble a fantastic garden of wonders, as, for instance, when she catalogues the grandeur of her third daughter's wedding ceremony, attended by the mayor to honour the groom who was a school principal. Boori Ma ascribes to that

nostalgic elsewhere and other time zones – clearly a phantasmatic locus – the fullness of being she expresses as a summation of delicacies, perfumes, precious furniture, that orchestrates a totalizing sensorial narrative, to guard her true habitation, that is, her present senso-reality. She wants to recapture the taste of life lost that she narrates in jarring contrast with her currently eating out of a rice pot and relying on the residents' generous offers of cups of tea and crackers: a somewhat divergent picture.

As for the truth of Boori Ma's tales, the general attitude is to suspend judgment, mixed with humorously questioning of the too obvious inconsistencies: in fact,

"every day, the perimeters of her former estate seemed to double, as did the contents of her *almari* and coffer boxes. No one doubted she was a refugee; the accent in her Bengali made that clear" (72).

Amidst the obvious fables, solely her voice carries a note of authenticity and elicits a collective posture of benevolent *complicité* – similar to how sympathetic adults respond to a child's fabrications, fantasies or lies as the case may be. The demarcation line, however, is around the caesura which condenses the historical fact of the deportation, its psychic import, and the boundary between a judicious *complicité* – akin to a ludic participation in a fiction, or a performance – and the madness of structured hallucinatory formations, which invite a response of defensive dissociation in the listener through logically disambiguating the categories of truth and falseness, reality, and fabrications.

By way of a brief explicatory notation, her account of the East Bengali border crossing is inconsistent: at times she referred to its having taken place on board of a truck together with a crowd of other refugees amidst hemp sacks, at other times, on a bullock cart. On this account, whenever she helped the children with their games, they would tease her for her mendacity and her retort "Why demand specifics? Why scrape lime from a betel" sounds all but disarming, revealing her recourse to the logic of concreteness, tangible like the fruit of the earth: lime and betel. She dismisses any other conversational register, which the reader surmises she probably never learnt.

The salient characteristic worth spotlighting is how Boori Ma always closes these wranglings with her arresting refrain "Believe me. Don't believe me. My life is composed of such griefs you cannot even dream them". Her enunciation offers significant motifs for reflection and in-depth psychoanalytic reading; therefore, I intend to extrapolate some of its several implications in a later section dedicated to imposture. At this point it suffices to emphasize its communicative strategy: whenever matters of truth and/or reality emerge in her social interactions, she loses her bearings and repairs in her refrain which rebuffs her interlocutors, keeping them at a safe distance.

One of the residents Mr. Dalal frames his understanding of her contradictions, proposing that she must feel *bechareh* – meaning helpless – with the author's original emphasis of the Hindu word. So helpless, Boori Ma is but a

figure of pity. Mr. Dala's piety is shared by the collectivity, who surmise that her grandiosity must be her way of mourning the loss of her family, *whose ashes fill her mouth*, and they ascribe her "harmless imposture" to her sorrow. As for their need to ground her bizarre grandiosity, their hypothesis is that she must have been employed at service in some landowner's home, where she presumably happened by the finery that she narratively appropriates. Crucially, everyone somehow complies with the innocuous imposture and comes to regard her excellent and reliable services as those of a *real durwan*. This is another shared and unobjectionable form of *complicité* – or, perhaps collective imposture – because they know that she could never be a real *durwan*, being a woman, which goes against tradition.

To the above, the psychoanalyst would bear in mind the coda of her address: my happy life is "something you cannot even dream of". Indeed, ordinarily sane people's achievement of the capacity to dream is out of reach for her, when she remains on the side of verbal communication through unrealistic phantasmagoria or the unsymbolized materiality of the body. Better than being cast off or precipitating into darkness and silence, as in her insomniac nights, perhaps.

Boori Ma's insomnia

One day, after her morning routine performed on the rooftop at the water cistern, Boori Ma is absorbed in forcefully beating her duvets to chase away the bedbugs she deems to be the culprit of her insomnia. Mrs. Dalal surprises her, when she arrives with her tray of lemon peel to sun dry. Mrs Dalal is solicitously maternal towards Boori Ma and is game to receive her child-like complaints against the mites. Purportedly intending to reassure, Mrs. Dalal examines Boori Ma's skin but, detecting no visible signs of insect bites, she concludes "you are imagining things, [...] it could be a case of prickly heat". Not only do these words not offer the intended comfort, but they seem to further inflame Boori Ma's (psychic) skin, and she insists that the mites must have wings and run away from her. What segues is her refrain whose content varies to befit the specific circumstance; what is consistent, however, is her emotional reactivity and defensiveness, that convey the impression that she does not feel believed.

"This is not prickly heat. [...] I used to keep a clean bed. Our linens were muslin. *Believe me, don't believe me*, our mosquito nets were as soft as silk. Such comforts you cannot even dream them" (74 emphasis added).

Skillfully evading the realistic dialogical register, Boori Ma reverts to her childish grandiosity, whilst Mrs. Dalal remains unchallengingly grounded and responds that, indeed, she herself cannot dream of the referenced luxury, living in crammed decaying lodgings with her husband who sells toilet parts. At this point Mrs. Dalal becomes aware of the poor state of the bedding and promises to get new duvets together with an oilcloth. She also offers a

soothing ointment for the skin to Boori Ma, who responds with ambivalence and apparent refusal. How can one understand such ambivalence? Is the *durwan* shunning the other's generosity? Their piety? Or the surrender to her own feeling *bechareh*, unconsciously threatening because potentially overwhelming and passivizing? Interestingly, she opposes resistance with her words — it is not prickly heat – the very weapon that is unavailable at night, when silence leaves her to struggle with her loneliness, fear, sadness, and helplessness.

The combat with her fear and insanity is fought on the battlefield of her skin-ego which, in Anzieu's words, is the "frontier between the psychical and bodily Egos, between the reality Ego and the ideal Ego, between what depends on the Self and what depends on other people" (1985, 7–8). Perhaps the compassionate Mrs. Dalal intuits on and through Boori Ma's skin the pitiable woman's suffering, thereby glimpsing the archaic inscription of her unspoken biography. And perhaps her true self pierces the epidermis from within, more than from without. Mrs. Dalal responds with the offer of soothing ointment and warm bedding, that are spontaneous gestures denoting her sympathetic understanding, beyond verbal semantics.

The psychic significance and function of the skin is one of the prime thematic organizers of my reading and discussion of this story, therefore I intend to explore it in some detail in the theoretical section that segues in the chapter.

The afternoon: a time of change

That same afternoon, the monsoon season pouring rain "came slapping across the roof, like a boy in slippers too big for him"; it washed away the tray of drying fruit peel and caused further damage to the previously frayed duvets, so that the resourceful Boori Ma was left to improvise a makeshift bed with a pile of newspapers where she could lie down for a restful nap. The morning encounter with the sensitive maternal figure has patently transformed Boori Ma's inner state if, upon waking, she seeks company and eventually decides to accept the offer of the ointment to relieve her skin discomfort. Moreover, Mrs. Dalal's voice infused with gentleness might have somewhat provided the emotional soothing and warmth she needed and thereby functioned like an enveloping embrace that induced sleep, like a small infant. The skin, the voice, the blanket: they are all signifiers of a holding and protective maternal presence, to be symbolically recovered in the surrounding environment.

While Boori Ma is on her way to the third floor, from the street Mr. Dalal calls out, asking for her help to carry upstairs two washbasins, one of which is meant for his home and the other is to be placed on the first-floor landing for the whole condominium to use. He was delighted to have been nominated for promotion at work and wanted to celebrate the anticipated financial gain

by improving his home condition and share the amelioration with the resident group.

Not entirely unexpectedly, however, the new object meant for everyone's comfort soon morphs into a seed of discord, in that it brings into the tenement a culture of qualitative financial differences and meritocratic achievements. Both these variations are predicated on learning and improving through hard work over time, and this factor changes the atmosphere thus far seemingly static and suspended in a timeless zone, solely punctuated by seasonal alternations. By the same token, psychic work introduces temporality, frames the painful past, differentiates it from the demanding present and opens a perspective onto an expectably more hopeful future.

Factoring in the temporal dimensions, Lahiri's strategy can be read as implicating the underlying motif of the diverse structural densities and forms of temporality, where the initial *after the event(ful)* Partition morphs into the *suspended time* of people's accommodation to their new life, where only the daily routine and nature's seasonal alternations beat the time. The excitement, confusion, and chaos engendered by the novelty segue, with the *accelerated tempo* of the conclusion of the story, which is marked by a flurry of activity and the feeling of a perturbing frenzy.

Returning to the significance of the basins, they are undoubtedly an improvement, but they also create havoc amongst the deprived inhabitants, whose initial curiosity, excitement, and delight is soon superseded by the undercurrents of covetousness, envy, and grievances which are unleashed, in lieu of the straightforward gratitude. These ambivalent reactions start with Mrs. Dalal's, who vociferously argues that the basin is pointless, when she was still cooking on kerosene, waiting for the fridge and telephone her husband had promised since they first got married. Still, at first there was the shared delight for the luxury item – the ultimate in elegance, Mr. Dalal thought – meant also to impress the important visitors he would frequent in his new position. With pleasure and alacrity, he then proceeded to demonstrate the workings of the wonderous item to the onlookers. Boori Ma herself could finally wash her hands in running water and the innovation very promptly elicited her comment: "[o]ur bathwater was scented with petals and attars. *Believe me, don't believe me*, it was a luxury you cannot dream". Her refrain grants her a safe refuge where she recovers her sense of self, turbulently upset by the changes, so much so that she had forgotten to rattle off her misfortunes, followed by the antidote of extolling the merits of her previous fine life. She had silently assisted the traffic around the basins and their installation, which required the expertise of the workmen, whose comings and goings interfered with her gatekeeping duties.

Soon the residents' mounting acrimony, manifestly motivated by needing to queue and their inability to leave their own soap and toothpaste, resulted in the collective impulsive rush to make home improvements, which the wives arranged and paid for by selling or pawning their meagre possessions.

Meanwhile, Mr. Dalal had taken to showering presents on his wife to placate her anger and eventually took her on vacation to Simla, a historically significant resort, which was, famously, the summer capital of the Raj. When the couple left, promising to bring sheep wool blankets to Boori Ma, she was the only one wishing them a safe journey at the gate, which she could no longer guard, because the workers occupied the tenement day and night. Of relevance is how this scene gestures to her intense attachment to the couple, especially to the wife. Afterwards, in fact, feeling lost and useless, Boori Ma begins to wander the streets, firstly staying in the building's vicinity and progressively going a little further afield every day. The text speaks of her having more time and less to do with the workmen's presence and uses a sparse factual lexicon: arguably here Lahiri lends her voice to Boori Ma who exclusively knows the logic of materiality and concreteness. However, a contextual listening to the logic of emotions, relationships, and the universal aspects of human sensibility could indicate that she is lost when she no longer has a place or a recognizable and socially purposeful activity.

In this regard, from the vertex of her observation and insight into the infantile mind, Anna Freud proposes that when children get lost and all too easily forget or lose their belongings, the underlying motive is their need to externalize their feeling of being lost and not kept in mind by the (m)other. Could this psychoanalytic concept provide *a fil rouge* to attain a mode of reading between the lines the affective undercurrents textured in the storyline, to probe the mystifying logic of the unconscious, the obscure fears, anxieties, and defenses? After all, Lahiri tells the reader that Boori Ma struggles with her feeling *bechareh*, a word-feeling left in the original version and not transcribed into English, so that it should remain there, at the origin of experience, untranslated (etymologically meaning carried across) into the field of thought. Indeed, to ward off these powerful and painful feelings, Boori Ma resorts to externalization and omnipotent fantasies, namely, manic defenses to repudiate her helplessness, neediness, and lack.

Relaying on this reading framework, I propose that loss and feeling lost – and the defensive negation – are crucial textual signifiers coalescing into the intimation of the precipitous actions and events that build up in a crescendo the dénouement in an accelerated pace. Haste, fast succession of events: such is the logic of naked factuality dissociated from emotions and thoughts, whose very possibility is curtailed through externalization and discharge into action. I am detailing the functioning of manic defenses the subject resorts to in the face of unbearable mental pain. Lahiri poignantly conveys this internal chaotic traffic through her textual strategies, when she writes:

> Workers began to occupy this particular flat-building night and day. To avoid the traffic, Boori Ma took to sleeping on the rooftop. So many people passed in and out through the collapsible gate, so many others

clogged the alley at all times, that there was no point keeping track of them.

(80)

Thereafter, Boori Ma repairs into the roof space and her retreat is final when she stops using the basin and her hygienic routine regresses to the use of the cistern, as she had always done. With her only remaining duty to polish the banister poles, which she performs diligently using the strips of her torn quilts, she has way too much empty time on her hands. So, she fills her long and lonely days wandering off, and takes to spending her life savings to buy herself treats. Here Lahiri's sparse words movingly convey Boori Ma's inner state, which comes close to the emotions of a child who feels abandoned, neglected, and deprived, and whose only resource is to compulsively give themselves treats, mindless of the finite amount of their resources and behaving, rather, as though they could tap into an ever-bountiful supply. Only the hypothesis that their unconscious fantasy of (re)finding a generous, satisfying object motivates their actions can interject some reason(s) into an otherwise incomprehensible, mad, or self-harming conduct.

The roof residence has turned Boori Ma into a figure of nature, almost removed from all signs of civilization, disconnected from human bonds and sociability. She no longer frequents the residents' homes, forgot when she was last invited for a cup of tea, and seeks the company of no one. She is exposed to the pouring rain and the drenched newspapers, her only head cover under the soaking awning, are running out; yet she feels a peculiar body comfort in being a prey of the elements, and the damper winds even ease her back pain. Her sole alive company are the monsoon ants, which she painstakingly observes while they busily run along the clothesline carrying their eggs. The only surviving thread to the social world is her thought about the Dalals, wondering when they might come back, like a child awaiting her parents' return when she has not yet learnt how to read the clock and feels lost in time. Disappeared are also the lamentations of her predicaments, counteracted with the fabricated glorious antecedents, the absence of which reveals their communicational and relational value: that is how she speaks to reach out to the other. Her silence mirrors their absence.

In her meanderings, one day Boori Ma gets as far as the produce market, and while standing by a stall to look at persimmons and jackfruits, she feels something yanking the hem of her sari. She looks and realizes that her life savings and skeleton keys have been stolen. What segues is her return to the tenement, only to see that the residents are up in arms for the theft of the basins, which had left but a marasmus of pulled out and torn pipes, and holes in the walls. Incited by the group mentality, they impetuously carry her to the rooftop, make her stand by the clothesline and begin their accusatorial invective. Pointing their fingers, someone goes as far as allegedly stating that she must have informed the thieves and delinquently disappeared when she

should have been performing her custodian duties. Whose connivance and complicity are here being denounced? – the reader might wonder.

Boori Ma faces the hostile group, where no one addresses her directly, and her only retort is: "*Believe me, believe me*, I did not inform the robbers". Equally collective is the residents' rejoinder: "For years we have put up with your lies. [...] You expect us now, to believe you?". A slew of angry words bombards Boori Ma, to convey the group's own retreat into a sanctimonious and demented posture whereby they depict themselves as hospitable and considerate, only to be paid back with betrayal and theft, rather than gratitude. A polarized vision indeed. Feeling betrayed, discombobulated, and frightened of the Dalals' return to the shambolic tenement, unsure of what to do, the condominium consulted Mr. Chatterjee, whom they regarded as savvy on worldly matters. Mr. Chatterjee had previously defined Boori Ma as a "victim of the changing times", but now he delivers a far less sympathetic pronouncement: "Boori Ma's mouth is full of ashes. But that is nothing new. What is new is the face of this building. What a building like this needs is a real *durwan*".

The residents promptly acted on Mr. Chatterjee's counsel and hastily set about finding a real *durwan*. They gathered together Boori Ma's rags, bucket, and broom and threw her out together with her sparse belongings. Taking her inseparable broom – the only tangible remnant of her identity – Boori Ma left, saying one more time *"Believe me, believe me"*. No other sound was audible afterwards, not even the rattle of her sari, to which her savings and skeleton keys were once attached.

Preliminary comment to the story

I would argue that the condominium's inordinate reaction is more understandable by formulating the hypothesis that the affects metaphorized as "the mouth full of ashes", namely, disappointment and rage for the loss of trust, beliefs, and ideals – ego ideals and ideal ego at once – is their joint lot, what they share with and project onto Boori Ma, "victim of the changing times". With this hypothesis I intend to reframe the presentation of individual suffering to rather inscribe it into the broader fields of cultural malaise, unconscious pacts and transmission. Implicating the societal ambit permits to view the provision of material existence, values, ideals, language, religion – all the factors that constitute the symbolic order – as culture's share of the pact which the subjects enter and abide by, through egotistical impulse renunciation and group identification, in exchange for the feeling of belonging and a modicum of protection and safeguard against dangers and aggressions of various sorts. With Freud, this interrogation concerns the process whereby the citizen comes into being, its facilitation and hindrance. Undoubtedly, political turmoil, crises, wars, genocides, and similar calamities cast serious doubts on the social contract and engender feelings of uncertainty, loss, and

mental pain. Trust in the self and in the civic society is undermined, the sense of futurity is but foreclosed and, with it, the horizon of hope and desire. Is Partition and its sequelae of civic unrest and instigated fratricidal hatred the real cause of the group's betrayal and disappointment? The shared history, the experience of a shattered world causing bewilderment and grief is, in fact, unlanguaged in the story, and yet, "in the unnamed is the universal", writes Montale, who Lahiri references as inspirational. The universally human sensibility responds with variegated specificities to geopolitical shocking phenomena, nonetheless, they always occasion predicaments the subject needs to acknowledge, experience, give meaning to and inscribe in their own biography.

I would like to propose a further critical engagement with the conclusive seemingly hysterical eruption of madness. Who duped whom when the residents and their *durwan* had entered the unconscious covenant they called *imposture*, knowingly meant to be a solution to their joint grief? It is likely to institute a melancholic solution when the loss is massive and exceeds the capacity for mourning, as I will also explore in the chapter on Amelia Rosselli.

If the itinerary of pain and mourning are inscribed into the narrated events, the group madness, their repudiation and rejection of Boori Ma acquire a more nuanced affective meaning. I will expand on this aspect in the discussion that follows, but to wrap up my summary, I wish to remark that it seems an ironical fulfillment of a prediction and a repetition, all at once, that Boori Ma should be "the victim of the changing times", once more, as always. Mr. Chatterjee thus defined Boori Ma's identity, perhaps speaking his words of wisdom about the group's prior unconscious designation of her as the sacrificial victim of their hopeful innovation and improvement. One is left wondering whether a substantial transformation might realistically come about when the ashes are still in the mouth, and someone carries the burden of the unprocessed grief. These group dynamics can only be understood afterwards, when inserting into the narrative the *après coup* introduced by Freud and reprised by Lacan as the elective temporality of trauma, sexuality, and the psychoanalytic understanding of history. Equally more accessible to comprehension becomes the duality of knowing and not knowing, where perhaps "*Believe me, don't believe me*" exposes the *complicité* of the collective defensive strategy against the excessive pain of sadness, grief, and guilt, attendant to extensive and mindless destruction. Indeed, while Boori Ma disappears into the distance, she cries "*Believe me, believe me*". Simply, clearly, unambiguously, but no one is there, willing to listen.

Thematic discussion

In spite of the brevity of the diegesis, a variety of themes can be extrapolated and aligned to psychoanalysis to champion a mutually enhancing conversation. My elective themes: the skin, imposture, and fantasy are all interlinked, they hinge on the broader vicissitudes of the formation of identity and,

consequently, articulate both the subjective and the cultural unconscious. By the same token, situated subjects present their own suffering and concurrently open the view to the functioning and the malaise of their civilization.

When reaching latency, the growing child has acquired the sense of having a body whose skin envelope delimits and protects the self, a self that is separate from but connected with others. The metaphorical equivalent is children's awareness that their skin-ego frames their minds, and inside they can put thoughts, feelings, perceptions, fantasies, and also lies. Psychically speaking, in fact, being able to lie is a developmental achievement, predicated on the knowledge of having a mind of one's own whose boundaries the (m)other cannot trespass. When things go well, children trust their secure possession of the metaphorical key to welcome friends and reject foes and invaders, share contents or keep secrets. The corollary is that if the most archaic fears are abated, the superego representatives of parental authority, and the semantic field of associations with hierarchical figures of command, dominion and power are amenable to pacts, dialogue, and negotiations; the superego can undergo disguise, and be softened by humour. Besides its individual salience, this psychic work has a purchase on culture, in that it institutes the process of enculturation and differentiation between rights and wrongs which connote the provinces of ethics and religion. Parenthetically, the etymology of ethics derives from the Greek word *ethos*, one of whose meanings is character. Both in *Nicomachean ethics* and *Poetics*, Aristotle prefers *ethos* to the more precise and currently used term *kharàcter*, that indicates the individual's temperament; he notably aligns depth of character to the capacity to accommodate inner conflicts between passions, impulses, and cultural mores, to eventually reach a cathartic resolution. These itineraries are the material of tragedy. It is noteworthy that the detailed journeying through conflictual predicaments pertaining to tragedy – Aristotle considers it the only worthy art form, unlike the comic – has many points of convergence with the Freudian *Kulturarbeit*, obviously mindful that the philosopher's theory is not undergirded by the theory of the unconscious.

This prelude intends to design a backdrop where Boori Ma's movements can be both subjectively and culturally signified inasmuch as identity occupies a transitional position, that bridges across the agencies of the mental apparatus and the external reality the character is embedded in. The Oedipus complex is the psychic structure tasked with organizing the processes of subjectivation and enculturation alike, both of which revolve around the gradual appropriation of what is passed on as inheritance.

With regard to her identity: who is Boori Ma? She is a stranger, whose provenance is undefined and, arguably, within the fictional economy she functions like a trope – similarly to Mr. Pirzada – devised to lay bare the unconscious workings and alliances of the residents' group. She reveals the otherness in each individual member of the small community and unmasks

their readiness to enter a pact of *complicité* which subverts tradition, by accepting a female *durwan*. Probing further, however, this pact may be thought to be embedded in the societal unconscious strategy to foil the working through of the momentous impact of India's proclamation of independence from Britain, which is juxtaposed with the regime after Partition. Copious historical documentation and personal accounts bear witness to the heinous cruelty, internecine divisions, gratuitous acts of unbounded violence, terror, and rape unleashed by the imposition of the new order. Such phenomena all too often typify circumstances of anomie, when the work of culture (*Kulturarbeit*) evidently flounders and, as Freud observed, the most superficial and recent acquisitions of civilization disintegrate.

As Lear proposes, the end of a civilization demands working through the previous establishment, its temporal and semantic horizon; the dream-work and the capacity to imagine a new order (2007) promote and foster the metabolic process. Perhaps Boori Ma could be regarded as the group symptom and the embodiment of the defaulting collective dream function, whose deterioration into sterile fabrications exists in the no-man's land, unbridged by the cultural reality.

First and foremost, the ego splits

In the aftermath of disproportionate collective unrest, many a time the working through exceeds the human resources to give narrative meaning to the external phenomena, which can result in the consolidation of modes of functioning comparable to those typifying the perversions, which essentially coalesce around the vertical split of the ego. This prevailing defense mechanism impacts people's capacity to exercise their plastic binocular vision, which is reduced to the superficial seeing and not seeing at once, so that the same object is both perceived and disavowed, with no discomfort for the contradiction. This psychic predicament is compounded by the demise of the cultural environment, which morphs into an encroaching demented factor and no longer provides the meta-psychic and symbolic guarantee (Kaës, 2012) necessary to ensure the continuity of being to the polity. This systemic defense overlays the disavowal of some portions of perceived reality and has a bearing on reality testing, owing to the underlying splintering of the ego, whose synthetic faculty is compromised.

Freud first began to explore the area of perversion and conceptualized the vertical splitting of the ego in his 1927 paper *Fetishism*, wherein he proposed that when the sight of an object is exceedingly traumatic owing to the existential threat it carries, the person might recoil in horror, and resort to adopting a generalized posture of disavowal and repudiation of the very object – and reality – they perceive. Initially postulated as a defense from castration anxiety, it was later paradigmatically extended to epitomize the radical obliteration of any perceived or fantasied existential threats to the

self. The mapping of the dissociation onto a society at a given historical juncture renders it an ego-syntonic cultural trait that connotes the anthropological context wherein subjectivities are embedded and consequently it becomes normalized.

As I previously argued, if the work of mourning fails, it intimates a strategic disavowal of a painful piece of reality: Freud had remarked that this sometimes can be transitory, in the face of a shocking event, or a sudden catastrophe. Different, however, are the clinical presentations where the rift of the ego constitutes the main structure – as in the case of fetishism or psychosis or historically determined mass psychopathology – because it organizes the character, or the culture, in lieu of the more sophisticated mechanism of repression. Freud had anticipated and detailed these dynamics in *Neurosis and psychosis* (1924). However, it is only in *The splitting of the ego in the process of defense*, an unfinished short contribution written in 1938 and published posthumously, that he properly discourses on the vertical rift in conjunction with his preoccupation with the destiny of the ego under pressure from psychic events – internal and/or external – that is ubiquitous in all pathologies, neurosis included, where its presence may be confined to certain psychic zones or functions, unlike its more extensive manifestations in pathological character organizations.

A letter Freud addresses to Arnold Zweig in 1933 bespeaks this despairing human truth:

> "Fury is mounting and gnawing away at the core. If only one could do something liberating!" The only liberating thing that remained for him in his predicament was in fact to turn away from a reality that had become unbearable and, through daydreaming, to enter into the realm of fantasy.
> (Grubrich-Simitis, 1997, 82)

Is this not what Boori Ma does as well?

In Freud's wake, many thinkers have advanced the examination of the splitting of the ego, which has partly been instantiated by the clinical exigencies posed by the treatment of patients whose suffering resides in the area of identity. In the aftermath of the world's demanding recovery from the tragedy of War World II, the preoccupation with traumatic causation of etiopathology which Freud had set aside, but never discarded, became topical and still is in contemporary psychoanalysis, with disasters, ecological and socio-economic disequilibria affecting ever larger groups of citizens and disenfranchised people the world over.

Once contextualized within the system of defense demanding the avoidance of the intolerable reality, the concept of imposture which Lahiri crucially poses in *The real durwan*, acquires greater depth and relevance. Paradoxically, in fact, Boori Ma is not a bogus gatekeeper, or an impostor in its more delinquent and malign connotation, because she does not

intentionally deceive or mean to harm anyone with her fabrications, which the residents define as "harmless imposture". How does one account for this level of meaning?

I would argue that Lahiri invites the reader to see that we are not in the regime of logic, where true and false collide, rather in the regime of reality, of the perception of a shared order of things – Merleau-Ponty's geography – which has to be subjectively experienced and signified – the landscape – for it to become real. When the given reality is too distressing, the ultimate emotional anchor in order not to succumb to helplessness is turning to daydream, as Freud unreservedly avows in his letter to Zweig. Moreover, to paraphrase Winnicott, the object-reality must be there and resist, to be usable to feel real, but it must not be overwhelming, impinging or too violent. If these conditions are not present, and if the symbolic guarantee supposedly accorded to the subject whose life and growth depend on the socio-cultural environment, grievously falter, in the hollow space therein a rent with reality can open, which phantasmagoric mendacities paper over.

It is of interest that the etymology of imposture derives from the Latin *in* +*ponere*, which denotes the act of posing or positioning over something else; this also calls to mind Freud's uniquely unedited perspective on delusion, when he postulated that the appearing of delusion is not the defining trait of madness, on the contrary, delusion is a fable invented by the psychotic or helplessly overwhelmed mind to attempt a self-cure by repairing the rent in the fabric of reality, where madness had previously produced psychic holes. Furthermore, delusion has the same structure of fantasy, albeit quantitatively greater, fixed and split, unlike the more dynamic contents powered by desire.

Boori Ma is not portrayed as a knave, but as a pitiable old lady, whose speech her listeners index under the rubric of "harmless imposture". Doubtlessly her words have no purchase on reality and, together with her guileless mannerism, interrogate the import of her enunciation. I would argue, however, that a more spacious semantic niche could accommodate the nuances of her speech act, rescuing it from the dichotomies truth/lie; real/fake; rather, inscribing her speech in the ontological ecology of a vacillating sense of self permits to embrace the spectrum of more subtle and articulated readings. Significant underpinning of my hypothesis is her refrain: *believe me, don't believe me*, which could be seen as having a *psychic skin* function that envelops her and permeably facilitates contact with the world of others. To an attentive psychoanalytic listening, her phrase *believe me, don't believe me* conveys the radical ambivalence of her address to the other: it expresses a wish for closeness and the terror of it, and the push–pull oscillation amounts to a solution to the insoluble dilemma of her lacking existential domicile. By defining her recurring phrase as a psychic skin, I am referring to the concept of skin-ego (Anzieu, 1985), the container of the self as a separate somato-psychic unity, and at the same time the point of contact – metaphorically skin to skin – with the other. On the collective plane, the skin-ego is a definer

of cultural identity and forms a protective barrier vis-à-vis- the foreigner, the stranger.

It would thus appear that Boori Ma's imposture, her tormented skin, her muddled invocation to the other, are all markers of the problematic question of identity, symptomatic of her vacillating subjectivity, whose only reliable support is the broom she can never part from. The broom, in fact, is also the only possession she carries when she is ousted from the tenement. Precariously, she adheres to the surface of objects like her broom, that give her a solid shape, so that her self does not leak, vanish or suffer annihilation.

In the next section I will temporarily reside with Boori Ma in her ontological niche, to accost her as a character, whom Lahiri pens as an allegorical shipwreck, and through Mr. Chatterjee's words, defines as "the victim of changing times". Patently a tragic figure, she demands to be rescued from the narrow nomination of scapegoat or sacrificial victim, to aid our exploration of the malaise – not just the discontent – of civilization, not organized by neurotic structures, but by predicaments in the psychic area of troubled identity. Whilst discontent would qualify the individual experience, malaise is preferred here as a synonym of collective wound and malady.

The place Boori Ma lives in

A private space to house and moor Boori Ma is conspicuously absent in the story. As a matter of fact, she sleeps and gathers her puny possessions in the communal parts of the tenement, at the bottom or top of the stairs. Boori Ma emotionally resides in her sheer physicality, but her body offers no safety or comfortable domicile because she inhabits an ontological ecology invaded by unrelenting torment(or)s, which she projectively designates as mites. Functioning as an operational character who linguistically moves amongst the concrete logic of thingness, she has found a suitable object for the idiomatic narration of her nocturnal restlessness, given that bedbugs are real but not easily detectable in the diurnal light. It is clear how her speech needs to be given credence for what it is, taken at face value, and when Mrs. Dalal attempts to transpose it onto the level of imagination –"I don't see anything. Boori Ma, you are imagining things" – such utterance cannot but encounter a vehement rebuttal. No-feelings, no-conflicts, no-worrying thoughts: an undoubtedly forceful disavowal is at work which is, arguably, an indication of the absence of a space inside, where to put things in, as Winnicott (1967) names the location of culture. The inner location is a potential space hosting polysemic signifiers and refers to the mind, the world, culture. Adhering to the surface of her narrative suggests that Boori Ma has her reasons for not imagining *things* – that would make her insane, or self-conscious, or even playful; and "it is not prickly heat": that would be a common enough ailment, perhaps only a seasonal one. Neither too common nor sophisticated enough to exist in the real or in the possibilities of the virtual – the space for

self-reflection or the playing of the imagination – the two dimensionality of her body surface could be the projection of her need to be visible, to exist, and she clamours to be seen where she is at, in her flat thingness, with her skin pierced by invisible tormentors.

Boori Ma insists that she lives outside the language circuit that engages others in communicating human affairs pertaining to their shared, ordinary life, whilst she stakes a claim to existing in the extraordinary realms of persecution or pleasure, whose density she can only perceive sensuously, on and through her body: the domain and the intense quality of the excessive. Psychically, she appears to function like a child who does not (yet) differentiate the inside from the outside, consequently reality and fantasy still intermingle. Does she truly understand the meaning of Mrs. Dalal's utterance "you are imagining it", which is undergirded by the firmly established awareness of having an internal world to contain imaginings?

Rather than attributing the idiosyncratic quality of Boori Ma's speech to her pathology, and advocate the talking cure treatment, I propose spotlighting the personage as embodiment of the malaise of her historical milieu. I would, therefore, regard her somato-psychic presentation as the very juncture where intrapsychic sensibilities, intersubjective relationships and their trans-personal cultural mappings intersect. Hereof, perhaps, the lack of a room of her own can be read as Lahiri's closely listening to and rendering in words Boori Ma's concrete speech and, at the same time, opening a metaphorizing space for further critical reflection through the work of reading.

Factoring in Freud's revolutionary contribution to the understanding of things human with his theory of the unconscious, gestures to the subject's need to signify, in whatever way they can, psychically or somatically, in the understanding that when the unconscious appears on or through the body, it does not know anything about itself, it is but an extended surface, not minded. It speaks but remains mute. In *The ego and the id* Freud proposes a developmental account of how the mind emerges from its initial bodily existence, through the incremental work of sensing, perceiving, and thinking the differences:

> A person's own body, and above all its surface, is a place from which both external and internal perceptions may spring. It is *seen* like any other objects, but to the *touch* it yields two kinds of sensations, one of which may be equivalent to an internal perception.
>
> (Freud, 1923, 25, original emphases)

Deception might be a pitfall of the visual, which is also the stuff of dreams, daydreams, mirages, mirror reflections, hallucinations: these are all forms of imaginings, with internal variations, one of which is playing, which takes place under the aegis of the ego and prized by a "yield of pleasure". The

touch makes the difference in better grounding the ego in reality, and tactility issues sensorial events of and on the skin.

The body in the story occupies a potential space, with multilayered meanings and, if it projects outwardly the mental workings of Boori Ma, it also carries the unconscious inscription of her story of past and present sufferings. Such is the destiny of the somatic unconscious: to carry the inscription of the human subject, since the origin inside the (m)other's body and mind, and whilst only parts of this story are shaped by language, others will be captured by inchoate forms which, if excessive, might even have the capacity to disrupt the symbolically civilized acquisitions. As Kristeva suggests, the symbolic of language is always at risk of the irruption and disorganization of the archaic semiotic level. Perhaps this origin is what resonates in the word *becharech*, that is, the utter infantile helplessness.

Ordinarily, separation from the primary state of two-ness starts at birth and continues throughout life, and this task is renewed through the succession of changes and concomitant losses. The momentous caesura of birth, both origin and model of this process, is thus described by the philosopher Nancy in his phenomenological language:

> I begin to exist apart from the other body – which is how I myself am a body – and this progressive detachment makes itself felt as such. My own existence is separate, but I am separate inasmuch as I am bonded and related to an external world from which I find myself severed.
>
> (Nancy, 2011, 25, my translation)

The ego, body-ego, skin-ego, cultural-ego

In 1923 Freud proposes a revision to his previous model of the psychic apparatus, which now comprises three agencies: respectively the *id* is deeply unconscious, and a cauldron seething with passions, impulses, and formless raw contents; the *ego* is a window open to reality and tasked with negotiating the traffic with both the external world and the pressure exerted by the id; the *superego*, mostly unconscious too, is the site of conscience and of the transgenerational transmission of norms, imperatives, values, customs, ideals, namely, the tradition comprehended by the word culture with the prescribed conditions for occupying a place as a recognized member of society. The very word *tradition* gestures to real and symbolic objects transferred across places and times in the shape of mandates to be carried out, contracts to be entered and all the unconscious pacts transmitted via the superego to the next generations. As well as rooted in the drives, due to its being unconscious, the superego is based on the introjection of the parental figures who function as models and mediators of cultural forms and attainments; Green calls this human proclivity "disposition to re-acquisition" (2002). It follows that the individual's identity is essentially embedded in the complex "we-ness" of the group, and its unconscious narcissistic layer is enveloped by the cultural skin-

ego which marks sameness and difference, separation and contact with the other culture.

Freud famously designates the ego as the agency responsible for reality testing; it emerges from the primary narcissistic fusion and needs to become cohesive enough to withstand the many pressures, to learn to focus its attention and reflect on the differences between feelings, sensations, and perception, which culminates with the knowledge of inhabiting a mind-body unit, alive amongst embodied others. Consequently, the corporeal subjectivity results from interweaving imaginative and ideational constructs through the accomplishment of the necessary psychic work within the historical context that provides the signifying alphabet to perceive, apperceive, name and think the body, including its colour coding! In this regard it may be useful to quote one of Freud's most complex and enigmatic excerpts from *The ego and the id*, a classic text that scholars pour over, read, reread and reinterpret.

> The ego is first and foremost a bodily ego; it is not merely a surface entity but is itself the projection of a surface.

A footnote added only to the English edition in 1927 continues:

> The ego is ultimately derived from bodily sensation, chiefly from those springing from the surface of the body. It may thus be regarded as a mental projection of the surface of the body, besides [...] representing the superficies of the mental apparatus.
>
> (1923 [1927], 26)

Freud does not explicitly single out the skin as the sense organ situated on the surface of the body and forming an envelope for the self. Anzieu (1985) develops the Freudian hypothesis into his detailed formulations of the sensorial and psychic envelops, of which skin and sound leave the earliest and most durable sensory impressions. More pertinently to our theme, Anzieu posits that the psyche has two objects of libidinal investment, governed by similar conscious and unconscious functioning, and essentially strives for independence, whereas in fact, it is always already doubly dependent on its biological endowment and on the stimuli, beliefs, norms, and representations emanating from the subject's social groups: the family and the cultural environment. Authors like Anzieu, Smadja, Kristeva, Laplanche, Green, and Kaës – to mention just a few – regard Freudian psychoanalysis as always already a cultural anthropology pivoting on the vicissitudes and assemblage of the libidinal and destructive drives active in the individual and group alike, and they show how they have absorbed the lesson of *Group psychology and the analysis of the ego*, especially the relevant passage that reads:

> It is true that individual psychology is concerned with the individual man and explores the paths by which he seeks satisfaction for his instinctual impulses; but only rarely and under certain exceptional conditions is individual psychology in a position to disregard the relations of this individual to others.
>
> (Freud, 1921, 69)

An appended proposition is that whenever it might be heuristically expedient to disarticulate the subject from the socius, it is still essential to keep in sight their complementarity and continue the multidisciplinary conversation, which is more enriching than specialist silos. This is also the principle underpinning the corpus of the ethnopsychoanalyst George Devereux who practised in non-western cultures. He put to work Freudian theories but inflected his observations within the specificity of the local mythologies, which he did, for instance, in his studies of phenomena of shamanic homosexuality or skin modifications amongst the Mohave Indians. Devereux's ethnopsychoanalysis informed his clinical method, he learnt the non-European languages spoken by his patients, who translated for him the culturally embedded semantics of their symptoms.

Returning to Boori Ma's skin, I propose a twofold perspective on its psychic salience – as metaphorized in Lahiri's story – to foreground it as the site of malaise, both her own and that of the group who made the unconscious pact of electing her as bearer of the affliction and the sacrificial victim. Her complaint convincingly shows that massive traumata perforate the psychic envelope, because the destructive strikes have the potential to inflict wounds to the symbolic order, undermine the existential feeling of safety, and expose the superficial layers of civilization, which all too easily unravel.

Boori Ma's skin-ego is not intact, it is pierced and full of tears, and equally fissured is her psychic container, whose alterations transpire in her voice. In fact, her sound envelope has deteriorated into a shrill vocalization, wrapped up in its own lamentations, and impaired is her speech's purchase on reality. Boori Ma does not desire to narrate her story – this would depend on an intact ego function – therefore, she cannot be soothed by transformative words which might be weaved into a meaningful thread and rouse her capacity to become her own bio-grapher, that is, a subject who inscribes her life in human history, telling of the ashes deposited by its deleterious forces. She seems to have no wish to tell her story, is settled in her solution of telling stories, but what is lacking is a story and a sense of history. She is not insane – her refrain *Believe me, don't believe me* is not a mad enunciation – she is, rather, truly *bechareh* and her voice bewails her despair and helplessness. Apposite words would describe her a melancholy, tragic character, a figure of sorrow, like a supplicant who carries epidermically and vocally the unutterable wretchedness for herself and the community.

Reframing story and imposture

Imposture draws from its Latin roots – *imponere in+ponere* – its meaning: *to place over* something else, or an emptied space. Only in the XVI century did the term begin to mean cheat, swindler and indicate someone who pretends to be what they are not. In our contemporary perspective, imposture more precisely denotes lack of authenticity and, when referred to characters, it qualifies socially situated identity. Alongside interpersonally communicated feeling, imposture implicates other organizers such as class, gender, status and the like, whose value is socially defined. In the more modern sense, imposture is synonymous with bad faith, malevolence, the wish to deceive, it is often an aggressive manipulation because it interposes a meta-level in the relationship with the socius, who is unaware of the reality when taken in by the fictitious imposition. In short: the conversation is not taking place between players who play the same social game and follow the same rules. Inwardly, however, imposture might point to strategies to defend from insecurity, feelings of inferiority and shame for what one is and, in this case, hiding the self takes priority over deceiving others. Unsurprisingly, imposture intrigues psychoanalysts and, from the pioneering studies of Helene Deutsch on the *as if personality*, to Winnicott's concept of *false self*, the extant literature is impressive, too copious for review. It suffices to mention that most of the studies convene on the self-protective aspect, even when its aggressive aim against the object is duly factored in. There is also concordance on the judicious link inauthenticity of character has with reactivity to traumatic encroachment that overwhelms the ego and violates the skin-ego.

Literature itself could be considered a variety of imposture, namely, a member of the class of edifices unrooted in the solid foundation of reality but solely predicated on potential reality, like playing. Therefore, further attribution of a metaliterary level to the titular *real durwan* leads to problematize the very notion of imposture, wherein the malignant aim is superseded by the play of the imagination so that, in essence, fiction forges a new object on the ruin of the past, (re)presents it and somewhat repairs the damaged fabric of thought. *The real durwan*, being a work of fiction, accesses the potential reading space and introduces the reader to a character unmoored in reality, inviting them to shift their gaze to the internal reality of the mind, and her storytelling.

Imaginings are stories with a precise trajectory: a beginning, a buildup, and a conclusion, and this quality distinguishes them from hallucinations and delusions, which are more permanent structures with different aims. To study psychosis, Freud took an interest in the *Memoirs* of President Schreber and advanced the view that delusions are the patient's attempts at spontaneous self-recovery from a psychotic break with reality by mending the rent with a phantasmatic construction. It follows that the purpose is mending the self, rather than bamboozling the other. By the same token, the fictional Boori

Ma makes up unrealistically glorious versions of herself to be someone in the world, to have something to tell, to engage and disengage from others, to dose the quantity of tolerable human interactions. She wants to interest and fascinate the listener stitching up a heroic mythology, in disregard of credibility which belongs to the aesthetic of realism and verisimilitude, which are rhetorical devises to facilitate the reader's identification with the character. To yet another field belong belief, credence, trust, which echo more fittingly in the refrain: *believe me, don't believe me*, engage and disengage. The reader cannot fully identify with such a character who masters and controls closeness and distance, hence their curiosity and questioning maintain the required distance.

Perhaps the questions of trust and belief must be recontextualized: if Boori Ma's words can and cannot carry credibility, similarly, her fellow inhabitants can hear and not hear, believe and not believe, as long as they abide by their pact of complicity, situated in an atemporal niche where the work of mourning is barred. This mode of being and relating outlines the psychic ecology Abraham and Torok named the *crypt* (1994), a melancholic locus where the living and the dead – life and death – are tied in their embrace full of shadowy *jouissance*. Whilst such wistful recess was instrumental to Amelia Rosselli, whose poetic words shuttle in and out of the crypt, in and out of language, which she mangles, uses and abuses, pushing it to the brink of destructuring, but ultimately rescues it from annihilation, Boori Ma is and has always been an impoverished subject living at the margin of language, therefore she cannot source this creative vein.

Venturing into what is unsaid but could be inserted as the unconscious *of* the narrative, the refrain might sound like: *Believe me, (YOU) don't believe me* and its final wording *Believe me, believe me* communicates that she truthfully was not complicitous with the lawless profiteers and, more, that she is ousted from and exits the unconscious pact of disavowal of the impact of the Partition. Indeed, *partition* consists in drawing a red line, and institutes such a radical division that renders any thought of reconciliation quite problematic, just as when the ego is vertically split and integration is perilous for the precarious internal equilibrium of the subject.

To consider specifically the fate of language in imposture, the first evidence is its disarticulation from its referent, which elicits the listener's confusion and disarray, and the resulting collective distrust of the organizing function of the symbolic order is perforce implicated. If we are not told simply a comforting story – as Boori Ma does when narrating her many losses in the form of a *harmless imposture* – the impos-ition of a new word-reality, like Partition, turns into a fact of power and domination. As I related in the previous chapter, Lahiri is conversant with the psychic reverberations of historical vicissitudes in their linguistic aspects, like colonization and de-colonization, which connote the *malaise in the culture* and compound the fixity of

domination, submission and untrustworthiness. Perhaps the writer revisits this history when she composes Boori Ma's story.

The artist can find/create a new, personal idiomatic expression and take up residence in her inner locality trusting that the battle between Eros and Thanatos can be fought and a new alive object can be born. In a sense, the artist too receives a cultural mandate when she lends her inner space to the collectivity, so as to resonate the anger, the pain, the deceit, and mourning of societal quandaries. Rosselli's poetry, as for instance *Bellicose Variations*, bears witness to the wounds and the destruction of the Mussolini regime, the destiny of its victims, and her linguistic new order; similarly, Lahiri gives dignity to her diasporic characters, marked by pain and loss and yet existing as figures of fiction. She listens to their voice when she intersperses her texts with words like *durwan* and *bechareh*, whose originality needs to remain untranslated.

Arguably, Lahiri portrays the malaise of language co-occurring with historical vicissitudes penning the dénouement which gestures to the demise of the symbolic, for language collapses into impulsive, unthought-out actions. The residents stop talking to Boori Ma and silence her, in a cavalier fashion they choose not to believe her, just when she wants to have her say, asking for help with the burdensome work of mourning she carries for them all. No longer a wounded speaking subject, Boori Ma is now but a cultural abject. Notwithstanding, when she clamours *Believe me, believe me*, her words resonate truthful, poignant, and sane, making her a character that will exist in the reader's imagination where she finally coheres, trustworthy and dignified.

Coda: a group perspective

Freud regarded his individual psychology always already a group psychology, and suggested that the same phenomena can be observed from two complementary perspectives. Many authors and practitioners expand the application of Freud's metapsychology – the unconscious, the drives, transference, dream-work, fantasy – to the analysis of groups, whilst some argue that the group as a whole has its own peculiar dynamic and expose the fallacy of the isomorphic assumptions that underlie Freud's conceptualization. This theoretical discussion is beyond the scope of this chapter, wherein my intent narrows down to an analytic deconstruction of the fictional Boori Ma, who carries a mandate on behalf of her community going through "changing times". Their projections and dissociative defenses render her the personification of grief that cannot be worked through. When the previously established order changes, lost is the *semantic horizon* within which subjects see themselves evolving in time. The phrase *semantic horizon* is here employed to indicate a signifying context wherein the individual inscribes the sense of who they are in the nexus of kinship, close family, friends, status, role, and

the ensuing obligations, rights, and belief system. It contains something like a literacy programme to signify experience, a temporal structure and a thread, together with the sense of historicity, because where the group come from comprehends where they are in the present and are likely to move in the future, which inflects the dimension of projects and desires. Working through is a necessary step to be able to imagine a new *semantic horizon*, instead of repeating in order to remember the disruptive past events that cannot be inscribed in historical continuity.

Changes are enmeshed with loss and disorientation, which affect as much the individual as their group and during the elaborative transition a "border psychology" (Volkan, 2015) prevails. The metaphorical border is a location of uncertainty, waiting, suspiciousness, persecutory fear of no longer being who one could claim to be, of not having the right documents and being found wanting. The fear of being seen as an impostor is the ineludible existential predicament. In the throes of this early anxiety, the group lose their differentiated structure, turn into an amorphous unconscious amalgam, and regressively look up to the leader who becomes the receptacle of their ego and superego. However, the reprieve from anxiety dovetails with the abrogation of the sense of responsibility towards the other. The group unconscious closes rank for fear of strangers, deemed to spread contagion. In groups the person becomes highly suggestible and prone +to passivity and fascination; all the "individual inhibitions fall away and all the cruel, brutal and disruptive instincts, which lie dormant in individuals as relics of a primitive epoch, are stirred up to find free gratification" (Freud, 1921, 76). Identifying with the group, subjects merge, their ego loosens the familiar boundaries, in similar fashion to falling and being in love. Freud proposes that in this hypnotic state "all that is evil in the human mind is contained as a predisposition" (74) and comes to fruition once the responsibility is delegated to the leader, whom the group love and fantastically experience reciprocation, denying feelings of jealousy, envy, and rivalry. The leader is regarded as a paternal, quasi-divine figure, viz, an embodiment of their ego ideal. The group mentality is captivated by the state of mind where everything is possible, reality testing is suspended, and guilt or remorse are not the worrisome consequences of the aggression and violence unleashed. This is a psychological rendering of a society pervaded by lawlessness – the sociologists' *anomie* – when the unsettling intuition of the end of a civilization elicits archaic anxiety felt to be an existential threat and finds an outlet in nihilistic actions to counter the danger to the self, dehumanizing the other.

Jonathan Lear emphasizes that imagination is a crucial resource for the group in these transitions, their capacity to dream tremendously assists the painful working through of "the end of a civilization" (Lear, 2007). And imagining/creating a new *semantic horizon* wherein the individual's identity, social role, family, and relationships can be inscribed, repairs the futurity of time and replaces the sense of foreboding and intimation of doom. Subjective

and/or group imagination involves the dream-work, and the reassurance that dreaming is qualitatively different from having nightmares or delusions and hallucinations.

Lahiri's imagination portrays a society traversing epochal changes, that are refracted in a group whose mourning and working through the losses is stalled, as evidenced by the dissociative processes at work and their designation of a victim, naturalized and nominated "the victim of changing times". How much is Boori Ma the "victim of the changing times"? Is it her character, her destiny, the masochistic psychic organization of her jouissance that renders her particularly eligible for such mandate? Or rather, can we view her figure as the emblem of tragedy, exemplifying the necessity of the group unconscious to designate a victim, which could be read into the dénouement of the story and open the space for the après coup account that the psychoanalytic imagination can offer?

Perhaps when Mr. Chatterjee, in his sanctioned leadership role, avers that they all knew about the losses and ashes deposited in Boori Ma, he is acknowledging the group's projections, and noting that intellectual awareness by itself is not sufficient, if unaccompanied by a genuine emotional understanding and elaboration. If anything, the splitting mechanisms, the negative of working through, are destined to break at the seam and erupt into violence. The closing scene of cruelty and humiliation of the sacrificial victim bears witness to the pathological transformations of mourning, whereby Boori Ma is cast away, like a representative of the untouchable caste – supposedly abolished at the time of the narration – obstinately resisting and reappearing in mutated forms. When she can no longer clean, order, and separate the dirt-impure from the purified group-ego, she turns into an imaginary pollutant herself, to be removed from the group, who regressively entrusts its ego ideal to its leader who promises that a new order will be instantiated by the search of a "real *durwan*". A man, a return to tradition, a messianic renewal and a repetition, and at the same time the triumph of nostalgia and absence of responsibility or guilt in the perpetrators, who, themselves, feel robbed of their manic transformative object, epitomized by the washbasins.

This discursive framework contributes a further layer of meaning to Boori Ma's remonstration that the tenement group cannot dream and to Mrs. Dalal's retort that she – and perhaps the entire tenement – is psychically too impoverished to dream or imagine a hopeful future or indeed use the past tense for their collective narration. With the working through stalled, the stasis of the collective imposture and the retreat into suspended time, the mimicry feature of the "as if" produces but unrealistic solutions of which, perhaps, the holiday in Simla (Shimla) is another instance, and a manic (re)appropriation of what had already been stolen by the Raj. Whether imposture might serve aggressive or self-preservative purposes, in this case it is undoubtfully a form of self- deception, in as much as it staves off the

elaboration of the losses and the recovery of temporality to pave the way for imagining and emotionally investing in a new cultural project.

For subjectivity and culture, the experience that is not remembered is demonically repeated, in

> various combinations and alternations [that] define distinctive features for each culture. In the social and cultural realms, repetition also translates into the effect of a trauma that, unable to find a way towards representation and working through, reappears and is actualized into a new return of the same, the identical.
>
> (Marucco, 2007, 310).

What repressed past is returning as re-actualization in the fiction? The shame of the caste structure? The 19th-century social reformists' abolitionist revolt? The British revision and reorganization of the society into Scheduled Castes and Scheduled Tribes (Madhusudana, 2015): a repetition of the same, only under a different nomenclature? The vicissitudes of Partition are the manifest historical backdrop, but they might well condense other past unelaborated vicissitudes of failure of the work of culture. They are enacted, but remain unnamed, and in their cultural specificity, they are the receptacles of the crux of human suffering.

Lahiri's literary imagination constructs a tableau of believable characters who stage as impulsive chaotic frenzy the history they cannot work through and invite the reader to inscribe in the text the universal story of humanity's adversities. In the face of the defaulting societal *Kulturarbeit*, the fictional work of culture can (re)imagine, (re)create, think, and symbolize the unlanguaged. When all is said and done, the practice of writing always entails mourning for the lost object, and only then the new cultural object is reshaped, and offers its yield of consolation and pleasure; not negligible gifts, at that.

References

Abraham, N., Torok, M. (1994). *The shell and the kernel*. Chicago University Press.
Anzieu, D. (1985). *The skin-ego*, transl. Segal, N.London. Karnac Books, 2016.
Devereux, G. (1972). *Ethnopsychanalyse complémentariste*. Paris. Flammarion.
Freud, S. (1915). *Thoughts for the time on war and death*. SE XIV.
Freud, S. (1921). *Group psychology and the analysis of the ego*. SE XVIII.
Freud, S. (1923). *The Ego and the id*. SE XIX.
Freud, S. (1927). *Fetishism*. SWXXI.
Freud, S. (1940[1938]). *The splitting of the ego in the process of defense*. SE XXIII.
Green, A. (2002). *Time in psychoanalysis: some contradictory aspects*. London. Free Association Books.
Grubrich-Simitis, E. (1997). *Early Freud and late Freud*. London. Routledge.
Kaës, R. (2012). *Le malêtre*. Paris. Gunod.

Lacan, J. (1977). *Ecrits a selection*. London. Tavistock Publications.
Lahiri, J. (1999). *The interpreter of maladies*. London. 4th Estate, Harper Collins Publishers.
Lear, J. (2007). Working through the end of civilization. *IJP* 88:291–308.
Madhusudana, V. (2015). Indian caste system: historical and psychoanalytic views. *American Journal of Psychoanalysis* 75(4):361–338.
Merleau-Ponty, M. (1945) *Phénoménologie de la perception*. Paris, Gallimard. *Phenomenology of Perception*. London, Routledge (2012).
Marucco, N.C. (2007). Between memory and destiny: repletion. *IJP* 88:309–328.
Nancy, J.-L. (2006). *La nascita dei sensi*. [The origins of sensoriality]. Milano. Raffaello Cortina.
Volkan, V.D. (2015). The intertwining of external and internal events in the changing world. *American Journal of Psychoanalysis* 75:353–360.
Winnicott, D.W. (1967). The location of cultural experience. *IJP* (48):368–372. Also published in the *Collected works of D.W. Winnicott*, vol. 8. (2016). (Caldwell, L., Taylor-Robinson, H. eds). Oxford University Press.

Chapter 5

Characters
Fictional, real, verisimilar, and plausible

By way of introduction

Ifemelu is the fictional character who animates the almost 500 pages of Chimamanda Ngozi Adichie's very successful novel *Americanah*. The talks, interviews, and public lectures copiously available online bespeak her considered authorial eagerness to portray a female character courageous enough to speak her mind, claim the legitimacy and normalcy of curiosity – and the infantile sexuality at its root – and to navigate divergent worlds and cultures. Ifemelu's sagacious observations, attention to details and her gift for braiding them into narratives laced with humour make her a formidable personality. There is much more to her personal story that is inchoate, implicit, hidden: conflicts, darker areas, unexplored zones, unknown and unknowable territories of the mind that make the journey perilous, uncertain, at times despairing, exhilarating, and exciting by turns.

Equally complex is the navigation of the psychoanalytic reading of a text. What are my reference points as I approach an imaginary character who, unlike the analysand, cannot engage in the back and forth of the analytic dialogue, the flow of associations, figurations, interpretations, and hypothetical constructions? What will be a thoughtful, generative analytic stance that will enable me to interrogate the text and let myself be interpellated by it, hold it inside and listen to its reverberations with my unconscious? When all is said and done, characterization, authorship, and readership come together through cross identifications that bear upon the shared existential drama.

Of the often-problematic contributions of psychoanalysis to the understanding of works of art, Freud's proposal that the beholder's countertransference (Freud, 1914) is implicated in the aesthetic experience is most valuable in that it involves their subjective quota, mostly unconscious, that emerges as a temporary disturbance. He arrived at his formulation noting his personal response to Michelangelo's Moses in San Pietro in Vincoli in Rome and found that attending and signifying the details of the artistic creation is co-terminus with heeding one's unconscious and entering into contact with the stimuli that prompted the artist's unconscious s/he is able to give artistic

form to. Freud postulates the existence of interlinked identifications when he writes:

> In my opinion, what grips us so powerfully can only be the artist's intention, in so far as he has succeeded in expressing it in his work and in getting us to understand it. I realize that this cannot be merely a matter of intellectual comprehension; what he aims at is to awaken in us the same emotional attitude, the same mental constellation as that which in him produced the impetus to create. [...] The product itself after all must admit of such an analysis, if it really is an effective expression of the intentions and emotional activities of the artist. To discover his intention, though, I must first find out the meaning and content of what is represented in his work; I must, in other words, be able to interpret it. I even venture to hope that the effect of the work will undergo no diminution after we have succeeded in thus analysing it.
> (Freud, 1914, The Moses of Michelangelo, 12)

Here Freud sounds more tentative than in his unceremoniously appropriative analysis of Jensen's *Gradiva*, instrumental to confirming his theories based on Harnold's repression of his infantile fixation, that supposedly underscored his symptomatic withdrawal from a full relational life. Having rather directed his epistemological inquiry towards Michelangelo's methodology, Freud explicates that artists avail themselves of the preconscious layer of their psyche to express unconscious contents, which they shape by idiomatically adapting the aesthetic forms transmitted by the cultural patrimony. He factors in the artist's motivation –intentional and purposive – whilst at the same time he acknowledges how the work of art comes to fruition when it can speak the universal idiom of emotions, mostly unconsciously.

So, returning to a methodical, piecemeal reading of *Americanah*, I will heed Adichie's purposeful design, while being mindful that the writer's volition does not exhaust the significance of literature because there is something more, something other, when a new object is posited in the domain of language. After all, the author speaks a language but is also spoken by language, she is the subject of the enunciation but also subjected to the symbolic system that always already exists independently and resists authorial – authoritarian – possessiveness. In parallel, the reader is the subject, receiver of the text that, however, remains elusive as the *third* in a dialectical process, safe from the trappings of any ideological reductionism. I am in agreement with Francis Baudry, who raises the question as to whether "texts have properties independent of the author which could be called psychological. The richness of meanings of a work of art is partly intentional, partly preconsciously and unconsciously determined, partly the result of the nature of language" (Baudry, 1984, 560).

In essence, I intend to approach the text as the independent *third* and a platform for a fruitful conversation with psychoanalysis, whose theoretical armamentarium of psychic development, conflicts, working through,

identification, paternal function, and internal structures will frame my reading of the process of subjectivation of the *Americanah* Ifemelu.

Americanah: what does the "woman-I" want?

This chapter follows Ifemelu's circuitous journey home and psychic habitation of her subjectivity through her self-discovery and realization of her desire. She journeys away from and back to her Nigerian home.

What does a woman want? So begins Freud's interrogation of female sexuality which interpellates him, and he responds setting out on an allegorical oedipal quest to face the sphinx-like enigma of womanhood. His corpus evinces a gamut of *transferential* affects, from the wish to conquer and possess the "dark continent" to counteract with epistemic certainty the horror of the passive position – bedrock of any analysis, for women and men – to the exercise of the sublimated seduction inherent in his treatment method. His patrician knowledge, conjugated with his analytic desire, insured against risky enactments with his hysteric patients, kindling, instead, his epistemic erotics, which was transferred onto the field of scientific inquiry. All the same, Freud appreciated that society demanded of women a burdensome inhibition of their potentialities that inflect the wish to know and experiment and presupposes a free deployment of curiosity. He understood, in fact, that an inquisitive mind is a passionate mind, and the alignment is rooted in the libidinal drive which ceaselessly, unerringly, metamorphoses infantile sexuality. I related in a previous chapter Freud's critique of the "civilized" sexual morality (Freud, 1908) that mortifies women's interlinked desire, curiosity, and thinking, whose judicious reprise is instrumental to accost *Americanah*'s protagonist, for Chimamanda underscores that curiosity is her salient character feature and an invaluable resource.

Exemplary is the passage where Chimamanda repeats *curious* three times in a brief exchange Ifemelu has with Obinze, jealous of the "sloe-eyed and thick-lipped Odein".

> "Kayode said he took you home after Osahon's party. You didn't tell me."
> "I forgot."
> "You forgot."
> "I told you he picked me up the other day, didn't I?"
> "Ifem, what is going on?"
> She sighed. "Ceiling, it's nothing. I'm just curious about him. Nothing is ever going to happen. But I am curious. You get curious about other girls, don't you?"
>
> (92)

A wilful Ifemelu asserts her desire, which she knows has protean manifestations, some fully satisfied in action, others sublimated in thoughts, friendships, conversations, humour.

In Ifemelu's self-representation curiosity is her cherished endowment which, in the novel, plausibly constitutes a *fil rouge* running through her external and internal dislocations, in a reiterated movement away from her psychic home, but in continuous oscillation with her recovering her sense of self through introspection. When she applies her curiosity to self-enquiry, she weaves links between diverse spaces and temporalities from childhood, adolescence through to adulthood, to fashion the historical continuity that composes the texture of her identity, to which the narrative bears witness.

Fortunes of the novel

Only a few years since it was first published *Americanah* is already considered a classic. It has received the US National Book Critics Circle Award for fiction, and Chimamanda Ngozi Adichie has secured a notoriety comparable to that granted to superstars. She is invited to give talks, sits on panels, gives lectures, and her presence commands uproars of applause and enthusiastic cheers, especially amongst black young people.

Elegantly written in the third person, the novel zooms in on the protagonist whose gaze offers a keen perspective on the fine grains of American culture. Ifemelu's observations are witty, nuanced, and astute, undoubtedly her irony is coterminous with her position as an outsider, as Kristeva proposes. Perhaps Ifemelu emblematizes a fertile ambiguity; she is the imaginary character the author identifies with, while retaining the obvious differences, but she is above all the word-bearer of the woman's urge for independent self-realization. Her image always appears in close-up in contrast with other characters, like Obinze, who is somewhat underwritten. Some passages forge ahead at fast pace, the narrative dense of events presents the reader with abrupt twists and, although one might wish for further explicative disentanglements, a second look reveals that the style mimetically reproduces Ifemelu's moods. Be that as it may, the enthusiastic acclaim *Americanah* was received with indicates that it speaks to our times, particularly to the younger generations who find in Ifemelu a heroine they nimbly identify with.

Critics have promptly – too promptly perhaps – ranked *Americanah* within numerous literary genres: it is a *Buildungroman*? A diasporic narrative? A socio-political novel? Intentionally feminist, or a story about race? Is it an instance of embedded narrative? At any rate, numerous interpretations view it as a novel propounding a thesis and transform it into an emblem of identity politics. This would be a current phenomenon worth interrogating, but it is beyond the scope of this monograph. Why does the novel solicit the desire to sequester it within ideological grids and *a priori* theses? Does the appropriation, the uproar betray a societal need for role models and ideals to believe in?

All the same, such classifications run counter to the author's stated intentions to portray a character with its own psychology, not meant to be

subsumed by pre-defined categories. And Ifemelu's unique posture as an onlooker, a commentator who will turn professional blogger, makes her rather a humorist, who laces with wit her annotations of the peculiarly American vice to have a noun for everything, so as to have a readymade solution. It is somewhat ironical that critics too should anxiously look for a noun to pin down a work of fiction that purports to be, on the contrary, experimental.

My counterintuitive analysis will focus on curiosity as Ifemelu's distinguishing trait: curiosity is a capacious enough quality to straddle the unconscious and the conscious mind and provides the judicious compass to navigate known and unknown territories of identities captured in the process of forging their idiomatic language of desire. Curiosity first emerges in childhood with regards to sexual matters and spurs children's investigations and theorizations about bodies, their origins and their distinctiveness – thus Freud maps the various trajectories of infantile sexuality.

I would argue that *Americanah* is *not* a novel about race because this would make Adichie an American, rather than the author of *Americanah*, whose narration leans on her autobiographical experience and ironic reflection of black-ness on her arrival in the United States. She recalls with great clarity the emotionally momentous realization that *black* was an attributive meaning the other gives to her identity which in Nigeria was connoted by referents of religion, class, ethnicity, but not the skin colour that in its homogeneity, could not function as a marker of difference. Adichie, like Ifemelu, became black in America. Arguably, this is likely to be an après coup construction: in the novel, Ifemelu gives meaning to her skin colour in the States, but – as I will point out in passages of the text – shades of colour as hallmarks of beauty and/or class are current in Nigeria, whether consciously or not, because they are culturally encoded in the long permanence of history through the inner structurization of colonial domination. Ifemelu's desire for freedom gestures to some unconscious conflicts, and her dispositional estrangement leads her to interrogate her identifications, role models, and structuring ideas of femininity.

In some of the interviews available on YouTube, Adichie laments the feeling of loss of control of her work after publication; of course, the marketplace governs, establishes its own rules, sells copyrights to film producers, despite her claim that she writes books, which should not be subject to trans modal renditions. The veritable dispossession of a work of art once it becomes an object of economic and monetary circulation is on a par with the categorical attribution of teleological ideologies, in that they equally expropriate authorship and assimilate the work through the logic of extraneous criteria of evaluations. In this regard it may be advantageous to recall that the Latin etymology of "author" is "augere", which means to increase, augment; hence an author augments and expands our knowledge of things

human, whereas paradoxically, ideological grids impose authoritarian and limiting voices over that of the author.

In synthesis and mindful of Adiche's proclamation that the project of writing the Ifemelu character permits her to experiment with uncharted narrative forms, viz the *blog post*, it seems more advantageous to let the narrative unfold and meander in its textual sinuosity and follow the character's journey in search of her personhood. If geography is the discovery of maps that compose a cartographic representation of the territory, this scenery needs to be subjectively inhabited with sentient introspection – I owe to Merleau-Ponty the felicitous evocative metaphor which differentiates external and internal perspectives.

Furthermore, I believe that tracing the itinerary of the character's self-discovery is true to the author's intent of locating universality in human vicissitudes, psychic life, loves, hates, friendships, desires. The sentiment of human citizenry resides in the existential journey of the subject and the transformative potency of stories in their plurality.

Synopsis

The titular Americanah is the risible epithet Nigerians coined for the returnees, the greater part from America or Great Britain. The neologism elongates the word ending onomatopoeically, just as the diasporic subject mimetically adopts American pronunciation. Amidst its nuances, Americanah broadly connotes the cosmopolitan foreigner – the Afropolitan – who is often the object of envy of those who remain, and it also designates the idealized image of the American that speaks to the adolescent's imaginary. In this latter sense, it can appear as a Nigerian inflection of the American dream that shapes the wish to leave in pursuit of a better life elsewhere, which often condenses freedom and choice. Therefore, it telescopes an amalgam that comprises ambitions, self-ideals, idealizations, and desires across times and spaces: it portends a phantasmatic regeneration, someplace else that hosts the project of becoming a subject and combating the apathy and lack-of-choice of living under an authoritarian regime.

In the novel the returnee is motivated by her desire to recover a sense of home, after completing her professional and sentimental education, driven by a wish to show her worldly success and/or to fulfill needs of intimacy. Ifemelu longs to reprise her love discourse with Obinze whom she "does not need to explain" to, to feel understood in her linguistic polyphony. Her professionalism and competence stand her in good stead and enhance her capacity to confidently assert her voice in her elected field. History features in the background, it is a world reconfigured by the emigration curb introduced after 9/11/2001, concurrently with the proclamation of the fourth Nigerian Republic that ended the military rule in the aftermath of the death of the General Abacha, in 1998. More capital flows into the country, often generated

through shady deals with the West; the fantasy of easy money circulating especially in the community of nouveaux riches aptly conveys the manic mood which imbues a new political regime.

The story commences with Ifemelu's journey from Princeton to Trenton, to have her hair braided, a practice which is unfamiliar to the predominantly white and cultivated demographics of the university town. With descriptive vividness Adichie portrays the predicament at the core of the identity of her character who nostalgically reminisces her fascination with Princeton when "in this place of affluent ease, she could pretend to be someone else, someone specially admitted into a hallowed American club, someone adorned with certainty" (p. 3). Looking for a pretence: this is meant to provide a solution to dilemmas and conflicts rooted in primary relationships and environmental influences. In such circumstance, taxing as it might be, foreignness offers the opportunity to re-invent the self, functioning as a code switch to feign cultural belonging, for instance mimicking the local accent. Old conflicts that are not resolved return disguised by new translations that, albeit more adequately expressive of the subject's development, are substantially unchanged. Ifemelu, in fact, is accustomed to pretending in order to feel safe, as she learnt in the relationship with her mother and further encouraged by her father: I will trace in a dedicated section the deep strata of her conflict between authenticity and pretence going back to her ambivalent feelings towards her mother. As expected, her mixed feelings skew her feminine identifications and the representations and construction of womanhood.

Ifemelu is preparing to return to Lagos after a lengthy stint in the States, culminated in a prestigious fellowship at Princeton. The braiding salon, so evocatively and quintessentially black and female, is a locale suspended from the surrounding externality and therefore functions as transitional space for rememorating and beginning the narration. Naturally, she is preoccupied with her imminent relocation, aware of the anxieties and uncertainties regarding her momentous choice, and her mind is full of the self-doubts typical of states of mourning, for she has recently shipped her car, sold her condominium flat, left her boyfriend Blaine and the notoriously successful blog that provided a platform for her to talk about race in America. This existential turning point organizes the plot in shifting temporalities, whereby memories, regrets, anticipation, and apprehension alternate in flashback and flashforward, devised as strategies to reproduce mimetically the protagonist's states of mind and associations. Following the shifts from synchronous to diachronic temporality, the reader can piece together and ascribe a historical continuity to the development of the character, in line with Ifemelu's own trajectory.

Growing up in Lagos

Ifemelu was born into a lower-middle-class family; she is an only child whose engaging looks, perspicacity, intelligence, and inquisitiveness distinguish her

from the surrounding prevailingly conformist culture, sexophobic and ruled by the Church. She speaks her mind and is often reproached for being impetuous and oppositional. Ifemelu is very distant from her mother, somewhat closer to her father whom, in her fantasies stemming from the oedipal family romance, she wished married to her favourite singer. When Ifemelu turned ten, a cousin of her father's moves in with the family to study medicine at the local university. Aunty Uju is only ten years her senior, a sororal intimacy and complicity is quickly established between them. Aunty Uju is the adult Ifemelu relies on, in respect of matters of the care and aesthetics of feminine bodies, sexuality, menstruation, loves, passions, and fears of pregnancy. This family constellation informs Ifemelu's oedipal itinerary, fantasies, illusions and role models, partly refracted through the images of female desire and agency embodied by Aunty Uju. Thereupon, the adolescent protagonist grows up nourishing her wishes for independence, self-realization and professional achievements, and secretly opposes the maternal rule by putting on a façade of compliance.

That Ifemelu's need of maternal care is unfulfilled evinces in her mode of engaging the female figures she admires and wishes to emulate. These internal states follow and are structuralized especially after her mother's psychotic episode, which occurred when she was ten. Parenthetically, I draw attention to the hiatus between the western psychiatric classification of the mother's action – that Ifemelu registered as profoundly disturbing – and the Nigerian repudiation, borne out by the absence of a name. In the story the attractive mother one day shaved her own hair in an apparently inexplicable gesture, that suggested obscure motives underlying her character deterioration. Until then – Ifemelu recalls – she had grown up "in the shadow of her mother's hair" – a metonymy of her sexual female beauty – and was shocked at witnessing the veritable self-mutilation the gesture entailed. Such astounding metamorphosis of physicality was accompanied by her decision to join a different congregation and embrace a dour morality that impacted the life of the family, as she became imperiously demanding that the daughter attend religious functions. A nun was assigned to oversee the religious and moral education of young girls and Ifemelu figured that her deep-seated motive was to enviously avenge her old age and sexual frustration by castigating the girls whose bodies showed their burgeoning femininity. The pre-pubertal Ifemelu acquiesced and complied with the maternal injunctions, entreated by the dubious complicitous pact with her father. Out of fear, misapprehension, and dismay, in fact, he could not exercise his paternal function to protect and separate the daughter from the mother's madness; on the contrary, he pleaded Ifemelu to concede to the mother, whose fragility he obviously intuited. It followed that father and daughter became the allied dyad of helpless fellow sufferers who could only feign their passive submission to the imperium of madness. A sombre mood clouded over the household: the laughter, the singing, the banter between the parents no longer resounded in the air, and

tension, loss, and gloom took their place, exacerbated by the father's dismissal, which was announced concurrently. The loss of status and function further undermined his paternal authoritativeness and intensified his shame, because he was fired when he refused to call his boss *Mummy*.

A theoretical section will analyze in some detail this narrativized family constellation whose singularity imbues Ifemelu's psychic structurization, and the complexity of her feminine and masculine identifications. Furthermore, this mentality will be inscribed in the mode of functioning of the society, where the demise of the paternal principle betrays a regressive authoritarian domination which demands the submissiveness of the citizens. Under the guise of the authoritarian patriarchy, the unconscious of the culture reveals the underlying imago of a cruel, omnipotent castrating figure – like Medusa – to be at work.

To return to Ifemelu's story, one day in an outburst of ire, she walked out of the nun's classes and asserted that she would never return, in a brave display of what her environment construed as obstreperous negativism. Fortunately, her academically vivacious spirit stood her in good stead and, despite the cultural impoverishment of her family and her lack of driving passions or ambitions, she was supported by her father and Aunty Uju to pursue further education. She was also popular. In secondary school she commanded the respect, admiration, and desire of her group of peers, who became her alternative family. The group culture offered Ifemelu a relief from her stifling home and the father's depression attendant to the humiliating unemployment, which was compounded by his wife's reproaches for not complying with his boss' belittling demand to be called Mummy.

Ifemelu turns to Aunty Uju who eventually disappoints her too, when she enforces the cultural demand to fit in with the submissive position expected of women. In line with the hypocritical mores, Aunty Uju effaces her professional competence to play the system and becomes the mistress of a powerful general, in exchange for protection, an appointment as medic, a luxurious home and all the privileges available to the rich. But Aunty Uju genuinely falls in love with the general, who – Ifemelu reminisces – was a grotesquely unpleasant character, who became the target of her unambivalent hostility. Aunty Uju bears his son, Dike, the general fathers with attentive devotion, rekindling her fantasy of being his favourite, until she is left alone with the one-year toddler to raise, following his death in a plane clash orchestrated by his political opponents after a failed attempted coup. Not only does Aunty Uju lose her status, but she is also dispossessed of her home by the general's family, is lost and distraught. Thereupon she emigrates to America to try to recover, and build a better life for herself and her fatherless son. Expectedly, the life of a black emigrant single mother proves to be challenging, she works at menial jobs while preparing for her exams to validate her medical qualifications, while her contacts with Ifemelu's family

become ever more sporadic, perhaps to hide her sense of failure, shame, and life struggles.

The transformative encounter

At a party organized by some secondary school friends, Ifemelu meets Obinze, the sought-after debonair boy who joined the group after moving to Lagos from his home in Nsukka where he lived with his mother. Obinze was meant to be paired off with the beautiful biracial Ginika and Ifemelu's closest friend, instead he ignores her and has eyes only for Ifemelu, whom he had admired from a distance since entering the school. An intense romance develops between the two, and in their emotional connection sexual passion seamlessly blends with the sharing of interests, books, and the exploration of the pleasures, apprehension, and restless anticipation of life ahead. Growing up together, Obinze fulfils Ifemelu's needs for a mentor to guide her in areas where he is more knowledgeable, which evinces his upbringing with an erudite mother who soon becomes a significant figure and role model of womanhood for Ifemelu, perhaps a substitute of Aunty Uju after her relocation to the States.

Ifemelu becomes a regular guest at Obinze's home, she witnesses the ease of the mother and son cooking partnership, intellectual dissension over American and British writers, acknowledgment of differences in literary tastes, all with a rousing mixture of exclusion, envy, and longing. Obinze's mother is beautiful, seductive, intelligent, and strong-minded but she also adamantly stakes exclusivity in her relationship with her son that translates into control of the couple's intimacy to the point of interferingly exacting that Ifemelu should preannounce their readiness to have sex. Yet another pact of complicity binds a compliant Ifemelu, while Obinze is free to voice his annoyance. The composite maternal imago casts a shadow on the girl's mind during her first complete sexual act, fraught rather than pleasurable, in spite of desiring and initiating it.

However, something in Ifemelu's psyche unabashedly claims her entitlement to being a desiring subject, against external pressures and strictures, and it emerges in the shape of her excitable and lively curiosity, the wish to explore her own erotics with and via another sexual body. In pursuit of sexual merging, she invents the expressive appellative "Ceiling" for Obinze and explicates that in the throes of her boundless jouissance, she sees the ceiling paradoxically disappearing into infinity under the sway of sensations of pleasure. Thereafter *Ceiling* is the adopted name of their secret engagement.

I would argue that the curiosity drive, rooted in infantile sexuality that spurs the search for the idiomatic articulation of her desire, is a distinct feature of Ifemelu's subjecthood and is also a motif underlying the idealization of American life, nourishing her project to leave home. Alongside the

youthful pep, the external reasons to go abroad abound, amongst them the disruption of academic life owing to the lecturers' strikes causes further uncertainty and turns into an opportunity for her to continue undergraduate studies in the US and join Aunty Uju. Obinze encourages the project and promises to join Ifemelu upon completion of his graduate education. Unfortunately, unlike her straightforward student visa application, easily obtained, Obinze encounters obstacles and his plans are thwarted in the aftermath of the terrorist bombs on the Twin Towers, which resulted in the rejection of male applicants.

Ifemelu in America

The America of the imagination is a different place from the real, complex, and challenging country that transforms characters in the process of adaptation. Upon arrival in Manhattan, Ifemelu meets a stranger-familiar Aunty Uju whose discontent and anxiety showed glaringly in her harsh, and churlish demeanour. Frustrated efforts to restore their lost intimacy aggravate Ifemelu's sense of uncanniness and dislocation, and her only consolation is the relationship with her cousin Dike, with whom she plays, watches television and slowly apprehends the cultural variations of every detail of quotidian life. The child's bonhomie somewhat softens the blow of the unanticipated extent of the country's alterity. For instance, ignoring the difference between sausages and hotdogs, she reluctantly abides by the instructions of the child who playfully teases her when she willfully insists on cooking the hot dogs as she was accustomed to frying sausages. Such touching vignettes illustrate the regression Ifemelu, like any diasporic subject, undergoes when learning how things are done elsewhere, a process that renews the labour of the first enculturation. Employing playful irony, Adichie tasks the child with the teaching, thus showing and at the same time softening the blow.

Perhaps partly resenting the closeness between her son and Ifemelu and partly overwhelmed by the added responsibility for her inurement, aunty Uju suggests that she find illegal work with the social security card she has borrowed from a friend. What segues is a series of fruitless applications, interviews followed by rejections, even for menial jobs in the hospitality sector; the additional burden of persecutory feelings, fears of forgetting to use the legitimate card holder's name, of being found out and reported only compound Ifemelu's frustration. She feels helpless, dejected, despondent, and isolated throughout the summer; only the assiduous dialogue with Obinze keeps her afloat, he is reliably calm, reassuring, and encouraging. Eventually, at the beginning of the Autumn term Ifemelu moves to Philadelphia; this is a welcome change and a move towards autonomous life, albeit saddened for leaving Dike.

In the new city Ginika welcomes Ifemelu, and her mentorship regarding the specifics of the American way is precious, especially the hints of what can or cannot be openly addressed, for instance, skin colour. Having relocated to the US in her teens to follow her father's career assignment, Ginika profited from her privileged circumstances to assimilate and became a successful law student. Mindful of Ifemelu's background, Ginika recovers some now obsolete Nigerian idiomatic expressions, to risible effect. All the same, Ginika proves to be helpful in many practical ways – finding a shared accommodation and a job – and as acute observer of how race is pervasively unlanguaged, which she remarks in a clothes store when a shop assistant to indicate a colleague resorts to qualifying attributes except the colour of her skin. Ifemelu, however, rejects Ginika's suggestion that she might be *depressed*, and distances herself from what she sees as the American vice of medicalizing everything. If Ginika's dual cultural perspective has countless advantages, to hear her distress named is problematic for Ifemelu, who promptly resorts to defensively othering her friend as American, because her words unwittingly touched the chord of her unresolved reckoning with her mother's mental disturbance.

Parenthetically, the book underscores the situatedness of depression and mental illness in general, because the person's suffering and the cultural context wherein it can be signified and remedied are interlocked in an inextricable nexus.

Ifemelu is awarded a partial grant, it is a struggle to pay rent, parttime work is hard to secure for a black student without a green card and, in a state of dejection, she replies to a tennis coach's advertisement for a "job" as personal assistant and one as a "relaxer". Desperation, naïveté and curiosity combine to make the prospect of easy earning appealing, and she submits to the coach's request to touch her sexually. Surprisingly, afterwards Ifemelu has rousing feelings of self-loathing and disgust for having sensed her body responding with wet excitement to being fondled. This crucial event marks a dramatic change; in its wake Ifemelu acts on an impulse and discontinues her contacts with Obinze, changes email address and leaves his calls unanswered. Hers is a regressive retreat from the world, including the solicitous Ginika, whose unwavering presence and genuine concern eventually get through, to communicate to Ifemelu Kimberly's offer to babysit her two children.

The temporary withdrawal could be seen as an unintentional but necessary mournful pause – albeit not considered explicitly from this angle – prompted by leaving home which implicates her affective disinvestment of the past in order to find her bearings in the American present. Her diaspora functions on the dual register of the real and the metaphorical journeying towards becoming a subject of her own experience, taking cognizance and ownership of her thoughts and desires. She needed to break up from Obinze – who too quickly had nurtured projects of marrying and having a family with her – but also from her parents, whom she kept at arm's length for many years,

limiting their contact to sporadic, formal, and polite telephone calls. She manufactured for them the news they wanted to hear and impersonated the fictional character of their American dream, partly to protect with secrecy the gestation of her core selfhood.

Kimberly is the mother of the children Ifemelu babysits: an overtly fragile woman, she elicits a protective attitude. Her life gravitates around her egotistical and shifty husband, she is naïve and generous; in time she comes to rely more and more on Ifemelu to whom she opened the door of her rich white household and her trusting heart. Ifemelu had her way with the children, especially the obstreperous and angry twelve-year-old Morgan, who clamoured for a no-nonsense educational approach and firm boundaries, neither of which she received by her parents. At a party hosted in their home Kimberly's dashing and rich cousin Curt appears and is instantly dazzled, sexually struck by Ifemelu's hearty laughter which he saw as portending unfettered eroticism. Could it be an exotic fantasy, culturally syntonic, embedded in the unconscious?

Adichie is a shrewd commentator of cultural subtleties and markers of one's being in the world, which manifest through the ever changing and multifarious representations of embodied subjectivities, where skin colour and hair are construed as elective semantics. The romance of Ifemelu and Curt provides the arena for her unsparing account of the underlying dynamics anticipated and often obtained in mixed couples. Yet, race is not the only constituent of the differential discourse, it is compounded by the sexual and class differences, because Curt is the only son of a well-established wealthy family – fatherless like Obinze – and lavishes on Ifemelu wordily goods and travels. Within easy reach of the well-connected young man are the right people who can offer Ifemelu a respectable, well-paid position and apply for her work permit. In preparation for her interview, she is counseled to relax her hair with unfortunate complications of skin burns and damage to the scalp. If body practices modify surface and looks, their internal reverberations cascade into moods and affects and eventually only a radical haircut can repair the damage. Ifemelu is distressed when she looks in the mirror, wants to hide, feels miserable and insecure: she no longer recognizes herself. Eventually her friend Wambui recommends she visit a blog dedicated to black women's hair; this proves to be a momentous encounter with the virtual sororal community and the beginning of recovery. Furthermore, the blog will later develop into a platform for Ifemelu to voice her original commentary laced with wit regarding the disavowed racism in America.

It is of no surprise that life with Curt is less wearisome, now that Ifemelu can profitably attend her classes, where she casts her perspicacious gaze on the structural functioning of academic life, which is a veritable microcosm of the American way. The closer involvement with the surrounding culture enhances her self-awareness; Wambui introduces her to a black students' union group where she establishes new friendships and nurtures new

sympathies, particularly towards the group leader whose calm demeanour and humour remind her of Obinze. Her life proceeds on the dual tracks of her association with the privileged white world and the affiliation with the African students, a cleavage that inevitably traverses the subjectivities of blacks in a predominantly white society. Her couple relationship exemplifies this dualism and becomes a receptacle of her ambivalence. Her fascination with the comforts made available by Curt, the golden American boy who lavishes his care on her, end up jarring with her resentment because she admires and begrudges him at once and her consistently underlying criticism in the long run destabilizes the relationship. Ifemelu expects him to intuitively see the world from her perspective and feels wounded, disappointed, and angry when she finds out that he does not and perhaps cannot. Whether this complexity instigates her betrayal and what role it plays in her fleeting sexual attraction for a white neighbor is left for the reader to hypothesize. The text narrates that Ifemelu betrays Curt and the admission of her "curiosity fornication" begins to unravel the relational skein until they eventually part ways.

Meanwhile, Ifemelu's blog gains followers and turns out to be a financially viable enterprise; she is invited to speak at dedicated conventions, to counsel on educational projects to enhance awareness of ethnic diversity, all told, she becomes an authoritative spokesperson in the conversation on race. At a blog event she re-encounters Blaine, a university lecturer whom she had fortuitously met on a train journey and felt an instinctive, immediate attraction to. She had longed for a segue to that brief encounter, but her repeated telephone calls remained unanswered, and she moved on. On looking at Blaine, she saw the embodiment of her idealized image: he was black like her but, unlike her, his American homeland provided good education and employment in a salient academic institution. What she saw when she first looked at him, and the perduring allure of that impression reactivated her longing to be understood without the need to explain. On renewing acquaintanceship after some years, in no time at all their passion was allowed free rein, after Blaine explained that he had not responded to her overture because he was going through the tumultuous breakup of a previous relationship.

Ifemelu moves in with Blaine, fatherless like Obinze and Curt. Orphanhood is a recurrent theme the reader will notice and index for its symbolic value. Blaine is a committed political activist, whose rigour borders on rigidity in all aspects of life, from his wholesome diet to his readings, fitness, intellectual engagement, his ethics. Her hope – and perhaps dread – of a perfect connection with him is slowly revealed to be illusory. Ideals, in fact, belong to the imaginary field and are fated to disappointment when put to the test of reality. Once more, Ifemelu is agitated by the predicament of her inner cleavage, struggling with her intense longings to feel whole and grounded.

Blaine blatantly shows his Pygmalion-like desires; he criticizes her unsubstantial readings, perhaps he also longs for a symbiotic union but not with Ifemelu-as-she-is, rather with a figment of his own imagination. As a result, Ifemelu never feels good or admirable enough and is jealous, particularly of his sister Shan and his former girlfriend Paula, who is a successful white academic who appears so much more compatible with him, at least in her eyes. Irony verges on parody in the passages where Adichie outlines in vivid vignettes the intellectual gatherings Ifemelu frequents with Blaine; the pretentiousness, self-importance and earnestness conveyed by the highfalutin attribution of the noun *salon* to their parties.

The couple relationship begins to fray owing to another betrayal – albeit ideological and metaphorical – when Ifemelu encounters the charismatic Senegalese professor Boubacar who becomes her mentor and encourages her to apply for a Princeton fellowship. Blaine tries to counter with glaring rivalry and jealousy the influence he has on Ifemelu and may be threatened by her burgeoning autonomy that Boubacar sponsors. Knowing full well that Blaine is unable to forgive her intellectual unfaithfulness, Ifemelu hurts him on that account by deliberately not turning up for a demonstration, and, to add salt to injury, she lies. This incident speciously ignites the fight that had been brewing up for a long time and now the ruckus would be final but for the momentary respite due to their shared expectant anxiety during Obama's electoral campaign. It culminated the night of the electoral victory, which they celebrated making love after a long time. If their ebullience was the reverberation of history within the black community, it was insufficient to repair their relationship lastingly, and in the end, they amicably split up. Thanks to her lucrative blog, Ifemelu can secure the purchase of a small condominium and the new hard-won independence affords her a space for self-reflection. Restlessness and discontent resurface, not so much rebound within a couple dynamics, rather as her epiphanic moment until she stops and wonders what is wrong with her. Thoughts of her essential evil nature evoke memories of her mother's indictment; dark moods dominate her mindset and at this juncture she acts impulsively on her wish to return to Nigeria. She follows the movement of her desire, outside the field of reason and when people inquire about such a momentous decision, the question troubles her, elicits doubts, anxieties, and magical thinking that can lean on whatsoever external signs she can read as portending the outcome of her renewed uprooting. She interrogates every sign as though she were consulting fortune tellers.

This is where the novel begins, in the hair braiding salon Ifemelu visits before her relocation, which morphs into a locality for reminiscence and anticipation and the present telescopes the other interlinked temporalities, past and future.

The returnee's life: the Americanah

Lagos welcomes Ifemelu and exercises her whole sensorium with its excesses of smell, noise, dirt, light, humid heat, and the shabby architecture that memorializes its colonial past. Her overall impression is uncanny; the city is both familiar and foreign and reflects her ambivalent homecoming. At the airport her school friend Ranyinudo greets her, introduces and comments on the changes so visible in the city, to ease her friend's sense of estrangement.

Adichie's strategy relies on symmetry; for instance, a friend from school welcomes Ifemelu and introduces her to the new life, in America and back in Nigeria. For the unconscious the friend, the sister, or the twin is paradoxically the-same-as-but-different-from-the-self, and this narrative item functions as a phantasmatic double to evoke the imaginary representation of what Ifemelu might have become, had she remained in Lagos like Ranyinudo, or if she had relocated to the States with her family like Ginika. The reader is cued to register the differences between the two friends in their conduct, views, and expectations of life, particularly in relation to men. I propose to read in Adichie's strategy a metadiegetic level which charts the multifarious markers of culture in the psychic processes, particularly in the journey to becoming a subject.

Returned to Lagos, Ifemelu secures a rented apartment in a good area and finds employment as editor of the glossy magazine Zoe whose readership is primarily female. Navigating her at-home-ness-in-her-estrangement implicates a complex work of identity and perhaps it begins to dawn on her that a paradox is constitutive of her subjectivity, and she always misses what is absent, whether it might be food, smells, climate, customs, in synthesis, her life elsewhere. In Lagos she is introduced to the circle of fellow returnees – the Nigerpolitans – her frequentations nourish her creative resources, and she initiates a blog to host her astute epigrams. At long last, Ifemelu inhabits her niche of foreignness with inventiveness, perhaps intuiting that she needed to return to occupy it with grace.

Subsequently, Ifemelu reencounters Obinze, after a gradual rapprochement per email before her move. In fact, friends from school had brought her up to date with his present circumstances, and she had learnt of his wealth, marriage and young family. Conjoined with learning the facts of his life, she had an intimate knowledge of his importance for her, intimated by the epiphanies of her unmet desire and longing to be understood without explanatory verbalizations. In a way, she had become aware that needing words to narrate and explain herself to the other epitomized a barrier she resented in all her loves, and eventually it roused disappointment, dissatisfaction, and restlessness.

Ifemelu and Obinze arrange to meet in a bookshop, where their initial embarrassment soon gives way to their rekindled attraction and intimate conversation. Words are undoubtedly a prized currency in their exchange:

words for the reciprocal narration to fill in the gaps of many years, occupied by experiences and lovers, words that instigate jealousy towards the others whose shadow presences intrude. The bilingualism Igbo-English stands for the psychic polyglotism of their mutuality. Obinze is pained by having to tell Ifemelu about his failed attempt to leave, and vents his bitter disappointment in Great Britain, where he spent some time as an illegal immigrant, but his experience culminated in a humiliating arrest and deportation which left its unspoken residue in his phobic avoidance of British Airways flights.

The most problematic area for the couple to address pertains to Obinze's marriage to the beautiful Kosi who is described as conventional, dogmatically religious, and whose ultimate values are the ambition to be the lady of the manor, partying with like-minded rich, to converse about the best international schools for their children and religious ceremonies. It soon becomes apparent how Obinze inhabits the margin of his quasi-caricatural bourgeois marriage; boredom and emptiness signal his inner malaise, which he seems to silence by going along with the masquerade and passively acquiescing to the wife's rule. Needless to remark that, despite the socio-economic divergence, the relational constellation Adichie outlines replicates the family structure Ifemelu has internalized but vehemently interrogates when she criticizes Obinze's cowardice. As for him, the passionate bodily, emotional, and verbal intimacy with Ifemelu galvanizes him, leads him to question the empty pillars of his existence and initializes a painful lengthy process that leads to his leaving the marital home. In the dénouement of the novel, Obinze arrives at Ifemelu's place, tells her that he loves her, wants a divorce but is determined to be a good father. She listens and invites him in.

References

Adichie, C.N. (2013). *Americanah*. London. 4th Estate.
Baudry, F. (1984) An essay on method in applied psychoanalysis. *Psychoanalytic Quarterly* 53:551–581.
Freud, S. (1908). "Civilized" sexual morality and modern nervous illness. SE IX.
Freud, S. (1914). *The Moses of Michelangelo*. SE XIII.

Chapter 6

Ideals in a world without fathers

Themes pertaining to the structuring of the situated subject, how she shapes her (ego)ideal, her available resources, where and how they are sourced, run through the novel, notably from the very title *Americanah*, a term which lacks referents to geography or a people and resides, instead, in the collective imaginary. *Americanah* is iconically invented to designate the conceivable, auto-generated identity, and it gains traction in conjunction with the leitmotif of the absence of fathers, names being a marker of filiation. Adichie's textual strategy capitalizes on the judicious reiteration of the adventure of filiation, which gives rise to the project of self-generation to make up for the lack of the father and foil the totalitarian engulfment by the maternal realm.

I am here establishing an equation between the autocracy of the maternal universe and the authoritarian regime, in that they both exclude thirdness (otherness), and suggest that Adichie's characters implicate the reader in identifying the broader symbolic significance of the paternal entity in the culture. The paternal principle is, in fact, the symbolic matrix, always already there the human being is born into and draws on to signify and inscribe their biographical narratives.

Psychoanalytic conceptualizations of the father – whether the emphasis is on the developmental or structural constituents – all together foreground its function in instantiating thirdness and the symbolic. The father is always outside the fusional dyad, being the messenger of the paternal function, or principle – as Delourmel renames it – which must be disarticulated from the paternal role that is socially prescribed and the object of sociological studies. At variance with the role, the paternal principle is the harbinger and driving force of the psychic apparatus, designates absence, alterity, and the broader location external to the symbiotic sameness. For André Green (2004) the paternal domain is always already symbolic whereas the maternal is essentially carnal; as such, its psychic existence will not depend on the real person of the father because its principal standing is the place of the father in the mother's psyche, as Lacan theorizes.

Thirdness undergirds symbolization, thinking, language, and the apprehension of time: these markers of enculturation are predicated upon the

DOI: 10.4324/9781032696959-7

internalization of the psychic structure inaugurated by the oedipal complex which portends the subjectivizing process. I wish to highlight that it is a process, qualitatively dynamic, never static or conclusive, owing to the human subject being fundamentally elusive, impelled and spoken by the unconscious. Freud famously debunked the illusionary unity of the subject that he saw, on the contrary, inhabited by obscure passions, identifications, unknown and unknowable drives and motives. Of necessity, the subject of psychoanalysis is destined to catch glimpses of itself on the surface of its epiphanic emergencies, sensorial perceptions, and actions in a temporality that is always an *afterwards*, according to the Freudian *Nachtraglichkeit*, that Lacan rendered as *après coup*.

The decentred temporality of the subject's life closely replicates the ex-centricity of her desire, which operates as a prime mover and continually morphs into actions, preceding thought. Her existential movements follow the psychic logic Green (2004) names the "heterogeneity of the signifier", to indicate the essentially polysemantic quality of our unconscious that signifies in whatever way it can, bodily and mentally, verbally and extra-verbally, and through actions. We speak even when we cannot or do not want to speak, like Freud's notorious case history of Dora testifies.

Emblematically, the opening gambit of the novel pens Ifemelu just so: she has effectively dismantled her American life to relocate to Nigeria, not knowing why. The inner demand for reflection and working through reaches her awareness in the form of anxiety stirred up by the other's question: why are you doing it?

"Everyone she had told she was moving back seemed surprised, expecting an explanation, and when she said she was doing it because she wanted to, puzzled lines would appear on foreheads" (13).

The other's face reflects Ifemelu's own uncertainty and doubts, conflating the restlessness which stirs her and speaks her desire. Perhaps, had she still been an adolescent, her retort might have been "I don't know", an answer to fob off, albeit closer and truer to the reverberation of her unconscious. Now an adult, she vaguely senses that she might be driven by her longing for Obinze since his image has lately cropped up, unprompted, more and more frequently to occupy her fantasies and invade her thoughts.

Writers intuit the workings of the unconscious and consign their ingenuity both to their imaginative characters and to the literary strategies they employ. In *Americanah* Adichie imprints a circular pace to the narrative, whose opening passages depict actions, decisions, transmigrations, projections, surfacing in the collateral questions formulated by the uncomprehending bystanders – and perhaps by the readers. Sustained tension and the wish to know undergird the plotline throughout its unfolding flashbacks and flashforwards that mimetically render the meanderings of Ifemelu the subject of the unconscious and only towards the dénouement does she align passions and awareness, desire and reason, now fully realized. Thus she narrativizes

the acquisition of knowledge that momentarily coheres in her desire and simultaneously answers the readers' wish to know that Ifemelu wishes to return to Nigeria to reunite with her lost love. With him – I would argue – she could mend the fissure between sexuality and love, having finally realized through her "curiosity fornication" how much her malaise reverberates the mode of relating between women and men embedded in her culture. I will expatiate on this hypothesis based on a comparative analysis of the models of femininity available to Ifemelu for identifications, which she rejects but pays the price of her ontological estrangement evinced in her disquiet. At the end of her journey – duplicated by the ending of the novel – she is a young woman who harbours the paradoxical feelings of foreignness and familiarity, being both a returnee and a stranger to herself, who has attained the freedom to inflect her own law of desire. Her geographical homecoming shows a more cohesive personality, that has found a metaphorical internal domicile.

If the adult Ifemelu is expected to know her motivation for wishing to change course, equally and perhaps more cogently one could wonder why she left in the first place. For certain, as a young person, she could not contact or express her innermost wishes, neither could she have known quite yet the stranger-within, namely, the unconscious drives underlaying her quest. Around the time of her departure, in fact, she was still navigating her late adolescence, her passions and ambitions had no definite shape, and she was influenceable; therefore, the nodal circumstantial density of her university years needs to be deconstructed and deciphered. which can only happen *a posteriori*.

Politically turbulent, in the 90s Nigeria was under military rule; the self-seeking generals dispensed favours nepotistically and disregarded any consideration for the common good of the civic society. The army had driven the country to a lawless state of chaos, welfare provisions were nonexistent for lack of investments, and existential precarity pervaded all the spheres of life. Power cuts, shortages, lack of employment prospects were lamentable, "the country was starved of hope" by the generals in power and their acolytes who, contrarywise, indulged their luxurious lifestyle. The breaking point for Ifemelu came with the university closure owing to the lecturers not getting their salary; to protest they abstained from work for extended periods, with inevitable disruption and uncertainty. It followed that Ifemelu had to leaved Nsukka to return to her family home in Lagos, where she was lonely, far away from Obinze, her friends, and her shared students' accommodation. In her state of regressive isolation, she responded to the solicitations of her loved ones to continue her studies abroad and made their desire her own. Beyond the irresoluteness typical of youth, an essential melancholy and impoverished core detectable in her character evinces in her lack of passions, personal projects to invest in, and conspicuous absence of driving ambition. Hence her propensity to being replenished by the Other's desire – a form of internal colonization? – that contours and orients her but slowly slides into fractious reactivity to their felt power over her. Time and time again the novel

details this drama of excesses: not enough or too much, too close and engulfing or too distant and lost, a dilemma which resurfaces in all relationships and all the while Ifemelu treads along the path of self-knowledge in alignment with the discovery of the passions that shape the circuit of her own desires.

The psychoanalytic method engages the internal world of the fictional Ifemelu, her developmental needs in adolescence, to inscribe the adjunctive hurdles she endures in the faltering societal milieu. Intended as a generative interpolation, akin to an intertextual thread, psychoanalysis complements the insight of literature into the vicissitudes of the situated subject, with reciprocal enhancement. In this instance psychoanalysis can contribute to shed light on the imbrication of the sustaining ideals and the demise of the paternal function in the designated cultural space of the time.

Three overlapping aspects coalesce in the paternal function, inextricable and critical to establishing the ecological niche for the budding subjectivity: firstly, the father is the representative of the Law that binds desire (Lacan) and salvages it from the overwhelming jouissance and self-annihilating pleasure unto death; secondly, he acts as the meta-psychic guarantor of the symbolic (Kaës); thirdly, he is the Freudian *Urvater*, the ancestor of the mythical prehistory and provider of the soil where primary identification and the ego ideals are embedded (Kristeva). We are indebted to Kristeva for her proposal of the "new maladies of the soul", amongst which features the "*maladie de l'idealité*" ("troubled ideality") inherent to the disturbances of identity which feature in the clinical presentation of melancholy and psychically depleted adolescents. Indeed, what are the ideals that can open to the youth the horizon of future temporality and meaning when the guarantors are army generals who starve the young generations of hope?

An aperçu of the diegesis evokes two complementary imagoes of manhood, respectively the dead or collapsed and humiliated father and its flipside, the despotic General, fated to be murdered so that a new order can be founded. The latter tallies with the archaic image deposited in our unconscious cultural memory which Freud articulated in the myth of the father of the horde in *Totem and taboo* (1913). Like the *Urvater* of the tribe, the General wants to possess all the women he sets his greedy eyes on, and at a party his gaze fixes on Aunty Uju, he waits in the back seat of a car for her to be collected by the driver and declares: "I like you, I want to take care of you". Thereupon he regales her a sumptuous home and grand luxuries, placing her in inauthentic circumstances of which he is the master and pulls all the strings whilst she is enslaved and abrogates her agency. Partly out of choice and partly out of love of the power she can only exercise vicariously, she is no longer the protagonist of her own life. In this brutal praxis of omnipotent dominion, the person is emptied of herself, subjugated to the cult of the phallus she believes the general has; she feels elevated, although she is humiliated and ever more enslaved. Such state of mind could be named emotional surrender and resembles hypnotic fascination: exercised by whom?

A man, love and/or a phantasmatic phallus? From her position outside the incantatory illusion, Ifemelu notes that:

> The General had yellowed eyes. [...] His solid thickset body spoke of fights that he had started and won, and the buck-teeth that gaped through his lips made him seem vaguely dangerous. [...] "I am a village man!" he said happily, as though to explain the drops of soup that landed on his shirt and table while he ate, or his loud burping afterwards.
>
> (79)

Adichie portrays a boorish, grotesque figure: reading it as a parodic, rather than a realistic representation of character, it lends itself to figure the archaic imago of the perversely narcissistic father, theorized by Freud, and impresses the reader as an allegory of masculinity and power. Moreover, her authorial courage does not baulk at delving into the murky territory of the masochistic vein of female sexuality that ties in with the fascination the General exerts on Aunty Uju. Is she enamored with an Oedipal father imago, an empty internal eidolon which stems from her feeling orphaned? At any rate, her love for him has a genuine component which complicates his seductive influence over her. After all, were she merely responding to the enticement of the amenities he bestowed upon her, this would sanction a mutually exploitative and perverse exchange, but her generous love transpires in her readiness to justify his shortcomings and in her pride for bearing his child. It is also possible to hypothesize that carrying his son and heir magnifies her fantasies of triumph over her rivals, including the General's lawful wife. Iconically condensed, the figure of the General intersects manyfold narrative planes and welds a multiplicity of symbolic meanings, comprising the carnivalesque and the murderous. It is noteworthy that the birth of the child is posited as an event that Ifemelu salutes as portending the changes which will slowly unfold for all the characters. It is a switch-point, thereupon the diegesis unravels the skein along parallel trajectories: the General's death announces the political upheaval to come when a coup overturns the regime in favour of a republican government and the bereft and destitute Aunty Uju's diaspora begins, as she nurtures her hope for a new beginning for herself and Dike, followed suit by Ifemelu.

The father of Ifemelu embodies the antithesis of the General's toxic masculinity and demands that the reader's mind lingers over his overdetermined figure of the *abject*, which compounds the infantilized, humiliated, and impotent injured manhood of the colonized man. As such, he is doomed to fail both in his paternal role within the family and as the representative of the symbolic guarantee of society. Excluded even from the illusory position of the limited patriarchal authority in the home, he cannot promote the daughter's path to autonomy, nor can he be a viable identificatory figure. The following words depict his prostration:

> He was fired for refusing to call his new boss Mummy. He came home earlier than usual, wracked with bitter disbelief, his termination letter in his hand, complaining about the absurdity of a grown man calling a grown woman Mummy because she had decided it was the best way to show her respect.
>
> (46)

This passage complements the discourse on the arbitrariness of power that all too easily degenerates into unabashed domination over the other, when unmoored by the law and the authoritativeness mandated by democratic representation.

Freud's *Urvater* belongs to the mythic imaginary and can be engaged with as a statement of the German artist Anselm Kiefer on the usefulness of myth in analyzing history. Wim Wenders' documentary *Anselm* shows the artist grappling with the elaboration of the past of his country and affirming that mythic reasoning yields a useful complementary perspective in parallel with the historiographical episteme when visceral and dark forces are at work and elude reason. Analogously, Freud writes his anthropological works unconcerned with the factual objectivity of history, but rather to provide a judicious mythography of the recursive oscillations of civilization and barbarism. This is my understanding of his claim in *Totem and taboo* that a pact between the sons and the father is the keystone of sound authority, whose contemporary echoes conjugate the principle of the legitimate channeling of the citizens' voice through democratic representation. In places and/or times where societal functioning displays the demise or vilification of the law of the father, this leaves free rein to a collective archaic omnipotent imago who abuses power and filiation with impunity to infantilize, dehumanize, and reduce the person to a state of abjection. The omnipotent boss exacts to be called Mummy, so she solipsistically construes the signs of the deference she demands, and the external checks and balances are conspicuously wanting.

Although the psychoanalytic language informing my analysis relies on gendered categories, my elective register of imagoes gestures to the structure of power and its mythologies, over the socially visible gender roles. Mythologies are narratives recursive across temporalities and cultures and constitute templates to study the psychic receptacle of the cultural unconscious, where imagoes are preverbal categories that critical thinking deconstructs and carries into the field of language. To amplify the emphasis on the differentiation of the discourse of the unconscious from the critique of gender roles pertaining to sociology, I enlist Marilia Aisenstein's words:

> the primacy accorded to the powerful paterfamilias over many centuries has influenced our thought and leads us to blend the theory of symbolic fatherhood with the historical weight of real fathers. Moreover, this

prevents us from focusing on the importance of the symbolic father function in its universality.

(Aisenstein, 2015, 352)

Returning to the textual strategies, alongside the public imago of the autocratic boss, there is the wife who rules the family, and the diegesis aligns them as figures of excess, devouring harpies, phallic and castrating at once. Seen in this light, the mad gesture of Ifemelu's mother shaving her hair becomes an overdetermined signifier, in that by self-mutilating her feminine beauty-as-power, she arrogates to herself a totalitarian omnipotence and takes the place of the father. To him, in fact, she intimates that he should comply with the boss' demands, and perhaps unconsciously identifies with the big-Other-Mummy who undermines and humiliates the man, so, ultimately, she defiles the Name-of-the-Father. Translated into disposition to psychopathology, this analysis describes the structure of psychosis (Lacan, 1965), operative in the individual and similarly visible in critical times of history. I would argue that in this diegetic juncture the family relationships, the work environment and the broader culture judiciously converge to showcase the failure of the paternal function which is largely the legacy of the disaster of the colonial past, whose consequent human suffering is long-lasting, grave, and real.

On fathers and ideals

According to Kristeva, the "need to believe" is an anthropologically universal, pre-religious antecedent to the "desire to know"; at their suture sits the foundation of the idea(l)s, where the cognate identifications and identity are embedded. Kristeva entwines belief and hope, which phantasmatically envision future possibilities, whereas knowledge is germane to the present and the past. Kristeva also underlines the nexus of the interweaving temporalities of the unconscious that incorporate transmission and destiny, again past and future. How the subject always already belongs in their history unequivocally evinces from her writing:

"Heirs of Freud, psychoanalysts know that cultural constructions not only inscribe history in the most intimate parts of the ego; these edifices also appear to provide cultural substitutes for intrapsychic conflicts in the development of ego ideals"(Kristeva, 2016a, my translation).

The cultural architecture implies that a bidirectional flow of projection and introjection inextricably links inner and outer reality and, perforce, the time of history is imprinted in and imprints layers of psychic times. Psychoanalytically framed, the term "idea(l)" invites wide-ranging associations, notably by directing the lens to the Greek etymology of the noun "eidos" (εἶδος), which means archetypal form and ideation. The related verb "idein" (ἰδεῖν) signifying "to see", expatiates into the fields of vision and knowledge, indicative

of both the perceptively and psychically deposited internal image of an object that was there but no longer is: in brief, to think equates to evoking and re-presenting the absent object.

The lexeme belief connotes the ineffable, the feeling state that belongs to the realm of being and essential trust in the world-environment one is merged with, like a baby in the amniotic fluid. The primary anchoring point of belief is the wish to re-experience the "oceanic feeling" of eternity – phrase coined by Romain Rolland – the state of fusion with, and in, the body of the (m) other. Rolland proposed his views in his correspondence with Freud who was rather suspicious and skeptical of such longing and wrote *The future of an illusion* (1927) to critique religion as a neurotic infantile residue. At any rate, Ifemelu reaches these quasi-mystical intensities during orgasm, which she names Ceiling.

Contrary to maternal unboundedness, the pursuit of knowledge – Kristeva suggests – "concerns the 'investment' in or the 'primary identification' with the 'father of individual prehistory': the beginning of the Ego-Ideal, anterior to the Oedipal father that separates and judges, has the 'qualities of both parents'" (Kristeva, 2016a). It's a foundational primal scene.

Headstrong and rebellious, Ifemelu is endowed with a questioning mind, coupled with the curiosity intrinsic to her libidinal impulse – the *sexual* – that drives her beyond the purlieus of the familiar, where "she had grown up in the shadow of her mother's hair", jet black and thick, which father's eyes cherished as "a crown of glory". Uncannily, around puberty she lost the shadow which paradoxically sheltered and absconded her, when she became visible in her own right as a winsome adolescent, whilst her mother's "crown of glory", hacked off, cast its shadow on her screen memories. Ifemelu lost her mother and was lost to the maternal gaze: here the reader wonders whether she might have felt not simply shadowed but overshadowed by a preoccupied mother whose regard was consistently elsewhere. To substantiate this hypothesis, textual traces gesture to the essential wary aloofness characterizing the mother–daughter relationship which motivates Ifemelu's search for substitute maternal figures, first in her intimacy with Aunty Uju and, subsequently, with Obinze's mother. The latter is a fitting catalyst for the resurfacing of Ifemelu's longing for an ideal mother, which she understands in *après coup* and discloses to Obinze when they reengage, and she learns of his mother's passing away. Now an adult, Ifemelu has become aware of her infantile longing for an ideal mother whom she saw embodied in Obinze's mother. Her teenage sensitivity was instantly captivated by that version of womanhood but, given that adolescence always reprises the infantile, this leads to the hypothesis that her family romance fantasies might have unconsciously been solicited in *après coup*. The reader, in fact, will recall that Ifemelu saw family resemblances between Obinze's mother and Ifemelu's favourite singer, who constituted an intermediate link to express her wish that her father was married to her. Parenthetically, the circular temporal

movement exquisitely pertaining to narration is analogous to the time framework of the psychoanalytic *après coup* whereby the past is constructed from the standpoint of the present. Both literary and psychoanalytic registers, in fact, carry into the field of language the heterochronic shifts between existential vicissitudes and their eventual elaboration. Rabaté (2014) aligns psychoanalysis and literature and proposes that their elective temporality is always the narrative *après coup*, owing to their mimetic rendering of the time elapsing for the re-transcription of existential data, premised by thoughtful elaboration.

Almost concurrently to the mother's psychotic decompensation, Ifemelu's father diverted his gaze from the daughter when he progressively withdrew into his despondent preoccupation after the humiliating blow to his manhood dealt by his overbearing boss. The ensuing poverty only sharpened his helpless impotence. These family circumstances prompted silent and lonely psychic work for Ifemelu who focused her thoughts on what she had always known about him, namely, that in his psyche was inscribed the century old essential colonial subjection. With the aid of her imagination, Ifemelu (re)constructs the aftermath of her own colonial history which she detected in the way it had shaped her father's character.

> Sometimes Ifemelu imagined him in a classroom in the fifties, an overzealous colonial subject wearing an ill-fitting school uniform of cheap cotton, jostling to impress his missionary teachers. Even his handwriting was mannered, all curves and flourishes, with a uniform elegance that looked like something printed … [H]is mannered English bothered her as she got older, because it was costume, his shield against insecurity. He was haunted by what he did not have – a postgraduate degree, an upper middle-class life – and so his affected words became his armour. She preferred it when he spoke Igbo; it was the only time he seemed unconscious of his own anxieties.
>
> (47–48)

Rooted in history, the "affected armour" characterizes the defensive structural inauthenticity of the false-self personality organization.

The adolescent's exigencies

Adolescence is a critical developmental passage. To highlight the need of the youth to be accompanied suffices to mention that cultures respond to their vulnerability through the provision of sanctioned and diverse rites of passage. Family instability due to supervening external challenges heightens the adolescent's hurdles, which can foment feelings of isolation, dejection, and the risk of withdrawal. The bodily transformations demand psychical accommodation to permit the adolescent to face the symbolic murder of the

parents to take their place in the generational chain. This entails substantial mourning work which needs the assistance of the real parents, whose sturdy and healthy availability is of primary importance. The young person's urgent questions pertaining to their identity are concomitant with the project of filiation and the inevitable maturational disillusionment with the parents of childhood.

Ifemelu traverses this delicate phase alone, save for Aunty Uju who responds to her timorous questions about menstruation, rapprochements with boys, loss of virginity, and the risks of pregnancy. Not only can Ifemelu not feel part of a cultural discourse and rely on objects available in the collective space for the construction of ego-ideals in identification with the father of the prehistory – as Kristeva proposes in her reprise of Freud – but her journeying to adulthood is burdened with the work of thinking and making sense of the colonial legacy. Her father is a problematic object for identification, being himself divided into an unscripted self, whose voice speaks Igbo, and an alienated subject whose self-consciousness is but a masquerade to protect his authentic being. He comes across as a frustrated, powerless man, who silences his insecurity and inferiority through identification with the oppressor, which Ferenczi and Anna Freud thought to be one of the defence mechanisms to combat helplessness, fear, and rage.

The diegesis evinces his defensive ploy when he addresses his daughter with disapproving grandiose words, such as "recalcitrant" and "mutinous". Ifemelu wryly quips that his pompous speech elevates her pranks to heroic feats, with certain comic effects. Her talent for (self)irony is somewhat less effective when her father advises compliance with the mad obscurantism of the Church, whose word-bearer his wife becomes in the aftermath of her crisis, and in so doing, he occupies the position of Ifemelu's fellow sufferer. The pathetic abrogation of his paternal function is in the service of denial of the mother's psychotic decompensation, of reality itself, and taps into the similarly hypocritical solution of the colonial subject, deployed for the sake of survival. As such, it is a symptom, a defensive strategy and the manifestation of the malaise of helpless submission whose dense syncretism signifies the personal and collective predicament of institutionalized colonialism.

It could be argued that this segment of the story veers towards an allegory of the history of colonial domination, seen through the prism of the characters in the aftermath of the destructive subjugation of the chthonic civilization – embodied in the Igbo idiom – to impose an overlay of alien weltanschauung and language. The people inhabiting this kind of milieu adopt mimetic defences which result in a false-self character organization – à la Winnicott – whereby the ego splits and an alien introject lodges in the mind but cannot be assimilated or integrated within the rest of the psyche. Seen in this light, the figure of the father appears overdetermined, similar to an oneiric rendering that condenses the role of the father in the family – wounded and humiliated – the failure of his paternal function in support of

the daughter's movement to separate from the mother and, lastly, the failure of the *Kulturarbeit* whose scope is guaranteeing a sustainable life for the citizens. Overdetermination being a property of unconscious contents, the fictional father functions like a cipher for the polyhedric derivatives germane to the individual, the family, and the culture.

The "need to believe" and "wish to know" come to Ifemelu mediated by Obinze, whose loving gaze reveals new vistas when he embraces her in his American dream, which she absorbs, reading his American literature.

Obinze's mother is a formidable woman, learned and urbane, politically engaged and spirited enough to speak truth to power. She is admirable – undoubtedly so in Ifemelu's eyes- but at the same time she has an intellectually seductive and overbearing effect on her fatherless son. An oedipal triangulation soon emerges in their relationship, and the woman knowingly uses the fascination she exerts on Ifemelu to secure her alliance so as to influence her son, and not just him. Her intrusiveness is, to some extent, roused by her jealousy, fear of exclusion and abandonment and reaches the high point of extorting from Ifemelu the promise to foretell her when the couple is ready to have a complete sexual experience.

In opposition to his mother's advocacy of British letters, Obinze elects his province of freedom in modern American literature, which he unconsciously tasks with disengaging him from her, and being the placeholder for his dead father. In fact, he locates his father's symbolic presence in America, where he studied, and his wish to retrace his steps aims at clearing an area of identification with him and disidentification from his father-devaluing mother. Obinze needs "to escape from the oppressive lethargy of choicelessness [...], conditioned from birth towards somewhere else, eternally convinced that real lives happened in that somewhere else" (276). To justify his love for America, whilst also needing his mother's approving understanding, to her reproachful utterances he responds:

> "I read American books because America is the future, Mummy. And remember that your husband was educated there."
>
> "That was when only dullards went to school in America. American universities were considered to be at the same level as British secondary schools then. I did a lot of brushing-up on that man, after I married him."
>
> <div style="text-align:right">(70)</div>

More misunderstandings, fear of loss, and humiliation of the father are conspicuous in her retort. Barely insinuated in the story, the reader nonetheless senses that this is a conflictual strand in their relationship and at heart Obinze knows that his mother disavows her jealousy of the third – the father before, and Ifemelu now – when she claims her affective territoriality through self-aggrandizement, which clearly transpires in the alternative albeit

spurious narratives she offers. The mother unabashedly aspires to be the one and only for her son and demonstrates her lack of mental place for the father in her devaluation of him.

The capitalized "Mummy" duplicates the Mummy-boss of Ifemelu's father, supported by her own mother who commands that he submit: aligning Obinze's mother with the reiterated figures of the maternal is a plausible strategy to circumvent the narrowness of pathography and rather bring to the fore the composite layers which compound the societal assumptions pertaining to the exercise of power. Under the guise of the woman's face triumphs the archaic imago of phallic totality-totalitarianism.

Adichie's text offers a patterned reiteration of the configuration of power and its reverberation in the relationship between the sexes, within the family and in the parent–child relationship. Despite the noticeable differences amongst the female characters, the reprised pattern of the omnipotent phallic mother enables Adichie to draw the reader's attention to the problematic triangulations which throttle the children's lives and skew all their identifications in undemocratic regimes.

Where does Ifem – Ginika's shortening of her name – stand in the process of reckoning with the culturally symbolic, so fundamental a task of the work of identity in adolescence? How can she become the "I-fem" feminine subjectivity and inhabit a comfortable womanhood? I would like to posit that hyphenating her name into I-fem permits to analyze the underlying movement the hospitable Gineka aids to initialize, so that Ifemelu can become the subject of her own female desire.

The journey across countries and cultures culminates in a composite geography of the mind where foreignness is Ifemelu's elected niche of freedom of choice: this reading is concordant with the psychoanalytic perspective on otherness, the symbolic, and thirdness. The narrative appends a return journey, which also lends itself to multifarious interpretations. The perspective I propose intends to debunk the philosophical subject from its privileged position to rather inscribe it in the psychoanalytic semiotics where it morphs into a shifter, owing to the inner otherness of the unconscious that renders the unitarian subject position all but an asymptotic location and an attractive ideal. In so doing, I echo Freud, the first architect of the revolutionary project of seeing the subject's internal divisions and structuring multiple identifications, whose epiphenomenon is the sense of *being elsewhere*, whilst paradoxically preserving a stable nucleus.

Green's theories have methodically attended to the triadic scope of the environment the infant is born into, starting from the conception of the fantasied baby of the parents' desire, whose semantics inflects the convergence of genitality and pre-genitality and their couple relationship. His concept of *thirdness* is an original synthesis of Freud, Bion, Lacan, and Winnicott's theories where the symbolic architecture comprehends and interweaves pre-oedipal and oedipal structures. To foreground the

paradoxical feature of thirdness as mental–cultural structure, Green cites Winnicott.

> "Between the mother who is physically holding the baby and the baby, there is a layer that we have to acknowledge which is an aspect of herself and at the same time an aspect of the baby. It is mad to hold this view, and yet the view must be maintained."
>
> (Winnicott 1988, 167).

The "mad view" obtains when the subject holds the *I and the not-I* together within their psyche, in the potential play area, and tolerates the paradox, not rushing to resolve it.

Ifemelu and Obinze's developmental trajectories bifurcate somewhat fortuitously from the Nigerian context of their love story, so intensely brief, and soon after her departure they become for each other an internal character they silently converse with. She extricates herself from home ensnares, whilst he remains embroidered in a world he inhabits as a marginal stranger, with apathetic resignation and submission to his wife's domestic regime. His malaise shapes his passivity, cowardice, and sense of inauthenticity, which he apperceives and struggles with, unlike Ifemelu's father, who exemplifies its flipside, namely, an ego-syntonic underlying depression organized in his character trait marked by the colonial history. The Obinze character is somewhat underwritten in the novel, perhaps intentionally in contrast with the finely chiselled protagonist. However, a psychoanalytic reading of the formal assemblage of the novel, aimed at catching the drift of the reverberations of the culture, speaks to the salience of his relationship with the mother and the outstanding demise of the paternal. Obinze tries in vain to escape, but the mother's illness first, his filial piety and responsibility and/or intervening external factors afterwards, hinder the realization of his project. In the end, Ifemelu leaves alone, albeit accompanied by Obinze's encouragement and love, whereas he obtains a six month's visa in the United Kingdom by pretending to be his mother's assistant, again he relies on her, his name on her passport, like a dependent minor. Her phallic power smuggles him into a clandestine existence, to eventually return him to her, depressed and ashamed, having endured deportation; she is there when he disembarks, and fate consigns him once more to her care.

Psychically, there is no escape for a son in the absence of a robust and supportive paternal entity. Interrogating the function that Obinze's American ideals have in his imaginary, reveals them to be but daydreams, unrealizable in the adverse reality. Were they perhaps akin to illusions, unrealistic fantasies of evasion, hampered by reality? Interlaced in this passage is the reemerge of the lacking and unresponsive symbolic father of the cultural realm who cannot ensure the meta-psychic and meta-social guarantee necessary for separation and individuation.

Dreams of the father

The imbrication of the internalized paternal imagoes and the building of ideals comes to the fore in Ifemelu's personality during the electoral campaign culminated in the nomination of the first black president of the United States.

At that time Ifemelu was aware of her unvoiced unease in the otherwise well-established relationship with Blaine and, once again, she came to realize, with sadness, that she did not feel the intensity she would have wished. She was increasingly critical of him on account of his self-righteousness, for he could be insufferable, so set in his rigidly principled ways; as for her, she thought – as she often did with men – that she was conforming to his Pygmalion-like wishes to mould her. Inwardly, she thought she was only too human and fallible in the face of his supercilious tendency to judge and struggled with her ambivalent wish to conform to his standards to be part of his intellectual and politically engaged circle of friends, and her fear of always being found wanting. It was ever so injurious to notice that he did not show towards her the signs of idealization of the passionate lover. But was he in love?

On the other hand, she had entered the relationship to escape the "gray-slate blur and boredom inside", which she knew was there and gnawed at her with the rising question: what is wrong with me? When Ifemelu became increasingly restless, she resorted to her familiar defences of betrayal, ostracism, and rebellion, as she did when she deliberately failed to turn up for a campus demonstration and opted, instead, for the invitation to the farewell lunch of a colleague of Boubacar's. When Blaine understood, he withdrew into an icy rage, was unforgiving and disappointed because not only had she breached their agreement but had dishonestly and provocatively pretended she was asleep. Although it was but a specious incident, it acquired magnified proportions and contributed to drive a wedge in between them, it being the epiphenomenon of Ifemelu's deeper discontent. Time after time her unhappiness returned, especially palpable in the relationship with her partner, wherein feelings of estrangement abruptly superseded closeness. As she felt increasingly alienated and isolated, her intimacy with Blaine lost meaning, which precipitated her into despondency. In the throes of her existential crisis, Ifemelu felt dislocated and longed for an affective, romantic, and cultural elsewhere, in the hope of reestablishing a sense of purpose and belonging.

"They did not fight until the relationship ended", yet undeniably and sadly

> [t]heir union was leached of passion, but there was a new passion, outside themselves, that united them in an intimacy they had never had before, an unfixed, unspoken, intuitive intimacy: Barack Obama. They

agreed, without any prodding, without the shadow of obligation or compromise, on Barack Obama.

(352)

These facts relate to the American election; however, to appreciate the reverberations of history in the psyche it is helpful to first review how cultural objects are installed in the social imaginary. Cultural objects are iconic figures that float in the public domain and gravitate in the transitional space of culture where they attract the subject's desire and instantiate the elaboration of their emotional entanglements. As Freud remarks and Kristeva recapitulates, it is a function of *Kultur* (*Kulturarbeit*) to offer the means for the subject to externalize their unconscious conflicts and expressively elaborate them in sublimated forms (Freud, 1930), therefore cultural objects function as templates fit for the inflection of personal idioms.

Chimamanda chronicles history and condenses events, details, and objects to foreground their projections on the psychic screen and reverberations in the life of her characters. Supposing that the data of history narratively function like the day residues the dream-work interweaves into the manifest dream, opens a bifocal field of associations analogous to the transitional space for the dialectical navigation of the external reality and its signification. *A posteriori* examination of these composite materials, once assembled together, permits to deconstruct them and trace their meandering intricacies, to catch the drift of the dream-thoughts disguised therein. A considered application of this analytic methodology to the plot foregrounds Obama's autobiography *Dreams from my father* (1995) as one such a transformative cultural object for Ifemelu, from the very moment she lifts the volume sitting on the pile of Blaine's books and is captivated by what she finds. In hindsight, she reckons that she would have not read it, had Blaine recommended it, because she detested and antagonized his self-elected mentor role. Whereas the memoir was her own find and spoke to her with unexpected urgency; the conjunction of the script and the cover photographs elicited associations that brought to her mind the Igbo words *Obi Ocha*, a "clear heart". In Obinze's lexicon, the phrase described people he liked, and the evocative poignancy of the Igbo idiom must have unconsciously resonated with the memory of the note of authenticity she heard in her father's voice when he spoke Igbo.

Starting from the hypothesis that Igbo is an overdetermined signifier, it can be thought to encrypt impressions, perceptions, memories, and emotions Ifemelu unconsciously attaches to what she sees when looking at the photos of Obama. As for the reader, linking image and word reveals unconscious derivatives and wishes, like tackling a riddle, a rebus or a manifest dream. In narration, as in a psychoanalysis, the present tense instigates the work of the *après coup*, it branches out into the co-existing temporal fragments and mimetically reproduces the prismatic temporality of the unconscious. In

conclusion, Ifemelu sees in Obama the black youth arduously journeying towards the identification with his father and learning to speak truth to power. The paternal introject she carries within is jarring, since her father left his own history unlanguaged and she, all alone, could only imagine that he must have guarded a hidden, somewhat secretive inner-self, uncompromised by the embarrassing colonial servility she bore witness to. Did he jealously fence off his more authentic self, rendering it unavailable for the father–daughter commerce? Did she see in Obama a man who dispended with defensive obfuscation and whose "heart" she could read on his face, in his image? He was someone who showed her the possibility of a gesture of brave vindication. Be that as it may, in a fragment of time the reader gathers mental pictures of the fatherless black child –personified by Obinze, Blaine, Aunty Uju, Dike, Barack and Ifemelu in identification with them – turned into a recomposed sanguine father figure, courageous enough to fight for a fairer world.

This is a pivotal passage, where the book shifts Ifemelu's loyalty and makes her a staunch supporter of Obama, drawing out a passionate political engagement that is a far cry from her previous detached admiration for the elegant appearance of Hillary Clinton. On Blaine's return she forthwith announces her novel alignment with his position and declares: "If only the man who wrote this book could be the president of America!". Blaine was dumbfounded and the basil chopping knife he was holding stopped moving as if he needed to recover from his incredulity that she could share his deeply held belief. Ifemelu's words effected their expectable magic and consequently rekindled their erotics in the name of Obama-the-symbolic-father.

Factoring in the group phenomena Freud illustrated in the chapter on identification of *Group psychology and the analysis of the ego* (Freud, 1921) spotlights how the libidinal Eros that binds group members together works both on the horizontal axis to strengthen their loving friendliness, and on the vertical axis of the love for the father. The power of this force transpires conspicuously when Ifemelu and Blaine clutch onto each other with expectant anxiety until the moment they finally witness the victory of the black president. It is no wonder that the historical event occasioned such exultation, but the intensity of Ifemelu's affective engagement during the campaign, her trepidation, and fears interrogate the reader on a deeper level.

> Every morning, Ifemelu woke up and checked to make sure that Obama was still alive. That no scandal had emerged, no story dug up from his past. She would turn on her computer, her breath still, her heart frantic in her chest, and then, reassured that he was still alive, she would read the latest news about him, quickly and greedily, seeking information and reassurance.
>
> (353)

Ifemelu's fear of loss of, and attack on, Obama reaches an unsuspected high pitch. But why? the attentive reader might wonder. Seen through her eyes, Obama embodies gravitas and yet he seems precarious: her anxiety conveys the impression that she might be inwardly burdened by the responsibility to keep him alive and preserve him from some shameful downfalls. Together with her racial sensibility, could she also be attending to her delicate internal work to institute a paternal figure endowed with a reliable aura of authoritativeness?

I suggest that a judicious interpolation of *Dreams from my father* yields the intertextual trace to unravel the skein of the reverberations within Ifemelu's psyche of the nexus of paternal lack with slavery and its specific architecture in the colonial imaginary. Famously, centuries of history persevere in people's mindsets over the *longue durée* of the unconscious temporalities as deep structures whose evolution lags behind socio-political discontinuities. They inform the internal world and have a bearing on the process of identity.

> [Where] were the fathers, the uncles and grandfathers, who could help explain this gash in our hearts? Where were the healers who might help us rescue meaning from defeat? They were gone, vanished, swallowed up by time. Only their cloudy images remained, and their once-a-year letters full of dime store advice .
>
> (Obama, 1995, 69)

Obama's stirring appeal to the absent ancestors speaks to Ifemelu. His eloquent words memorialized his personal struggle to construct his internal father, who in reality was the epitome of excess, being both absent and overbearingly present with his stentorian voice. A locus of lonely abandonment and lack, an impossible search, the address to the father is the subject's fervent plea to stay afloat and not sink into the despair and meaninglessness of de-subjectivation. Obama's interrogation is imploratory and reproachful at once, heartfelt and melancholy, and it plausibly went to the heart of the matter of Ifemelu's predicament.

The chapter on the electoral campaign reads like a rich tapestry whose threads can be finely embroidered with a complementary psychoanalytic reading; when all is said and done, to borrow Rabaté's felicitous metaphor, artists are "ambassadors" of the unconscious (Rabaté, 2014), and warmly welcomed at the psychoanalysts' banquet. So, the memoir and Obama reenter the lost triangulation with Ifemelu and Blaine, whose relationship had yielded to the dominion–submission logic.

In conclusion, I propose that the recursive triangular architecture of the narrative provides the underlying scaffolding to support the structure of desire – whether of an alluring elsewhere or of an enticing other – which extricates Ifemelu from engulfing sameness and symbiosis in her love

relationships. Moreover, this is how paradigmatically the paternal function organizes the psyche. Tellingly apropos of sexual desire, when Obama became the nominee of the Democratic Party, "Ifemelu and Blaine made love for the first time in weeks, and Obama was there, like an unspoken prayer, a third emotional presence" (356).

Obama inaugurates the advent of the third. This shift exemplifies the symbolic reparation of the filial tie, damaged and reneged by the paternal absence, when the son receives his dream/gifts, which is vital to reconstitute the intergenerational continuity. To think of this dynamic in its more abstract formalism, applicable to the economy of desire, it signals the coming alive and, on the hell of Plato's myth, the birth of Eros from lack (Penia) and thought, knowledge (Poros). Once again, we see that desire drives psychic work, it is also the creative force that shapes the subject's ambitions and agency, thanks to the support of the synthetic ego. The script showcases to what extent thirdness inflects the grammar of desire, when the disaffected couple is reunited by the book, which acquires the status of symbolic transformational object for both. What is more, through Obama Ifemelu recovers memories of Obinze by way of associating to the Igbo phrase "clear heart". Here another triangle emerges, the shape formed by the images, photo, the Igbo expression and its English translation demanded for the reader's comprehension. The repetition of triangularities emphasizes the rebirth of desire in lieu of the repeated engulfing dyads. I will reprise the theme of the structure of desire circumscribed to the erotic field and sexuality, but here my prime concern is to show its link with the place of the father in psychic structuring and in symbolization.

Marilia Aisenstein comments on *Dreams from my father* (Obama, 1995) in an article dedicated to the conjugations of the paternal; her essay is referenced as another intertextual contribution which I would like to enlist to endorse the psychoanalytic perspective.

Aisenstein writes that *Dreams from my father* is:

> a book that gives a perfect illustration of the difference between the symbolic father, the function, the principle, and the real presence of the father. [...] This fascinating memoir – what might be called an autobiographical novel – is an account of Obama's childhood mixed with adult reflections. After his father had returned to Africa, he was brought up by his mother alone, who had to get up at 4:00 in the morning to make him do his homework before she went to work. She asked him whether he thought she enjoyed getting up so early to wake "him, but then pointed out that she had no choice. I think we see here how a single mother can introduce the law as a third element to which we are all subjected – that is to say, to represent the paternal function.[...]
>
> (Aisenstein, 2015, 352)

So we can see that the young Barack was taught to carry within him the paternal function or principle that he eventually reclaimed as his own to take his place as President, the symbolic father of a nation. Ifemelu imagines only too well the tortuous path whereby the "boy who knew his grandmother was afraid of black men" – quoted in the memoir – has become "a man telling that story to redeem himself" (357).

The structure of belief

The climate around the election is the fulcrum of chapter 40 of *Americanah*, which iterates the noun "belief" and its cognate predicate "to believe" numerous times. Is there a link with the iconic figure of Obama? Rather than commenting on the election per se as a momentous event in the public life of a country, I will concentrate on Ifemelu's use of the campaign as an evocative object (Bollas, 2008, 2018) to repair her confidence in herself and the feeling of agency, this being a matter of self-belief.

Psychoanalysis disarticulates belief from official religion and rather situates it within the psychic capacity to develop personal and collective ideals which in some circumstances might include a religious faith. If shared, ideals bear upon the symbolic – as for instance a flag, or the colour of a sports club – but the more idiosyncratically personal they are, the more they unfold primarily along the spectrum of the wishful, the fantastic, and the imaginary. Again, a belief can range from hopeful anticipation to delusion, hallucination, even madness, where the demarcation line is their foundation in shared realism, rather than being solipsistic convictions or utter pipe dreams. Thus delineated, belief is to be located in the transitional space, for it partakes both the internal and the socially endorsed reality – as Winnicott posits – and it is a sophisticated function predicated upon the capacity for playing, imagining, and dreaming. The child at play and the adult watching a play or having a dream confide in the resolution of the experience that can, in time, be related to a fellow subject. Indeed, the virtual reality of playing and the analogous fictional film or theatre production are supported by a relational structure holding the situation in a set time (Winnicott, 1951, 1971), with a beginning, development and closure. Precursor of this dialectical movement is the mother who has a psychic space that allows for the transit in and out of the dyad and includes the father who functions as the third. The figure of father time is symbolically represented in this alternation that prevents the descent into the engulfing timelessness of madness.

The capacity to believe has a crucially structuring function in adolescence. As Kristeva notes, the adolescent needs to believe with a sense of ingenuity and urgency akin to a hunger that impels satisfaction if it is not to leave a gaping hole. Moreover, a want like hunger, evokes the archaic and primal, viz, the state of mind of primary identification, fusion, and being at one with the other, which persists throughout life in dialectical oscillation with

individuality and separateness. Well known revisitations of fusion are the ordinary orgasmic, mystical, and/or aesthetic mergers. Simply put, belief is interwoven with all the components of the personality that compound the embedding of the self in the social matrix and promote the sense of being and time for becoming.

In a letter addressed to Freud in 1927, Romain Rolland proposed the phrase "oceanic feeling" for the state of merging with the world co-occurring with a transitory loss of ego-boundaries. Mystics and saints practice various techniques to achieve the communion with a godly entity and record their testimonies in their writings – somewhat at variance with Freud's sensibility. Freud was a sceptic and critiqued the yearning for merger in *The future of an illusion* (1927) and *Civilization and its discontent* (1930), viewing it as the neurotic remnant of the infantile terror of death-as-annihilation, which the belief in the almighty God assuages with the promise of an afterlife. It is of interest that Freud, nonetheless, salvaged the phenomenon of the blurring of ego boundaries in the healthy aesthetic enjoyment of beauty and art and in the ties the individual establishes with other members of a group. In organized groups, in fact, the mutual primary identification between members, in parallel with their identification with the leader who supposedly loves each of them equally, is the cornerstone of group cohesion. The salient characteristic common to the foregoing experiences is the suspension of dis-belief, essentially of reality testing. Freud identifies illusion as the common trait of all these phenomena and posited that beliefs and ideals share the same structure of wishes and desires, imagination being ubiquitously at play in them all, regardless of reality. Freud was steeped in the philosophy of Enlightenment, which made him a staunch critic of religion, therefore he could only see the affirmative quality of illusion in children's playing – typified in his grandson's fort-da game – and in the arts, because both promised a "yield of pleasure" unalloyed by existential angst. The freedom of pleasure rather than the symptomatic defence from anxiety is the discriminating factor.

Parenthetically, my emphasis on the "yield of pleasure", which is an attribute both of the ludic and the aesthetic, gains traction from its re-emerging in the Freudian treatment of humour, as I will illustrate in the next chapter. What marks out pleasure is that it organizes a plurality of phenomena, individual and social, some more sensorial, other more subliminal and/or sublimated. Ultimately, the common thread linking the aforesaid narratives of pleasure is their essential embeddedness in the feeling of being at one with the (m)other, who ministers the primary care. As Freud states in *An outline of psychoanalysis*, the child's mother

> not only nourishes it but also looks after it and thus arouses in it a number of physical sensations, pleasurable and unpleasurable. By her care of the child's body she becomes its first seducer. In these two relations lies the root of a mother's importance, unique, without parallel,

established unalterably for a whole lifetime as the first and strongest love object and as the prototype of all love-relations – for both sexes.

(Freud, 1938, 188)

Mother "seduces", that is, conduces us towards the aggregate of life pleasures through the apprehension of the amorous language of synesthetic sensoriality that coalesces in a psychic envelope that institutes the variegated human erotics – Bollas even speaks of *ego orgasm*! Additional work of sublimation devises the idiom apt to modulate and stylize the kaleidoscopic sensoriality into aesthetic form and symbolic language. I will reprise the theme of pleasure and its reverberations within the political context in chapter 7, on Ifemelu's inspired expression though her blogs.

To return to and expand on the states of merger, it is notable how they have acquired a rightful place in contemporary psychoanalytic discourse, owing to the less rigid demarcation between the maternal – primeval site of the mnemonic trace of the oceanic feeling – and the paternal symbolic domain that Freud typified in the Lawgiver Moses. Mirroring, recognition, bearing witness, claiming: these are all psychic provisions of the (m)other's gaze and denote human experiences in the province of primary identification, where "being (like) you" precedes "I want you, I have secured you inside me by becoming like you", that is, the later secondary identification.

We owe to Kristeva a conspicuous body of work whose scholarship and breadth expatiates several disciplines, and whose dedicated nucleus remains the intermingling of the archaic – she calls the semiotic – and the symbolic, in the vicissitudes of love, ecstasis, writing, and meaningful living. She astutely writes about forms of "ecstasis" whereby the ego moves towards the other (etymologically from the Latin ex-stasis) and foregrounds the co-existence of narcissistic fusion and object-relationship, in dialectical movement therein. If the semiotic breaks through and into the symbolic, it is the flesh (*la chair*), the body, passions, excitement, and even perversions that enliven the symbolic and language. *Histoires d'amour* (*Tales of love*), affirms that love is rooted in desire and pleasure, insouciant about the ego that experiences and apprehends it symbolically and imaginatively, because love is situated at the border between narcissism and idealization (Kristeva, 1983). I will return to idealization, I only wish to emphasize here the lack thereof as a component of Ifemelu's suffering in her life with Blaine, whom she idealized since their train encounter, whilst she does not find her idealized self in his eyes. Her conscious discourse frames her malaise in the racial differentials: she sees him as the desirable black American, whilst his gaze returns to her the image of the unfocused, lazy, wayward African. Here the colour of their skin is not a signifier of kinship but is sequestered by the racialized logic of stereotyping typical of the "*narcissism of minor differences*" (Freud, 1930, 114 my emphasis), that is deployed to define identity. And the narcissism of minor differences is a substantial feature of all ethnic conflicts because it

functions primarily as a marker of identity and, in a similar way, it can be used in intimacy to delimit the territorial border for each individual. Ifemelu and Blaine evince this dynamic and showcase the nexus of intrapsychic and interpersonal communication.

Ifemelu's insecurity acts as a formidable counterpoint to undermine the couple's harmony; it foments her envy and jealousy of both Shan, Blaine's adored sister, and Paula, who epitomizes the outstanding white intellectual she could never aspire to be. Dispirited, Ifemelu withdraws from the female agon for Blaine's affection and admiration, only to feel aggrieved in solitude. Still, the triangle of rivalry resurfaces, together with the reappearing of its painful underlying determinants, such as her sense of inner impoverishment and injured self-regard. But, unexpectedly, the commotion around the election repairs the doleful state of affairs in the couple, albeit only temporarily, for Ifemelu's inherent malaise, still unthought and unexpressed, returns epiphenomenally as symptomatic boredom and loss of sexual desire.

I hypothesize that Obama's memoir speaks to Ifemelu as an "evocative object", according to the felicitous definition Bollas (2008) proposes for those objects and figures of the real world that lend themselves to be used as transitional objects. They gravitate in the cultural space and are apt to inflect the idiom of the subject, owing to their capacity to attract memories, fantasies, dreams, and hopeful anticipations, hence they speak to the private self. Based on preconscious or unconscious perceptions – the book sensorially catches Ifemelu's eye – "evocative objects" activate free associations, like day residues threaded into the fabric of the dream images, they condense heterogeneous temporalities and galvanize the subject by filling their empty core and replacing its sheer negativity. Bollas calls "ego orgasm" the pleasure we derive when we chance upon an evocative object. Could the "unspoken prayer" that complements Ifemelu and Blaine's sexual pleasure be viewed as orgasm of the ego that relaxes its boundaries in the experience of being-at-one with the world, inclusive of mystical and ecstatic eroticism? However, if momentarily the orgasmic elation restores the couple, their relationship remains problematic and unfulfilling for both, and eventually leads to a breakup.

Development has its own rhythm in each person's life and in relationships: the novel seems to signal just this when it organizes the transformative effects of Obama's victory on the macrolevel of history and in the microcosm of Ifemelu who sets off on her journey towards autonomy, to shape her own projects. She moves to Princeton to begin her fellowship and, more broadly, independent life. The gnawing feeling that "[t]here was something wrong with her ... [a] hunger, a restlessness, [a]n incomplete knowledge of herself ... [t]he sense of something further away, beyond her reach" (289, 290) somewhat abated, to slowly give way to the capacity to shape her own destiny against thinking that life merely happened to her.

Idealization, desire, love: a rhapsody

Sensations of hunger exert intense internal pressure and, whether they are bodily or emotional needs, their urgent exigency circumvents deferment or thinking. Transposed into metaphor, the cognate appetite, craving, pining, yearning, and inquietude are all comparable epiphenomena emanating from innermost emptiness, an absence, a perceived lack, which can morph into desire only if worked through. The transformative power of thinking, in fact, in time, evokes ideas, fantasies, images, and anticipations of the missing object, by retrieving its traces registered in memory. Where self-reflection makes a substantive difference is in salvaging the subject from descent into sheer negativity and the (self) destructiveness aimed at negating the threat of being engulfed by a nameless and dreadful want. Incidentally, in western philosophy the process of transformation of lack into desire is a well frequented trope; suffice a brief mention of Plato's myth of Eros who saw his genealogy in Poros (resource) and Penia (poverty, lack).

Ifemelu senses the nexus between her hunger and the forlorn restlessness at the basis of her proclivity to act impulsively in search of instant fulfilment. But is it only lust, as she believes? Naming it "lust" causes the self-reproach which temporarily allays her shame and guilt – in identification with the critical maternal voice – but her recurrent malaise in romantic affairs verisimilarly exposes her disjunction between sexuality and love. Have they ever come together for her? Ifemelu is cognizant of the part played by her curiosity in the wish for sexual exploration, and she reassures Aunty Uju that there is nothing amiss with Dike when he is caught playing sexual games with a girl in school, because "we all know *that* curiosity", it is normal (emphasis added). During latency, children displace a portion of sexual curiosity onto the sublimated goals they pursue with passionate dedication; taking pride in their intellectual prowess – even exhibiting it, I daresay – enhances their self-esteem and permits their bodies to prepare for mature sexual pleasure, slowly and unobtrusively. The Freudian revolution has acquainted us with the notion that ambitions and passions are erotics by another name, and we are attentive to how children are spirited by their sexual curiosity to venture on their epistemological trails, and, in turn, their cognitive acquisitions and ideals nourish their internal world, instituting a virtuous circle.

It is, therefore, an epiphanic moment when Ifemelu signifies her hunger as defective self-knowledge which, perhaps, she had previously obfuscated by adopting and identifying with the ideals and passions cherished by her significant others to sate her emptiness. But her unconscious tactics are only a temporary remedy, because the solidity of life in a dyad sooner or later appears incomplete, ephemeral, and ultimately becomes stifling. In relationships Ifemelu lives a precarious existence, always at risk of obliterating her singularity that she then needs to reaffirm vehemently by resorting to

aggressive opposition. Her unnegotiable plea for freedom from the stricture of the bond is multilayered and overdetermined – as all unconscious contents are – and undoubtedly the master–slave dynamic echoes the structuralized colonial domination too, but Ifemelu's comprehension remains superficial when she eludes introspection and defiantly reclaims her curiosity as her character trademark. Be that as it may, her revindication could also be interpreted as a defensive retreat to a familiar narrative compounded by self-blame and withdrawal from the other who she nudges to criticize her as insolent and brazen.

Could it be that her curiosity is sequestered largely in the service of her ideal-self, in permanent revolt against her forbidding mother and the Church apparatus the disturbed woman enlisted as her saviour? Certainly, there is rawness in her curiosity – now problematized as "curiosity copulation" – which periodically recurs, fractures the status quo and disrupts her love life, when she feels ensnared and threatened by dependence and closeness. Unthinkingly, she resorts to aggression tinged with erotization to recover her autonomy and a degree of mastery over her life. This defensive strategy would give traction to the interpretation of Ifemelu's repetition of the finale of her relationships with Obinze and Curt: in both cases the sexual encounter with a stranger resulted in the rupture which left her feeling bitter, ashamed, and hating herself. But her aching losses remain unmourned and cumulatively deepen the grief for the earlier disappointment which stands dissociated and is projected on her body.

Ifemelu's sexual body becomes the site of fissure, when it signals an excitation demanding instant satisfaction of lust, at one remove from the psychic apparatus and from fantasy, imagination and thought-out desire. For instance, she was caught unawares and later felt betrayed by her physical pleasure in response to the coach-customer's sexual touch; thereupon she withdrew in her lair, burdened by her shameful secret, and abruptly discontinued all contact with the mystified and worried Obinze. Years later, undoubtedly sexually mature and more experienced, she unconsciously orchestrated a similar *mis-en-scene* through the "curiosity fornication" with her white neighbor. What is commanding the reiteration?

Compulsive patterns and strategies re-present in a quest to be represented and make on the mind the demand to work to gain some understanding of their communicational import and underlying motives, in their past and present intricacies. This is where psychoanalysis can foster insight into the troubled identity of the character, not only of the idiosyncrasies of her story but also of her situated subjectivity, marked by the malaise engendered by the material and symbolic depletion of her culture, lacking unmarred ego-ideals. In brief, in the aftermath of her periodic need to discharge inner tension by resorting to acting impulsively and compulsively – sometimes with dire consequences – Ifemelu sights the *other* within; the stranger–familiar unconscious part comes into view in her relationships, whether the man is an

African like herself, a white wealthy American, or a black American. The repetitions appear to draw attention to Ifemelu's patchy skin-ego, whose constitution is still underway, consequently her predicament is bound to manifest in the intimate encounter with the other.

When Ifemelu returns after fifteen years, her estranged gaze on Nigeria meets a society that coheres around the idolatry of "big money", which has become a collective fetish. Women's aspirations reside in their power to deploy their youthful bodies to allure rich married men who provide luxury goods in exchange of sexual favours. Meanwhile they wait for the arrival of someone to marry and have a family. Ifemelu entertains the daunting thought that she might have become that typical Nigerian woman, had she not set sail for her American journey. To her returnee's gaze that quintessentially Nigerian woman appears to be merely living on the surface of things, in contrast with the newly acquired self-awareness of her malaise she names "hunger and incomplete knowledge". She formulates this expression through her laborious emotional learning; it is truly her own introspective conclusion, it is neither the borrowed American diagnostic of depression, nor the repudiation of suffering she now observes in the missing idiom for psychic pain in the Nigerian vocabulary.

Upon her homecoming, Ifemelu gifts her – imagined – abandoned self and the sorority of Nigerians the cultural object of her witty writings published in blogs and magazines: an offering and a reparative gesture at once, spurred by recognition and gratitude for her fortune and the laboriously won freedom to choose. She is by now capable of veritable, autonomous self-regard, beyond the remit of the defining gaze of men, their power and the hypocrisy of religion. Unsurprisingly, in this section of the novel the reader's attention is drawn to the violent power dynamic that inflects the relationships between the sexes, that is, after all, the primary phenomenon of any cultural codification. Furthermore, this narrative register navigates both inner and outer reality and functions – in my view – as a *mise-en-abime* of the colonial hegemony, whose noxious legacy is still today an evidential precipitate in the psychic structuring.

The interpretation of the overdetermination of the re-emergence of the uncanny-other within undergirds my analysis of the situated subject and endorses the emphasis on the significance of the work of culture (*Kulturarbeit*). In this regard Rabaté proposes that "literature teaches us something by making us play the role of an 'ambassador' from the court of the Unconscious" (Rabaté, 2014, 200), where the unconscious of the reader reverberates the inner logic of the historically situated characters. Therefore, Adichie's *Americanah* can be read on the dual registers of the protagonist's singularity and of the social plurality, in an exercise of capacious binocular vision, and it becomes a cultural object in its own right, positioned in the global space to widen our perspectives on the complexities of addressing alterity. As Rabeté affirms, "literature offers a privileged mode of entrance to

'culture', a term that combines personal engagement with formalized modes of fiction with a compendium of the values defining a whole civilization (*Kultur*)" (Rabaté, 2014, 4, original emphasis).

Chimamanda's prose effectively sustains the tension created by the obscure forces that trouble Ifemelu's internal world and are paradoxically both in excess of her resolve to contain them, and a symptom of her hitherto unrecognized suffering. Only at the beginning of part four, halfway through the book, does Ifemelu's arresting realization arrive, inducing a pause for reflection. Chapter 31 opens with her conversation with Ginika, after the relationship with Curt came to an ugly, hurtful ending unconsciously set up via her "curiosity fornication" with a neighbor and her confession, met with his unforgiving, shaming epithet *bitch*. Curt repairs his injured pride with offensive words laced with male prejudice, nonetheless, his judgement strikes a deep chord in Ifemelu. If her glib retort "it was a mistake, people make mistakes" conveys her exculpating rationalization, in her mind his words speak the voice of guilt and shame, both in excess and defensively repudiated. On the other hand, her internal dialogue resonates on an altogether different note.

> The sex was good the first time, she was on top of him, gliding and moaning and grasping the hair on his chest, and feeling faintly and glamorously theatrical as she did so. But the second time, after she arrived at his apartment and he pulled her into his arms, a great torpor descended on her. [...] In the elevator, she was overcome with the frightening sense that she was looking for something solid, flailing, and all she touched dissolved into nothingness.
>
> (288)

The void kernel takes the disguise of boredom, and the supervening affect signals the meaninglessness previously papered over by the excitement. Something is wrong, for certain, but what is the nature of the disguising pleasure she wished to attain and that heightened her orgasm with performative panache? Dissociated from emotional engagement, it is sex for the sake of mastery and power – being on top – over a white male body, which can be posited to be an isolated spin-off of the relationship with Curt, who loved her, made her feel vulnerable and protected and was her "crested wave" on the American life. If indebtedness and gratitude are the elicited feelings, how can they not be contrasted, even compromised, by the racial power dynamics? These relational events are better elucidated if read alongside the sardonic witty commentary Ifemelu posts in her blog: "The simplest solution to the race problem in America? Romantic love".

This excerpt chimes with Fanon's account of the racialized sequestration of the sexual imaginary produced by centuries of colonialization. *Black skin, white mask* (Fanon, 1952) sheds an impassionate if pained light on the

vengeful redress of the power dynamics between blacks and whites, which are played out in the sexual encounter, where control and mastery become the highly charged constituents of pleasure. Here we are in the territory of pleasure-in-sadism. Factoring in her preexistent dissociative defences, perhaps seducing and "being on top" of the white neighbor allowed Ifemelu to externalize and live through the alienation she explored afterwards, and especially figured herself as actor and spectator at once: exemplar of a truly split subject. The "curiosity fornication" condenses her polyvalent feeling of triumph, ineludible and necessary, nonetheless it leaves in its wake bitterness, self-doubts and the recognition of her need to feel grounded, which is inherent but ensconced and still unthought in her episodic destructiveness.

Taking her time to build up this interlude, Adichie's prose has wrought in America a niche for Ifemelu to have a sexual and sentimental education, journeying through a geography that morphs into exploratory landscape. From teenage into adulthood, her experiments with work, love, and relationships offer the sounding board to interrogate all facets of her identity, whose density primarily resides in her blackness and femaleness. Plausibly another thread here needs disentangling, in that Chimamanda seems to make the point that sexual desire is an attribute of being human, hence women should legitimately claim it, rather than disingenuously project it into men and then "give them what they want", as Curt and Aunty Uju would have it. Unarguably this is a cogent argument – Freud invented psychoanalysis to save the hysteric from obfuscating her desire by becoming ill! However it leaves open the crucial question of how to probe further into the function that dissociation of sexuality and love has in the character's psychic economy. I will address this question further.

Throughout her existential voyage Ifemelu hears several voices, that of Ginika who states: "I think you are a self-sabotager. That's why you cut off Obinze like that. And now you cheat on Curt because at some level you don't think you deserve happiness". Her speech echoes the global American culture, with its penchant for popular psychologizing explanations and medicalization, the prescription of pills to instantaneously solve manifestations of pain, anxiety, discontent, resentment, and injustice by silencing them. She also hears Curt's voice calling her "bitch" and, ultimately, her mother's saying that the devil must have possessed her. Ifemelu's psychic life has no trace of a consoling maternal embrace stored in memory, she oscillates between emptiness and feeling essentially "sassy" and reprehensible. To account for misfortunes and misery, the mother invokes the devil, but the problem with the devil is its elusive unfathomableness, its regime beyond responsibility, accountability, and words, unlike the province of desire and ethics.

Etiological and psychopathological reasoning is beyond the scope of this interdisciplinary study, here I simply intend to point out how the chorus of critical voices find an anchorage in the maternal mis-attunement. Indeed, how can a woman be emotionally attuned and claim with maternal passion

the infant she deems to be a child of the devil? Possessiveness – an emotional, rather than religious meaning of possession – is the quality of a mother capable of giving herself to her baby, it sources in erotism and is transmuted into tenderness. As for the devil, it seems to be a defensive figuration of Ifemelu's mother's sexophobic mindset that the religiose Church contributed to render ego-syntonic. Consequently, by thinking her thoughts, the adult Ifemelu glimpses at the nexus of her primal lack, sense of incompleteness, hunger of love and self-knowledge, with her (self) destructiveness, that is the badness of devilish filiation. Thus she ruefully inscribes in a biographical continuum the disarticulated fragments of herself, paradoxically confirmed by her experiences. There is no doubt that destructiveness is at work in her abruptly terminating relationships – Ifemelu acknowledges it – or when passionate engagements dissolve into boredom, and curiosity takes her in centrifugal directions, in the hope of recovering the sense of being alive. But isn't the engulfment and sudden need to break off an epiphenomenon of her malaise, as though her empty core suddenly becomes an attractor of the negative and exerts a magnetic pull? When the work of the negative takes hold of her, distressing as it is, Ifemelu is almost possessed by something she does not understand and feels driven, but this is unarguably an obligatory route to learn and discover what she authentically wants.

This itinerary leads her somewhere else, far from the preordained definitions and stereotypical destinations prescribed by her native culture, towards her love. Indeed, love is something else, always already an emotion in motion towards the other but only possible by being grounded in one's internal home.

No word for grief

Before delving into the tangles and triangles of the love story, I wish to spotlight the pivotal point detailed in chapter 15, which follows Ifemelu's speech in praise of the normalcy of sexual curiosity and precedes the narrative switch – and shifter – that culminates in her meeting with her perspective employer Kimberly, her family, and her cousin Curt. It is a critical moment for the protagonist when she flounders in a state of forlorn dejection and helplessness; the intimiste tone and slower rhythm of the chapter make for a pensive reading and are a departure from the faster pace of the account of Ifemelu's American epiphanies. The nested quality of the writing conveys the overwhelming grief which Ifemelu cannot speak, neither can her loved ones. Eventually, she leaves behind the poignant juncture, together with everything else that is unthought and unmourned of her Nigerian life, like her family and Obinze, whom she will resume seeing only fifteen years hence.

To an extent the crisis can be ascribed to the hardship of life in America for a black student on a paltry scholarship, which is very challenging indeed, still, factoring in the underlying emotional factors complicates the picture. When hard pressed to raise the rent money, on impulse Ifemelu replies to the

advert of a tennis coach who gives one hundred dollars as compensation to young women who would let him touch them sexually to relax. Adichie does not demur from painting a squalid picture, neither does she summon exclusively the practical contingencies. Her prose is not organized by canons of realism, rather her consistent focus on the privacy of her character nudges the reader to feel interpellated and invited to cast a respectful gaze on the experience that leaves Ifemelu feeling dirty, ashamed, contaminated, angry, and helpless. As she was preparing to go, Ifemelu imaginatively anticipates the encounter and

> [s]he shaved her underarms, dug out the lipstick she had not worn since the day she left Lagos, most of it left smeared on Obinze's neck at the airport. What would happen with the tennis coach? [...] Perhaps he was one of those white men she had read about, with strange tastes, who wanted women to drag a feather on their back or urinate on them. She could certainly do that, urinate on a man for one hundred dollars. The thought amused her, and she smiled a small, wry smile.
>
> (153)

On the heels of the chain of associations to the lipstick we find Obinze, Ifemelu's inchoate knowledge of herself as a sexual being based solely on their love story, her hasty departure from Lagos, the misapprehension of the finality of their separation, which at that time was glossed over with the promise of an imminent reunion, and, lastly, her conscious and unconscious fantasies. Alongside the financial circumstances, this episode intimates the equally crucial psychic urgencies which – I would argue – cohere around the unrecognized loss and grief for her hasty departure without adequate farewell. All these strands indicate that leaving was a rupture Ifemelu was unprepared for, and afterwards she lacked the affective vocabulary to articulate her predicament. Ifemelu is lost, disoriented, and disheartened by the existential hardship; verisimilarly she might unconsciously bear resentment towards Obinze, whose ideals about American fomented her, only to land alone in a foreign, hostile environment. She could well feel deceived and betrayed – by whom and whose ideals anyway?

The psychoanalytic perspective would ascribe this succession of shapeshifting events to the vicissitudes of the young person who perceives life beckoning with its exciting promises, new discoveries and possibilities, intensities of encounters and, crucially, the freedom to explore her sexuality in a milieu far away from the familiar prescriptions. Composing the grammar of her desire is, in fact, the adolescent's developmental priority, where interrogating the internalized norm is a steppingstone towards establishing her own ethics. Essentially, for Ifemelu transgression implicates freedom from the imperious face of the mad mother, the repressive hypocrisy of the Church and the admirable but equally forbidding and domineering image of Obinze's

mother. The theme of sexual curiosity traverses and knits together all these strands and informs Ifemelu's overarching, conscious – but mostly unconscious – mindset.

Politics contributes additional salience in that the proximity of white male and black female naked bodies epitomizes sexual transgression for the colonial imaginary, and it further weighs on the temptation of breaching the taboo. Ifemelu's fantasies of urinating on the white male tinges her fantasies with the excitement of the power to humiliate him for his passive un-manly wishes. Her imagination contours a scene where the coach reduces her to the status of a purchasable commodity, which she redresses by urinating on his body; her wry smile reveals her anticipatory pleasure. And hyper-erotizing urination pertains to the phallic position of the Freudian infantile sexuality.

The power motif infiltrates the phantasmatic *mis-en-scene*, whose determinants impress the dual register of the external and internal realities, both consonantly embedded in the dialectics of domination and submission. Power signifiers follow several trajectories and serve diverse functions, some developmentally functional – viz, the acquisition of ego-mastery or agency – whilst others are prone to defensively structure rigidity of character, as, for instance, sado-masochistic perversions or object relationships often employed as bulwark against the work of mourning. That said, the latter view informs my interpretation of the chapter, whose reading arrestingly illustrates how the idiom of domination and submission serves to feel "on top" of the pain of elaboration of the current losses as well as reckoning with the colonial catastrophe. All the same, the manic flight from home expedites Ifemelu's assurance of her survival and resourcefulness. Elaboration of the losses must be postponed, but this intricate knot contributes to and fuels the future reiterations – famously the repetition compulsion. What comes back is the return of the repressed, to reopen the space for thinking and understanding.

A possible outcome of the failed work of mourning is melancholia – whose metapsychology Freud detailed in the titular work of 1917 – that is essentially the intrapsychic war waged by the harsh superego, the "pure culture of the death instinct" (1923, 53), that savagely attacks the depleted ego. The self-reproach spares the abandoning object the rage it deserves, rage that the subject turns against the self to the point of endangering life itself. This picture obtains when the internal relationship is particularly ambivalent, causing the object to be neither internalized nor given up: I will accost some textual passages to support my thesis.

The impactful *sexual* saturates the scene with the coach: it was "sordid" that Ifemelu should find herself there, with "a stranger who already knew she would stay [...] because she had come. She was already there, already tainted" (154). This citation insists on the adverb *already* to evoke the predetermination, perhaps timelessness of the unconscious contribution in the construction of the scene, where impulse and curiosity clash with the imperative that "she should leave", that she repeatedly recites inwardly.

Perhaps the fantasy of urinating on the tennis coach – an overdetermined fantasy, like all unconscious contents are – is used here in the service of exerting power over him but also over her own obscure impulses. In the end she feels but defeated, rather than "on top", he is the powerful one because she has come, solicited by a stranger who shows "complete assuredness", touches her while she perceives her body "rousing to a sickening wetness" and she recoils recalling that when "he placed her hand between his legs, she had curled and moved her fingers" (154).

The dissociation of body and feelings here described shows the constellation typical of affects overwhelming the ego and reducing it to helplessness. Freud names *Hilflosigkeit* (helplessness) the ontological predicaments that clamour for a helpful other to transform, similarly to how maternal intervention ameliorates the distress of the helpless infant. Exogenous factors needn't necessarily be present; there can be, in fact, endogenous ones like the epiphany of sexuality, which is always already traumatic for a child. Of course, Ifemelu is no longer a child, but the discovery of the *sexual* per se, as a physical affectless fact with a white stranger is an overpowering and revelatory experience. When the lustful body – the Freudian body of the drive – signals its increasing excitation, so excessive and mystifying, it reveals the stranger within, the other-of-the-unconscious. And the psychoanalytic unconscious *is* the sexual and aggressive, viz, infantile sexuality.

It is advantageous to recall the principal tenets of the Freudian theory of the infantile where the stranger-seducer, the uncannily familiar, the body of the drive all conflate to announce to the child's sensibility its own "polymorphously perverse" impulses and fantasies. In parallel the endogenous source incites the child's epistemological research and theories to answer questions and satisfy their curiosity about things sexual. Ifemelu's words addressed to Aunty Uju "we all know that curiosity" speak to that overlapping body–mind imbrication, from the perspective of the adult looking back on childhood.

Considered association of this textual excerpt to the Freudian account of the child's mindset identifies the permanence of psychic structures that in adulthood can be modulated and more smoothly navigated but are never superseded. Our psychological mobility makes us adaptable whilst also liable to regression, in a back-and-forth fluctuation, and we are prone to relapse into earlier modes of functioning under the impact of stressors which overwhelm the resources of the ego. Herein a valid hypothesis is that migration and the challenges Ifemelu confronted reactivated the dormant forces that powered the scenario she consciously adhered to, and perhaps unconsciously contributed to orchestrate. Eventually and somewhat surprisingly, she discovered a masturbatory solipsistic pleasure, where the other was instrumental, rather than a partner with whom to journey beyond the binding *Ceiling*. It follows that staging the encounter with the tennis coach responds to the exigencies of reality but it also needs to be inscribed in the

protagonist's psychic economy where it primarily functions to severe her ties with her former close relationships. Her self-loathing, shame, and contamination, all in excess of her containing capacity, could not just be washed away. Certainly, they are imputable to her participation in the "sordid" situation, but only that? Arguably Ifemelu's emotional reaction straddles across reality and metaphor, linking the present with her infantile wishes and fantasies. She feels burdened and would have liked to "confess" to Aunty Uju, but her tentative plea fell on deaf ears, so she withdrew into her parlous, regressive isolation.

Chimamanda has established that Ifemelu has a disposition to react to unexamined experiences and the attendant troubling feelings; true to form, in this situation too she sunders all links to Nigeria, to the extent of shunning news broadcasts. She puts herself in mournful exile, which may be temporarily necessary, but that begs the question of how her psychic pain is channeled into actions that bypass thinking. Maybe because Ifemelu lacks the words to acknowledge and signify her grief. In the grip of helplessness and dismay, her sole perceived longing is to be in a safe place, to return to Lagos, having lost sight of the meaning of her current existence; she struggles to understand, but "[w]ords took so long to form meaning" (157). She does not know what or whom she has lost, she is lost for words, thus her nameless malaise slides into sheer meaninglessness.

The chapter draws to a close and the episode remains encapsulated, which is rendered in its stylistic choice: as it is not reprised or integrated in the narrative continuity, I would argue that it offers a literary exemplification of the onset of repression that cloaks with amnesia the infantile sexual fantasies. Repression bars psychic contents from memory and consciousness, except as disguised derivatives. Furthermore, by adopting this formal strategy, the author seems to mimetically reproduce the unintegrated statute of the shameful secret that Ifemelu cannot work through and inscribe in the flow of her autobiographical history.

Truly cosmopolitan and always a foreigner who navigates many worlds and languages, Chimamanda has penned a situated character whose culture does not acknowledge or adequately sponsor the laborious process of journeying across spaces and phases, namely, the perilous voyages of the mind, which always implicate working through what is left behind. Parenthetically, after her father's death, Adichie wrote a memoir of her grief, aimed at translating the language of psychic pain into her Nigerian idiom, wherein – she claims –mourning is scotomized and denied, only to be sequestered by the Church as a source of profit to be made for organizing funeral services. Grief clamours for the presence of receptive fellow humans, for mourning is always already social and needs encoded cultural provisions and rituals: whether manifesting as linguistic lack or captivated by the arrogant discourse of medicalization and the diagnostics of depression, if psychic pain is repudiated, it remains unlanguaged and can only be encrypted by symptoms.

The captive(ated) core. Love and the story of love

The allure of the image – a concept overarching ideals, ideal-self, ego-ideals, and deceptive mirrors – is crucial in Ifemelu's romantic engagements, and sponsors her need to believe and invest in future projects. Granting that idealization is ubiquitous in all facets of love, from passion to agape, because it borders "between narcissism and idealization" – as Kristeva remarks – (Kristeva, 1983), the boredom and discontent that take its place in Ifemelu's relationships warrant interrogating further. Whenever she pays attention to her woe, Ifemelu listens to herself and wonders what's wrong with her, with some concern. I would hypothesize that the persistence of her nucleus of emptiness exacerbates her malaise, it remains mostly unattended, hence it still clamours to be replenished by the affirming gaze of the Other. Only fleetingly did Ifemelu experience that very fullness of being when she impressed Obinze who overlaid on her the icon of the black American. However, flattening as it might have been, it was an ideal image misaligned with her – and their shared – Africanness; so perhaps the borrowed ideal bonded them at that time, similarly to how Obama functioned in her relationship with Blaine years later, when the advent of the revitalizing third-as-ideal showcased its import in Ifemelu's psychic economy. Perhaps Ifemelu lives on the surface of the Other's loaned belief, but what does she genuinely hold true wholeheartedly?

Discussion of the void core implicates several developmental and structural layers and connotes that constitutive "misunderstanding" whose origin goes back to the Lacanian mirror phase, wherein the exhilarating feeling of completeness is roused and instantiates all subsequent identifications. The misapprehension, founded on illusion, disguises the intrinsically alienating process, which Lacan foregrounds.

> Unable as yet to walk, or even to stand up, and held tightly as he is by some support, human or artificial, ... [the baby] nevertheless overcomes, in a flutter of jubilant activity, the obstructions of his support and, fixing his attitude in a slightly leaning-forward position, in order to hold it in his gaze, brings back an instantaneous aspect of the image.
> (Lacan, 1949, 1–2)

For Lacan the child identifies with the whole body-ego the gestalt mirror reflects and is deceived because its body is still psychically unintegrated (*corps morcelé*), in fragments, he says. The consequence is that the misapprehension of completeness exists only in the imaginary register, and this process paves the way for the disavowal of the essential lack of human beings (*le manque à être*) (Lacan, 1949), namely, the misalliance between wished for plenitude of jouissance and reality. Lacan famously links the false impression to the concepts of *imago* and *identification*, especially to the Ideal-I, a

narcissistic structure, and concludes with the statement that the mirror paves the way to our destiny of alienating identificatory socialization.

By contrast, Winnicott considers the mirror stage foundational and posits that its precursor is the mother's face; for him it is a developmentally earlier phase and is crucial to foster the infant's burgeoning subjectivity. Winnicott brings to the fore the subjectivizing function of mirroring and to his statement "there is no such a thing as a baby" may be added that there is no such a thing as a mirror, which is always already embedded in the primary relationship with the holding object who supports the illusion of completeness, because "*the precursor of the mirror is mother's face*" (Winnicott, 1967, 211, original emphasis).

The presence of lamentable feelings of unsubstantiality, futility, and weariness indicate the unstable investment in the self, which is rooted in the nucleus of deprivation and fates the person to a constant search for external supplies. Winnicott's versatile notion of the primacy of the nurturing and mirroring environment has far-reaching applications, on and beyond the analytic couch; indeed, in putting centre stage the constitution of the ontological ecology, he implicitly embeds parental provision in culture.

The interpolation of Winnicott's text places Ifemelu in her original milieu, which is now a mental construct and accompanies her through her voyages, while she remains – as Adichie intends – a character with her distinctive psychology and struggle to forge her own world. Chimamanda's stylistic flashback and flashforward movements, arguably, speak to the permanence of the relational past, which is embroidered in the present and, to an extent, colours her future choices. As the author insinuates, *Americanah* should not be read as a *roman-à-these* (novel with a message), whether racial or feminist or broadly political, and in my reading, Ifemelu retains its fictionality, corroborated by the representation of her situated sensibility. Therefore, in view of, and concordant with, the author's stated aims, a plausible interpretation of Ifemelu's malaise calls upon her psychological structurization, whence the hypothesis of her early deprivation gains traction. What she internally lacks transpires when she most cherishes Obinze's calm, assured, and reflective presence that supports, encourages and strengthens her resources. His quality of "transformational object" (Bollas, 1987) mutates her affective state and she sees in his gaze the person she could and would like to become, in time. But when she is unexpectedly alone in America, Obinze is but an absence and, disoriented, she clamours to recover the lost plenitude which has left a trace, a kind of template reenergized in new encounters which foreshadow, for her, future possibilities. She longs for another "transformational object".

Initially Blaine had not seen her, whilst she was transfixed on him, when he was but the stranger sitting next to her, and it is uncanny how her perception conjoins her internalized icon of the black American she had seen through Obinze's eyes. She felt an intense, arresting emotion and "in her mind, he had become the perfect American partner that she would never

have", the incarnation of the ideal substantiality that might complement her depleted self, and she wished to seduce and conquer him. *I want but I can't have*, is this not the articulation of the oedipal child who aspires to a desirable big Other and to be the object of their desire? Might there be the oedipal interdict at work, albeit unconsciously, in the feeling of inferiority that reaches her awareness?

Ifemelu garnered from Blaine's appearance, gait, and comportment, "the fine-grained mark that culture stamps on people", that he was the descendent of the black men and women who had been settled in America for centuries. He impressed her as "a man who looked at himself in the mirror" with moderation, and she began to imagine being a couple shopping in the mall, despite his avowed disdain for shopping prescints.

> She began to imagine what he would be like in bed: he would be a kind, attentive lover for whom emotional fulfilment was just as important as ejaculation, he would not judge her slack flesh, he would wake up even-tempered every morning. She hastily looked away, afraid that he might have read her mind, so startling clear were the images there.
>
> (180)

This lovelorn epiphanic moment brings together loving care and lust, it reads like a waking oneiric construction, thereby, it signals unconscious derivatives and wishes. The leitmotif running through all those imaginings is the search of a "transformational object", someone whose gaze could see her as lovable, unique, ideal, warts and all: is it not the magic property of the loving maternal embrace to bestow on the infant the feeling of being at the centre of her world?

Blaine looks like a black American intellectual, subtly communicates his assured physicality that foments Ifemelu's self-ideal: is he perhaps the person she would have liked to be or to have all the time? Off stage resounds for the reader Obinze's influential voice, when he would look at her and appreciatively remark: "You look like a black American" which was his ultimate compliment, when she wore a nice dress, or when her hair was done in large braids. "Go to Manhattan and see how things are" (67) he would intimate. Now, in a flare of synesthetic intensities, Ifemelu feels emboldened, galvanized and swiftly begins to flirt with the man who exudes his feeling at ease, for he is someone who legitimately stakes a claim in his American world.

The encounter with the stranger on the train is set against the backdrop of Ifemelu's diasporic predicament and longing for an imaginary sanctuary of certainty to shelter her from adversity: such states of mind she represents *a posteriori* with perspicacious metaphors, like wanting a "crested wave", an "entry into a hallowed American kingdom". She yearns for a romantic relationship to be both an avenue to recover her fullness of being and the institutional pathway to express her marriage fantasies, in yet another variation on the theme of the transformational object through which to feel at home in

her womanliness. The story with Blaine – confined to her imaginings at this stage – is subsequently reprised on the occasion of a fortuitus meeting at an event where Ifemelu is celebrated as a renown blogger, after the end of her relationship with Curt.

Curt is the "crested wave" Ifemelu rides for a time, driven more by his desire for her writ large on his face, than by her own passion. "It was with Curt that she had first looked in the mirror and, with a flash of accomplishment, seen someone else" (191). She recalled how effortlessly she had slipped out of her own skin to enter the world of white privilege holding Curt's hand, and was "proud to be with him, of him". What colour and whose skin was this version of Ifemelu – the reader might wonder. The narrative portrays a masquerade: but is this only the case of wearing a white mask (Fanon, 1952) or rather it gestures to the intimation of the more spacious masquerade of femininity? Or both? Ifemelu is the black beauty – her body fits the American male fantasies – as Ginika had forewarned – whose hearty laughter portends orgasmic delights that instantaneously enthrall Curt and ignite his erotic imaginings. He had never had a black girlfriend before, a detail that permits Adichie to nuance the chromatic possibilities of their respective sexual fantasies, inexorably imbricated with the racialized dialectical power oscillations within the couple. Plausibly, each unconsciously represented for the other a trophy conquered through the oedipal transgression of being attracted to the non-oedipal, racially divergent other. Here the writing is replete with ambiguities to adroitly facilitate the reader's non-judgmental inquiry into the cultural signifiers of the psychosexual bodies, how these are negotiated and/or betrayed in intimate situations. At the same time reiterating the themes of oedipal interdict and transgression both in loving and loveless encounters, permits Adichie to foreground Ifemelu's itinerary towards becoming a subject through a plurality of experiences, of which the racial connotation is one, rather than the determining aspect.

It is tempting to pin down Ifemelu's affective intermittences in the relationship with Curt to racial friction, at the risk of disregarding that her oscillation between feeling gratitude and envy, pride and criticism, has deeper and compelling roots, more persuasively attributable to how readily slipping into the otherness-of-the-other is the unvarying hallmark of her love life. In this instance exiting one skin and entering another functions on the dual register of both reality and incarnated metaphor, it being but a modern edition of the seasoned falseness, the well-rehearsed, ritualized rule of engagement Ifemelu unconsciously practiced all her life, having expediently acquired it in her interactions with her mother. Both her parents, in fact, demanded she comply with the commandeering mother whose fragility she guiltily feared but whom, ultimately, she did not love. Ifemelu's begrudging submissiveness was punctuated by episodic outbursts of rebellion as, for instance, when she stopped going to catechism. Inscribing the slippage into a masquerade in the

broader character strategy, locates its *raison d'être* in the compulsion to escape the emotional misattunement through betrayal, which, in the last analysis, turns into betrayal of herself, when it instantiates violent ruptures that leave her feeling guilty and empty. Feeling estranged to her own self coupled with the question "what is wrong with me?" open the avenue to the psychic work of rapprochement with the alien-ness that has always been there, inside. The stranger within sends a symptomatic alarm signal: what is wrong? when Ifemelu, finally alone, begins her self-analytic journey that takes her to realize how she longs for a solid psychic home wherein to gather her fragmented selves lost, cut off, abandoned, repudiated, or even destroyed.

The real and psychological dislocation run on parallel trajectories, both entailing fluid back and forward journeys for a genuine understanding to come to fruition. Ifemelu needs to go back home, where she left too many ruptured threads, and phobically avoided returning to Nigeria for some fifteen years. It is not without significance that she envisions relocating at the time when she is a well-established, successful adult – as far as her pragmatical circumstances are concerned – and the time is opportune for introspection. The shift still to come is from the position "tell me what you want, and I will become that object of your desire, so that I can symbiotically adhere to you and find meaning" to the new, more intimate interrogation: "what do I desire to feel that life is worth living?" Thereupon she ships to Lagos all her possessions, after leaving Blaine, selling her flat and her profitable blog. Is this tantamount to a self-destructive move undergirded by a counterintuitive logic? Adichie plants this seed of doubt in the reader's mind; the bemused Ginika voices it and qualifies her friend's decision as self-sabotage. I reckon, instead, that the author employs a canonic form to enhance the suspensive pause which draws attention to the two pillars of ordinary adult life, viz, the capacity to love and work, wherein Freud posited the possibility of psychic health. This is a momentous transition for Ifemelu who is ostensibly uncertain, easily destabilized and sensitive to the doubts her decision engenders in the questioning others. Granted that well thought-out reasons are not exhaustive of theories of motivation, factoring in the unconscious troubles the narrative, and implicates time because profound understanding can only be achieved in the *après coup*, which is the exquisitely Freudian temporality.

Our mental processes unfold in time, allowing for the latency between lived experience and the laborious introspection to grapple with the underlying motives of our choices and actions, which are also predicated on the multilayered determinants that coexist in our internal world. All the time we review the assessment of our history, and subject to *a-posteriori* resignification, we attribute unedited meanings to the past which, to an extent, is always constructed in the present and foreshadows the future. Psychoanalysis has flagged the paradoxical nature of human temporality and shown that alongside its linear arrow sits a biographical time-reversing outlook, without jarring effect. That said, I would argue that Ifemelu's project of becoming the desiring subject of her life implicates the work of the negative – viz,

overthrowing the mainstays of her adult acquisitions in her professional and romantic life – when she becomes aware of her proclivity to adhere to the Other's narrative, only to feel engulfed afterwards. I have explicated the role this aspect plays in her intimacy, yet Ifemelu felt equally dispossessed and engulfed by her blog, which she conceived on the suggestion of her Kenyan friend Wambui, but then she lost her drive, a fact that Blaine remarked in his critical view of her "lazy African-ness". Ifemelu needed to appropriate the blog as her own design.

Destruction is a prerequisite for (re)construction. In Lagos the returnee Ifemelu discovers her capacity to be alone in her existential home, she orchestrates a fruitful conversation amongst her plural selves and, above all, searches in herself the passions that inflect her writing inspiration. Interestingly, although her idiomatic core is enriched by the many languages apprehended though her journey, her longing for a relationship wherein she "need not explain" leads her back to Obinze. The circulation of words between the two is pregnant with meaning and Ifemelu narrates herself, confiding in being understood, and she listens attentively to Obinze's narrative of his adult life. Notwithstanding, their reciprocity and affinity are crucially beyond words. Alongside their present circumstances, they rediscover what they share, and these intensities may be only signified by the coinage *Ceiling*, secret invention of their love. Ceiling is a curious word, it sounds cryptic, even nonsensical, like lovers' words often are. If read as switch-word, however, it reveals an intriguing polysemy: a ceiling has solidity and a definite quality of thingness, for it shelters and frames the lovers' privacy, but is also metaphorical. What spurs Ifemelu's invention is the orgasmic pleasure that takes her beyond her self-boundary, crosses the "border", including transgressing the stricture of the maternal canon, sanctioned by the Church, that only lays bare fear and hatred of female sexuality.

I suggest that Ifemelu's *Ceiling* is the unconscious metaphor for a porous skin-ego that delimits the subject, whilst permitting the erotic merger in alternation with the recovery of the subject position. By analogy with the psychoanalytic frame, *ceiling* creates the transitional space where the dialectic of finitude and infinite exists in a state of tension, like the fusionality and separateness of two desiring subjects who are not subjected to (someone else's) desire but take different subject positions in the reciprocal articulation of their innermost wishes. When Ifemelu asserts that she does not want to be Obinze's mistress, she commands her desire that he should be her solid "ceiling", unambivalently loudly and clearly and it must be heeded, before she opens the door.

Psychoanalytic theories on identity are fundamentally dynamic and rely on concepts such as identifications, that are capacious enough to embrace the paradox of the plurality of subjectivities, who live multifarious experiences, are situated in disparate locations, are members of several groups, communities, and institutions, yet concurrently perceive their continuity across time. According to Erik Erikson identity is a sense of psychosocial well-being. "Its

most obvious concomitants are a feeling of being at home in one's body, a sense of 'knowing where one is going,' and an inner assuredness of anticipated recognition from those who count" (Erikson, 1968, 165). Feeling at home inside one's skin is its crucial corollary.

At the end of her itinerary, Ifemelu has become the protagonist of her own story and can narrate the tortuous route to prideful womanliness with dignity, having learned to navigate the temptation to wilfully subjugate the self to internal and external hegemonic colonization, in her quest for safety, grounding, and consistence.

The proto conversation of love

Visiting a nearby shopping precinct with Curt, Ifemelu runs into a former school friend she had lost touch with. Now a well-established professional, he lives in Maryland and indicates that he had hoped to see her, since learning her whereabouts from Obinze, who still inquires about her. Being made privy to her enduring presence in Obinze's mind, Ifemelu feels perturbed and confronted with her failed attempt at detaching from him by severing all communication. Even greater are her embarrassment, guilt, and undiminished longings. In the throes of her secret turmoil, Ifemelu reprises corresponding with Obinze and learns of his mother's death. A confessional register transpires in her reply, but even more allusive sounds the disclosure of her early fantasies about the dead woman.

> *I am crying as I write this. Do you know how often I wished that she was my mother? She was the only adult – except for Aunty Uju – who treated me like a person with an opinion that mattered. You were so fortunate to be raised by her. She was everything I wanted to be.*
>
> (371, original emphasis)

Children deprived of good enough primary care develop precocious self-holding capacities and defensively retreat into their dissociated fantasies to redress their wound by creating scenarios of ideal mothers, perhaps braiding them in storylines of rescue. Ifemelu's letter corroborates the view that her early deficit somewhat accounts for her impoverished and needy nucleus. A satisfactory parent–infant engagement lays the foundation for the development of a cohesive ego, equally essential is its structuring the grammar of love, as a crucible of verbal, non-verbal, and proto-verbal erotic discourse.

Strikingly sparse are Ifemelu's memories of the mother, whose voice always reverberates with reprobation and admonitory reminders of the devil, never with tenderness.

I suggest that her internalized mother voices Ifemelu's verisimilar fear of meltdown. Ifemelu, in fact, must have registered the paralyzing terror she felt when she witnessed her mother's visionary evocation of the devil while she

shaved off her beautiful mane. It was a sacrificial gesture to barter salvation and well-being for her family in her commerce with the almighty powers. A psychoanalytic interpretation would consider the mother's a veritable breakdown that the Nigerian culture had no name for, hence it denied its very possibility.

> Dark grey smoke curled up into the air. From the veranda, Ifemelu began to cry because she sensed that something had happened, and the woman standing by the fire, splashing in more kerosene as it dimmed and stepping back as it flared, the woman who was bald and blank, was not her mother, could not be her mother. When her mother came back inside, Ifemelu backed away.
>
> (41)

The adjective *blank* – the vacant expression the daughter captures on her mother's face – qualifies the fading away of human aliveness, as the full-blown psychosis manifests. But was it preceded by a *blank psychotic* organization of her mothering, as theorized by Green in "the dead mother complex"(Green, 1983)? As Green proposes, when the mother is only physically present but lacking aliveness and depressed, hence emotionally absent and unavailable, the infant experiences the psychically dead mother as an uncanny phantom. But again, how can anyone tell, if the word for depression is missing, and the condition is, therefore, unthinkable within the culture? Looking for evidence of the quality of early mothering, the text tells that the maternal embrace is conspicuous for its absence even as memory traces in the daughter. So, perhaps the memory of the psychotic episode is a screen memory that encapsulates the aggregate of Ifemelu's sense of being-with her mother from before and after her breakdown.

The text states that Ifemelu "backed away" speechless: her movement conveys bewilderment and fright and vividly represents her disavowal of the mother as a figure of identification – in later years, in fact, she wanted to be like Obinze's mother. It follows that the process of identity is problematic if the bond of filiation and the identification with parental introjects is barred. Adichie emphasizes that Ifemelu could not understand "her mother's ability to tell herself stories about her reality that did not even resemble her reality" (45). Taking this to be a screen memory, readers whose unconscious resonates with the writing are led to wonder whether there might have been precursors to the manifest psychotic decompensation and how the woman might have managed mothering her little girl. Plainly, the maternal imago is always a composite, a psychic construct distorted by subjective feelings – in this case predominantly the estrangement concomitant with fear, suspicion, and hostility – but, as Freud remarks, distortion resulting from projection is where and how the unconscious speaks. Therefore, these excerpts are convincing enough evidence of the persistently unsatisfactory quality of the mother–daughter rapport, accounting for the blocked pathway to identification with the

disturbed woman and for the lack of a helpful, sympathetic internal mother to conjure in dark moments of helplessness and despair. On the other hand, Ifemelu knows how much she craves for the gaze of a mother, not hers though, whom she rather keeps at arm's length and repudiates, but the idealized mother of her imaginings, she projects in that of Obinze.

Being seen and mattering to mother is foundational for the newborn: in her gaze we first apprehend our whole being – as per Lacan's mirror phase – and in her enveloping embrace we engage in the proto-conversation of love; conversely, the lack of the (m)other's amorous regard transmutes into a psychic blank and installs in the unconscious an early triangulation with an imaginary other – a twin – who is deemed to be better endowed, more deserving, and capable of love. Thus, the initial deprivation is signified as a perspective but inevitable theft by the rival and, if this nucleus of suffering is not worked over, memorialized and located in the historical past, it tinges the future with a sense of foreboding. This deeply impoverished psychic constellation informs Ifemelu's feelings of not being good enough to rouse the desired other's desire, which initially distorts her perceptions in all her encounters. As, for instance, when she anticipated that Obinze would be attracted to Ginika, universally considered more becoming and a more congruous match for him: this is the ideation of a depressed person, precluded from expecting anything auspicious. It is also a reedition of the triangle of rivalry where the third is a white woman who occupies phantasmatic scenarios of jealousy in both the relationships with Curt and Blaine, whose previous partner was a white academic.

Does this configuration have a bearing on the "malady of ideality"? It undoubtedly compromises the mutual idealization intrinsic to love. In *Tales of love* Kristeva writes: "Love is the space and time where the 'I' claims its entitlement to be extraordinary. Sovereign, without having been an individual" (1983, 2012, 6, my translation from Italian). Being in love causes the ego to expand and revisit the archaic "his/her majesty the baby" in mutual absorption with the lover. It is an experience of enthusiastic infatuation –Green calls it the ordinary madness of passion of the origin (Green, 1986) – which coexists with the love for the object-qua-other: sense and nonsense, finite and infinity, ideal and sexuality inextricably intertwined.

The destination of her journey finally reached, Ifemelu has found her own voice and when faced by the return of triangularity with the stunningly beautiful Kosi, she can say out loud that she wants to weave her uncompromising extraordinary tale of love, unrivalled.

References

Adichie, C.N. (2013). *Americanah*. London. 4th Estate.
Aisenstein, M. (2015). The question of the father in 2015. *Psychoanalytic Quarterly* 84 (2):352–361.

Bollas, C. (1987). *The transformational object in the shadow of the object.* London. Free Association Books.
Bollas, C. (2018). *The evocative object.* London. Routledge.
Coblence, F., Montes de Oca, M. (2022). Une vie psychique est une vie dans le temps. http://www.kristeva.fr/2022/JK-une-vie-psychique.pdf.
Erikson, E.H. (1968). *Identity: Youth in crisis.* New York: Norton.
Fanon, F. (1952). *Peau noire, masque blanque.* Edition du Seuil [*Black skin, white mask.* London. Pluto Press, 1986].
Freud, S. (1913). *Totem and taboo.* SE XIII.
Freud, S. (1921). *Group psychology and the analysis of the ego.* SE XVIII.
Freud, S. (1923). *The ego and the id.* SE XIX.
Freud, S. (1927). *The future of an illusion.* SE XXI.
Freud, S. (1930). *Civilization and its discontent.* SE XXIII.
Freud, S. (1938). *An outline of psychoanalysis.* SE XXIII.
Green, A. (1983). The dead mother, in *On private madness.* London. Karnac (1996).
Green, A. (1986). Passions and their vicissitudes, in *On private madness.* London. Karnac (1996).
Green, A. (2004). On thirdness. *Psychoanalytic Quarterly* 73:99–135.
Kristeva, J. (1983). *Histoires d'amour.* Paris. Gallimard. [*Tales of love.* Columbia University Press (1989).]
Kristeva, J. (2012). *Storie d'amore.* Milano. Donzelli Editore. [Love tales with an introduction by the author.]
Kristeva, J. (2016a). Colloque de la SPPLa vie psychique, à tout prix. L'effroi peut-il s'élaborer?1926–2016: Colloque du 90e anniversaire, 19 novembre 2016.
Kristeva, J. (2016b). Interpreting radical evil. Keynote delivered at the titular conference held in Stockholm.
Lacan, J. (1949). L'étade du miroir [The mirror stage] in *Ecrits.* Norton & Co. Inc.
Lacan, J. (1965). Homage fait à Marguerite Duras du ravissement de Lol V. *Cahiers Renaud-Barrault* 52:7–15 (1977).
Obama, B. (1995). *Dreams from my father.* Random House Usa Inc. (2004).
Rabaté, J.-M. (2014). *The Cambridge introduction to literature and psychoanalysis.* Cambridge University Press.
Winnicott, D.W. (1951, 1971). Transitional objects and transitional phenomena. *The Collected Works of D. W. Winnicott.* Vols 3 and 9. Oxford University Press (2016).
Winnicott, D.W. (1967). Mirror-role of mother and family in child development. *The Collected Works of D. W. Winnicott.* Vol. 8. Oxford University Press (2016).
Winnicott, D.W. (1988). *Human nature. The Collected Works of D. W. Winnicott.* Vol. 11. Oxford University Press (2016).

Chapter 7

Americanah
The blogger, the humourist

Laughter is an emotion whose polysemantic expressiveness is always in excess, it infects and primarily engages the body. Amongst its manifestations there is the full-bodied laughter but also the "broken humour" which Freud theorized as a mode of humour that smiles through tears in his *Jokes and their relation to the unconscious* (1905). In this chapter the psychoanalytic lens on humour will frame my close reading of some of its implications in *Americanah*.

Ifemelu is the protagonist of the novel; she is winsome in many respects, most of all for her gift of humour, which she finely attunes to her addressee, whether it might be her dialogical self, or the person she is conversing with, or the anonymous followers of her blog. The reader notes this consistent trait of her personality which metaphorically is a portable traveling companion, receives many tributaries along the way of her development and experiences, to eventually moor her in a professional realization that combines her subjective, political, and ethical stance. Her humour, whose tonality varies from the consolatory to the punchy, the gracious, the sharp, the impactful, to the startling, has the quality of a sanguine transformational potentiality and is her elected strategy when she needs to recover her poise in the face of life's many challenges.

An inquisitive and acute observer of people and situations, Ifemelu positions herself as her own intimate raconteur and transforms her affects into comic stories destined to address an empathic listener or to be written in the blog format for a wide albeit anonymous readership. Regarding affects, humour is her elective expedient to rein in and transfigure credibly overwhelming feelings such as pity, anger, sense of injustice, bewilderment, dislocation, and loneliness, which she frames in verbal renditions, thereby garnering the additional "yield of pleasure" that Freud postulates to be the essential feature of jokes and the comic genre, all of which conform to the rubric of playfulness. It goes without saying that a real or phantasmatic relationship with an internal receiver contours the "yield of pleasure" in advance of the telling, because humour is always social.

For Freud, playing is the infantile precursor of humour, which emerges when children begin to make up words with gusto, transform, deform, and

reform them. Often, they invent a new, secret lexicon to kindle their auto-erotic "yield of pleasure" that lays the building block for the later "envelope for thought" (Freud, 1905, 92), an essential function assisting their growth. Moreover, laughter is conducive to cultivating the seeds of rebellion against authority, grants "a liberation from its pressure" (105), and enables to channel various forms of resistance.

Jokes and their relation to the unconscious saw publication in 1905, the same year as *A case of hysteria* and *Three essays*. Ernest Jones writes in his biography of Freud that the three texts sat on his desk concurrently and he chose which one to continue working on, on a day-to-day basis, spurred by his changing desire and inspiration. Clearly enough, his preoccupation with infantile sexuality constitutes the *fil rouge* of the essays and links the infantile unconscious, the transformation of affects, the idiomatic invention of auto-erotic pleasure, and the development of symptoms, all interweaved together in a state of tension, albeit fecund. In all these instances the end results are compromise formations and depend on the route most viable to the disguised drive derivatives and defences.

Successively, Freud expatiates on the theme of the rebellion against and liberation from the strictures of inner authority in the brief paper *Humour* (1927), where he reprises the topic of the subject's struggle for freedom to inscribe it in the structural model of the mind, which posits the superego as the psychical representative of parental authority. What is most innovative in the later essay is the transformation instantiated in the superego, when a more cohesive and robust ego, capable of addressing it humorously, can mollify and render it a benevolent ally. This dynamic outcome is the reverse of melancholia where, instead, the superego humiliates and belittles the ego which retreats into its enveloping masochistic suffering, whereas in humour the ego triumphs. I will return to this point to appraise the structure of politics implicated in humour, which is a crucial feature of Ifemelu's blogs.

But where does it all begin, bearing in mind that the fabric of affects is imbued with the vicissitudes of the primary relationships, which are gradually internalized, encoded, inscribed, and revisited in private scripts that imbue later interpersonal dynamics?

I propose to methodologically, if arbitrarily, punctuate the passage of the novel where Ifemelu rememorizes her childhood, to select as a starting point the handling of her anger, pity and shame all knotted together, that transpire from her musings over her father's idiosyncratic, quirky, and pretentious lexicon. Ifemelu intuits in his affectation a pathetic illusion of self-aggrandizement, which she astutely sees through as betraying his colonial feelings of inferiority. Too weak and embarrassing to convincingly carry the intended reproach and criticism to be expected of the paternal authority, this is the legacy transmitted to her and troubling her conscience. She treats the mnemonic material with hyperbolizing causticity, which includes self-irony, recalling how his pompous words "made her little actions seem epic and almost prideworthy. But his mannered English bothered her"(47) – he was a

joke! – and she astutely detected his defensive inauthenticity which served to both deny and turn against himself his frustration and helpless subjection. Ifemelu resorts to her witty "envelope for thought" to construct a picture of his – and her own – colonial past, deposited in her father's demeanor but never properly historicized or conveyed in consequential language.

In the text the father functions both as a character and as exemplar of the complicated mourning of the collective trauma of colonialization which encroaches on the following generations. Psychoanalysis has significantly contributed to elucidate the intergenerational transmission of unelaborated traumata which cast their shadow and (pre)occupy the children's internal world. The substantial body of clinically informed research into the psychological effect of imperialist dominion have foregrounded that especially in the construction of manhood, the colonial subject suffers being cast into a debased effeminate role by the sadistic assertion of phallic power. So helplessly emasculated and infantized, he cannot be a viable internal figure of identification, that is a much-needed support to the filiation project.[1] The theme of stultified masculinity is reiterated in the father's subjugation to his wife, to evince that the familial organization and the psyche mirror the external structure of power and accrue the man's state of paradigmatic marginality. For the sake of her psychic survival, Ifemelu-the-humourist rises "above it" and disengages from the adverse present and past factuality. From her position of defensive superiority, her father appears but a figure of embarrassment, and through laughter she triumphs over her pain, pity, sadness, and primarily over her repudiation of him and the attendant guilt. If her talent fortifies her personal resources in those instances where her "broken humour smiles through the tears", nonetheless the oscillation of laughter, anger, and pity occupies the site where a potent paternal imago should be, and she is all the poorer for this lack. While her feelings loom threateningly uncontained, she distances herself, laughs, takes her time to grow and formulate her original repertoire of diagnostic categories, as for instance she does with her hilarious invention of the nosological definition of "foreign pathology". I will expand on this narrative excerpt in the segue of this chapter where I trace the itinerary of her psychiatric coinage.

Artful mastery through estrangement

Across cultures the licensed rites of passage assist the young in navigating pivotal moments, such as leaving home to embark on geographical, metaphorical and maturational journeys whose destination is the shaping of their adult identity, to eventually take their place in the chain of the generations. The emotional disengagement is at once painful, liberating, and exciting, replete, as it always is, with unforeseen encounters and potentialities. Might it also in some cases turn into "foreign pathology", viz, the malaise of estrangement, when the frightened subject absconds and takes permanent

residence in a solitary enclave? It is a risk Ifemelu averts to some extent – albeit not completely – wilfully banking on her talent for humour that is her reliable resource in the face of adversities.

To exemplify Ifemelu's comic ingenuity, let us start with the diagnosis of "foreign pathology" she coins to classify the incongruity of the data of her experience and observation, set against what she is accustomed to as familiar. Is being a foreigner a distinct psychopathology or rather does she keep her own suffering at arm's length using this facetious turn of phrase? Also, could "foreign" be attributed to her own feeling of misrecognition of the noun *depression* that Ginika – à la American – all too readily ascribes to her friend's predicament, but is unnamed, hence does not exist in Nigeria? In this context "foreign" is an ambiguous signifier, through which Ifemelu recovers her sense of belonging by drawing a steady partition line between "us" and "them" – the blacks and the Americans – when she imagines telling Obinze her funny stories. She enlists her internalized image of him to restore her sense of agency, cognizant that he "pulled every strand of story from her, going over details, asking her questions, and sometimes he would laugh, the sound echoing down the line" (129).

Occasion for Ifemelu's medical neologism is her first student party invitation where, unsurprisingly, she feels the outlier, especially given that all the others are white. She soon calls to mind Obinze, the secret companion she engages in silent dialogue and seeking repair and solace, she anticipates relating the event and making up entertaining stories for him. Her ironic gaze helps her to detach from the unfamiliar context, allays her awkward self-consciousness and feeling out of place, and to release some of her self-preservative aggression by polarizing the blacks and the Americans. As for the relationship with Obinze, this is Ifemelu's first term at university, their bond is still intense, and she relies on his encouraging presence brought into her room by the telephone. The funny incident occurs on her way to the party in the company of her roommates; a look at their casual attire prompts her question: "won't you get dressed?" and their riposte that they are indeed dressed. Is Ifemelu over-dressed by comparison? Does she suddenly feel the self-conscious outsider, who is not awake to the in-group dress code, which is a manifest cultural signifier? Her ironical gift turns the tables when she anticipates giving Obinze a blow-by-blow account of their "foreign pathology", fully complemented with mimicry of accents, cadences, tones of voices and the lexical quirks of the partygoers. With a parenthetic flashforward which gestures to the continuous thread and the après coup temporality of fiction, Adichie notes:

> Years later, a blog post would read: *When it comes to dressing well, American culture is so self-fulfilled that it has not only disregarded this courtesy of self-presentation, but has turned that disregard into a virtue. "We are too superior/busy/cool/not up-tight to bother about how we look*

to other people, and so we can wear pajamas to school and underwear to the mall."

(129, original emphasis).The blog reads like the dense utterance of a situated cultural commentator, able to discern the underlying mentality of disregard for otherness, lack of curiosity, and gracelessness, covered over with ideological radicalism which poorly masks the righteous exceptionalism of the Americans. Thus speaks the astute publicist of the cultural normativity of the hegemonic colonial power. Ifemelu's ingenuity laced with witty critique is delivered through condensation in words and images, and gesturally by imitation and mimicry, a strategy similar to that of the dream-work and joke-work. Displacement and condensation evince in the phrase "foreign pathology", like in the dream-work: both dreams and jokes, in fact, are original productions available to the subject to conceal and reveal at the same time, the unconscious derivates in a sublimated form, fitting for public disclosure. Dream-thoughts and joke-thoughts are equally latent and require a disguise to mitigate the shame if they were too directly manifested.

To tease out the textual latent thoughts, I would posit that upon her arrival to the States, Ifemelu transforms her unease, loneliness, and dislocation by constructing colourful vignettes for Obinze. Ascribing the strangeness to the "pathology of the foreigner", she turns the cause of her discomfort into a risible object to objectify with Obinze. This triangulation – the teller, the hearer, and the object of ridicule – is overdetermined and carries the implicit potential of becoming a genuine political act. I am here referring to Freud's remarks that due to its triadic structure, humour is always already social. Furthermore, in this instance, it reaffirms Ifemelu's complicitous alliance with Obinze, reestablishes their erotic bond which in his absence instantiates thoughts and fantasies and morphs into the sublimated erotics of words, highlighting that what they share is the comic "yield of pleasure". Adding the variable of race to the equation, humour expresses Ifemelu's hostility towards the other-than-self and the hegemonic whites, which further substantiates her politics and at the same time unconsciously distances her from her subaltern father.

Humour unfolds in two phases whereby the listener's initial bewilderment is followed by enlightenment, which releases tension and incites pleasure. The text exercises the rich potential of the ambiguity of language as a malleable tool to convey and signify complex psychic processes instantiated by external and/or internal vicissitudes. The flashback and forward strategy can be regarded as a mimetic literary rendering of the movement of free association in psychoanalysis, where memories, anticipations, affectively charged dialogues with internalized figures alternate in temporal shifts that interweave the dialectic of loss and recovery of the continuity of being across variegated experiences. As previously proposed, humour reads as the mainstay of

Ifemelu's subjectivity through her journeys and, arguably, the comic is the *fil rouge* that bridges the spatio-temporal and cultural variations, for it is the attribute Ifemelu prizes most in herself and others who she sees as attractive when she senses that they can laugh at the same jokes. It also typifies the nonverbal self–other commerce and mutual recognition, in that the sense of humour inflects the narcissism of minor differences which delimits group identity – those who "get it" – indeed, we ordinarily speak of a British, American, French, etc. ... distinctive sense of humour. Laughing is ascribable to the ludic and, like playing, implicates entering the realm of potential reality based on a tacit accord, it is joyful and erotic, and its sublimated form strengthens the social bond, facilitates the group members' mutual recognition and identification and gesturally reaffirms cultural belonging.

A judicious detour to examine Freud's writings on the comic, respectively *Jokes and their relation to the unconscious* (1905) and the short essay *Humour* (1927) aims to advance my analysis.

Freud: jokes, humour, the comic

In the checkered dialogue between psychoanalysis and literature insufficient credit has been given to the chapter dedicated to technique in *Jokes and their relation to the unconscious* (1905), which can veritably be read as a short compendium of rhetoric. Freud compares the joke-work and dream-work; both employ the strategies of "condensation" and "displacement" but, unlike dreams that tap into the unconscious, jokes rely solely on verbal intelligence and inventiveness. Acting with quick-firing brevity, the privileged rhythmicity of wit creates in the listener a momentary confusion before regaling its "yield of pleasure", as detailed in the chosen exemplary phrase "foreign pathology". Irony plays with the cognitive dissonance between the manifest and the latent meaning of the text; in parallel, the joke, the riddle, the author, the humourist, the dreamer play hide and seek with the Other.

Freud is at pains to illustrate the analogy the tempo of wit has with the biphasic movement of the sexual fore-pleasure and orgasm – albeit in the sublimated form of the erotics of words – because in his early formulation of the theory of the psychic apparatus all forms of pleasure are rooted in the unconscious. In fact, *Jokes* and the *Three essays* were written contemporaneously within the framework classed under the rubric of the topographical model, wherein Freud's "object was to discover the source of the pleasure obtained from humour, and [...] to show that the yield of humorous pleasure arises from an economy in expenditure upon feeling" (Freud, 1927, 161), a principle applicable to all psychic contents. All the same, the sociopolitical layer of humour is discernable once we factor in the dialogical relationship adumbrated in the wish to make the other laugh and to laugh together.

> The humorous attitude—whatever it may consist in—can be directed either towards the subject's own self or towards other people; it is to be assumed that it brings a yield of pleasure to the person who adopts it, and a similar yield of pleasure falls to the share of the non-participating onlooker, [...] affected, as it were, at long-range by the humorous production.
>
> (Freud, 1927, 161).

Additionally, the pleasure the subject derives from their playful dissent presupposes their capacity to judiciously use aggression and channel it towards constructive, rather than destructive aims. The emphasis on governing aggression will gain momentum in the short essay *Humour* written after Freud revised his model of the psychic apparatus – in the 20s – which now consists essentially in the internal dynamics between the three structures of the id, ego and superego. Another important theoretical shift concerns Freud's formulation of the theory of narcissism, namely, the state of the ego, whose struggle with the superego occupies center stage in the structural model. The playful exercise of humour empowers the ego to gain ascendancy over the frustrations of reality and the humiliation of the superego, whilst guarding its axiomatic and paradoxical ambiguity. Like Janus, in fact, the ego looks inwards and outwards, it claims centrality but "is also the supreme embodiment of de-centralization and narcissistic detachment" (Kupermann, 2014, 3).

In humour the ego swells with elation, joy, jubilation, and laughter: a spectrum of feeling states antithetical to depression. Naturally there might be a psychopathological outcome when laughter turns into mania in the service of denial of reality, unlike the expression of the *joie de vivre* which involves an intrapsychically dynamic alternation of sadness and joy and averts the danger of melancholia. Where in the latter the superego mortifies the enfeebled ego, in the former the ego wins the agon, availing itself of the resource of humour and its ability to rein in aggressiveness and command it effectively. In Freud's words,

> Like jokes and the comic, humour has something liberating about it; but it also has something of grandeur and elevation, which is lacking in the other two ways of obtaining pleasure from intellectual activity. The grandeur in it clearly lies in the triumph of narcissism, the victorious assertion of the ego's invulnerability. The ego refuses to be distressed by the provocations of reality, to let itself be compelled to suffer. It insists that it cannot be affected by the traumas of the external world; it shows, in fact, that such traumas are no more than occasions for it to gain pleasure. This last feature is a quite essential element of humour.
>
> (Freud, 1927, 162)

The baleful occurrence dreaded as potentially overwhelming thus morphs into an occasion of laughter and the ego, now identified with the adult position, regards benevolently its own infantile terrors, for witticism takes the edge off the persecutory predicaments and reveals the substantive change within the superego, whose prior harshness mellows, turning its authoritarianism into gravitas.

Parenthetically, the terms authority and author etymologically derive from the Latin "augere", which means to augment, to grow, to develop, to recognize someone's skills and capabilities. The humourist's psyche evinces the conquest of the superego's favour and this internal structure acknowledges the authorial ego and legitimizes its feeling of being a master in its own home, at least as long as the joke lasts!

Daniel Kupermann affirms that Freud's body of work is imbued with the theme of wit (*Witz*) through and through, that constitutes its veritable political framework, where politics references the structure and the process, rather than the ideological contents. Kupermann argues that the triangularity of wit – the teller, the receiver and the target — configures its conviviality and that

> the act of telling a joke often has the purpose of exposing current rigidities and hypocrisies, promoting a deterritorialization in the established styles of existence, clearing the way for fresh thinking and creating ways of sociability so far unheard of.
>
> (2014, 5)

Kuperman's emphasis on the underlying political aspect of the Freudian oeuvre corroborates my hypothesis that the psychoanalyst can infer the culturally sanctioned mindset from the investigation of individual depth psychology. Hence, we can equally presuppose the possibility of garnering the cultural malaise lodged in the psyche in the consulting room. Is this not another way of saying that the analytic work is tantamount to performing the *work-of-culture*? Indeed, the *Kulturarbeit* always infuses and is implicated in clinical practice as well as in the theory.

With regard to *Americanah*, Adichie exemplifies in the protagonist the function of critiquing and troubling the mores of the society she visits as a foreigner; her diasporic existence creates for Ifemelu the ecological niche that facilitates the inflection of her political idiom, instrumental to her becoming a humourist-blogger. The humourist is an external observer, her political discourse is both solitary and collective, her marginality can situationally induce feelings of dejection and helplessness – as I illustrated in a previous chapter – that reactivate infantile states and fears, but she capitalized on her ingenuity to recover her feelings of empowerment.

But what is the intrapsychic state of affairs? A window needs to be opened onto the psychic structure where social mores sediment through the

internalization of ancestral voices and ideals, where ethical norms and repressive mechanisms are installed, that is, the superego. Kupermann suggests that access to the sources of *witz* is predicated on the prior work *of de-idealization*, whereby the subject mourns the loss of the omnipotent parental imagoes of infancy – which Freud sees projected onto God – accepts their orphanhood and rekindles from the ashes the possibility of autonomous, spontaneous, and creative gesture. The sombre subject turns humourist through the vicissitudes of orphanhood and learns to tolerate life without parents or gods. Only thereafter does the prospect of symbolically parenting herself become available, so that she can birth her enunciating subjectivity, who is able to take responsibility and speak her own desire. Ifemelu's original lack and loneliness remain her constitutive features, but they also nourish the poetic vein through the condensation and displacement that flow into the rhetoric of *witz*.

The Standard Edition indexes *Humour* in the same volume as *The future of an illusion*, both of which were completed and published in 1927. Kupermann's reading of the Freudian texts pivots on the conceptual pair of helplessness–idealization underlying, inter alia, the religious credence. In religion, the illusion-based faith is the vehicle to narcissistically identify with an almighty divinity to assuage the feeling of helplessness, whereas the work of de-idealization opens the path to sublimation. Moreover, according to Freud humour is a defensive strategy to overcome the sense of helplessness by creating an "illusion" that retains its contact with reality, unlike the psychotic or perverse rupture.

The blog provides Ifemelu with a platform to publicize her astute observations about the constitutive structure of race in America: race is both an obsessional cultural trait and denied at the same time. Her voice is irreverent, her witticism iconoclastic; she does not comply with any master, having dis-identified from the colonial subjugation epitomized by her father, and can see through the idiosyncratic fables of her mad mother. In the novel the reader accompanies Ifemelu through the shapeshifting densities of her sagacity, until she eventually finds her professional niche and becomes the humourist–author of her blog which narrates the Nigerpolitanism that she knows so well.

The blog: fluctuations, transitions

In an interview with the Dutch journalist Synne Rifbjerg for the "International Author's Stage" (2014) Adichie mused on her choice to make her character a blogger: "I wanted this novel to also be social commentary, but I wanted to say it in ways that are different from what one is supposed to say in literary fiction". She underscores the "different ways" in regard to the explicit cultural critique of their contents and equally of their distinguishable form, whose font and indentation are at variance with the main text. The

topics of the blogs are discrete themes summarized in the title, they frequently address the reader directly and emulate a missive with advice and recommendation delivered ironically. Often revisiting an episode of the plotline – as though they were meant as a *mise en abime* – the blogs evince the second-degree reflection and incisiveness that follow a lived experience. So, besides being metanarrative intertextual devises, they produce the effect of temporal duality and draw attention to the *après coup* tempo of fiction. The overall trope is racism which Ifemelu encounters as the identity attributed, almost superimposed as an administrative performative act, by the Other – in her words, she became black in America. Thereupon she unsparingly morphs into blogposts her non-American black perspective and notes that racism is the deeply encoded yet silenced organizer of American culture in all its complexity. Matching the protagonist of her novel, Chimamanda responded to the CNN interviewer Christiane Amanpour's inquiry: "I think that race is America's original sin and it's not surprising that it remains a problem. Actually, sometimes I find it surprising that some people find it surprising that it remains a problem" (2017). The original sin is inscribed in the semantic field of the transmission of guilt, confession, viz, the acknowledgment in speech to the respondent of one's own responsibility, the attendant work of thinking, reparation, memorialization, historicization: these processes make demands for psychic work both on the subjective and collective mentality. In conclusion, I argue that Chimanda entrusts to Ifemelu's blog the denunciation that in America obfuscation, disavowal, and wordlessness fill the gap left open by the failure of the work of mourning of historic slavery

To return to Ifemelu's trajectory towards becoming a subject, a close reading of the role the online journal plays in her psychic economy proves useful. Undoubtedly the reader notices that the blogs have a textual life of their own, proceed at their own rhythm, reflect the vicissitudes of the blogging-I, pause when she sells up to return to Nigeria, and become a lively project she wholeheartedly invests in when she establishes her *Nigerpolitan* home. One might say that at the end of her itinerary, Ifemelu integrates her blogging-self as a dependable psychic resource, having apprehended from her experience that she writes about what is meaningful and she cares about. As previously remarked, the road towards the discovery of her dedication and passionate commitment to writing is rather tortuous: initially it is a borrowed object of desire – when Wambui first planted the seed of the idea of initiating a blog – destined to be lost through relocation, and finally reclaimed and recovered as her own. It all starts when in the throe of frustration one evening Ifemelu wrote to Wambui

> all the things she didn't tell Curt, things unsaid and unfinished. It was a long e-mail, digging, questioning, unearthing. In her reply, Wambui

advised, "This is so raw and true. More people should read this. You should start a blog".

(295)

There seems to be a wide consensus that the online journal is an embedded narrative –according to Genette's definition – to get across the black novelist/protagonist's discourse about race in America. I refer the reader to Guarracino (2014) for a literature review of this vast field of study, which, in brief, aligns the emerging diasporic subjectivities and the empowerment granted by the innovative forms of writing through technology, whose purposeful effects are immediacy, visibility, direct responsiveness, the sharing of experiences and language (Castells, 2009).

In addition, the psychoanalytic episteme would inscribe the blog within the potential narrative space wherein Adichie gives hospitality to her character's autonomous and evolving perspectives on the cultures she comes to inhabit. I am indebted to Winnicott and Green for the formulation of the tertiary position in the maternal psyche which encompasses her I-not-I, and the infant-other-not-other, holding them in a paradox and I have previously referenced these authors. Applying this framework to the text, I propose that Adichie-the-author constructs a space for Ifemelu to come into being as a subject of her autonomous desire, reflecting capacities and writing forms. In other words, the omniscient author exits her centre-stage position to make space for the character-in-her-mind and observe how she gradually develops her independent authorial self. Humour is a crucial aspect of this shift of narrating author-reality, which mimetically reproduces the softer posture of the superego, that Kupermann believes to be a constitutive feature of the structure of politics, as Freud writes in the essay on *Humour*. Creative distance is of the essence in the conversation –internal and externally staged – between ego and superego, parent and child, authorial voice and fictional personage.

To delve into the deep unconscious reasons why Ifemelu discontinues her American blog, my hypothesis is that she acted primarily on her feeling *subsumed* by it. *Subsumed* is a condensed term which contains her contrarian defensiveness that leads her to refute whatever and whoever elicits her fear of being taken over and engulfed, which is tantamount to an unconscious existential threat of annihilation. I enucleated the instances when this anxiety and attendant defence become symptomatic in all her relationships, and she impulsively reacts by disengaging abruptly. If this is the case, psychological coherence would have it that the character's proclivity to feel *hetero-directed* extends to feeling *hetero-narrated*, therefore the textual reverberation of her predicament would result in the author's choice of conferring the blog its autonomous organization by turning it into an embedded subtext.

To limit my presupposition to the aforementioned, I will return to the structural softening of the superego from judgmental agency to internal

companion-commentator; it is a psychic transformation evinced in humour and playfulness, more broadly. The working through runs in parallel with the process of de-idealization and sublimation, which could be described metaphorically as dethroning the idols from their privileged position on the altarpiece, to then recompose the fragments into a new object. The previous credence in illusory salvation – i.e. Ifemelu's fantasied sense of safety projectively deposited in living on the "crest" of the American life with Curt – crumbles in disillusionment, trust is interrogated, to later be salvaged by other means, so as to produce the imaginative artistry of making something new and herself anew.

I have detailed the reparative process underlying the re-creative possibilities that reshape both the erotic and the aggressive drives, which are played out in the construction of a subject capable of unfettered expressions. This emerges in the renewal of the blogs the Americanah-Ifemelu writes and that she yearns should be meaningful, conspicuous, and a resourceful presence to signal her newly found psychic home. Thus evinces Ifemelu's mature situatedness, now that she is more at ease with her feelings, does not discharge them into impulsive actions, rather she mulls them over, as she does with her designs for her blogs, before regaling them to the readers. Where they previously guaranteed an outlet when she needed bearing witness, recognition, and a platform to transform her rage into mordant words, in Nigeria the blogs are a vehicle to reach the women who are the protagonists of their own life, hence they could be role models for the younger generations. Later on, she intends to travel across Nigeria, get to know her country of origin, listen to, and give voice to the plurality of both ancestral and contemporary stories. What she has learned she wishes to hand down and teach and this is further evidence that some reparation of her internal damage has occurred.

Some variations of the comic register

Adichie consigns her poetics to plural nuances of the comic register to render a spectrum of discrete moods, affects, ambience. To illustrate some of the complex functions humour fulfils I propose a comparison between two excerpts: one is a post Ifemelu writes in the first person, the other is the account of an embarrassing scene in which the protagonist is portrayed by the narrating author.

> The simplest solution to the problem of race in America? Romantic love. Not friendship. Not the kind of safe, shallow love where the objective is that both people remain comfortable. But real deep romantic love, the kind that twists you and wrings you out and makes you breathe through the nostrils of your beloved. And because that real deep romantic love is so rare, and because American society is set up to make it even rarer

between American Black and American White, the problem of race in America will never be solved.

(296)

The blog recites *a posteriori* an earlier incident that occurred at a party in Manhattan, where a group of intellectual and arty people had convened to celebrate Obama's candidacy. Conversing over dinner, a Haitian poet claimed that race was not an issue when she dated a white man for three years. "That's a lie" – Ifemelu retorted – and to the incredulous woman's "What?" she repeated:

> "It's a lie", and even though she knew she should have left it alone, she did not. She *could* not. The words had, once again, overtaken her, they overpowered her throat and tumbled out.
> "The only reason you say race is not an issue is because you wish it was not. We all wish it was not. But it's a lie. I came from a country where race is not an issue; I did not think of myself as black and I only became black when I came to America. When you are black in America and you fall in love with a white person, race doesn't matter when you are alone together because it's just you and your love. But we don't talk about it. [....] We let it pile up inside our heads and when we come to nice liberal dinners like this, we say that race doesn't matter because that's what we're supposed to say, to keep our nice liberal friends comfortable. It's true. I speak from experience.
>
> (290–291, emphasis added)

Ifemelu's spiel is infused with vehemence, anger, and righteousness, her intention appears to want to unmask the hypocrisy of the liberal classes who reciprocate with complicit acquiescence the claim they can rightfully have a stake in American society. But is the Haitian woman's denial not another version of the culture of repression, deeply implanted in the collective psyche? The reader of the literature review parsing Adichie's use of the blog frequently encounters the adjectives "truthful" and "raw", which the author also avails herself of in the cited interview (2014). "Truthful" and "raw" may well describe the persistent quality of Ifemelu's utterances, still, the substantial difference is that whilst the latter passage is an invective, the former is a satire. Ifemelu's exposé at the party is a veritable *J'accuse* that she delivers in earnest to interpellate the allegedly liberal-minded guests. She dares speak without inhibition after she drank too much white wine at the dinner. Afterwards she acknowledges that her disorderly affects temporarily overpowered and ultimately embarrassed her, finally prompting an apology after sobering up.

Arguably, intrapsychically the alcohol had loosened her critically harsh superego, which she externalized by turning the tables and momentarily

projected onto the guests, but *a posteriori* felt ashamed for her lack of restraint and social grace. As Freud famously quipped, "the superego is soluble in alcohol" due to the liberating effect of intoxication, which does not substantially alter its savagery, if anything, it exacerbates it. A comparison with the anonymous blog written after a time lapse – the content is essentially the same, what differs is the blogpost delivery, reliant on paradox – foregrounds how the elaboration of the "raw" affects appeases the superego, strengthens the ego, now empowered and able to source its wittiness. The coupling of the ego with the friendlier superego generatively elicits a laughter that invites the listeners-readers to accept the unpalatable truth, enhances their awareness which deterritorializes established mores, and consequently fosters change. In the last analysis, the two rhetorical strategies can be interpreted as epiphenomena of a psychic *revolution:* where the ancient duress was, the laughter shall be – to paraphrase Freud. Welcoming anew literature's invitation to become ambassadors of the unconscious, it is possible to highlight and appreciate the intricacies of the psychic shift in determining cultural transformations – as Adichie indicates – which both for the subject and society alike are analogously predicated on de-idealization, renunciation, loss, namely, the ineluctable work of mourning.

On the heels of Kupermann, it could be suggested that Adichie's humour structurally inf(l)ects her political discourse and modulates some variations of the comic register to capture the micro events that subtend cultural shifts. Furthermore, the resulting changes in the power dynamics reverberate in the relationship between the sexes, classes, and races, intersecting one another, and are obliquely alluded to in the journal.

The cited satirical blog opens with a conundrum: "The simplest solution to the problem of race?". The choice of a riddle is intriguing. Why this strategy? Since the Middle Ages riddles were ascribed to the comic genre and their inclusion in Freud's *Joke* book portends one aspect of the fertile dialogue of psychoanalysis with literature. In fact, the extension of the compass of psychoanalysis applied to the deconstruction of the comic effect showcases how the riddle – indeed *witz* in general – forces the hearer to adopt two points of view and perform a task they are expected to fail by giving the wrong answer. Would the error reveal their bias, misconception, misunderstandings, in other words the unconscious and the unthought? The hearer-reader is destabilized by the question and is situated in the position of the subject-failing-to-know, whilst she who poses the riddle reveals her embodied knowledge and finally concedes to include them. In point of fact, as Freud remarks, the riddle's final aim is to affect and infect the hearer, unlike the joke that establishes superiority over them.

Listening to the visceral tone, the closing remark of Ifemelu's captious address to the party guests – "I speak from experience" – sounds like a poignant plea to win their assent, since, after all, she is the embodied testimony of the truth value of the conversation about race in America. But is

she the petitioner or the apologist? Her passions in excess might well indicate that Ifemelu herself is in the throes of a conundrum rooted in her own history: what does she want? To be the sanctimonious judge or the child clamouring to be acknowledged as a subject of speech? Both, or neither, when the balance so easily tips over? Or else, might she be expressing the need to be seen and heard, ever so insistent and never waning in a person's life? Perhaps her malaise has deeper and ancient determinants and notably betrays, in the present, the impasse of her troubled and vexing superego.

In a previous chapter I have detailed an analogous cluster of phenomena – albeit examined from a different vertex – located in the province of the paternal regime, that psychoanalysis deems to be the organizing principle of the social order, informs the psychic apparatus, and instantiates the symbolic capacity. Now, it may appear as a foregone conclusion that the emotional transformations inspiring the recourse to the riddle in the blog are the by-product of the reworking of the superego, which is the site of the unconscious transmission of cultural contents, identifications, mandates, and unelaborated fragments of history.

Journeys across cultures face the migrating subject with the imperative of code-switching, so urgent as they delve into the semantics of displacement. Curiosity combined with cultural code-switching promotes growth, in that it decentres the self and enforces other, more distant perspectives, similarly to the process instituted by humour. Internally, code-switching can serve to deterritorialize the internalized canon, when it becomes apparent that the "[r]ules had shifted, fallen into the cracks of distance and foreignness" (315). In this passage the word "rules" produces a slippage from external to internal reality and if the norms that govern private conduct differ across cultures, the rules that fall and crack are primarily those transmitted by the parents whose idealized representations fall and crack through the process of de-idealization in the course of development.

Adichie illuminates the criticality of the superego functioning under the combined effects of growth and cultural adaptation, working in parallel towards the construction of a multifaceted subjectivity with the overarching capacity to cast an ironical gaze on the self and on the other.

Ifemelu, spirited and at long last free of the maternal injunction, tells her parents that she wishes to move in with Blaine and relocate to New Haven. She could have lied or partially omitted information – so Ifemelu muses – but decided to stand her ground and tell them about him, even though no marriage is planned in the foreseeable future. Unlike her, the parents' vocabulary confers to the word "marriage" the magic of clearing the route to the open acknowledgment of her sexuality.

"He's an American." She continues.

> She heard the symbolism in her own words, traveling thousands of miles to Nigeria, and she knew what her parents would understand. […] "An

American Negro?" her father asked, sounding baffled. Ifemelu burst out laughing. "Daddy, nobody says Negro anymore."

"But why a Negro? Is there a substantive scarcity of Nigerians there?" She ignored him, still laughing.

(315)

Laughter wins the day over bitter harangue, deception, secrecy, fear, and the shame, the sense of inferiority and annoyance that are the matrix of her filiation.

Another instance of code-switching showcases in Ifemelu's character. Her capacity to put to good use her dispositional irreverence superbly substantiates the cultural coding and decoding of every subjective mode of being, what with her character trait going from being reproachable for lacking respect in Nigeria, to increasingly acquiring ludic qualities in her blog writing. It is, in fact, in the aftermath of her phone call to her parents, that "still amused, she decided to change the title of her blog to *Raceteenth or Various Observations About American Blacks (Those Formerly Known as Negroes) by a Non-American Black*". This textual sequence conjures the analytic method of free associations, whereby the unconscious derivatives signal the psychic movements by producing a new thought, a dream, a change, a fresh understanding. Here the association is instigated by her unverbalized recollection of the class where the word Negro was interdicted. She can now link Negro and Black, can insert the words in her blog, laced with her wit that also gestures to the paradox of the cancel culture deployed in the service of the repression and obfuscation of effecting the work of memorialization.

Job Vacancy in America—National Arbiter in Chief of "Who Is Racist"
Somebody has to be able to say that racists are not monsters. They are people with loving families, regular folk who pay taxes. Somebody needs to get the job of deciding who is racist and who isn't. Or maybe it's time to just scrap the word "racist." Find something new. Like Racial Disorder Syndrome. And we could have different categories for sufferers of this syndrome: mild, medium, and acute.

(316).

The satire targets some distinctly American ways of effacing their slaveholding history and the sequelae of contemporary racism which paradoxically is all the more gripping the more it is shirked by sanitizing language to cleanse conscience, evincing that metonymy is at work. The end result is the paradox of the collective obstinacy with terminology that strives to erase any memorial trace in language to circumvent the guilt which would promote the work of mourning. The more language is cleansed, the more the realistic possibilities of reparation are obstructed. Americans – Ifemelu

perspicaciously remarks – display an overall inclination to evade pain and discomfort, which they only too readily index as organic ailments to relegate to the medics and their ready-made pharmacological solutions. Hers is the caustic repartee of a sophisticated foreigner that, should it be conveyed by way of explanations, political analyses, or intellectual discourse, would surely be an ex-cathedra lecture, easily dismissed, unlike the comic effect based on condensation that initially produces bewilderment, to then segue with enlightenment and mirth. But the joke is on *you Americans* – Ifemelu seems to imply – because you remain on the surface of things and diagnose otherness by looking at skin, hair, and bone structure. The blog showcases her astute, witty vein, beguiling for its synthetic capacity to convey through the condensation of the joke-work a polysemic and multi-layered chain of meanings. Ultimately humour outsmarts the offenders, exposes their contradictions and their prized self-aggrandizing preoccupation, undergirded by omnipotent fantasies of rewriting history by erasing the culprit-words threatening the return of the repressed and attendant conflict.

Parenthetically, the exposé perhaps obliquely engages with Stuart Hall's theory of race as a floating signifier, which the facetious disguise renders accessible, thought-provoking, and personally relevant. The following excerpt of another post jibes with the previous underlying message and could validate this hypothesis further. After inscribing her analysis in the American mythologies about various component ethnicities – Eastern Europeans, Italians, Puerto Ricans, Latinos, Jews, Jim Crow, etc. – the blog interpellates the white fellows directly:

> Finally, don't put on a Let's Be Fair tone and say "But black people are racist too." Because of course we're all prejudiced (I can't even stand some of my blood relatives, grasping, selfish folks), but racism is about the power of a group and in America it's white folks who have that power.
>
> (328)

Including the power of language is the fitting textual addendum:

> [s]ometimes they say "culture" when they mean race. They say a film is "mainstream" when they mean "white folks like it or made it." When they say "urban" it means black and poor and possibly dangerous and potentially exciting. "Racially charged" means we are uncomfortable saying "racist".
>
> (353)

In continuity with Hall's theory, the message is that the phenotypical variety of the geomorphic organisms who evince the somato-biological adaptability of the human race is not what is at stake, rather how the sciences and even

language are sequestered to justify and perpetrate the organization of power. Returning to the blog rhetoric, its sagacity reins in the crescendo of passions and harnesses the verbal mordacity of the following blog that introduces Ifemelu-the-polemicist, insistent on unmasking the wily use of language to perpetrate the hegemonic power.

> They would rather not have racist shit happen. So maybe when they say something is about race, it's maybe because it actually is? Don't say "I'm colour-blind," because if you are colour-blind, then you need to see a doctor and it means that when a black man is shown on TV as a crime suspect in your neighbourhood, all you see is a blurry purplish-grayish-creamish figure.
>
> (328)

Here Adichie's strategy adopts a pungent oscillation between the metaphorizing and demetaphorizing properties of language; thus she obtains the effect of *witz* and exposes the mystifying fallacy of the prevailing discourse. The intermittently convenient disappearance of colour-blindness masks the real issue at stake, that is, the only too easy attribution of crimes to the black-skinned. The defect of vision is unconvincing, much more persuasive is the thought that its recourse betrays a discursive ruse to perpetrate the essentializing mindsets based on stereotyping. In the wake of Stuart Hall, Ifemelu is Adichie's word-bearer and targets the recourse to science as the ultimate arbiter to anchor and justify the conversation about race.

A similar impetus infuses the blog titled "So what's the deal?" a critique of the specious medical argument of the incidence of organic affections according to race.

> They tell us race is an invention, that there is more genetic variation between two black people than there is between a black person and a white person. Then they tell us black people have a worse kind of breast cancer and get more fibroids. And white folk get cystic fibrosis and osteoporosis. So what's the deal, doctors in the house? Is race an invention or not?
>
> (304)

In conclusion, a savvy use of paradox, ambiguity, and a controlled instillation of confusion trouble the hegemonic paradigms about race, compound the texture of the online journal and are Ifemelu's elected method to promote critical thinking. Declarations based on her pragmatic realization – "It's my own experience" – ground and guarantee the veracity of her speech – here the subject-ive "I" reclaims the right to be the spokesperson of the choral narrative. Most significantly, her discourse is imbued with humour, the

rhetorical device that Freudian psychoanalysis posits as always already there, saturating the structure of politics.

The lyrical blog

In contradistinction to the previous, a uniquely elegiac tenor filters through the last blog of the novel. At this point of the story, Ifemelu is alone and melancholy because she misses Obinze in what turns out to be a necessary and decisive discontinuity of their affair following her unapologetic refusal to be his lover. Her love brooks no compromise, and she resolutely commands exclusivity. I cite most of the extract that a disingenuously signed "anonymous" commentator opines *"is like poetry"*.

> It is morning. A truck, a government truck, stops near the tall office building, beside the hawkers' shacks, and men spill out, men hitting and destroying and leveling and trampling. They destroy the shacks, reduce them to flat pieces of wood. They are doing their job, wearing "demolish" like crisp business suits. They themselves eat in shacks like these, and if all the shacks like these disappeared in Lagos, they will go lunchless, unable to afford anything else. But they are smashing, trampling, hitting. One of them slaps a woman, because she does not grab her pot and her wares and run. She stands there and tries to talk to them. Later, her face is burning from the slap as she watches her biscuits buried in dust. Her eyes trace a line towards the bleak sky. She does not know yet what she will do but she will do something, she will regroup and recoup and go somewhere else and sell her beans and rice and spaghetti cooked to a near mush, her Coke and sweets and biscuits.
>
> It is evening. Outside the tall office building, daylight is fading and the staff buses are waiting. Women walk up to them, wearing flat slippers and telling slow stories of no consequence. Their high-heeled shoes are in their bags. From one woman's unzipped bag, a heel sticks out like a dull dagger. The men walk more quickly to the buses. They walk under a cluster of trees which, only hours ago, housed the livelihoods of food hawkers. There, drivers and messengers bought their lunch. But now the shacks are gone. They are erased, and nothing is left, not a stray biscuit wrapper, not a bottle that once held water, nothing to suggest that they were once there.
>
> (474)

With exquisite pictorial sensibility Ifemelu composes the verbal portrayal of a tableau of a day's life in Lagos; the palette of colours bristling with vividness is delicately nuanced. The morning glow and the crepuscular light frame in temporality the scene of destruction of the familiar way of making a living, and the marginality of its economics renders human beings all but

expendable. Ifemelu depicts the unlicensed food hawkers as figures of nostalgia, associated to the aromas and flavours she had missed, so much so that on her return to Lagos she found that their cooking originality yielded a more intense pleasure than the highly acclaimed and fashionable restaurants that now were well within her means. If politics inflects the narration, this is no longer conveyed through the "broken" humour" that smiles through tears, since a bitter-sweet sadness has broken through, gained momentum and now infuses the elegiac chant. Also, the musicality of the passage aligns it with the lyrical form, one that the western canon designates to explore romantic feelings and in antiquity was sung with the accompaniment of the lyre. The female vendor who raises her eyes to the sky is the lyrical heroine who maybe Ifemelu identifies with; she is dispossessed and bruised, yet she embodies dignity, and her mindset nourishes fortitude and hope. She does not know what she will do but relies on her resourcefulness, courage, and capacity to produce something new. In the excerpt framed within the scene the woman's gaze turns to the sombre sky which, despite being mournful, is a space beyond the fragments of her present of loss and ruins which, indeed, need to be mourned.

Ifemelu is curious to see what responses the post elicits in the multitude of readers amongst whom she recognizes Obinze's voice in the anonymous comment: *This is like poetry*. Based on this evocative interplay, I propose a psychoanalytic interpretation of the dénouement of the novel that hinges on the polysemy of *poetry* and is my elective signifier, as it appears to transit freely from Adichie to Obinze, to Ifemelu, through to the reader. The etymology of the noun poetry derives from the Greek verb "*poieo*" "ποιέω", meaning "to make", hence the poet is the author-maker of an original artifact, but also the maker of the self by actualizing her imaginative ideation. It describes a veritable epiphany, and to cite Adichie "She [Ifemelu] had, finally, spun herself fully into being" (472).

This sentence speaks to a paper by Winnicott where he states: "The study of the pure distilled uncontaminated female element leads us to BEING, and this forms the only basis for self-discovery and a sense of existing" (Winnicott, 1966). He indicates in *feminine* and *masculine* two constitutive elements of every subject – respectively the *being* and *doing* modes – which in alternation inflect nuanced and complex subjective forms. Theorizing further these dialectical modes and applying them to the origin and source of creativity, Winnicott proposes that states of unintegrated *formlessness* precede the finding of a *form* to contain, integrate, and express them, if *formlessness* is sustained, without anxiously reaching for a premature resolution. It is a truism that the artist needs to invent an idiomatic form, their original cypher, to shape and convey their inspiration: this appears to be the scope of the blog.

To wrap up my interpretation of the unconscious bidirectional destination of Ifemelu's journey, one trajectory leads to the construction of her composite identity, the other towards the search for fulfilment in love. "She had

finally spun herself fully into being", to spin, to weave, to braid, to write a text: these words gesture to the texture of being and the intricacies of her womanly creativity. At long last Ifemelu inhabits her psychic domicile as a situated subject and feels entitled to voice her desires. She imagines further travels across her country, to gather and publicize the cultural traditions whose testimonial word-bearer she wishes to become. Her envisioned itinerant life is coterminus with her writing, wherein her ontological foreignness truly comes to fruition. The writer is the true foreigner – as Kristeva states – and in the question of authorship, which is primarily the making of the self, Chimamanda portrays a character curious, protean, and witty enough to wrestle with the challenge of the encounter with otherness in herself and in the outside world. She endures solitude, learns to stay with and learn from it, en route to becoming a desiring subject who will revisit and remain in intimate dialogue with the stranger within.

To interrogate the political discourse weaved into the text, it could be argued that Adichie's heroine puts her novel to the test of her "local" culture. In the cited interview, in fact, she avers that when the book was first published in Nigeria, she was subjected to moralistic criticism for fictionalizing the reprehensible character of the "husband snatcher", that hurts the readers' sensibilities and goes against the grain of the local conventions of what constitutes the appropriate code of conduct for women. Perhaps, in parallel with Ifemelu, the author puts her own foreignness in the service of her writing and imagines her character as someone who lives beyond the borders of unexamined rules of conduct, which she indeed denounces as hypocritical and constrictive to the point of sacrifice. Parenthetically, I return on this theme – detailed beforehand albeit with a different slant – with the aim to emphasize how Adichie's cultural critique chimes with Freud's perspective on the duplicity of the sexual mores that, if disjointed from love, engender the psychosocial suffering more common amongst women, diagnosed as hysteria (1908).

Attentive work of reading can infer further common ground with psychoanalysis, whose practice aspires to enhance the subject's freedom to embody their full speech that clamours to be uttered but resists being uttered. Freedom informs the method of free association and the analyst's suspended hovering attention, which intermittently pauses on arresting slippages and gaps in the analysand's speech that signal the workings of the unconscious. Moreover a political perspective designates a specialized practice to empower the word to speak truth to power, when the dominant agent speaks an authoritarian internal and external voice.

By way of conclusion, I would like to memorialize Freud's metaphor of the train journey to introduce the "fundamental rule" of free association to his analysands to whom he indicated that, just like abord a train carriage, they could and should endeavour to tell whatever passed through their minds' eyes. Geography and landscape cohere to design subjective geomorphism. A

striking interweaving of passivity and activity – highlighted à propos of masculine and feminine in Winnicott – permeates the semantic halo of Freud's *einfallen* which, unlike its English rendition into *free association*, in German indicates an idea or a word unanticipatedly *fallen* or *happened* in one's train of thought. As it is often the case, this more passive shadow meaning is lost in Strachey's translation of free association in the Standard Edition. However, if we reinsert Freud's original word into the discursive chain, we trouble and complexify the picture of free association and its close reverberation in psychic life. Being receptive to whatever affect, thought, image, or word captivates the subject's attention, and shaping it into language for the addresse vividly depicts a spontaneous generative act that incorporates male and female aspects in a symbolic bisexual unity.

In a similar mode, psychoanalysis and literature join in the conversation which senses the cultural malaise and shapes it into a fitting language to tell. Might this be the veritable achievement of the revolutionary Freudian *Kulturarbeit*?

Note

1 The last few decades have seen a growing interest in the application of psychoanalysis to history, culture and politics. By now intersectionality can rightfully claim to be a specialized field of study that has produced a sizeable body of works where the conflation of paternal function, transgenerational transmission, and the state and psychopathology of the superego are crucial features. Alongside Aisenstien, Delourmel, Freud, Green, Kaës, Kristeva and Lacan – previously referenced – Ruth Stein (*For love of the father*, 2009) and Fethi Benslana (*Un furieux désir de sacrifice*, 2016), to mention just a few, address the perverse, self-destructive and/or masochistic violence aimed at projectively repudiating without substantially modifying the self-hatred and shame at the core of the bond of filiation in post-traumatic history, including (post)colonialization. Conversely, the joke-work evinces that a transformative process has occurred in the intermediate symbolic arena, now accessible and, if undoubtedly there is aggression, this is played out as cutting orality and caustic language. In a chapter on Ghandi, Livio Boni (ed., *L'Inde de la psychanalyse. Le sous-continent de l'inconscient* 2011) deconstructs Ghandi's ascetic body practice of de-emasculation as a form of resistance against the model of virility identified with the colonizer's ideal of phallic masculinity.

References

Adichie, C.N. (2013). *Americanah*. London. 4th Estate..
Adichie, C.N. (2014) Interview with Synne Rifbjerg, "International Author's Stage". https://www.google.com/url?sa=t&source=web&rct=j&opi=89978449&url=https://www.youtube.com/watch%3Fv%3Db8r-dP9NqX8&ved=2ahUKEwiappu4gf-.
Adichie, C.N. (2017) Interview with Christiane Amanpour, CNN. https://ynaija.com/racism-is-americas-original-sin-chimamanda-adichie-says-in-interview-with-cnn/.

Antinucci, G. (2019). D.W. Winnicott: Being and doing, the feminine and the masculine. Silos of difference or nuance of complexity? Panel paper presented at the IPA Congress, London.

Castells, M. (2009). *Communication power.* Oxford. Oxford University Press.

Guarracino, S. (2014) Writing "so raw and true": Blogging in Chimamanda Ngozi Adichie's *Americanah. Between* 4(8)(Novembre/November).

Freud, S. (1905). *Jokes and their relation to the unconscious.* SE VIII.

Freud, S. (1908). *"Civilized" sexual morality and modern nervous illness.* SE IX.

Freud, S. (1927). *Humour.* SE XXI.

Kristeva, J. (1988). *Etrangers à nous-memes.* Paris. Gallimard.

Kupermann, D. (2014). Humour, sublimation and the politics of psychoanalysis. *Free Associations* 15(2):1–15.

WinnicottD.W. (1966) The split-off male and female elements to be found in men and women. *The Collected Works of D. W. Winnicott* Vol. 7, 1964–1966. Oxford University Press.

Chapter 8

The intermittent epiphanies of trauma

The melancholic discourse of the trilingual poet Amelia Rosselli[1]

The arresting stanzas of Amelia Rosselli speak to the theme of the present monograph; her blistering self-presentation in her *Diario in tre lingue* (1955–1956) reads: "*Into the forest of no time/Stranger in your own land*". Tragically lacking a spatio-temporal locus, the subject is lost and cannot come into being. Rosselli's strategy is reiterated in *Obtuse diary* (1954–1968) wherein her insistence on the diary trope conveys the urgency of the conflation of subjective and collective existential predicament: "*Irremediable was the evil of the world/And my own evil with it*" (2018, 55).

This chapter proposes a psychoanalytic reading of selected writings of the trilingual poet Amelia Rosselli who lost her father when she was seven years old. The brothers Carlo and Nello Rosselli were well-known antifascist militants and were treacherously murdered by members of the extreme right-wing terrorist organization La Cagoule, henchmen of Mussolini, in an ambush in Normandy.

Rosselli poetically journeys towards radical forms to articulate the circumstantial conflation of *History* and *her-story*: such vicissitudes foment inextricable personal and societal ordeals in excess of the human capacity to grieve and memorialize. It follows that haunting reverberations also travail language, in need of repair, salvage, (re)sacralization; Rosselli's corpus testifies to the predicaments of the subject of the 20th century, their dislocation, alienation and inner irreconcilable divisions. Poet of the collective "state of alarm", she inhabits an idiomatic "homicile" she elects as a compositionally hybrid place to moor, urged by her fiendishly restless dialectical battle between life and death, at the very margin of language.

Crucial to my study is *Diary in three tongues* (1955–1956), her most autobiographical and veritably self-analytical text. In the *Diary* Rosselli employs modernist strategies to convey the fracturing and destructuring of language that artfully morphs into the locus of her traumata, while also expressing the wound inflicted to the whole symbolic order. Moreover, her idiom foregrounds the structure of politics and inextricably intertwines form and contents to voice the congeries of collective disruptions, her bellicose resistance and passionate choral elegy.

DOI: 10.4324/9781032696959-9

I hope to demonstrate how some of her unconscious memories resurface in her estranged and melancholic discourse which becomes the crucible to modulate her impossible mourning, in a complex commingling of Eros and Thanatos. Rosselli's experimental poetics, based on alternating destruction and recreation of language, guaranteed her psychical survival and established her position as a prominent literary figure of international acclaim. My primary engagement will be with Freud's theory of mourning and melancholia, subsequently developed by Kristeva, who maintains that the melancholic speech finds an outlet in the preverbal and infra-verbal aspects of language – she calls "semiotics" – in dialectic conjunction with the symbolic register.

Parenthetically, close reading of literary texts aligns to the psychoanalytic mode of listening: both are potential avenues to garner surplus meanings, inferentially based on the semantics of prosodic elements and inchoate forms of psychic contents, always already unutterable like trauma, raw affects, mnemic traces, namely, the residual unrepresented and/or unrepresentable.

> *Born in Paris labored in the epic of our fallacious*
> *generation. Laid in America amid the rich fields of landowners and the statal State.*
> *Experienced in Italy, barbarous country. Escaped from England country of sophisticates.*
> *Hopeful In the West where nothing for the moment grows.*
> (*Variations*, [Scappettone 2012], 81)

It is opportune to cite Rosselli's own eloquent presentation and only explicit declaration of her identity to allude to the dialectical movement from the personal to the socio-political which informs her poetics. The French-Anglo-Italian trilingual Amelia Rosselli is the most important and original female exponent of 20th century Italian poetry, whose international standing is corroborated by the extensive scholarship and ever-increasing translations of her output.

Her identity is exemplary international and polyglottal, though she poignantly emphasized that her cosmopolitanism was not elective, owing to the historic tragedies that turned her and her family into refugees. Her diasporic plights put centre stage the question of language(s) and linguistic identity, forever shifting and precarious, even when she dwells in any one language, which is the elective Italian of her mature creative years. I define *shadow language* the motley and problematic longing for one idiom – the trope of nostalgic mother-tongue – whilst being unceasingly inhabited by a plurality of languages which destabilize and disarticulate any chosen linguistic register. Moreover, I propose the term "shadow" for its ambiguity and polysemic capaciousness which aptly conveys the underlying leitmotif of Rosselli's poetics, where languages are the memorial crypt and dwelling of her unmourned lost love objects. Furthermore, the phrase *shadow language* intends

to spotlight the consistent presence of the absent multitudes in her mindset, that create halos of allusions and intersect her interlingual translations.

Amelia shuns all known forms of confessional lyricism, in the name of her quest for an objective narration of universal claim, for she intends to recite the nefarious conjunction of History and her own history. Therefore, her writings bear witness to the destructive force of reiterative traumata that overwhelm the ego resources and impact on the elaborative potentials. On the other hand, these ruptures, together with her exile and multilingualism, constitute the major, albeit tormented, thrust of her poetic innovation. Therefore, her work interrogates and puts to work the psychoanalytic understanding of language, its scope and symbolic possibilities, the traces left by unrepresented experiences as prosodic reverberations, and its status within the psychic world of a profoundly injured subject.

Much as her personal narrative acts as backdrop to her writing, Rosselli's work is not *biographism*, but *bio-graphism* in the literal meaning of the word, which the critic Nelson Moe astutely defines the writing of a life wherein "certainly historically determined formations of personal experiences come to structure the field of possibilities for the practice of writing" (Moe, 1992, 185). Rosselli, in fact, firmly repudiated writers' practice of pouring themselves and their neurosis into their work; rather she recommended they have analysis before committing themselves to writing. Conversely, she draws on the vicissitudes of her biography, the sources of inspiration to legitimize her being the ethically situated witness, tasked to sing a concerted litany. She practiced her staunch commitment to elide the narrative "I" – as she stated in a 1984 interview, published posthumously – "The I is no longer the expressive centre, it is placed in the shadows, or to the side. I believe that it is only in this way that valid poetic and moral responses are reached, values useful to society" (2010, 64).

Rosselli's ethical commitment renders her polyglotism a vector of the dislocation, uprootedness, and estrangement of the subject who inhabits the world (*unheimlich*) that emerged from that dark page of European history culminating in World War II:

> *We count the infinite dead! The dance is almost done for! death*
> *the blast, the swallow lying wounded on the ground, illness,*
> *and hardship, poverty and the demon are my dynamite*
> *drawers. Late I was arriving at pity – late I was lying amongst*
> *pocketed invoices upset by a peace unoffered.*
> (*Variations*, [Scappettone 2012], 81)

Her authorial imagination purports to embody and wail the victims' helplessness, shame and fury, together with her sorrowful indictment of the universal human complicity in perpetrating horror and destruction. She reproduces through sonic mimesis the blow to the symbolic order, renders

the uninterrupted, unremitting rhythm of her verses assaults and dismemberments of language as a symbolic vehicle of human communication, destabilizes it, and locates it on the site of the traumatic void. Thus Rosselli becomes – similarly to Stephan Zweig – the bewildered survivor of the

> world of yesterday: a world collapsed and turned topsy-turvy, that made its children pay the price in full, putting them through the rapids of life, tearing them from their former roots, hunting them, victims and yet also obscurely and guiltily conniving with the mysterious forces of power.
> (Zweig, 1942 my translation)

Rosselli's discourse is inscribed in the context of the modernist preoccupation with the juncture of cultural and subjective malaise, correspondingly featuring in the pages of authors as diverse as Pound, Joyce, Woolf, Stein, Eliot, Beckett, and Celan – to mention only some – who enunciate the foreboding, paralysis, dismay, and despair of humanity, when reckoning with unaccountable destructiveness and evil. These historical vicissitudes are compounded by the blow meted out to the idea – and ideal – of a unitary subject authorized to claim a cohesive "I". Freud debunked this comforting myth as he expanded his epistemic research to include the unconscious, identifications, internal lost objects that constitute the graveyard of the ego, and the impulses which act through and upon the subject with obscure forces and motives. Stream of consciousness, rapid transition from internal to external reality, fragmented and mutually intersecting temporalities, altered grammar and syntax, affectless and empty speech are some of the strategies employed by modernist writers to transmit the rupture, the crisis and the symbolic impoverishment of the world they inhabited, and we inherited.

In *Mourning and melancholia* Freud writes: "Mourning is regularly the reaction to the loss of a loved person, or to the loss of some abstraction which has taken the place of one, such as one's country, liberty, an ideal, and so on" (1917, 243). Melancholia results from the failure of the work of mourning: when the loss is not internalized, the lost object is incorporated and becomes the support of a phantasmatic scenario, which drains emotional investment and meaning from the space shared with others.

Reprising the enquiry into melancholia, Kristeva (1984, 1987) dislodges it from the constrictive psychiatric diagnostic manual and inserts it at the core of language, whose preexisting symbolic construct is inherently predicated on the loss of the reference to concrete thingness. She conceptualizes the juncture where the speaking being enters the triadic structure whereby the paternal symbolic separates from and bars the reverse journey of the *in-fans* to the maternal *Khore*. The melancholia, however, institutes their dialectic, for the semantic level potentially disrupts and destabilizes the symbolic, whilst also enriching and revitalizing it, by preserving its link with the feminine kernel. The semantic halo is carried by the sonic, visual, and multisensorial infra-

verbal properties of discourse and reconstitutes its innovative potential by tapping into the "poiesis", viz, language in the making. According to Kristeva, the *semantic* alludes to what is residual in language, and is always already in excess of symbolic representation.

The global devastation subsequent to World War II put western civilization in a state of shock; the failure of the mourning work instantiated a generalized cultural melancholia, whose literary manifestations are the repudiation, disarticulation, and revolt against the received canons of discourse, coupled with the longing and nostalgia for the "mother" tongue writers like Rosselli and Celan feel dispossessed of. Notwithstanding their unresolvable love and rage towards their murderous native idiom, they feel cursed to use it as their exclusive inspiring source. Authorially organized, their register of orality-aurality is the sonic vector of the melancholia, the traumatic trace and the gordian knot of ambivalence. In a sense, the "world of yesterday" cast a shadow on the world of today and its word, which is infected – and inflected – with trauma and melancholia.

To reprise a previously mentioned theme, it could be argued that Rosselli pursues a measure of self-cure through writing, when she adopts a self-listening position to be receptive to the voices of her unconscious that compound and cradle the muses she invokes. Does she rely on her unconscious as a muse? At any rate, all the inner voices conflate and she orderly composes their messages within the framing structure of the poetic form, as it can be gleaned from the verses of a stanza of *Hospital series*.

> *Seeking a response to an unconscious voice*
> *or through her thinking to find it – I saw the muses bewitch themselves,*
> *spreading void veils on their hands not correcting themselves at the door.*
> (*Variations*, [Scappettone 2012], 125)

The tragic circumstances

Amelia Rosselli was born in 1930 in Paris, where her political refugee parents had fled to safety from the fascist regime persecution. That same year saw the publication of the radical, liberal critique of Marxism, *Socialisme liberal*, which her father authored in French. Carlo was born into a prominent, wealthy Italian cosmopolitan Jewish family, with a long-standing history of political commitment within the libertarian tradition. His mother, Amelia Pincherle-Moravia, was a well-known playwright and author of children's books, who married a wealthy and talented composer, whose penchant for women and high society life was a major character shortcoming and drove him to squander the family fortune and abandon his wife and three children. Carlo grew up very close to his brother Nello, only one and a half year his junior: they both developed into accomplished minds, passionate anti-fascist militants and eventually became Resistance martyrs.

Marion Cave was Amelia's mother, one of five children of a provincial, English Quaker family, the only one who obtained university education. Marion was well versed in languages, was schooled in music and awake to politics, all of which took her to frequent the circle of young intellectual Socialists in Florence, where she met the Rosselli brothers. These were founders of the non-Marxist resistance movement Giustizia e Libertà (Justice and Liberty), inspired by English Fabian and liberal socialist tenets which counted distinguished adherents, such as Primo Levi.

In 1929, just a few years after their marriage, Marion and Carlo were arrested and sentenced to confinement in the penal colony of the Lipari Island, due to Carlo's indictment for masterminding the escape of the socialist leader Filippo Turati, thereupon he turned the trial into a tribune for counterinformation. Carlo orchestrated his escape with Marion who was expecting their second child, Amelia, and whose ischemic heart condition deteriorated through the strain of exile and unmitigated onus of child rearing. Carlo, in fact, spent the greater part of his time abroad on political assignments, which unarguably took priority over his personal and family life. When the Spanish Civil War broke out, Carlo recruited volunteers across Europe to fight against Franco's militias and incited them with the slogan: "Today in Spain, tomorrow in Italy" to ignite their combatant spirit. Soon, however, he reported wounds that compelled him to return to France where Nello visited him, solicited by their mother. The brothers met in a hotel in Normandy, where members of the extremist rightwing terrorist organization La Cagoule, mandated by Mussolini, savagely murdered them. They hacked Nello's body into 17 pieces, gun-shot and knifed Carlo. The Rosselli brothers' funeral in Paris was a grand political event, attended by many prominent figures such as Pablo Picasso, André Breton and Fernand Leger who signed a statement with the closing remark: "The assassination of Matteotti signalled the end of liberty in Italy, the assassination of the Rosselli brothers signals the death of liberty in Europe".

Undoubtedly different from his father for high-mindedness, intellectual, and political commitment, Carlo, however, unwittingly ended up inflicting on his family a destiny of loss and deprivation, similar to what he himself had suffered in childhood. Carlo, too, in fact, left his children in a state of indigence, after devolving most of his estate to Giustizia e Libertà. In an uncanny way, personal, transgenerational, and massive traumatic fates conflated into one dramatic event for Amelia. The demise of the paternal libertarian political ideals heightened her experience of collective loss, as can be gleaned by its figurative reiteration in Amelia's opus. *On Fatherish Men* appears in the collection of poems titled *October Elizabethans* composed in October 1956, where Amelia employs idiosyncratically the mother's tongue to engage with and parody the English metaphysical tradition. Parody is a rhetorical figure, alongside mockery and travesty that Rosselli puts to use as

she revisits the metaphysical lyrical canon, distorts and stretches it to accommodate her politics within the comic form[2]

In *Jokes and their relation to the unconscious* (1905) Freud proposes the dynamic concept of "joke-work" in analogy with the "dream-work": they both rely on condensation and displacement, whose equivalent rhetorical forms are metonymy and metaphor. The comic –comprising jokes and humour, purposefully nuanced – reveals a partial failure of repression that permits the return of the repressed unconscious derivatives surfacing as parody and travesty, in the service of the economy of affects. Thus contained, affects do not overwhelm the subject, who retains a quota of pleasure and mastery. Specifically germane to Rosselli's recourse to the English language is the authoritativeness of a tradition imbibing the figure of the jester. This offers her a capaciously distancing register to articulate her loss in identification with her mother who, in another poem of the same collection, features conspicuously in the reiterated consonant "w" of the word game "window-widow" – "brown windows of widows" – thus Rosselli writes – and the corresponding overdetermined letter "v", which appears twice in the Italian term "vedova" (widowed) and becomes the signifier of absence and deprivation, namely the woman *without* her man.

Cross reference to the meta-narrative essay "Metrical spaces" (1962) is an expedient intertextual insertion to accrue our polysemic reading; therein, in fact, Rosselli theorizes her strategy to convey a conglomerate of ideas through the smallest particle of discursive sound or noise, such as the letter. She proposes that each letter is embedded in an associative ideational chain and is virtually a form of essential ideo-graphic writing. That said, the letters "v" and "w" are, arguably, signifiers of *lack and absence* in the woman-widowed, but nervously and swiftly slip into the defiant tonal revolt against the ambivalent, debased "fatherish" imagoes that condense the polyhedric father, grand-father, literary fathers, and God, thus addressed:

> Great Pompous Ague, and Vapid Arguments do
> they use, to Use you. The Branch is Loaded
> with Ripe Oats, smothered into the Air. With Tinkling fingers I do
> Shake it down. So you would have me 'pon your Knees Quite
> Freely? Pay then First! Then will I Join you
> At the Feverish tree, and sing a song of
> Exstasie (short-cut, 'tis the Youths we Turn to).
> Or would Ye be my Grande-Father? No, too Dulle this proves: An
> Olde Man, well ripe in Lust,
> Or None[...]
>
> (*October Elizabethans*, [Tandello, 2012], 586).

An atmosphere dense with feverish frenzy, ecstatic and violent eroticism infuse the poem, which sets the stage for the representation of the oedipal

scene contoured with anal yearnings. The "grande", (big, ideal, God-like) father is desecrated, portrayed essentially as a lustful old grand-father who perversely exploits and feeds off the youth to palliate his despair and nihilistically satisfy his depravity. The rapid shift from the second to the first person instantiates a *doppelganger*, a confusional mirror game of complicity wherein the omnipotent father and the little girl are mutually contaminated by the ambiguous excitement stemming from the unconscious incestuous fantasies unleashed in a critical juncture of civilization.

Breaking the news

On a tragic day of 1937 the seven year-old Amelia – the "child with no childhood" (*A Birth*, 1962, 657) – and her younger brother Andrea were summoned to the parents' bedroom by their mother who delivered the feral news as a question pertaining to language: "Do you know what the word assassination means?" "We said yes, then all I remember is that we returned together to our room" (Spagnoletti, 1987, quoted in Baldacci, 2007).

I propose that Rosselli's words outline the magnetic field where the disjunction of affects and verbal representation is a process always in the making, at that very point meaning risks toppling into nonsense, time and time again. Being so overdetermined, words undergird tumultuous affects and act as amnesic screen memory that foments the return of the repressed. Rosselli's illuminating interview indicates that her strategies might well be compromise formations journeying back and forth to the amnesic-mnestic trace that vertiginously forges diversified itineraries in language(s) to mask and unmask the otherwise unreachable psychic contents.

> *The lighted beacon which had furthest announced its rainbow joy, is delirious, soulfully*
> *singing rot*
> *into the crashed ears*
>
> (*Sleep: Poems in English*, [Tandello, 2012], 908)

Rosselli's language reproduces *a posteriori* the sensorial clangour whereby the shattering event resonates with shooting noise: "rot" substitutes the "shot" which caused her world to crash, and she metonymically renders into "crashed ears" by displacement, whilst the "rainbow joy" seems but illusory, unreachable. The combined defensive and rhetorical strategy consists of turning passive into active, so that the auditive organ of her perceptive apparatus is crushed by the bewildering mixture of childish jubilation for knowing the word "assassination" and the reality it portends. What remains is the melancholic soulful singing of the "rot" (the Italian adjective *rotto* means broken), the truncated translingual word that carries the psychic and semantic rupture. These *memories in language* gather the fragmented acoustic

traces of the dramatic event in Amelia's inner world, when words disarticulated from the traumatic *thing* that haunted her throughout life, and is always there, ghostly *revenant* overshadowing her body of work.

The internal movements within Rosselli's poetry allow the psychoanalyst to hypothesize the impact the actual trauma had on the psyche of Amelia, whose conscious registration of the experience as-lived-in-time is available only for emotionally dissociated recall, whilst its shocking effect reverberates within the register of language, whose infra-verbal semantics mimic the blow and the attendant disintegration of its very structure, as I will show in my analysis of *Diario in tre lingue/Diary in Three Tongues* (1955–1956).

To return to her biography: after Carlo and Nello were murdered, the Rosselli extended family was subjected to vexation of all sorts and fled to England, a country they discovered disappointingly unsafe and inhospitable. For a time, they moved between Switzerland and France until, thanks to Lady Eleanor Roosvelt's solicitous intervention, they were finally able to migrate to the United States and remain until 1946. During a subsequent brief spell in Florence, the Rossellis discovered that the Italian education system rejected Amelia's American high school diploma, thenceforth she returned to London to complete her education at St Paul's School for Girls and obtain the equivalent. In Amelia's own words, "All the subsequent migrations forced upon me have produced a linguistic dissociation and a permanent feeling of inconsistence" (Interview, Spagnoletti, 1987); her state of diasporic dispossession prompted her reactive striving to reach the minimal essential core in the musical rhythm of language lodged in single letters or syllables.

In London she was fortunate to further her musical education and learned to play the piano, organ, and violin; such scholarship laid the groundwork for her future career as a musicologist and she was able to pursue her interest in dodecaphonic music, specializing in compositions for theatre productions. Music is, in fact, alongside her polyglotism, a crucial tributary of her poetic discourse, which she restlessly disassembles into phonosyllables she conceptualizes as the minimal particles of sound and meaning. Rosselli destroys and recreates the phonosyllables through the infra-linguistic transmutations she calls "semantic short-circuit" that constitutes the distinguishing feature of her poetics. Rosselli's sustained research in the theory of form and composition provides the architectural underpinning of her entire oeuvre and she eventually systematized her scattered notations in the metalinguistic "Metrical spaces" (1962), where she maintains that each word, including articles and prepositions, has the value of idea and needs to be seen in association with its proximal idea. For Rosselli the poetic form is always closely linked to music: each component of speech, down to the singular letter, has a "mental form", tone, colour, perception of the movement of the eye muscle, and this ensemble coalesces into a phrase which has the value of a semantic system. The more intellectual and abstract register of her texts showcases her

ambition to align her stanzas with philosophical Platonism which confers primacy to the idea over the material object. A further and important element of Rosselli's experimentation is her study of Chinese, which she puts to use to attain a highly systematized and intellectualized foundational level of language, made of ideograms or pictograms. When she reduces the conventional grammar to shreds, she strives to create an *ideo-grammar*, where every particle of speech, including articles and prepositions, signifies a thought, albeit inchoate. Exemplary of the condensation of image/word/idea is the "quadro" (square), which in Italian indicates a geometrical figure, a painting, and also a frame: the "quadro" becomes, for the author, the tight metrical structure within which the lines of her stanzas will unfold, all of the same length and, where possible, containing the same number of syllables ("Metrical spaces", 1962).

Fate had in store additional tragic losses for Amelia; when she was 19 and lived for a while in Florence with her paternal grandmother, the sudden deterioration of her mother's cardiac condition caused her untimely death. This second momentous loss reopened the previous fractures and ensued in grievous depression, regression, and symptomatic amnesia. Feeling ambivalently guilty for abandoning her ill mother, but needy of maternal love, Amelia *became* Marion and adopted her mother's first name, childishly wishing to be indissolubly fused with her – as her cousin Aldo recollected in an interview (quoted in Baldacci, 2007). Parenthetically, it is of psychic oedipal significance that Amelia continued to use her mother's name in the correspondence with the psychiatrist and novelist Mario Tobino, who was twenty years her senior. Tobino was married and she could only have him as secret lover; so, by becoming his *Marion* she was externalizing a primal scene and staging equivocal fantasies of incest, seduction, transference enactment and punishment, all at once. Moreover, Amelia's repetition compulsion evinces in her amorous entanglements with illustrious, paternal, and unavailable men, a fact which might corroborate the hypothesis that she had weaved into her identity the polysemic semantics of widowhood. Even considering the flipside, perhaps more unconscious, of the recursive positioning herself as secret oedipal victor, the plural scenarios are still the preserve of melancholia. Ultimately, albeit literary generative, her melancholia caused much existential anguish, but perhaps, posturing herself as a vestal virgin and sacrificing her womanhood on the altar and in the name of her father was all she could manage. Not a negligible achievement, at that!

Four years after her mother died, Amelia endured the premature loss of the young artist and intimate friend, Rocco Scotellaro, that precipitated her breakdown and admission to a Swiss mental hospital, under the care of Ludwig Binswager. She generously and lucidly writes about her mental suffering, somatic ailments, and the attendant infirmity and helplessness, in *Sanatorio* (*Sanatorium*) (1954), a prose poem in French, and *Serie Ospedaliera* – arguably imbibed in Virginia Woolf's pages on illness – (*Hospital*

Series) (1963–1965), composed in Italian. She expatiates on her method of free associations with the dual intent of invoking her muses and allowing free rein to the contents of her mind, the "scommingling" (*Bellicose Variations*, 1964, 75; Scappettone, 2013) of good and bad contents to surface. Besides being advantageous to tap into her creative imaginary, the technique certainly enhanced her self-analytic exploration.

From the 1950s onwards, Rosselli sought psychoanalytic treatment at various times. She consulted a Freudian clinician at first; subsequently she underwent an 8-month Jungian analysis, and many years later she entered further Freudian treatment in Rome. Whilst she acknowledges being helped, primarily to recover her childhood memories which the shock of her mother's death had repressed, she also avers that her analysts steered away from her earlier traumatic experiences, deemed too dangerous for her psychic survival. However, her tragic past re-emerges forcibly in the pages of *Diary in three tongues*, which can ostensibly be read as a piece of self-analytic document.

When her health allowed until 1981, the intellectually omnivorous Rosselli continued to work on her poetry, prose, translations, literary criticism – she wrote on T.S. Eliot, Boris Pasternak, Virginia Wolf, and Gregory Corso, among others – musical compositions and ethnomusicology essays. Besides the aforementioned works, she published in Italian *La libellula*, (*The dragonfly*) (1958), *Documento* (*Document*) (1966–1973) *Diario ottuso* (*Obtuse diary*) (1954–1968), *Appunti sparsi e persi* (*Notes scattered and lost*) (1966–1977), her final long poem *Impromptu* (1981), and in English *Sleep* (1953–1966). When Rosselli became too ill with Parkinson's disease to carry on writing, feeling despondent and utterly abandoned even by her beloved poetry, in 1996 she jumped out of the window of her Rome apartment on the 33th anniversary of the death of Sylvia Plath, whom she had loved and translated, while also identifying with her as the little girl who also lost her father at the age of seven, albeit in less politically dark and dramatic circumstances.

Like Celan, Bettleheim, and Levi, Rosselli's melancholic desire to be dead testifies to the permanence of the traumatic trace, beyond Eros' binding power through words and symbolization, in the face of tragedies that exceed the human capacity to grieve.

Diario in tre lingue – Diary in three tongues

Diary in three tongues (1955–1956) finds a place in the anthology of *Early writings* (1952–1963): it is a lengthy poem of roughly fifty pages and her most overtly autobiographical. Ostensibly its stylistic context is the discourse of the post-war vanguard, nonetheless the *Diary* owes its uniqueness to the (trans)linguistic experimentation and can be read as a platform of Rosselli's perturbing polyphony. The *Early writings* corpus features compositions where English, French, and Italian are employed at times distinctly, at other

times in alternations-alterations-altercations. Her graphic and sonic lexical shifts morph into a hybrid idiosyncratic idiom made of coinages, intentional grammatical errors, and pronoun switches to heightened destabilizing effects. The languages assault one another, interfere with one another, to testify and render sonically the clangour of symbolic destruction. Language being the very locus of trauma, exile, and fragmentation, it curves to yield an eerie atmosphere of spatio-temporal disarticulation, exemplarily suggested by the verses "into the forest of no time, straniero nelle tua terra (stranger in your own land)" (*Diary*, 639).

Undoubtedly, her *bio-graphic* genre bespeaks the subjective–collective dialectic – whose tension embeds her ethical stance – but, just as readily, it anchors the literary construction of her history "pregnant with death", for she situates the marker of her poetic identity in her exercise of part-languages. Largely, French and English confer compositional structural dynamism, however both are often loan translations of the ambivalent and adhesive paternal Italian, which will become the elected language in her more mature works, after a lengthy permanence in English, as the collection of 130 poems titled *Sleep* (1953–1963) illustrates. Notwithstanding, the attentive reader will be alerted to the persistent presence of the shadow languages by the sudden insertion, for instance, in an Italian poem, of a term like "car" which pertains equivocally and simultaneously to French and/or English vocabularies. *Diary* commands the capacity to suspend the search for meaning and be receptive to the words disintegrating into sound, to capture the making and dismantling of signification in language, whereby Rosselli foregrounds how the linguistic sign inherently retains its communication value even at the zero point of signification. The multilayered fissures open windows onto the despair, annihilation and violence that threaten de-symbolization and states of de-subjectivation. Baldacci (2007) suggests that hermeneutic fervour is renounced, as we are invited to wonder what concretely goes on in the text and what poetic itineraries it traces with its continuous recourse to cuts, interruptions, and mutual interference of sound and meaning.

I propose that destabilizing language, stretching it to the brink of meaninglessness, whilst preserving the playfulness which is rooted in the erotics of mockery and nonsense, is Rosselli's way to represent – namely, making present (Scarfone, 2013) – her auditory response to learning about her father's assassination. She stages the oscillatory – and jubilatory – movement towards and away from psychotic de-subjectivation, by mastering its vortex through her poetics, essentially consisting in making the symbolic object-language disappear and reappear. Seemingly, language(s) morph into a fort-da game analogous to Freud's nephew Ernst's invention (Freud, 1920a) and instantiate the effect of absence and presence of the psychic contents lacing the text. Like Ernst further playing the fort-da game in front of the mirror, the author appears and disappears as subject of speech.

Most prominently in *Diary in three tongues* Rosselli's strategies gain traction and aggregate to showcase "the short-circuit of meaning" ("Metrical spaces", 1962) whereby she deliberately subverts discursive representational logic to expose the dramatic and traumatic tension within language and its constitutive violence. In particular, the *Diary* articulates a discourse rooted in the silence and annihilation attendant to traumatic vicissitudes and the violence of aesthetic mimesis can but resonate in the ruinous babel of tongues, to finally break down into the crudity of the signifier, which is the word "son", as I will argue in my close reading.

The following passage is virtually untranslatable, owing to the deceptive French that attentive scrutiny reveals to be a neo-linguistic concoction of puns, plays on words, assonances and alliterations to frame the main thought: "a small necessary autobiographical concept", viz, the murder of her uncle and the unspeakable assassination of her father. The associative chain pivots on the main signifier "son" – point of convergence of the three languages – that condenses different thoughts and meanings: "sound", "his", "son", respectively in Italian, French and English, to finally slip into "sionel",
"Zionel", "uncle Nello".

> *C'est un parterre*
> *parte-guère*
> *partenaire*
> *exceptionelsensationel sans sa*
> *surté (sureté) de s'y*
> *bien trouver « chanson »*
> *« chants on »*
> *chant-son*
> *[…]doublesens*
> *sationel*
> *rationel*
> *sens st sa son Zio Nello (petite notion autobiographic nécessaire auto-bi-*
> *proport*
> *sionel*
> *ZioNel*
>
> *-zijons-y*
> *Haché (accentué) (fuorché) (tronché)*
> *tronqué*
> *tranché*
> *gravitionel*
> *elisionel*
> *desésiliés*
> *recoupé(s) d'un vieux journeau-meussieur la*
> *terrible légende des*

coupés-à-mort en 17 pièces
dépourvoues de vie
(c'est toujours la tragédie qui s'y balance tout en hochant sa tête)
gravement
Nonchalemment
<p style="text-align:right">(*Diario in tre lingue*, [Tandello, 2012], 615–616).</p>

Raw brutal images come into view on two levels: the first is *overground*, where the imagination locates the seventeen fragments of the hacked body of uncle Nello, and fused with it, the father's image, featured in archival document photographs. *Under-ground* there is a crypt, that is the elective place of Amelia's melancholic poetry. The key word is "parterre" (on the ground) which is soon broken down into "parte-guère", to address the cause of such tragic events and their disquieting reverberations in language: "guère", the insignificant French adverb meaning "almost" or "little", by assonance turns into the ominous "guerre", the plural of "guerra", that is, the many "wars".

Rosselli repeatedly revisits the Underworld, wherein she belongs not only as a partner (partenaire) and cohabitee of the shadowed enclave; a more hidden semantic association surfaces when translating from more ancient, unconscious codes. In this instance "partenaire" is etymologically rooted in "parthenos" that in classical Greek denotes the young unmarried woman, perhaps a virgin, according to some translators, such as St. Jerome. I would propose this reading: She, who sings like a son (chant-son), has renounced a life embodied in her feminine self and, through her pen, she shares the fate of the exiles whose choral words fill the head and mouth unremittingly, leaving no gaps, to keep off the abyss, just as the melancholic does, to stage a representation of the phantasy of oral incorporation of the dead object (Kristeva, 1987). Manically and in quick succession, words run fast: "actions in my brain: these verbs, whose celerity resists all pain" (1953–1955, 968).

Rosselli's language carries a paradoxical fate: being itself wounded, menaced, traumatized, and assaulted, it disaggregates, deforms, to then recompose in a tormented dialectic, whilst it defensively assails, parodies, and dissipates the tragic experience, by turning into a joke and a nonsense what is ultimately unutterable, and only doomed to jar in silencing full stop. At the same time, steering away from a possible drift into a romantic idealization of the ineffable, the poet strives to show how the unutterable can only be said through double entendre, semantic polymorphism, even nonsense: such is the armory of the compromise formation straddling the drive to signification and the desire for cancelation.

Diary intimates that language is contaminated by the "sordid History", speech is "soiled and vain", "maudits mots – dits" (*Sanatorio*, 1954, 23–24) (damned, badly uttered words), sullied by fraternal blood and drained of life like their defiled bodies. Everything is duplicitous and partakes of Heaven and Hell; the hankering for a promised land restlessly troubles the stanzas:

"ZioNel" slides into "zijons-y", and gestures to the Rosselli brothers' Jewish identity, recovered in the assonance with Zion – in Italian "zio" is uncle – whilst the French adverb "y", meaning there, configures a utopian promised land, the always already nostalgic elsewhere of the poetic word.

The reiteration of the assonances weaved into the associative chain of "son-zio-zijons-sion" underlines the horizontal brotherly relationship, with ambiguous echoes of generational confusion: son-uncle-believers in the ideal of Zion, the Rosselli brothers grew up fatherless and had a very intimate relationship, to make up for the absence of their father, who abandoned them in childhood. The failure of paternal function they experienced merged into the greater demise of the cultural symbolic structure typified in Mussolini's regime, which perversely murdered citizens and political opponents, and set for the following generations a fatherless, uncertain, bewildered and confused futurity. Once again History and the Rossellis' history conflate and epitomize the cultural crisis, its lawlessness, paranoia, betrayal, and the splitting into friend or foe that characterizes wartime, with its exceeding density of homoerotic and fratricidal impulses. The widespread regression from the level of the differentiating oedipal structure to the amalgam of anal and phallic omnipotent functioning sees the concomitant prevalence of the narcissistic figures of the double, the same, and the twin. Amelia's poetry affectingly reflects how the breach of the symbolic order instigates the confusional relapse into symbiotic sameness, especially in the love poems of *Sleep*, where the reader encounters twin lovers, shifting identities, pronouns, and mirroring doubles. The daughter/son is ensnared in the homoerotic posturing of shape-shifting doubles which becomes a source of erotic, melancholy pleasure in the poetics within the crypt.

Diary makes abundant use of the comic form – condensation, multiple use, reduction, pun – to express dramatic contents, otherwise unutterable: by eschewing the comic effect of laughter, however, readers are not allowed to divert their attention but remain analytically alive to the content, in a back and forth movement towards the locus of (non)representation, in a dialectic of meaning and meaninglessness, "bewilderment and illumination" (Freud, 1905, 13), through which the subject achieves mastery over potentially overwhelming affects. The poet employs free associations in a similar fashion to a multilingual child or analytic patient, and she lets words acoustically call one another, run into one another, with an unceremonious disregard for logic or meaning, in the service of maximizing her "yield of pleasure".

It could be argued that authoring *Diary* was for Amelia the elective, unique pathway to psychically access and remain in the proximity of her tragedy through poetic displacement. The text interpellated then – and still does – a plural addressee, for them to bear witness to the "irremediable evil of the world" that eventuated in the burdensome task of signifying the paradoxical feeling of being the injured victim and at the same time culpably implicated. Moreover, she had understood that her trauma was out of the

reach of her two analyses, hence she deploys the inter-lingual to unconsciously forge, in displacement, new affective and associative trajectories in *the present* to reach some place where before she could not be, when the blow of the news of her father's murder was not even registered. "I do not remember anything" – she states – and her screen amnesia gestures to the lack of psychic encryption of her experience, whose trace remained an abstraction, a word – "do you know the meaning of the word assassination?" Her disquieting feeling innocent and guilty echoes the excess of excitation wherein fear and erotization typically come together for children that may result in inhibition. Conversely for Rosselli, the undercurrent of epistemic verbal passions evincing in *Diary*, knits thing-presentation and word-presentations, by always shifting linguistic registers, consistently moored in an associative field to grant language ludic use of whole and part-words, phonemes, assonances, play on words. This locus of semantic generativity is coterminous with the "potential space of potential function of meaning situated in the pre-syntactical vocalizations of young children before language acquisition" (Winnicott, 1951, quoted in Amati-Mehler, Argentieri, & Canestri 1993, 130).

The short prose poem in English, *A birth*, also included in the *Early writings* collection, further corroborates the contention that Rosselli needed to revisit her childhood – erased from memory by the traumatic shock – through her self-analytical writings. "The child stares. The child is there. The child is gone" (1962, 659) leads up to her inventive restaging of the *fort-da* game (Freud, 1920b) to articulate the loss of father and mother – "cold mother, harsh father invisible" (Rosselli, 1962) – experienced in the register of self-effacement. If lost to the other's gaze, she disappears from her inner mirror, in identification with the invisible father, her only anchoring point, albeit but a vorticose void. Once again, Amelia's words resemble the peek-a-boo game Freud's grandson Ernst plays with his own mirror image, to imitate – and therefore perceive – the object's disappearance and its effects upon the self.

Attempting to recover some fragments, "the child fakes remembrance ... child who regains memory as a loaf of bread is turned, is child with no childhood" (1962, 657). What follows is the only conscious memory of Carlo the reader encounters in the corpus of Rosselli, who avows that she aligns her poetry-making to the memorialization contingent on the mourning-work, albeit only mimetically – it is a "fake" remembrance, an *a posteriori* construction. Unarguably her fictional memoir is a vehicle of emotional urgency, cogent; a deeper psychoanalytic glimpse at the process of faking captures its divalent tenor, in that its analogy with the fabrication of a fetish is symptomatic of the failure of the work of mourning, whilst also being a construction like those made in the *après-coup* temporality of analysis, to enable the subject to inscribe their autobiography in historical and transgenerational sequence. Such nuance of meaning is ostensible in the Greek etymology of

"poetic", rooted in the verb "poiein" (ποιεῖν), signifying "to do, to make". Rosselli is alive to this artistry when she situates her muse in the paradox whereby the paternal figure, truly only an absence, must be (re)created as poetic "fake", to confer timelessness and rescue it from nothingness.

> *If I lay back layers of time, and the man dark simpering and sad with his cracked smile ... If I lay back layers of time I might still render the rage softened by undisturbed love. If I lay back on layers of time I could find Poppy laughing, roaring softly, blurred against the round sky over the steeple chase tower. If I lay back on layers of time fit for murder with laughter collapsing marauding into a new dynasty.*
> (*A birth*, 1962, [Tandello, 2012], 657).

Subjective and universal, grotesquely disfigured by tragic history and exquisitely human, these verses trace the fate of all internal absences, after all the psychic object has always already been lost but can veritably be (re)created by language. There are shades of feelings, subtle mood changes: Rosselli excavates layers of history, but soon lays back on those constructed memories to seek comfort through a soothing repetition of consonants, first a "t", then an "f" ("if I were a town towering or a tower bloody ... why fit a fight with your fist in it? ..." (*A birth*, 660) that echo a rocking lullaby and morph into pleasure, laugher and triumphant mastery. The narrative reads like modernist prose, comprising intersecting pictures, memories, imaging, mentally evoked photographs, and somatic impressions. Within the crucible of haphazard objects emerges the portrait of a lonely and frightened "child narrowing at a window larger, freer, emptier with its wealth ruling over nothing, since nothingness was crammed with brown windows of widows ..." (660). In this passage, once again, the reiterated "w" gestures to the overdetermined signifier of loss and deprivation, the feeling of "being without", observed from a distance, through a window frame.

I propose that Rosselli employs her mother's tongue in the *Early writings* to achieve an ironic distance from her father – and analysts? – and give free rein to her ambivalence, not just towards paternal imagoes, but also towards mother, and womanhood identified with widowhood, through parody and desecration. Moreover, if the combative stance of the later Italian *Bellicose variations* exemplifies Amelia's warring poetry fought in the name of the father – as Moe suggests – the *other*, shadow language, extends the antagonistic field to the name of the structuring father, namely the whole paternal symbolic register.

Although the trilingual experimentations, variations, alliterations, slippages, and cross- contaminations virtually draw to a close with the *Early writings* and subsequently Rosselli uses only one tongue at any one time, the languages in abeyance function as shadow languages, which either contribute to the creation of neologisms – as, for instance, "'pon the Lind page" (linda = clean in Italian) – or form ambiguous figures, as in the case of the title of the long

poem *La libellula*, which is a delicate insect, whose transparent wings allow it a balanced and graceful flight. On the contrary, its English shadow-noun, dragonfly, conveys a sense of foreboding, associated with a flaming monster, which is the ambiguous metaphor for the Justice and Liberty Party, whose devouring mouth wielded its destructive power.

Slipping into *Sleep*

Between 1953 and 1966, Rosselli kept a "little airy-fairy private book" (*Poesia*, 1990, interview, my translation) of 130 poems composed in her own idiosyncratic early modern English, she calls Elizabethan. Her pertinacious reluctance to translate the collection *Sleep* was deep-rooted and, after much working-through and a piecemeal selection, she finally consigned 88 lyrics to the scholar Emmanuela Tandello, working closely with her to render them into Italian. The richly polysemic titular compilation establishes a continuity with Rosselli's earlier poetic strategies based on intentional slippages of the tongue(s), which occur when words attract one another with their acoustic echo, alliteration, and assonance, or when the first verse runs into the second to form an uninterrupted chain. By elongating the "i" sound, slip becomes "sleep", which Rosselli associates to a softer, more feminine space, namely, the province of dreaming and dreams which accesses the associative trace of the unconscious. Additionally, as she slips into English, the poet delves into the maternal symbolic universe, where she finds baroque expressions and creatures of the imagination, such as appeared when "sleep fell on, the reason/went" (*Sleep*, 2003, 938). In essence, *Sleep* engages with Shakespeare and crucially with Hamlet, who becomes a figure of identification for Amelia, like him, the bearer of the filial mandate to avenge the murder of the father. The following lyric articulates the compelling force of her melancholy that saps the symbolic capaciousness of thought and language; once voided, the remainder is a by-product only suited for discharge, without expressive or semantic value. More complexly paradoxical, however, is that the symbolical sacrifice is necessary for the subject not to die.

> *Actions in my brain: these verbs, whose celerity*
> *resists all pain. Tenderness itself is dangerous when*
> *out of claim; quick birds these verbs*
> *do claim ignorance. The black branch of thought*
> *leaves no life to thought; it resists all cankering*
> *with craft, spice, tiresome desires and tries, in*
> *its black fashion that it should not die. […]*
> (*Sleep*, [Tandello, 2012], 968)

Sleep is a narrative of love diversely inflected within the thematic register of passionate and mystical love, after the metaphysical tradition of Donne and

Gerald Manley Hopkins. Demonstrating an excellent knowledge of that canon, Rosselli subverts it through a feminine impersonation of the character of the *fool* who wears the typical three-pointed hat. She hyperbolizes the figure of the Shakespearian jester, conflated into a grotesque parody of the western canon of love poetry, wherein a subjective lyrical masculine ego defines its domain. Rosselli melancholically revolts against and debunks the lyrical male subjectivity, and rather propounds the canon of objectivity – as previously noted:

the terrible transport of love

(a hidden fibre of hate) recovers its
grace, when we slip
by its roaring gate. Do
come rose
dew

kill the cold horse

galloping its mane flying outwards.
(*Sleep*, [Tandello, 2012], 880)

Rosselli's nuclear polyglotism deploys translingual codes to metaphorize her fractured identity, whose punctuating moments of confusion – "radioactive confusion bit into/my brain radiant with multitudes" (934) – clamour for recognition of her internal divisions in the historically situated collectivity. When all is said and done, she can be regarded as a bard of our contemporary sensibilities and, using the comic possibilities of shapeshifting images, pronouns, and genders, her strategy uncannily speaks to the historically situated and universally human being. Moreover, the recourse to the rhetoric of fluidly protean "short-circuit" of sense, which at all time borders on nonsense, interrogates the very symbolic structure of language:

[…]I am his
sister in the navel, he is my prince in the heart,
you are his king in the juice; I am his row of
dominion.
(Poems not included in *Sleep*, [Tandello 2012],
1098)

If the English poems contain farcical declensions of love – which Rosselli parodies and mocks – they also display possessive variations of passion, embodied by the characters of Desdemona and Othello, hence they outline fusional, symbiotic, and ultimately devouring tangles, when they speak of "twin lovers" with their "twin breadths" and reach the apex of mockery in the verse: "To call to love is but to make the name of usury!" (*Sleep*, 924)

with detectable Poundian echoes. Constant remain the presence of word games and the creation of neologisms based on translingual contaminations. For instance, Rosselli proposes the verb "drit to", derived from dropping the "f" of "drift", to coin a neologism through the assonance with the Italian adverb "dritto" meaning "straight to"; she writes the Italian "spine" for "thorns"; uses "gaudy" in a way that acquires meaning in the shadow of the *other* – Italian – language, where "godi" indicates a "lustful pleasure". The literary English of *Sleep* is the ambivalent maternal preserve, she did not consistently practice it in writing even though she retained at all times in the semantic halo of words, even when she eventually elected Italian to be the melancholic language of her loves lost. As it is fitting for the poet of melancholy, the object of desire is always a perduring absence, unlike the trope of the lyrical canon whose impetus evokes its presence. Her rhetorical figures subvert the genre:

In the pale bloom of flower love laid hold of its
impossibility and swam back into the round shaped earth
waving tears of departure into the mist.
<div style="text-align: right">(Sleep, [Tandello, 2012], 916)</div>

Love is represented as a dialogue with an evanescent *Other*; likewise, the I/you differentiation is equally elusive and shifting, in a dizzying carousel of blurred boundaries culminating in arresting separation and loss.

Oh, you sweet heart, oh you condescending
minstrel of my tuberculous heart oh the belly-
ache testifying to my withdrawal in
the field of war. [...]

Oh since you left you wept and felt this
strong tie terminating in exercise of pen
needless to say it was with a hen that he
identified the self – the pen rusting in its
rustic balloon, oval-shaped.
<div style="text-align: right">(Sleep, [Tandello, 2012], 1010)</div>

In these verses the identification with the departed love object is absolute and adhesive – "you left you wept" – but writing contrapuntally introduces a modicum of separateness, it is a "terminating exercise" which could be seen as fueled by an unconscious murderous wish to break free of a deadly embrace, by the "exercise of pen". What remains, however, is a laughter infused with uncanny mockery and self-mockery, as shown by the play on words "pen" and "hen". In Italian, in fact, "hen" (gallina) is the derogatory appellative of an empty-headed, brainless, thoughtless, and gullible female.

The unutterable farewell

Jennifer Scappettone, editor and translator of the bilingual volume *Locomotrix: Selected poetry and prose of Amelia Rosselli*, writes in her comprehensively analytical introduction: "Rosselli's choice to compose principally in a language that would voice the void left by two central male figures in her life suggests that she means to found in language a crucible for the work of mourning – or of melancholy, that less successfully elegiac affective force"(Scappettone, 2012, 17) and references Freud. Close attention to Rosselli's strategy sets the reader on the path of the fate of the internal object that – as Freud states – in melancholia is not mourned, lost, or renounced, but firmly lodged in the internal space where it casts a shadow upon the abject subject's own ego, which is consequently impoverished and mortified, or finds relief by turning grief into aggression (Freud, 1917). Rosselli's unresolved grief emerges in the form of 'bellicose variations' that propel forcefully all her writing and emulate the beat of war through the unremitting dodecaphonic and eerily uncanny rhythm of her verses.

Moe, in his article *At the Margins of Dominion: The Poetry of Amelia Rosselli* argues that her versification is engaged in an unflagging war "in the memory of the father", which employs the weapons of poetry, and in which the subject fights a nameless, indefinite enemy in an uncanny scenario, whose fate is the final implosion of her resources. It is a "warring poetry, poetry as a continuation of war by other means" (1992, 181), conducted on the dual register of contents and form and compounded by the intermingling of Eros and Thanatos, whose revolutionary power subverts, parodies, and dismembers well-established, institutionalized discourse.

> ... But what am I researching
>
> *if the song of weak piety is nothing other*
> *than this invented invective of mine ...*
> *... and that finds no adieu to anyone, and that says*
> *adieu always and to no one*
> (*The dragonfly*, 1958, [Scappettone, 2012], 63)

Inscribed in the text, to lend additional thrust to the dismembering power of her stylistic cipher, grief is not a transformable emotion; sorrow is the "invented invective" and the fast repetition of the "inve" (against) sound turns the weakness of piety (the weakness of the suffering self-proclaimed losers, "i vinti") into an invoked "invective", or an abusive discourse, whose aim is to combat with words. Rosselli's is essentially an *ars oratoria*, which fuses into one selfsame verbal expression the rhetorical form of an argument, an exhortation and a prayer, "in the name of the father", to whom no farewell has been said, nor can it be said. The unuttered farewell is a poetic

unutterable valedictory, if the author-subject is to ward off the danger of suicide. When Amelia was forced to pronounce her farewell to poetry, the ineluctable fate of death was bound to befall her, because her writing is located "behind the curtain of the adieus" (*The dragonfly*, 1958, 63), "la tenda degli addii". *La tenda degli addii* is an overdetermined, recurrent spatial metaphor in her writings, precariously housing her tormented existence, homelessness, and, counterintuitively, also her psychic home, so elementally constitutive of her restlessness. The Italian word employed is "tenda", which means tent as well as curtain. A tent is a lair, a place for children to retrait, play hide and seek, make a pretend home; tenda/tent also shelters wounded soldiers, accommodate armies at war, it is exemplary transient, for death is a possibility at all times, what renders every adieu an uncertain game, "a game of polysyllables". To God – à Dieu – "adieu" is an illusion, a consoling infantile belief, in the face of an absence that cannot be symbolized and is trapped in the circularity of negation, including the denial of time: *no adieu to anyone … adieu always and to no one*. It needs to be added that God instigates Rosselli's revolt, He is the "traumaturgic God" of the later poem *Palermo* (1963, 55): the omnipotent father has been turned into a clown-like and perversely grotesque character by the childlike play on words –the "r" replaces the "h"- but remains an ambivalent object of devotion and invocation. To the psychoanalytic reader of a text that addresses unmourned losses, the notions of cannibalistic phantasies and of the phantasmatic superego are conceptual tools which can be rediscovered in the literary rendition of Rosselli's verses, as they lament:

> *[…]to know that every*
> *piece of your flesh is craved by dogs, behind*
> *the curtains of adieus, behind the single tear of the solitary,*
> *behind the significance that just barely*
> *brings you company if you are alone.*
> (*The dragonfly*, 1958, [Scappettone 2012], 59)

In this excerpt the phrase "behind the significance" substitutes the phrase "behind the curtains (of adieus)" in the following verse, so that the two metaphors condense and overlap. A further inquiry into the etymological depths of the word "significance" reveals its Latinate roots in "signum-facere", that is, "making signs" by detaching the word from its referential and concrete materiality. I would argue that these verses mimic the ambiguous itineraries of language, either towards binding the raw experience to be symbolized, or towards instituting the curtain of dissociation. The drapery authorizes the (un)imaginable and unthinkable cannibalistic scene of corpses torn to pieces by jackals in an unceremoniously funereal ritual meal. Indeed, the "curtains of significance" ("tenda") seems to showcase the crucial dissociation resulting from the vertical split of the ego, whereby seeing and not seeing, knowing and not knowing, saying and not saying, conflate in the

paradoxical generation of the words to say it. This is the psychic fate of trauma, caught up in circular intermittent epiphanies in search of stable signification.

Conclusion

Similar to the polyphony of the chorus at the close of Greek tragedy, whose chant vocalizes the despair and emptiness residual to all violent acts spent, Rosselli's verses pour forth a river of words, in a polylingual associative flow, accompanied by dodecaphonic disquieting rhythms, to testify to the subjectively plural predicaments of the 20th century's world. Like Antigone, Cassandra, and Andromache, Rosselli articulates the helplessness of the victims, their unhealing wounds and scars, their indignation and revolt, so as not to allow the obliteration of silence to set in. By its intrinsic paradox, the libidinal bond with language and poetry is centripetally recovered and reclaimed, time and time again, at the very point of the generation of the signifier, which she captures in the making, through her polylingual verve.

Like Antigone, Rosselli inhabits the burial home of her father and exposes her poetics constituted by a multiplicity of victim and exile selves, whom she keeps alive on the cusp of de-subjectivation. But the chasm closes at the very point of devouring and eclipsing meaning. Her poetics strives to penetrate the inner core of language, only to denounce its precarious existence, on the brink of collapsing into the meaningless and foolishness of destructive and annihilating deeds: the triumph of the negativity of the death drive. Nonetheless, her volcanic passion dialectically intermingles Eros and Thanatos, gives rise to her subversive force to parody and dismember institutionalized and authoritarian power discourse; hers is counter-power fueled and nourished by her only reliable love, her love of phonosyllables.

Notes

1 The author takes full responsibility for the interpretative rendition of the untranslated – and untranslatable – *Diario in tre lingue* 1955–1956 (*Diary in three tongues*). It may be confusing for the reader to see that some extracts are from *Locomotrix*, a bilingual edition of the *Selected poetry and prose of Amelia Rosselli*, edited by Jennifer Scappettone (2012), some from Emanuela Tandello (ed. 2012) *Amelia Rosselli. L'opera poetica*, and one – *Obtuse diary* – from a bilingual selection edited by D. Woodard. To help the navigation I have square bracketed each editor's name and relevant page number.
2 My reading of Rosselli's poetics aligns to the distinction between the contents and the structure of politics, as I outlined in chapter 7 where I discussed my engagement with Freud. The various rhetorical strategies subsumed under the rubric of the comic are the expressive vectors of the human dimension – the Aristotelian Zoon Politikon – that Freud expatiated to comprehend the unconscious, the drive transformations, compromise formations, and their displacement towards sublimated symbolic outlets.

References

Amati-Mehler J., Argentieri S., Canestri J. (1993). *The Babel of the unconscious*. New York. International UP.
Baldacci, A. (2007). *Amelia Rosselli*. Bari. Laterza.
Caporali M., ed. (1990). *Sleep*. Poesie in inglese di Amelia Rosselli. Interview published in *Poesia*, 28 April.
Freud, S. (1905). *Jokes and their relation to the unconscious*. SE VIII:1–247.
Freud, S. (1917 [1915]). *Mourning and melancholia*. SE XIV:247–258.
Freud, S. (1920a). *Beyond the pleasure principle*. SE XVIII:1–283.
Freud, S. (1920b). *A note on the prehistory of the technique of analysis*. SE XXIII:263–265.
Kristeva, J. (1984). *Revolution in poetic language*. New York. Columbia UP.
Kristeva, J. (1987). *Black sun*. New York. Columbia UP, 1989, 1341.
Moe, N. (1992). *At the margins of dominion: the poetry of Amelia Rosselli. Italica* 69 (2):177–197.
Rosselli, A. (2010). *E' vostra la vita che ho perso: Conversazioni e interviste, 1964–1995*. M. Venturini and S. De March, eds. Firenze. Le Lettere.
Rosselli, A. (2012) *Diario ottuso (1954–1968)*. Roma. Empiria.
Rosselli, A.(2018) *Obtuse diary (1954–1968). A bilingual edition*, D. Woodard, R. Antognini, and D. De Pasquale, eds. Seattle. Entre Rios Books.
Scappettone, J., ed. (2012). *Locomotrix: Selected poetry and prose of Amelia Rosselli*. Chicago. Chicago UP.
Scappettone, J. (2013). YouTube, available at: https://www.youtube.com/watch?v=M4oZSf3LI8E.
Scarfone, D. (2013). *From traces to signs: presenting and representing*. In: H.B. Levine, G.S. Reed, and D. Scarfone, eds. *Unrepresented states and the construction of meaning*, 75–94..: Karnac.
Spagnoletti, G. (1987). *Extreme facts: An interview with Giacinto Spagnoletti*. First printed in Antologia poetica. Milan. Garzanti.
Tandello, E. (1997). *Rosselli Amelia. Le poesie*. Milan: Garzanti.
Tandello, E. (2001). Amelia Rosselli. Cortocircuiti del senso. In: B. Frabotta ed *Poeti della Malinconia*, 179–189. Rome. Donzelli.
Tandello, E. (2012). *Amelia Rosselli. L'opera poetica*. Milano. I Meridiani, Mondadori.
Zweig, S. (1942). *The world of yesterday*. London: Viking Press, 1342a.

Index

Footnotes will be denoted by the letter 'n' and Note number following the page number.

Abraham, N., *The shell and the kernal* 41
Adichie, Chimamanda Ngozi:
 Americanah see Americanah (Adichie); autobiographical experience, use of 102; awards for *Americanah* 101; blogs, experiments with 103, 165; foreign observations 31; grief of 146; loss of control of work after publication 102–103; notoriety of 101; prose of 140; reflections on blackness when arriving in the U.S. 102
adolescents, exigencies of 123–127
aesthetics 3–4, 11; and the arts 31; and counter-transference 98; critique 4; enjoyment of beauty 134; of feminine bodies 105; form 1, 3, 54, 99, 135; formal 4; mergers 134; mimesis 192; objects 3, 21; patterns 21; of realism and verisimilitude 92; of repair 4; of Romanticism 18; utility 42; of weaving and plaiting 18, 20
aggression 7, 168, 178n.1; channelling of 30, 40, 163; in *Civilization and its discontent* 24; grounds for frustration leading to 27; inherent in all humans 40; manipulation 91; and neurosis 27; of others 27, 30; recourse to 38, 137–138; safeguarding against 80; self-preservative 95, 160; turning inwards 23; and violence 94
Aisenstein, M. 120–121, 132
Amanpour, C. 166
Amati-Mehler J. 48
Americanah (Adichie) 8, 9; adolescents, exigencies of 123–127; Africanness 111, 135, 139, 147, 152; Afropolitan, portrayal of 103; American versus Nigerian views on medicine 109; belief, structure of 133–136; black characters 69, 101, 102, 104, 106, 109–112, 130, 133, 147–149, 160, 166, 169; blankness 154; blogs 165–168, 169; character of Aunty Uju 105–108, 118, 119, 122, 124, 130, 137, 141, 145, 146, 153; character of Blaine 104, 111–112, 128–132, 135, 136, 147–152, 155, 171; character of Curt 110, 111, 138, 140–142, 150, 153, 155, 166, 168; character of Ginika 107, 109, 113, 126, 140, 141, 150, 151, 155, 160; character of Ifemelu (protagonist) 9, 28, 44, 98, 100–114, 116–119, 121–133, 135–155, 157–162, 164–177; character of Kimberly 109, 110, 142; character of Obinze 100, 101, 103, 107–111, 113–114, 116, 117, 122, 125–127, 129, 132, 138, 141–144, 147–149, 152–155, 160, 161, 175, 176; colonization, collective trauma of 159; curiosity in 98, 100–102, 107–109, 111, 122, 137, 138, 140, 141, 145; depression in 106, 109, 127, 160; desire 100, 102, 105, 107, 113, 116, 117, 126, 129, 131, 132, 136–138, 141, 143, 150–152, 155, 165–167, 177; encounter between Ifemelu and Obinze 107–108; estrangement 159–162; father-figure 119–120; food hawkers 175, 176; genre, analysis of 101; grief of Ifemelu 138, 142, 143, 146; hair

braiding salon 104, 112; hardship of life in America 142–143; hetero-directed/hetero-narrated, feelings of being 167; humour and laughter in 9, 157–179; idealization 107, 137; ideals and the father 121–123; identifications 117; and identity 39; Ifemelu growing up in Lagos, Nigeria 104–107; Ifemelu in America 104, 108–112; Ifemelu wishing to return to Lagos after living in the U.S. 104, 112, 117; Ifemelu's appellative "Ceiling" for Obinze 100, 107, 122, 145, 152; Ifemelu's fellowship at Princeton 104, 136; Ifemelu's return to Lagos 112–114, 116, 139; illegal work theme 108; and lack of father figure 115–156; love 147–156; lust 137, 138, 145; maternal care, Ifemelu's need of 105; mental illness theme 109, 160; mothering 154; novel about race, questioning 102; piecemeal reading of 99; possessiveness in 99, 142; proto conversation of love 153–156; psychoanalytic method in 115, 118; race in 102, 104, 109–111, 161, 165, 166, 168–170, 174; sadism 141; satirical blogs 170; sexuality in 107, 122, 138, 140–141; signifiers in 116, 121, 129, 144, 150, 160, 173; skin-ego 139; skin/skin colour in 102, 109, 110, 150, 153, 173; subjectivation process of Ifemelu 100; subsumed, feelings of being 167; success of novel 98, 101; synopsis 103–104; third person, written in 101; titular Americanah 103; uncanny other 139; US National Book Critics Circle Award 101; yield of pleasure 8; *see also* Nigeria
animal kingdom 17
anthropological narratives 14–15
anxiety 24, 28, 34, 63, 108, 116, 131, 134, 141, 167: archaic 94; castration 83; expectant 112, 130; ontological 62; persecutory 41
Anzieu, D. 76, 89
après coup 48–49, 51, 53, 95, 102, 122; of fiction 160–161, 166; Lacan on 81, 116; psychoanalytic 123, 129; temporality 151, 160, 195; *see also Nachtraglichkeit*

Argentieri S. 48
Aristotle: *Nicomachean Ethics* 25, 82; *Poetics* 82
art/the arts: contributions of psychoanalysis to works of art 98; dispossession of works of art 102; Freud on works of art 1; mutuality between the arts and psychoanalysis 4; pathobiographical interpretation of art object 3; psychobiographical interpretation of art object 3; response to 4; work of culture 31
Attias, K. 4
auteur theory 60
authority: authority-as-dominion 46; inner 158; pact of 43, 120; parental 82, 158; patriarchal 119; rebellion against 158; socio-political factors 65; terminology 164
An autobiographical study (Freud) 13

Baldacci, A. 191
barbarism 28, 29; and civilization 8, 17, 18, 120
Barlow, P. 4
Baudry, F. 99
Beckett, S. 183
belief: and hope 121; need to believe 121; structure of, in *Americanah* 133–136
Bellemin-Noel, J. 60; *Vers l'inconscient du text* 59
Beyond the Pleasure Principle (Freud) 6
Binswager, L. 189
biographism 182, 191
Bion, W. 34
A Birth (Rosselli) 195
bisexuality 26, 27, 178
black community: in *Americanah* 69, 101, 102, 104, 106, 109–112, 130, 133, 147–149, 160, 166, 169; black female naked bodies 144; black novelists 167; genetic variation 174; imagined black U.S. President 128, 130; power dynamics between blacks and whites 141; racism of 173; seen as crime suspects 174; in the United States 128, 130, 135, 139, 142, 149; *see also* race; skin colour
Bloch, Marc 33
blogs: of Ifemelu in *Americanah* 167, 169; lyrical 175–178; satirical 170
Boas, F. 17

Bollas, C. 135, 136, 148
Bonaparte, M. 3
Boni, L. 178n.1
Breton, A. 185
Broca, P. 16

Canestri J. 48
Celan, P. 183, 184, 190
Césaire, A. 47
Christianity 15, 25, 26: the Church 105, 124, 138, 142, 143, 146, 152
civilization 24–29, 79; and barbarism 8, 17, 18, 120; chthonic 124; critical junctures of 187; demands of 22; demands of, submitting to 22; disintegration of acquisitions 83; end of 83, 94; Freud on 6, 11, 12, 13, 26, 30; and German upper classes 18; and *Kultur* 12; malaise of 35, 82, 86; mores of 6; recursive oscillations of 120; and social class 18; superficial layers of 90; technological acquisitions of 22; terminology 11, 17, 18; trajectory towards 26; undermining 13; unraveling of 30; western 184; whole, defining 140; women's contribution to 20, 22
Civilization and its Discontents (Freud) 7, 14–15, 24, 25–26, 29, 40, 134
"Civilized" sexual morality and modern nervous illness (Freud) 12, 13, 19, 21–22, 40
Clinton, Hillary 130
code-switching 172; cultural 171; *see also* cultural codes
Cold War 62, 65
collective unconscious 18
colonial domination 102, 124, 138
colonial hegemony 139
colonial history 64, 113, 121, 123, 159
colonial imaginary 131, 144
colonial legacy 124
colonial subject 123, 159
colonialism 17, 64; expansionism 15, 18; feelings of inferiority 158; ideology underpinning 16–17; institutionalized 124; post-colonialism 9, 33; servility 130; *see also* colonial domination; colonial hegemony; colonial history; colonial imaginary; colonial legacy; colonial subject
colonialization 140, 159, 178n.1

colonization 46, 47, 92; external 153; hegemonic 153; injured manhood of colonized man 119; internal 117, 153
comic register, variation of 168–175
complemental series 14
Controversial Discussions 34
Corso, G. 190
couch, Freudian 1
countertransference 4, 12, 98
"Creative Writers and Day-Dreaming" (Freud) 1
crimes against humanity 29, 41; *see also* Holocaust
cultural anthropology 15
cultural codes 58, 66–67, 139, 172; cultural code-switching 171
cultural space 9n.1, 39, 58, 118, 136
culture: cultural domain 30; cultural work 12; enculturation process 17; failure of work of 26; genealogy of 34; and language 29; malaise of 33–44; *per se* 40; psychic work of 12, 28, 43, 82; of repression 169; and subjectivity 96; symbolic depletion of 138; transgenerational cultural transmission 53; unconscious of 106; Winnicott on 33, 86; work of culture 12, 22, 26, 30, 31, 164; work of the culture 12, 22; *see also* cultural anthropology; cultural codes; cultural space; *Kultur*; *Kulturarbeit* (work-of-culture)
curiosity 40, 51, 144; in *Americanah* 98, 100–102, 107–109, 111, 122, 137, 138, 140, 141, 145; and code-switching 171; "curiosity copulation" 138, 140, 141; "curiosity fornication" 111, 117, 138, 140; drive 107; lack of 161; in *A real Durwan* (Lahiri) 77, 92; and sexuality 122, 137, 142, 144, 145; towards otherness 5; transgressive 64; in *When Mr Pirzada came to Dine* (Lahairi) 56, 57, 61, 64; of women 23
customs 18, 19

da Vinci, Leonardo 3
Darwin, C. 16
daydreams 45, 50, 56, 87, 127
death instinct 6, 144
decolonization 8, 15, 92–93
defence mechanisms 124, 128, 134, 141, 158, 167
de-idealization 165, 168, 170, 171

Delusion and Dream in Jensen's Gradiva (Freud) 1
depersonalization 34
depression 34, 154, 163, 189: in *Americanah* 106, 109, 127, 160; diagnostics 139, 146
desire 30, 85, 129, 193; in *Americanah* 100, 102, 105, 107, 113, 116, 117, 126, 129, 131, 132, 136–138, 141, 143, 150–152, 155, 165–167, 177; analytic 100; auto-erotic 37; autonomous 167; changes in 158; economy of 132; erotic 26; and ethics 7, 8, 141; and fathers 118; female 2, 20, 100, 105, 126; forbidden 20; grammar of 132, 143; and hope 81; and identity 55; idiomatic language of 102; to know 121; and language 56, 102; melancholic 190; objects of 151, 166, 199; of others 152, 155; parental 126; place of 29; and pleasure 15, 135; psychic work, driving 132; repressive regimentation of 24; sexual 26, 132, 136, 141; structure of 131, 132; subjectivity of 19; sublimation of 51; thought-out 138; unmet 113; unruliness of 55
de-subjectivation 35
dominion and subjection 47
doppelganger (mirror game) 187
Dostoevsky, F.M., *Karamazov Brothers* 14
dreams 45, 49, 50, 55, 60, 71, 87, 136, 197; and jokes 161; and the unconscious 162; *see also* daydreams; dream-work; *The interpretation of dreams* (Freud)
dream-work 71, 83, 93, 95, 129; and joke-work 161, 162, 186
drives 7, 68, 93; aggressive 27, 168; conflicting 14; curiosity 107; erotic 168; instinctual 6, 21; libidinal 25, 89, 100; against repressive cultures 20–24; theory 25; and thinking 55; and the unconscious 60, 88, 117; unknowable 27, 116; unruly 13, 27
Durkheim, E. 17

Early Writings (Rosselli): *A birth* 195; *Diary in three tongues* 180, 188, 190–196
École historique des Annales (Febvre and Bloch) 33

ego 26, 87, 88, 91, 94, 200; *auteur* theory 60; bodily 89; conscious 68; depleted 144; developing from the id 36; "ego orgasm" 135, 136; ego-boundaries 134; ego-ideal *see* ego-ideal; ego-mastery 144; ego-syntonic 127, 142; enhancement of 55; and Freud's three structures (id, ego, superego) 11, 88; functions 19; group-ego 95; and humour 163; ideal ego 80; internalized object 37; intimate parts of 121; mastery of 13; and narcissism 36; overwhelming 145; plastic capacity of 45; psychic agency of 19; reality testing 89; signifying 63; skin-ego *see* skin-ego; splitting of 83–86, 92, 124, 201; swelling of 163; synthetic 132
ego-ideal 30, 35, 80, 94, 95, 115, 118, 124, 147; and narcissism 37–38
Elias, N. 20
Eliot, T.S. 183, 190
enculturation 13, 36, 56, 108: markers of 115–116; process of 17, 54, 82
Enlightenment 13, 134
Erikson, E. 152–153
Eros: and Ananke 26; binding power of 190; birth of 132; and death instinct 6; eternal 28; libidinal 130; of life 51; Plato's theory of 26, 137; and pleasure 7, 8; and Thanatos 25, 93, 181, 200, 202; in *When Mr Pirzada came to Dine* 67; work of 7, 8, 45
estrangement, in *Americanah* 159–162
ethical codes 66
ethical norms 165
ethical theorists 21
ethical values 35
ethics 40, 143, 157; and desire 7, 8, 141; and ethos 18–19; etymology 19, 82; motifs of 48; and political resistance 48; and religion 82; of Rosselli 182, 191; *see also* ethical codes; ethical norms; ethical theorists; ethical values; morality

false self concept 91
Family romances (Freud) 51, 54, 55
Fanon, F., *Black skin, white masks* 47, 140–141
fathers/father-figures: as characters and exemplars of complicated mourning 159; and desire 118; father-as-structure

29; and ideals 121–123; lack of father figure 115–156; loss of in childhood 180; perverse and narcissistic 30; place of in mother's mind (Lacan's theory) 23, 115; psychoanalytic conceptualizations of the father 115; structural phantasmatic father 29; *see also* paternal principle
Febvre, Lucien 33
Femininity (Freud) 2
Ferenczi, S. 67, 124
Fetishism (Freud) 83
field research 17
food, significance of: in *Americanah* 175, 176; as signifier 62–65; in *When Mr Pirzada came to Dine* 52, 56, 58, 61, 63
foundation myths 25, 28, 48; anthropological narratives 14–15; *see also* myths
fragmentation 34, 191: institutional 18; psychic 39
Frazer, J.G. 16; *The golden bough* 15
free association 2–3, 178, 190; in psychoanalysis 161, 177
French intellectual discourse 33
Freud, A. 78, 124
Freud, S. 6, 31, 73; and artists/works of art 1, 3; autobiography 5; case histories 3, 116; on civilization 6, 11, 12, 13, 26, 30; "Copernican revolution" 50; educational background 13–14; Freudian disjunction 40; Freud-the-social-critic 12; Goethe prize 1; on illusion *see* illusion; on individual/group psychology 93; lifelong engagement with the humanities 13, 15; metapsychology 11, 14, 34, 93, 144; method as "artist's method" 2; mourning and melancholia, theory of 181; *Nachtraglichkeit* 62, 116; on Oedipus Complex *see* Oedipus Complex; paradoxical feelings when reading Schnitzler's works 6; talking cure 18, 20, 23, 24; as a theorist *avant la lettre* 4, 23; train journey metaphor 177; *Urvater* (ancestor of mythical prehistory) 118, 120; womanhood, examination of 100; writings of *see* writings of Freud; ; *see also* civilization; melancholia; mourning

Freudian couch 1
The future of an illusion (Freud) 12, 122, 134, 165

gaze, the 15, 91, 101, 118, 123, 149; affirming 147; of American-other 68, 69; of beholder 63; benevolent 73; defining, of men 139; estranged 139; foundational, of the other 69; of infant 147, 155; ironic 160, 171; loving 38, 125; of male doctor 21; maternal 122, 135, 155; mutual 38; observing 24; of other 195; perspicacious 110; respectful 143; women's 176
genealogy 38, 63–64, 137; of culture 34; psychic 14, 36
Genesis 27
geography 5, 61, 64, 85, 103, 115, 141; anatomical, of the body and its organs 49; composite, of the mind 126; and homecoming 117; and landscape 71, 177; real 71
Germany: Gymnasium 14; language 12, 178; upper classes 18; *see also* Hitler, A.; Holocaust; Nazi Germany
Goethe, J.W. van 1, 30, 37
Gombrich, E. 42
Green, A. 60, 115, 116, 154; "heterogeneity of the signifier" 60, 116
grief 34, 74; in *Americanah* 138, 142, 143, 146; complicated mourning of collective trauma of colonization 159; joint 81; and mourning work 38; personification 93; and secondary identification 41; turning into aggression 200; unprocessed 81; unresolved 200; working through 45; *see also* mourning
group perspective: group-ego 95; identity 88–89; libidinal reservoir of whole group 38; narcissism and group mentality 37–39; in *A real Durwan* (Lahiri) 93–96
group psychology 36
Group Psychology and the analysis of the ego (Freud) 14, 89–90, 130
Grubrich-Simitis, E. 42, 84
guarantors/guarantees 8, 17; cultural 43; failure of 31; functions of 40; meta-psychic 9, 27, 35, 39, 83, 118, 127; meta-social 9, 35, 39, 127; of privacy 53; of psychical survival 181;

symbolic 83, 85, 118, 119; of transitional psychic space 39–42

habitus 19, 21
Hall, S. 173, 174
Hartog, F. 35
Hitler, A. 28
Hobbes, T. 27, 43
Holocaust 29, 42
homoerotism 26
humour 9; in *Americanah* 9, 157–179; broken 157; comic register, variation of 168–175; and the ego 163; and play 157–158; and pleasure 161, 162, 186; satirical blogs 170; and wit 162; *see also* Humour (Freud); *Jokes and their relation to the unconscious* (Freud)
Humour (Freud) 158, 163, 165
hypnosis 21
hypocrisy 12, 22, 106, 124, 164, 169, 177; of religion 139, 143
hysteria 20, 21, 141

id 11, 13, 19, 36, 87, 88, 163; *see also* ego; superego
idealization: in *Americanah* 107, 137; de-idealization 165, 168, 170, 171; helplessness– idealization 165; Kristeva on 147; and love 128, 147, 155; mutual 155; and narcissism 135, 147, 165; romantic 193; signs of 128
ideals 30, 37, 40, 80, 101, 118, 165; American 127, 143; and beliefs 134; building of 128; collective 133; and fathers 121–123; and passions 137; paternal libertarian political 185; personal 133; *a posteriori* 46; self-ideals 103; *see also* ego-ideal
identifications 3, 19; cross-identifications 40, 98; feminine 104; figures of identification 40; of Freud, with writer 6; group 80; and imago 147; of individual with collective 19; interlinked 99; lost/renounced objects, with 19; markers of 56; mimetic 47; multiple 20, 36; mutual 37, 55; narcissistic 56; with the Other 47; parental imagos, with 9; post-oedipal, with relinquished childhood love objects 38; pre- and infra-verbal primary 19; primary 37, 38, 55, 56; of reader, with a character 92; secondary 41; shifting 53; theory of identification 19, 20
identity: adolescent 126; adult 159; autogenerated 115; and community 28; construction of 20, 40; cultural 18, 37, 69, 86; defining 28, 135; and desire 55; disturbances of 118; ethnic 67, 69, 102, 194; feminine 63; formation of 42, 81; fractured 198; group 14, 17, 30, 37, 38, 88–89, 162; identity politics 101; individual 88, 94; Kaës on 44; markers of 9n.1, 34, 56, 136; and narcissism 15, 19, 55; national 67; and need to believe 121; new 45; and Oedipus Complex 28; paradoxical 38; parental 53, 56; pathologies of 43; personal 55; poetic 191; and postcolonialism 9; pre- and infra-verbal primary identifications 19; process of 30, 131, 152, 154; psychoanalytic theory of 39, 152–153; psychosocial well-being, sense of 152–153; racial 102; representational symbols 30; and Rosselli 181–182; shaping 46; socially situated 91; and splitting of the ego 84; troubled 86, 138; unique 58; work 113; work of 30, 35, 68, 71, 126; of young people 124, 126
ideo-grammar 189
illusion: adieu as 201; affirmative quality, in children's play 134; of completeness 148; debunking of the individual illusion of unity and agency 60; illusion-based faith 165; incantatory 119; loss of 46; of self-aggrandizement 158; and structure of belief 134; of unity and agency 60; utopian 16; and the void 147; *see also The future of an illusion* (Freud)
imago, concept of 106, 147; autocratic boss 121; and identification 147; maternal 107, 154; narcissistic father 119; omnipotent 120; paternal 119, 159; phallic totality-totalitarianism 126
imposture: collective 75, 95; etymology 85; falsifying 50; harmless 75, 85, 92; innocuous 75; and language 92; in *A real Durwan* (Lahiri) 74, 75, 81, 84–86, 91–93; and reframing 91–93
"Impression" writing method 2
India, Partition of *see* Partition of India (1947)

infantile sexuality 3, 54, 59, 98, 100, 102, 144, 145, 158; curiosity drive 107; psychoanalytic orienting frameworks 50; signifiers 57
intergenerational transmission 17, 159
The interpretation of dreams (Freud) 12
Interpreter of Maladies (Lahiri) 9, 45, 49–50; *A real Durwan* see *A real Durwan* (Lahiri); *When Mr Pirzada came to Dine* see *When Mr Pirzada came to Dine* (Lahiri);
intersubjectivity 14, 31, 36, 37
intrapsychic, the 36

Jensen, W. 1
Jokes and their relation to the unconscious (Freud) 157, 158, 162, 170, 186
Jones, E. 158
Joyce, J. 183
Jung, C. 18

Kaës, R. 9, 15, 20, 24, 31, 34–44, 89, 96, 118; on *Kulturarbeit* 28; on meta-psychic guarantee 27; writings 36
Kiefer, A. 120
Klein, M. 34, 41
Kristeva, J. 7, 15, 48, 49, 55, 56–57; on adolescence 133–134; and *Americanah* 101, 118, 121, 124, 129; *Histoires d'amour* 135; on idealization 147; on mourning and melancholia 181, 183–184; *Tales of love* 155; on writers as foreigners 177
Kultur 11–32, 129; in anthropological sense 11; and civilization 12; first mention of word 11; Freud's choice of 18; malaise of 4, 33–44; and nationhood 18; polysemic term 11–12; social contract 22
Kulturarbeit (work-of-culture) 4–5, 7–9, 11, 12, 15, 24, 27; collective 43; failure of 39, 43; *A real Durwan* (Lahiri) 82, 83; societal 96; unraveling of 29; Zaltman on 40–41
Kupermann, D. 164, 165, 170

La Cagoule (terrorist organization) 185
Lacan, J. 7, 23; and *après coup* 116; debunking of the individual illusion of unity and agency 60; influence on French psychoanalysis 18; Lacanian theory 59; mirror phase 47, 147–148, 155; on place of the father 23, 29, 81, 115
Lahiri, J.: ambiguity of English used 46; application of psychoanalytic method 46; on Bengali and English languages 46, 47; birth/early life 46; chanting of mournful songs 31; discovery of cross-cultural, transitional space 47–48; emigration from England to the U.S. 46; engagement with languages 46, 47; ethics and political resistance in writings 48; in Florence 47; on *Interpreter of Maladies* see *Interpreter of Maladies* (Lahiri); love for Italian language 47–48; motifs of ethics in writings 48; political resistance in writings 48; short stories set against Partition of India 8, 50, 55–56, 72, 73, 77, 81, 83; as a shuttle-translator 47; study of Renaissance arts, in Italy 47; titular monograph on self-translation 46; on the universally human 45
laissez-faire writing method 2
landscape 23, 85; exploratory 141; and geography 71, 177; inner 71; nocturnal 71
language 8, 17; and construction of the human being 6–7; and culture 29; and desire 56, 102; detecting the implicit in 16; of dominion 47; Freudian 12; Lahiri on 46, 47; memories in 187–188; multilingualism 182; preverbal and infra-verbal aspects 181; psychoanalytic 120; shadow language 181–182; signification in 191; Smadja on 18; symbolic 88, 135, 183, 191, 197, 198; and the unconscious 7, 59
Laplanche, J. 9, 12, 25, 28, 35, 50, 59, 63, 65, 67; concept of translation 45; critique of Freud 50–51; on sexual death drive 29; theory of seduction 51; translations of Freud's work 33
Laub, D. 4
laughter 164, 170; comic effect 194; cultivating rebellion against authority 158; full-bodied 157; lack of, in fiction 105; and mockery 199; and swelling of the ego 163; *see also* humour
Lear, Jonathan 94–95
Leger, F. 185
Levi, P. 185, 190

libidinal drive 25, 89, 100, 122
listening 181
loss 36, 38, 45, 52, 94, 186; in *Americanah* 106, 124, 125, 131, 136, 138, 143; collective 185; concomitant 88; of control of work 102; current losses 144; and deprivation 196; fear of 125, 131; and feeling lost 78; of feelings of safety 31; of home 28; and humour 161; of illusion 46; in Lahiri's writing 72, 73, 75, 78, 80–82, 93; and mourning 183; murder of Amelia Rosselli's father Carlo and uncle Nello 8, 9, 43, 180, 187, 188; negated 41; of the omnipotent parental imagoes of infancy 165; parental 123–124, 195; of the phantasmatic object 46; in *A real Durwan* (Lahiri) 73, 75, 78, 80, 81, 92; and separation 199; of sexual desire 136; of status and function 106; sudden 50; symbolic 28; transitory, of ego-boundaries 134; of trust, beliefs and ideals 80; unmourned 54, 138, 201; unrecognized 143; of war victims 62; working through, failure of 71, 95; *see also Americanah* (Adichie); grief; mourning; *A real Durwan* (Lahiri); Rosselli, A.
love 6, 14, 21, 23; in *Americanah* 147–156; idealization of 15; objects of 25; in poetry 198–199; proto conversation of 153–156; and sexuality 24
lust 145, 187, 199; in *Americanah* 137, 138, 145, 149

macro-history 8
malaise 24–25; of civilization 35, 82, 86; of culture 4, 33–44, 164; "in" and engendered by culture 42–44; narcissism and group mentality 37–39; transitional psychic space, guarantors of 39–42
Mann, Thomas 1
Marucco, N.C. 96
mass psychology 36
melancholia 158, 163, 183, 189, 200; cultural 184; and mourning 144, 181; and trauma 184; *see also Mourning and melancholia* (Freud)
melancholic encryption 41
Merleau-Ponty, M. 71, 85, 103

metapsychology, of Freud 11, 14, 34, 93, 144
Michelangelo 99; Moses sculpture 1, 3, 98
mirror 149, 150, 187, 191; as dual reflecting device 38; inner mirror 195; Lacan's mirror phase 47, 147–148, 155; mirror images 68; psyche 159; reflections 87; Winnicott on mirror stage 148
Mnemosyne Atlas 42
Moe, N. 182; *At the Margins of Dominion: The Poetry of Amelia Rosselli* 200
Montale, E. 45, 81
morality: etymological roots of 18–19; moral education 105; moral obligation 7; moral responses 182; *see also "Civilized" sexual morality and modern nervous illness* (Freud); ethics; sexual morality
mores 6, 12, 18; contemporary 15; cultural 82; and customs 18; established 170; and ethos 19; hypocritical 106; sexual 177; social 164–165; of society 164
Moses (Lawgiver) 135
Moses and monotheism (Freud) 14
The Moses of Michelangelo (Freud) 99
mourning 4, 5, 47; capacity for 81; collective 43–44; complex 9, 159; failed work of 144; of historic slavery 166; for lost object 96; and melancholia 144, 181; pain of 54; pathological transformations of 95; of Rosselli 181; states of 104; unresolved 61; work of 8, 34, 35, 38, 41, 42, 44, 46, 52, 61, 84, 92, 93, 124, 144, 170, 172, 183, 184, 195, 200
Mourning and melancholia (Freud) 183
multidisciplinary discourse, role of psychoanalysis in 15–20
Mussolini, B. 8, 9, 43, 185
myths: debunking 183; of father of the horde 118; foundational 25, 28–29, 43, 48; Plato's myth 132, 137; use of in analysis of history 120

Nachtraglichkeit 49, 62, 116; *see also après coup*
narcissism 9n.1, 29, 35, 38, 165, 194; chain of primary narcissistic identifications 56; child–adult

nurturing bond 55; detachment 163; ego-ideal 37–38; fraternal relationship 27; and group mentality 37–39; and idealization 135, 147, 165; identifications 56; and identity 15, 19, 55; Kaës on 38, 39, 41; and language 17; of minor differences 37–38, 57, 135–136, 162; narcissistic fusion 89, 135; narcissistic love 27; and object love 26; perverse narcissistic father 30, 119; of small differences 57; structure 41, 147; structure of 37, 55; theory 163; and the unconscious 37, 88
nature versus nurture 16, 20
Nazi Germany 29
neurosis 6, 12, 13, 30, 122, 134, 182; and aggression 27; of artist 3; grounds for frustration leading to 27; neurotic subject 14; structures 86; symptoms 2, 22–23; *see also* Neurosis and psychosis (Freud)
Neurosis and psychosis (Freud) 84
newborn, valorization of 19
Nigeria: blogs 168; culture 154; and decolonization 8; fourth Nigerian Republic 103; military rule 117; Nigerian woman 139; portrayed in *Americanah* 100, 102, 103, 105, 109, 112, 113, 116, 117, 127, 139, 142, 146, 151, 154, 160, 166, 168, 171, 172, 177; vocabulary 139
Norman, H. 48
"A note on the prehistory of the technique of analysis" (Freud) 2

Obama, Barack 128–129, 130, 133, 136; *Dreams from my father* 129, 131, 132
Oedipus Complex 64–65, 82, 116; defining 14; family romance linked to 50, 53, 54, 56; and identity 28; meaning 28; parameters of 58; repression 51–52; structural 14, 28; waning of 36, 52, 68
ontogenesis 14
original sin *see* sin/original sin
Othello (Shakespeare) 198
otherness 30, 68, 82, 126, 161, 177; cultural 15; and curiosity 5; defining 9n.1; diagnosing 173; disregard for 161; foreigner-as-other 68; gaze of the other 195; identification with the Other 47; otherness-of-the-other 150; otherness-of-the-unconscious 5; in *A real Durwan* (Lahiri) 82; of the self 68, 177; and thirdness 115, 126; unconscious 5, 13, 15, 126; in *When Mr Pirzada came to Dine* 68; *see also* thirdness
An Outline of psychoanalysis (Freud) 134–135
Ovid, *Metamorphoses* 47

Palermo (Rosselli) 201
Pappenheim, Bertha (Anna O) 23
Partition of India (1947) 8, 9, 77, 81, 83, 96; *A real Durwan* (Lahiri) 50, 72, 73, 77, 83, 92; *When Mr Pirzada came to Dine* (Lahiri) 50, 55–56
Pasternak, B. 190
paternal principle 30, 106, 115; symbolic father 43, 135, 183
pathobiographical interpretation of art object 3
Perelberg, R. 29
perversion 83
phonosyllables 188, 202
phylogenesis 14
physiognomy 16
Picasso, P. 185
Pincherle-Moravia, Amelia (mother of Carlo Rosselli) 184
Plato: on Eros 26, 137; hermaphrodite story 27; myth 132, 137; *Symposium* 25, 27
pleasure 7, 30, 107, 136; anticipatory 144; auto-erotic 158; and desire 15, 135; of eating confectionary 57, 59, 61, 64; and food hawkers 176; and humour 161, 162, 186; intellectual activity 163; lustful 199; masturbatory solipsistic 145; melancholy 194; narratives 134; of passivation 57; pleasure-in-sadism 141; principle 26; pursuing in and of itself 25; of reading 8; in *A real Durwan* (Lahiri) 77, 87; relinquishing 27; rightful 22; self-annihilating 118; sexual 136, 137, 138, 140, 141, 152, 162, 199; sublimated libidinal 14; voyeuristic 21; yield of pleasure 8, 87, 96, 134, 157, 158, 161–163, 194; *see also Beyond the Pleasure Principle* (Freud)
Podell, D. 4
Poe, E.A. 3

Poesia (Rosselli), *Sleep* collection 197–199
poetry: and blogs 175, 176; Italian 181; love poems 198; melancholic 193; polysemy of 176; of Rosselli 2, 93, 188, 190, 193–196; warring 196, 200; weapons of 200
political conservatism 16
Pollock, Griselda 21
polyglotism 113, 182, 188, 198
polylingualism 3
Pontalis, J., *Freud avec les écrivains* 1
possessiveness 198; in *Americanah* 99, 142
Pound, E. 183, 199
presentism 35
primitive mind 16
projection 41, 87, 89, 121, 154
psyche 2, 6, 41, 43, 60, 124, 127, 132, 159; of artist 3; collective 169; constitution of 36; cultural malaise 164; domination– submission dialectic structuralized within 33; dynamic work of 11; genealogy of 14; of humourist 164; individual and collective 29; maternal 29, 115, 167; objects of libidinal investment 89; preconscious layer of 99; of protagonists in works of fiction examined 9, 107, 123, 131; reverberations of history in 129; of Amelia Rosselli 188; and the social 63, 65; structuring of 46; transformative potential 11; *see also* psychic agency; psychic work
psychic agency 11, 19, 30, 35
psychic pain 34
psychic work 7, 20, 45, 50, 71, 77, 89, 132, 151; centripetal 36; of culture 12, 28, 43, 82; notion of 18, 26
psychoanalysis: anglophone tradition 33; British 34; contemporary attitudes to 3; contributions to understanding of works of art 98; culturally situated 33; essentializing classification of 16; and forms of artistic representation 5–8; French 34; Freudian couch as prime symbol of 1; language 120; listening 181; mutuality between the arts and psychoanalysis 4; psychoanalytic orienting frameworks 50–52; psychoanalytic reading 53, 74, 98, 127, 131, 180; rediscovery of 4; and religion 133; role in multidisciplinary discourse 15–20; temporality of 49; and transference 45
psychobiographical interpretation of art object 3
psychology: border 94; depth 164; group 36, 37, 93; individual 90, 93, 164; mass 36; social 14; *see also* metapsychology, of Freud
psychosexuality 22, 67
psychosis 121

Rabaté, J.-M. 123, 131, 139–140; *The Cambridge introduction to literature and psychoanalysis* 3
race 16, 17, 101, 170; in *Americanah* 102, 104, 109–111, 161, 165, 166, 168–170, 174; versus culture 173; as a floating signifier 173; hegemonic paradigms about 174; human race 173; invention, whether 174; naturalized taxonomy of races 17; in the United States 104, 140, 165–170
racism 110, 166, 172, 173
Rank, Otto, *The myth of the birth of the hero* 54
reading 16, 26, 47; close readings of texts examined 8, 9, 31, 45, 49–50, 68, 69, 157, 181, 192; of Freudian texts 165; piecemeal 99; pleasure of 8; polysemic 186; psychoanalytic 53, 74, 98, 127, 131, 180; reader as the third in a dialectical process 99; space of 91; thematic 39; work of 20, 58, 87, 177
A real Durwan (Lahiri) 9, 49–50; accelerated tempo of conclusion 77; *Believe me. Don't believe me* refrain 74, 75, 77, 81, 85, 90, 92, 93; character of Boori Ma (protagonist), gatekeeper of a settlement 39, 72–88, 90, 92, 93, 95; character of Mr. Chatterjee 80, 81, 86, 95; character of Mr. Dalal 74, 76–78; character of Mrs Dalal 75–77, 86, 87, 95; comment on story 80–81; curiosity in 77, 92; deportation of Boori Ma to Calcutta 73; East Bengali border crossing 74; feelings of being lost and useless 78; group perspective 93–96; helplessness of Boori Ma, feelings of (*bechareh*) 74–76, 78, 90, 93; "Her mouth is full of ashes" description of Boori Ma 73, 75, 80, 81, 95; imposture, concept of 74, 75,

81, 84–86, 91–93, 95; insomnia of Boori Ma 72–73, 75–76; manic defenses 78; monsoon rain 76; nostalgia of Boori Ma 74, 95; otherness 82; Partition of India (1947) 50, 72, 73, 77, 83, 92; physical situatedness 72–73, 86–88; a *real durwan* seen as a man 72, 75; search for a *real durwan* 80, 95; skin, theme of 75, 76, 86, 87, 88, 90; skin-ego of Boori Ma 90; and splitting of the ego 88; synopsis 72–75; temporality theme 77; terminology 72; thematic discussion 81–83; titular *real durwan* 91; two washbasins, significance of 76–77; yield of pleasure 8
reality principle 26
religion 11, 15, 23, 80; ceremonies 114; critiquing 122, 134; dogmatism 114; education 105; elementary forms of 17; and ethics 82; functions 105; help-lessness– idealization underlying 165; hypocrisy of 139, 143; illusory promises of 25, 165; official 133; and possession 142; and psychoanalysis 133; religious needs 25; religious shared meanings 56; and sexuality 142; and structure of belief 133–136; vector of intergenerational transmission 17; *see also* Christianity; sin/original sin
repression 26, 99, 146, 172; agencies 24; in *Americanah* 99; authoritarian 42; culture of 169; and the ego 84; incestuous objects 57; mechanisms 165; oedipal fantasies/desires 62; Oedipus Complex 51–52; partial failure of 186; primary 51; psychic contents 59; repressive hypocrisy of the Church 143; return of the repressed 52, 57, 59, 62, 64, 144, 173, 186, 187; sexual 12, 22, 40, 57; in *When Mr Pirzada came to Dine* 64, 68, 96; wishes 55
Rifbjerg, S. 165
Riviere, Joan 24, 25
Rolland, R. 122, 134
Roosevelt, E. 188
Rosselli, A. 43, 81; birth/early life 184; effect of family murders on 188; experimental poetics 181; and identity 181–182; loss of father at seven 180; mental illness 189, 190; murder of father Carlo and uncle Nello 8, 9, 43, 180, 187, 188; musical education 188; Parkinson's disease 190; pleasure in writings 8; on poetic form 188; poetry of 2, 93, 180–203; polyglotism 182, 188, 198; psychoanalytic treatment 190; rage of 31; suicide (1996) 190; unresolved grief 200–201; writings of *see* writings of Rosselli;
Rosselli, Andrea (brother of Amelia) 184
Rosselli, C. (father of Amelia) 184; Carlo 8
Rosselli, M. (née Cave), mother of Amelia 185; death of 189
Rosselli, N. (uncle of Amelia) 184
Roudinesco, Elizabeth 20

sadism 27, 28; in *Americanah* 141
Said, E. 5, 14; "Freud and the non-European" 15
Sandler, J. 59
Scappettone, J. 181, 182, 184, 201, 202n.1; *Locomotrix: Selected poetry and prose of Amelia Rosselli* 200
Scheduled Castes and Scheduled Tribes 96
Schnitzler, Arthur 1, 5, 6
scientific logos 16–17
Scotellaro, R. 189
seduction 51
semantic, the 184
semiotics 88, 135, 181; psychoanalytic 126
sexual morality 19, 27; "civilized" sexual 100; "double" sexual 22; *see also* morality
sexuality: and affect, in unconscious nexus 62; in *Americanah* 107, 122, 138, 140–141; and curiosity 122, 137, 142, 144, 145; desire *see* desire; female 2, 20, 51, 100, 105, 126; homoeroticism 26; infantile 3, 16, 50, 54, 57, 59, 98, 100, 102, 107, 144, 145, 158; pleasure 136, 137, 138, 140, 141, 152, 162, 199; and repression 40; sexual death drive 29; sexual imaginary 140–141; and thought, co-presence of 55; *see also* bisexuality; sexual morality
shadow language 181–182
signification 48, 129; drive to 36–37, 193; in language 191; layers of 63; of migration 53; Oedipus Complex 28; process of 42, 67; stable 202
signifiers: of absence 186; ambiguous 160; in *Americanah* 116, 121, 129, 144,

150, 160, 173; capturing in the making 202; crudity of 192; cultural 150, 160; elective 176; enigmatic 56; etymological 14; floating 173; food as 62–65; in-group 18; heterogeneity of 60, 116; of infantile sexuality 57; linguistic 17; maternal 76; overdetermined 121, 129, 196; polysemic 86; power 144; of seduction 57, 58; status of 61; in storytelling 54; textual 78

signs: for blogs 168; of civilization 79; of difference 57; gestural system of 38; of idealization 128; making 201; shared gestural system of 38

sin/original sin 15, 27, 166

skin: in *Americanah* 150, 153, 173; colour of *see* race; skin colour; feeling at home inside 153; Freud on 89; metaphorical formation 39; Mohave Indians 90; psychic 43, 75, 85; psycho-cultural 35; in *A real Durwan* (Lahiri) 75, 76, 86, 87, 88, 90; *see also* skin colour; skin-ego

skin colour 56, 68, 69; in *Americanah* 102, 109, 110; and stereotyping 135; *see also* race

skin-ego 42, 53, 76, 82, 85–86; in *Americanah* 139; cultural 88–89; in *A real Durwan* (Lahiri) 90; violating 91; *see also* ego

Sleep (Rosselli) 191, 197–199

Smadja, E. 20, 24; *Freud and Culture* 18

social anthropology 16; French 17; texts 29

social contract 22

social psychology 14

space: absence of 86; for close reading 50; of consulting room 49; cultural 9n.1, 39, 58, 118, 136; empty 72; feminine 197; global 139; intermediate 33, 35; internal 200; metaphorizing 87; narrative 8; narrow 31; open 64; potential 58, 86, 88, 195; private 86; psychic 9n.1, 23; reading 91; for self-refection 86–87; space-in-between 40; thinking 53; transitional *see* transitional space;

The splitting of the ego in the process of defense (Freud) 84

splitting of the ego, vertical 83–86, 92, 124

Stein, R. 178n.1, 183

Strachey, G.L. 9, 12, 22, 25, 54, 178

subjectivity 31, 37, 48, 68, 118; authorial 62; corporeal 89; cultural situatedness 19; and culture 96; of desire 19; feminine 126; of infant 148; male 198; multifaceted 171; psychic habitation of 100; situated 19, 138; vacillating 86

sublimation 3, 18, 48, 165; additional work 135; capacity for 56; and de-idealization 168; in Freud's work 48; of homoerotism 26; labour of 48; psychoanalytic theories of 48; securing adequate performance 64; of sexual drive 22; of writing 54

superego 11, 30, 88, 94, 171; change within 164; cultural 35; disguise 82; ethical norms and repressive mechanisms 165; and Freud's three structures (id, ego, superego) 19, 88, 163; harsh 144, 169–170; and humour 167; intra-psychic benevolent 35; and the law 40; parental authority, psychical representation of 36, 82, 88, 158; phantasmatic 178n.1; protective 66; psychic agency of 19; shaming 65; structural softening 167–168; *see also* ego; id

suspended time 77

symbolic, the 11, 29, 55, 99, 115, 178n.1; bisexual unity 178; capacity 171; culturally symbolic 126, 138, 194; demise of 93; destabilizing of 183; destruction 191; excess of symbolic representation 184; and ideas 133; impoverishment 183; of language 88, 135, 183, 191, 197, 198; maternal 196, 197; meanings 63, 119; murder of parents 123–124, 188; objects 88; reparation of filial tie 132; sublimated symbolic outlets 202n.2; transformational object 132; and the unconscious 59; *see also* symbolic agency; symbolic architecture; symbolic compass; symbolic guarantee; symbolic loss; symbolic matrix; symbolic order; symbolic presence; symbolic principle; symbolic process; symbolic register; symbolic representatives; symbolic structures; symbolic third; symbolic value; symbols

symbolic agency 35

symbolic architecture 126

symbolic compass 34

symbolic father 120–121, 127, 130, 132, 133; paternal principle/domain 43, 135, 183
symbolic guarantee 83, 85, 118, 119
symbolic loss 28
symbolic matrix 115
symbolic order 6, 9, 15, 29, 31, 40, 47, 80, 90, 92, 180, 182, 194; symbolic oedipal order 14
symbolic presence 125
symbolic principle 30
symbolic process 31, 36–37, 42
symbolic register 8, 17, 46, 54, 181; paternal symbolic 196
symbolic representatives 37
symbolic structures 28, 43, 198
symbolic third 28, 126
symbolic value 111
symbols 1, 15, 30, 63; polyvalent functions of 17; representational 30

talking cure 24, 45, 87; and Freud 18, 20, 23, 24
Tandello, E. 192–193, 197
temporality 16, 118, 175; absent 60–61; *après coup* 151, 160, 195; cyclic 68, 72; decentred 116; diachronic 104; diphasic 62; elective 81, 123; Freudian 151; at intersection of past, present and future 64; opaque 72; paradigmatic linear temporality of maturation 47; paradoxical nature of 151; *a posteriori* 62; prismatic, of the unconscious 129; of psychoanalysis 49; in *A real Durwan* (Lahiri) 72, 77; recovery of 96; ritualized 52; structural densities and forms 77; of trauma 66; in *When Mr Pirzada came to Dine* 52, 60–61
Thanatos, and Eros 25, 93, 181, 200, 202
thirdness 31, 115–116, 132; as mental-cultural structure 126–127; *see also* otherness
Three essays on the theory of sexuality (Freud) 25, 51, 158, 162
Tobino, M. 189
Torok, M., *The shell and the kernal* 41
Totem and Taboo (Freud) 29, 37, 118, 120; foundation myths 14, 28, 43
transference 1, 4, 5, 21, 48, 49, 93, 189; objects of 57, 59; and psychoanalysis 45
transferential affects 100

transgenerational transmission 19, 23
transitional space: and beliefs 133; creating 152; cross-cultural 47–48; of culture 39, 129; theory 30–31; transitional psychic space, guarantors of 39–42; *see also* space; Winnicott, D.W.
transsubjective, the 36
trauma: art of 4; art/literature of 42; collective 9; early model of psychic apparatus 50; and melancholia 184; personal 9; tempo of 66; temporality of 66; transmission of 40; trauma-as-dissatisfaction 23
Turati, F. 185
Tylor, E.B. 17

uncanny other, in *Americanah* 139
unconscious, the 2, 6, 16, 33, 36, 49, 63, 138, 154, 161; of adult 51; of artist 98; Bellemin-Noel on 59; collective 18; conflicts 129; co-presence of sexuality and thought 55; covenants 81; cryptography of 19; cultural 17, 18, 35, 82, 106; cultural memory 118; derivatives and wishes 129, 149; differentiating from discourse from gender critique 120; and dreams 162; and drives 60, 88, 117; drives 117; dynamic 27, 71; early triangulation with an imaginary father 155; and enculturation 54; existential threat of annihilation 167; fantasies 14, 50, 51, 79, 143, 145; forms of pleasure rooted in 162; Freud trying to comprehend 202; genealogy of culture 34; Green on 60; groups 82, 94, 95; and guilt 30; hostility 24; and the id 88; infantile sexuality 50; infantile unconscious 2, 25, 158; intersubjective ties 31; and language 7, 59; logic of 78; messaging 59; metaphors 152; and narcissism 37, 88; and neurosis 22; nexus, affect and sexuality in 62; other scene of 5–6; otherness/otherness-of-the-unconscious 5, 13, 15, 126, 145; and overdetermination 125; pacts 80, 88, 90, 92; polysemantic quality of 116; prismatic temporality of 129; of psyche 99; and psychoanalytic reading of a text 98, 145; questioning 55; reasons for actions 167; and scene

construction 144; seduction fantasies 14, 51; societal unconscious strategies 83; somatic 88; subject of 60; of superego 88; a-temporal 68; temporality 121, 129, 131; theory of 4, 13, 21, 82, 87; transgenerational transmission of culture 14, 53; and translation 45; turbulent 27; unknowable 11; in *When Mr Pirzada came to Dine* 59–62; workings of 116; *see also Jokes and their relation to the unconscious* (Freud)
Urvater (ancestor of mythical prehistory) 118, 120

Warburg, A. 42
Warner, Marina 1, 21
weaving 20, 21
weltanschauung (world view) 38, 55, 124
Wenders, W. 120
When Mr Pirzada came to Dine (Lahiri) 2, 8, 9, 49–50; curiosity in 56, 57, 61, 64; daydreams, creation of 56; enculturation process 54; Eros 67; family romances 53, 54–56; food, significance of 52, 56, 58, 61, 63; Halloween festivities 65–69; and identity 39; Lilia (protagonist) 50, 51, 52–59, 60–62, 63–69; non-Indianness of Mr. Pirzada 55–57; otherness 68; Partition of India (1947) 55–56; plot and Lilia's story 52–54; political background 52; shame 64–65; unconscious, portrayal of 59–62; yield of pleasure 8
Wilkinson, G. 2
Winnicott, D.W. 9n.1, 34, 39, 85, 124, 167, 176, 178; on belief 133; on culture 33, 86; false self concept 91; on mirror stage 148; reading with Freud 31; theories 126, 127; *see also* transitional space
wit 102, 110, 162, 164, 172; ironic 31; *see also* humour
women: contribution to civilization 20, 22; curiosity of 23; and desire 20, 100, 105, 126; displacement of sexual desire 23; female sexuality/desire 2, 20, 51, 100, 105, 126
Woolf, V. 183, 189–190
work of culture 12, 22, 26, 30, 31
work of the culture 12, 22
World War II 42, 84
writings of Freud: *An autobiographical study* 13; *Beyond the Pleasure Principle* 6; *Civilization and its Discontents* 7, 14–15, 24, 25–26, 29, 40, 134; *"Civilized" sexual morality and modern nervous illness.* 12, 13, 19, 40; "Creative Writers and Day-Dreaming" 1; *Delusion and Dream in Jensen's Gradiva* 1; *Family romances* 2, 51, 54, 55; *Femininity* 2; *Fetishism* 83; *The future of an illusion* 12, 122, 134, 165; *Group Psychology and the analysis of the ego* 14, 89–90, 130; *Humour* 158, 163, 165; *The interpretation of dreams* 12; *Jokes and their relation to the unconscious* 157, 158, 162, 170, 186; *Moses and monotheism* 14, 15; *The Moses of Michelangelo* 99; *Mourning and melancholia* 183; *Neurosis and psychosis* 84; "A note on the prehistory of the technique of analysis" 2; *An Outline of psychoanalysis* 134–135; *The splitting of the ego in the process of defense* 84; *Three essays on the theory of sexuality* 25, 51, 158, 162; *Totem and Taboo* 14, 28, 29, 37, 43, 118, 120
writings of Rosselli: *Diary in three tongues* 180, 188, 190–196; *Early Writings* 180, 188, 190–196; *On Fatherish Men* 185; "Metrical spaces" 186, 188; *Obtuse diary* 180; *October Elizabethans* 185, 186; *Palermo* 201; *Poesia* 197; *Sanatorio (Sanatorium)* 189; *Sleep* 191, 197–199

yield of pleasure 8, 87, 96, 107, 134, 157, 158, 161–163, 194

Zaltzman, N. 24, 40–41
Zweig, A. 84, 85, 183

For Product Safety Concerns and Information please contact our EU representative GPSR@taylorandfrancis.com
Taylor & Francis Verlag GmbH, Kaufingerstraße 24, 80331 München, Germany

www.ingramcontent.com/pod-product-compliance
Lightning Source LLC
Chambersburg PA
CBHW052133010526
44113CB00035B/2091